WHAT GALILEO SAW

WHAT GALILEO SAW

IMAGINING THE
SCIENTIFIC REVOLUTION

LAWRENCE LIPKING

CORNELL UNIVERSITY PRESS
Ithaca and London

First published 2014 by Cornell University Press

Printed in the United States of America

Library of Congress Cataloging-in-Publication Data

Lipking, Lawrence, author.
 What Galileo saw : imagining the scientific revolution / Lawrence Lipking.
 pages cm
 Includes bibliographical references and index.
 ISBN 978-0-8014-5297-0 (cloth : alk. paper)
 1. Literature and science—History—17th century.
2. Europe—Intellectual life—17th century. 3. Science—History—17th century. 4. Galilei, Galileo, 1564–1642—Influence. I. Title.
 PR149.S4L56 2014
 001.09'032—dc23 2014017110

Cornell University Press strives to use environmentally responsible suppliers and materials to the fullest extent possible in the publishing of its books. Such materials include vegetable-based, low-VOC inks and acid-free papers that are recycled, totally chlorine-free, or partly composed of nonwood fibers. For further information, visit our website at www.cornellpress.cornell.edu.

Cloth printing 10 9 8 7 6 5 4 3 2 1

❦ CONTENTS

� ILLUSTRATIONS

✍ PREFACE

What Galileo saw, when he looked through his homemade spyglass at the sky, has been a source of fascination and hindsight for 400 years. It brings together an intimate, private act—one man's effort to make sense of the flickering images in his eyes—and an earthshaking historical event—perhaps the making of the modern world. Something important happened then, as everyone agrees. Yet every aspect of what occurred is subject to interpretation. No one can ever know exactly what Galileo saw, of course, and the evidence that he provided, in skillful wash drawings and etchings as well as verbal descriptions, could never record his first impressions directly; instead he offers his later reflections on them.[1] Nor does the significance of what he saw speak for itself. If Galileo started a revolution, the meaning of that revolution has not yet been settled.

Even the phrase "what Galileo saw" can point in different directions. An emphasis on the "what" highlights the heavenly objects of his vision: the patchy, shining face of the moon, the countless stars that decompose the Milky Way into individual dots, the moons of Jupiter, and later the phases of Venus and spots on the sun. Scholars have taken pains to show how well these observations match the photographic evidence of later times. But Galileo's discoveries extended much further. They opened a universe of boundless unknown possible worlds, explored by ever-improving instruments in a farsighted future. In 2003 an essay by Michael Benson told the story of the Galileo Orbiter, which after touring the solar system found several new moons of Jupiter and took close-ups of Europa before crashing into the planet.[2] The title of the essay, "What Galileo Saw," suggests a continuity between the man and the spacecraft, as if the orbiter had refined and completed his mission. This was what Galileo began long ago with his own explorations.

Yet an emphasis on what Galileo *saw* might lead to different conclusions. Other observers, using their naked eyes, had already noticed some spots on the moon and the sun. When Dante is transported to the moon, in canto 2 of the *Paradiso*, he can hardly wait to ask Beatrice, "What are the dark marks on this body?"[3] With the aid of his spyglass, Galileo perceives those spots much

more clearly, of course. But the crucial point for him is that, unlike Dante, he knows, or comes to know, that the moon is a body much like the earth, so that the dark marks are not anomalies of an unearthly, spotless sphere but topographical features, analogous to valleys in this world. Familiar with the art of perspective, Galileo sees things in three dimensions.[4] What he makes of those things, however, depends still more on a set of underlying assumptions, at once the product of a Copernican worldview and a confirmation of it; the eyes and the mind work together. In this respect the definition of seeing seems very complex. The scare quotes in I. Bernard Cohen's "What Galileo 'Saw' in the Heavens" acknowledge that what someone sees cannot be taken for granted: "the raw data of sense experience," those spots on the moon, came into focus only when they were transformed into "a new concept: a lunar surface with mountains and valleys."[5] Observers who resisted that concept also denied that they saw anything resembling Galileo's moonscapes. Some doubted that the spyglass worked; others suspected that Galileo's imagination had led him astray.[6]

Surely those doubters were wrong. But it was not wrong to link the new phenomena in the sky to the power of imagination. In retrospect the truth of what Galileo saw may seem so irresistible that only a fool or fanatic could disbelieve it. Yet to accept his vision at the time required a bold leap of faith. When Johannes Kepler quickly endorsed Galileo's findings, even before he had looked through a spyglass himself, he admitted that such a rush to judgment might seem rash, but his eagerness to embrace new ideas drove him to imagine much more than Galileo had vouched for—for instance, he guessed there were inhabitants on Jupiter as well as on the moon.[7] Kepler's own sparks of vision predisposed him to put his mind's eye at the service of a magnified Copernican cosmos; he did not need an instrument to see that. To be sure, he also insisted on precise and time-consuming calculations. Both Galileo and Kepler pictured a universe composed of mathematical figures, presided over by its Creator, a master geometer and engineer. But that picture drew on conjectures and intuitions, not only on what could be measured. Both men often fell into error when they tried to impose their mental images on the world. Galileo, a maestro of motion, was sure that motions of the earth explained the tides, and Kepler, who found patterns everywhere, arranged the solar system according to Platonic solids or Pythagorean harmonics. At times their visionary casts of mind led them too far. Without such leaps into the unknown, however, the truths and laws that they discovered would likely have been much harder to perceive. The observations that changed the world were shaped not only by what could be seen but also by insight and foresight.

A similar double vision can provide a perspective on the Scientific Revolution itself. From one point of view, its history might seem a straightforward record of progress, as modern science dramatically replaced the myths and fallacies of earlier ages with objective facts and verifiable theories. But that oversimplified story tends to brush over the to-and-fro of what actually happened, as well as its later reception. Each break with the past left a trail of lingering, unresolved issues. In some fields, such as medicine, many seventeenth-century European assumptions and practices might even be viewed as regressive, compared with the expert knowledge of some medieval Arabian clinics.[8] Sometimes science leaps backward or sideways rather than forward. Selective memory distorts the character of previous achievements, and some apparent revolutions are merely renewals. Nor do breakthroughs in understanding arrive at a steady, predictable pace. The record of scientific advances charts a line of zigzags and swerves, as observers suddenly grasp the implications of what they have seen. No history can afford to ignore what Keats called the "wild surmise," the flash of amazed recognition.

Those visions also mark the process of discovery. To see the moon anew, to see the world anew, hard facts and better instruments are not enough; one needs to know how to see. Galileo created a story about his perceptions. While he rejoiced at the sights that he alone had found, the message that he first conveyed insisted above all on the accuracy of his account. The naked eye was not dependable; its illusions required correction by his own cool head and well-adjusted lenses.[9] But the revolution in which Galileo took part depended on something else as well. "What is now proved was once, only imagin'd," according to William Blake,[10] and someone who turned conjectures and dreams into matters of fact had to master both ways of thinking. Galileo imagined a solar system long before he could hope to prove it. The process continues today. The Scientific Revolution consists not only of a series of events but also of a series of stories, created at the time and revised ever since. Its significance changes whenever a new school of thought fastens on a different aspect of science. During the last fifty years, views of the Scientific Revolution have shifted with dazzling speed. What people saw then, what people see now, depends on the kind of story they might choose to tell.

This book takes those competing versions as its point of departure. By paying attention to stories as well as events, it opens a bridge to the past, when people tried to puzzle out what their work meant. The puzzles remain; in the twenty-first century, many have not yet been solved. Some of Kepler's geometrical models, for instance, anticipate fractals and other as yet unresolved explorations of chaos. In this regard the last page of the story has never been written. The revolution in science goes on, connecting the past

with the present and future. It passes through many dimensions; it moves through time as well as space, and keeps shifting shape. This book tries to follow that back-and-forth, multidimensional medley of stories. Resisting two temptations—the historicism that treats early science as immured in its own time, and the teleology that treats it as the embryonic form of our own full-grown and consummate science—my analysis traces the living relations between what was thought then and what is thought now. Again and again it asks two interpenetrating questions: How did seventeenth-century natural philosophers and natural historians imagine the new world-pictures and books of nature that they constructed? And how has posterity imagined them, right up to the present day?

The answers to those questions are the heart of this book. Collectively they try to bring fresh life to a history that sometimes seems to have been theorized out of existence. No single answer or theory can possibly offer a key. The Scientific Revolution has been imagined in any number of different ways, and people who look through the telescope and the microscope visualize things that have very little in common. Hence each chapter of this book addresses a different set of problems, which vary according to what is observed and who has observed it. At the same time, however, each chapter consistently faces two ways: toward the formation of early scientific ideas at a time when they still were forming, before they had been accepted and codified and turned into "science"; and toward the later narratives that eventually shaped those ideas into precursors of modern thought. The advancement of learning that Francis Bacon defined requires both perspectives. It takes in individual ventures and thoughts in the days when their implications had not yet been given a name, and it also survives as a twenty-first-century story whose reverberations might still have some power to make sense of the world.

That story brings heterogeneous issues together, and any book that wants to respond to its full scope cannot be content to fix on any one science or any one point of view. Many histories equate the Scientific Revolution with striking changes in cosmology, as if the heavens superintended life on earth. That is a plausible thesis, but it ignores developments in other fields that may have been just as important. Bacon, who fathered the revolution in England, never accepted Copernican theory.[11] Practical knowledge meant most to him, and in the long run, advances in engineering, natural history, and the life sciences might affect lives more deeply than astronomical speculations. A history that charts such pursuits will have to make room for people who paid little attention to the grand scheme that Galileo saw. This book tries to do justice to the plurality of views in an age when "science" did not imply any unified method or practice. While some of my chapters turn an eye with

Galileo toward the heavens, others stay close to earth, keeping watch on the fall of a snowflake, a flickering breath, or the embryo of a frog.

Nor does this book admit any rigid distinction between science and art. During the early modern period, scientific theories were often spun out in verse or rendered in pictures. Lucretius's great Latin poem *De rerum natura* (*On the Nature of Things*, ca. 60 BC), rediscovered in 1417, served as a model for atomists and other natural philosophers well into the seventeenth century. A love of poetry runs through the nimble prose of Galileo, Kepler, Bacon, and Descartes, whose worldviews were expressed in stylish dialogues and speculative fictions. Bonds to science were drawn still tighter by the visual arts. Fields such as natural history and anatomy could hardly have developed without illustrations; in *De Humani Corporis Fabrica* (*On the Fabric of the Human Body*, 1543) Vesalius famously coordinated pictures and text. And the works that brought the new philosophy home to the public depended on art. Galileo taught viewers to see the new heavens in his own drawings, Descartes explained the clockwork of his universe by sketching its gears and springs, and Robert Hooke's tiny world came alive in the spectacular designs of *Micrographia*. From this point of view, the Scientific Revolution succeeded largely as a training exercise in how and where to look.

The structure of this book responds to its dual perspective. Each chapter moves from specific events toward their historical repercussions—from seeing to believing—and each tells a story about the efforts of thoughtful people to make sense of what they saw. Those stories embody ideas about the natural order; about the authority of the ancients; progress; living creatures; life and death; standards of truth; the place of human beings in the cosmos; the outsize strokes of individual genius; and the possibility of understanding how the world was made. The questions such stories raise have never been settled. Their twists and turns, their appeals to imagination, continue to drive the ways we think about science and art. In this respect the history and meaning of the Scientific Revolution, evolving across four centuries, mirror the choices and conflicts of modern times.

Many stories remain to be told. This book passes over some plausible views of seventeenth-century science and art. Through its focus on major figures, for instance, it tends to neglect the host of coworkers, as well as the institutions, that made the Scientific Revolution grow. The particular social, political, and religious contexts within which the new philosophy arose, and the networks of communication that spread the word, receive only scattered attention; nor does this book pretend to trace the internal logic of scientific advances. Excellent scholarship has been devoted to all those perspectives. But this book attempts something else. In its style as well as its substance, it

tries to imagine a world in which science and literature and art are not locked in separate compartments. The Scientific Revolution brought about new kinds of discourse and new kinds of art, and often one person mastered both kinds. Such doers and thinkers straddle the lines that later eras have drawn; to see what Galileo and Bacon and Kepler and Descartes and Hooke saw requires some attention to what they imagined. That story has seldom been told. By carrying messages across the boundaries of disciplines, it serves to remind us that past times were different from ours. In seventeenth-century Europe, philosophers and historians of nature kept company with artists and poets, and their conversations helped to transform the world. To bring them together once more is the aim and the hope of this book.

🍎 ACKNOWLEDGMENTS

This book has been slowly growing for a very long time. Its seeds were planted in my earliest years as a scholar, when conversations with Erwin Panofsky and Marjorie Nicolson—figures already legendary then—brought home to me the bonds between the arts and sciences. Perhaps a literary scholar could find fresh things to say about the Scientific Revolution. During two decades at Princeton, I often had the opportunity to talk with Charles Gillispie, Thomas Kuhn, and John Wheeler, whose wide-ranging interests all spanned the usual academic disciplines. Later, the Science and Human Culture program at Northwestern provided a forum where humanists and scientists exchanged ideas, and where my colleagues Claudia Swan and Ken Alder helped me to think again about what the arts and sciences might share.

Along the way I have been aided by some generous support from institutions. The first glimmerings of this book emerged during a term as a Fairchild Fellow at the California Institute of Technology. I began to draft chapters as a Fellow at Northwestern University's Kaplan Center for the Humanities, and continued during a residency at the Bellagio Center of the Rockefeller Foundation. An Emeritus Fellowship from the Andrew W. Mellon Foundation, as well as a term as a Visiting Fellow at Clare Hall, Cambridge, enabled me to carry the project through. And I applied some finishing touches as M. H. Abrams Distinguished Visiting Professor at Cornell University. I am grateful for all these favors, not only for financial assistance but also for the intellectual communities they helped me to enter.

My debts to the students whom I have taught in many courses on the issues of this book, and from whom I have learned so much, are too great to be counted. Best of all were the occasions when young people from opposite ends of the campus came together, bringing habits of thought from many different fields, and found that someone else's perspectives could change their minds as well as the mind of their teacher. Many of the chapters of this book were born in a classroom. In addition, many were first formulated as lectures. For ten years, as a Phi Beta Kappa Lecturer, I traveled around the country,

gathering shrewd responses and searching questions, which often became my own. My ideas have also been clarified through talks and exchanges at the University of Notre Dame, the University of Virginia, Northwestern University, the University of the South, the University of Chicago, the University of California at Santa Barbara, the University of Reading, the University of Cambridge, and Cornell University. This book represents the meeting—and sometimes the collision—of a great many minds.

Any number of people, too many to credit or to remember, have lent me a helping hand. Jessica Keating and Samuel Y. Edgerton read and commented on the manuscript as a whole. David Bevington, Paul Breslin, Julia Douthwaite, Christopher D. Johnson, Peter Sacks, and William West offered advice on individual sections. Robert Ackerman, Stanley Bill, Peter Dear, Alan Donagan, Freeman Dyson, Patricia Fara, Jeffrey Garrett, Reginald Gibbons, Owen Gingerich, Daniel Heller-Roazen, Rob Iliffe, Nick Jardine, Christopher Lane, Seth Lerer, Heather McHugh, Martin Mueller, Guy Ortolano, Sylvie Romanowski, Simon Schaffer, Richard Streier, Noel Swerdlow, and Helen Thompson have all assisted my project. And my wife, Joanna B. Lipking, posed questions that kept me from thinking I had all the answers, even while she provided unfailing support.

WHAT GALILEO SAW

CHAPTER 1

Introducing a Revolution

The Disenchantment of Nature

On Christmas morning of 1629, John Milton, just turned twenty-one, conceived his first great poem, the ode "On the morning of CHRISTS Nativity." As a birthday present for Christ, the poem recreates the dawn of a new dispensation: the whole world is struck with amazement and celebrates the infant God in his manger. But the climax of the ode turns away from the Babe and pictures the global consequences of his coming. What happened in that dawn? The disenchantment of nature. As soon as the child is born, "the aged Earth" begins to shake, and the pagan deities are flushed from their homes in rivers and hearths and shrines and trees. The new truth hurts; the old gods have to go.

> The lonely mountains o're,
> And the resounding shore,
> A voice of weeping heard, and loud lament;
> From haunted spring and dale
> Edg'd with poplar pale,
> The parting Genius is with sighing sent,
> With flowre-inwov'n tresses torn
> The Nimphs in twilight shade of tangled thickets mourn.[1]

The "Genius" or Spirit of the Place melts away, while ghosts descend to their "infernall jail," and a murmur of sorrow sweeps through the emptied landscape. Hence a curious wailing and whining take over the birthday. Joy to the world! the poem says, but the reader also feels that some part of the world has died.

The poet himself, as a Christian, allows no regrets. When the ancient fables vanished, they made way for truth, and no one should miss their fanciful mumbo jumbo. Sensible people bade good riddance to nature worship, to dryads and sylphs and lares and fairies, a long time ago. From a skeptical, modern point of view, Milton's eviction notice might well be considered somewhat belated, postdated 1,629 years. It was at the beginning of Christian time when nature learned that "her part was don," according to the poem, "And that her raign had here its last fulfilling." Why should this disenchantment still seem like news?

As a matter of fact, it did have news value in Milton's time. Though the heathen gods had long since faded, the notion that Nature herself was a goddess—full of intentions and purposes, vital and sentient—continued to flourish. Milton personifies her as a wanton woman in "naked shame," polluted by original sin. Yet poets could hardly resist her charms, and many other people also accepted her reign. "Thou, Nature, art my goddess"; as late as Johnson's *Dictionary*, in 1755, Edmund's words in *Lear* exemplify the first definition of "Nature": "An imaginary being supposed to preside over the material and animal world." But the last definition (number 11) is "Physics; the science which teaches the qualities of things," illustrated by Alexander Pope's familiar epitaph for Newton: "NATURE and Nature's Laws lay hid in Night. / God said, *Let Newton be!* and All was *Light*." By then the world had changed. It was no longer moved by godlings and godkins, or even by the Love that Dante thought had power to move the sun and stars, but by impersonal forces like the laws of gravity and thermodynamics.

The change had begun almost the moment Milton was born. Just in that year, 1608, word started to spread of an amazing new invention, the spyglass, later called the telescope. The following year Galileo pointed his upgraded homemade spyglass at the night sky, and the moon and the sun and the planets and stars would never again be the same. If any one date can be said to open the Scientific Revolution (all such dates are controversial, of course), a majority vote might settle on the Ides of March in 1610, when *Sidereus Nuncius—The Starry Message*—revealed what Galileo had seen. Immediately the closed and stable universe began to crack. The cracks were still widening two decades later, when Milton wrote his Nativity Ode, and they gaped beyond repair a decade after that, when he visited Florence and

"found the famous *Galileo* grown old, a prisner to the Inquisition, for think-
ing in Astronomy otherwise then the Franciscan and Dominican licencers
thought."[2] Milton waged a holy war against the papacy and thought control.
Perhaps the Nativity Ode itself is aimed at Catholic idol-worship; both the
pope and king Charles had often been associated with a pagan god, Apollo,
whom the poem expunges along with his "pale-ey'd Priest[s]."[3] In any case,
no educated person of Milton's age could help being conscious that revolu-
tions were in the air.

Those revolutions have not yet come to rest. The Protestant break from
a church that had reigned for more than a millennium, the discoveries of
lands across the seas, the revelations—by Michelangelo, Shakespeare, Monte-
verdi, and many others—of unknown territories that art might explore, and a
renaissance of learning in Europe all seemed, at least in retrospect, to change
the course of history forever. Above all, the story of a decisive and irrevers-
ible breakthrough revolves around a new way of perceiving the world, a
perspective that eventually came to be known as "science." If Christian time
began with the nativity of Christ, then another age, the dawn of modern
times, began when Galileo looked through his spyglass. Even the name of
the Scientific Revolution asserts its uniqueness. That story still casts its spell;
some skeptics may doubt it, but they too fall helplessly under its sway.[4] Yet its
meaning and significance remain disputed. Whole schools of thought have
gathered around rival interpretations of each word: "scientific," "revolution,"
and "*the*." Evidently the issues raised by the story have never been settled,
and they are alive today. Understanding how the modern world came to be
depends, to a large extent, on constructing a narrative about the Scientific
Revolution.[5]

At least three basic versions of that story are in wide circulation. Though
they sometimes overlap, so that a casual observer might think them the same,
their differences can be dramatic. A major academic discipline, the history
of science, took shape largely through constant debates about them. Each
version represents an interpretation of history as well as of science. The
first, which Milton would have understood quite well, is epitomized by Max
Weber's famous phrase "the disenchantment of the world" (*die Entzauber-
ung* ["demagicking"] *der Welt*).[6] Weber ascribed that disenchantment to the
influence of Protestantism and Puritanism, which "thought of science as the
way to God"; by studying His works, in the exact natural sciences, people
hoped "to find clues to His intentions for the world."[7] But more generally
this view of history defines the Scientific Revolution in terms of a single
effect, an unrelenting assault on superstition. What Christ did to the pagan
gods, according to the Nativity Ode, the heroes of the new philosophy did

to the false beliefs and inherited misinformation that had deluded humanity for thousands of years. Mystification would now be exposed; a curtain had been lifted on the ancient wizards of Oz. If this story is told in French, Descartes and the *philosophes* traditionally play the role of its heroes. In English, Francis Bacon usually gets the lion's share of the credit. It was he who had smashed the Idols: Idols of the Tribe, the Cave, the Theater, and the Marketplace (by which Bacon means primarily the trade in inexact and misleading words). In place of these Idols, he would found a great New Instauration firmly on principles of observation and experimentation.[8] And Bacon succeeded (according to this version of the story). The triumph of the Royal Society, a product of the "Bacon-faced generation," confirms the victory of his method, whether we call it Empiricism (in English) or Enlightenment (more popular in German and French).[9]

A second version of the story of the Scientific Revolution would shift its emphasis from smashing idols to designing machines. Leading seventeenth-century scientists such as Pierre Gassendi and Robert Boyle preferred the term "mechanical philosophy" to the older "natural philosophy," on the grounds that nature itself was best conceived as a sort of machine.[10] The model of clockwork, whirring its wheels and ticking away without any hand or interior soul to guide it, became the leading metaphor of this philosophy.[11] Aristotle had patiently explained that the stars were living beings, moving with purpose—"We are inclined to think of the stars as mere bodies or units, occuring in a certain order but entirely inanimate; whereas we ought to think of them as enjoying action and life"—and Giordano Bruno added that they had souls.[12] It was as if the spirits that Christ and Milton had banished still animated the world. But the new philosophy finally sealed their doom. Although Johannes Kepler was always tempted to believe that something like a mind steered the course of each planet, in 1605 he declared that his goal was "to show that the celestial machine is not some kind of divine living being, but similar to a clock."[13] A century later the 4th Earl of Orrery commissioned a beautiful model of the solar system, the apparatus named the *orrery*, whose gears not only represented planetary motions but could also function as a calendar or timepiece. Nor was astronomy the only clockwork science. If the stars were not living beings, it came to be thought, then neither were flora and fauna, scientifically speaking, since they were driven by internal gears and springs rather than by the immaterial spirits or occult vital forces that former times identified with "life." Even people, seen with the eye of a good engineer, could be explained quite adequately as ingenious mechanical devices.[14] The most notorious example of this line of thought

is Descartes's conclusion that animals have no intelligence or rational soul at all, that they are *nothing but* the wheels and springs that move them— not ghosts in a machine but pure machines.[15] This dogma may have done incalculable harm, from later humane points of view. But the mechanical philosophy certainly did lead to inventing better machines. One virtue of this story is that it helps to account for the technological as well as the scientific revolution. Today most of us take scientific progress for granted, because machinery has furnished visible proof of its theories: airplanes, atomic bombs, computers, and genetic engineering.

Yet another version of the story relies on less tangible evidence: the elegant, bodiless proofs of mathematics. Even if Galileo had never looked through a spyglass or built a machine, he would be remembered for refuting Aristotle's theories of motion. Archimedes was Galileo's first hero, geometry was his love, and if he had written his own epitaph, it probably would have read something like this: "He showed that the real world was made of mathematics."[16] That project might describe the Scientific Revolution as a whole. Descartes was among the greatest mathematicians of the seventeenth century. Despite his obsession with machines, his important early work on "universal mathematics" accustomed him to the relentless pursuit of abstractions that climaxed in the metaphysical thought experiments of his *Meditations*. A similar point might be made about Pascal. Although his famous wager on God's existence occurs in a fragment often labeled "Discourse concerning the Machine," it has nothing to do with mechanics and everything to do with his groundbreaking studies of calculus and probability theory.[17] God himself, in this view, was the consummate mathematician. And the book that finally crowned the revolution and converted everyone to nature's laws (though hardly anyone could understand them), Newton's *Principia* (1687), spells out the "mathematical principles of natural philosophy." At the same time, Newton left tasks for future mathematicians: the calculations of time and space, of quanta, of multiverses, or at last of a Theory of Everything, a manipulation of symbols that might or might not have any consequences for insignificant creatures like us who live on earth.

This book will not try to decide which version of the story might be best, nor will it sort out or adjudicate their various claims. Historians of science will debate such issues for ages to come. But it is worth noting that all three versions have something in common: a definition of the Scientific Revolution that explicitly opposes the methods of science to the wanderings of imagination. Breaking icons, building machines, and reducing nature to mathematics all partake in a distrust of myths and fictions and fancies. At an extreme, one might say that they share a deep suspicion of what most people think of as

"life"—the messy stuff that fouls machines and spoils the perfect logic of equations. But without going so far as that, one still might argue that the defining moment of the Scientific Revolution has been understood essentially as a new conception of science itself: an activity that, whatever it studies, rejects all ways of grasping the world but those that deal with facts, experiments, and systematic principles.[18] Science occupies a separate sphere—housed in a different part of the campus from the arts and humanities—and what it wants is to recast the world as science. This story dominates most efforts to account for modern times. The emptying of the landscape depicted by Milton's ode, the removal of human interest and sympathies from nature, signals the new god arriving—not Christ alone but the irresistible truth and power of science.

Along with the triumph of this arrival comes a good deal of weeping and wailing. A year after Galileo's *Starry Message*, John Donne's *First Anniversarie: An Anatomy of the World* (1611) famously mourned that nature was dying or dead, because the "new Philosophy cals all in doubt, / … 'Tis all in pieces, all cohærence gone."[19] Donne was lamenting the death of a woman, Elizabeth Drury, not Aristotle or Ptolemy, but his anatomy leaves little doubt that scientific knowledge has delivered a deathblow to the world in which people once thought they lived. We have been hearing similar accusations ever since then. When science won its divorce from imagination, two points of view began to divide the world, and the custody battle continues. Most scientists feel understandably defensive about being stereotyped as enemies of life, as well as about the preposterous assumption that their work lacks imagination. But the charge has not been easy to dismiss. It lingers as the dark side of their glorious success, the story of freeing nature from illusions—particularly from the illusion that nature somehow resembles a person and responds to our interest in it. If the emptying of the landscape draws on a myth, nevertheless it summons a haunting pathos. "—But there's a Tree, of many, one, / A single Field which I have looked upon, / Both of them speak of something that is gone: / … Whither is fled the visionary gleam? / Where is it now, the glory and the dream?"[20] As Wordsworth's ode suggests, his sense of loss is not unique but shared by everyone who still remembers childhood, when mysterious presences seemed to fill the world. In this regard science stands for the killjoy grown-up. It shines its flashlight into dark places to show that nothing is there; it numbers everything and roots out imagination.

New Worlds of Imagination

No one can turn back the clock and return to a past that was already moldering in Milton's time. But I do want to argue that something is wrong with

the usual story, in all three versions. At the very least it is anachronistic; that is, untrue or incomplete as an account of what actually happened during the Scientific Revolution. Imagination flourished then and energized the minds of those who made the revolution. To change the old order, they needed first to conceive some possible new order. Any number of different ways of picturing the world, and other worlds as well, competed for attention, as this book will show.[21] Moreover, stories that discount imagination promulgate a dubious view of science that can still do damage not only to those who believe that it has nothing to offer them but also to scientists themselves.

To some extent the modern distrust of imagination reflects the doubts of earlier times. According to the psychology originated by Aristotle and developed by Avicenna and others, *phantasia*, the faculty in which illusory appearances arise, as in dreams, belongs to the organic or sensitive soul, not to the rational soul.[22] Sometimes it was distinguished from *imaginatio*, which forms a mental concept of something not present to the senses, and which occupies a different part of the brain.[23] Hence imagination might be viewed either as a breeder of phantoms and deceits or as a productive, mindful type of cognition. During the early modern period both views were in play. Imagination might be lunacy or devil's work, according to some moralists and physicians, but other theorists exalted the positive power of artistic creation, which might conceive a better, golden world.[24] Moreover, that power might alter the world in which humans live. "*A strong imagination creates the event*, say the scholars";[25] Montaigne entertains the possibility that imagination can affect external objects, as when witches kill with a glance or children in the womb are marked by their mother's fancies. At any rate he endorses the placebo effect; the mind seems helpless to resist whatever images are planted in it, so that the power of suggestion alone can harm or cure the body. From this point of view, imagination could no longer be regarded as merely one faculty among others, an idle source of dreams. Instead it threatened to become the master of the mind, which might replace reality itself with its illusions.

In the seventeenth century most natural philosophers waged war against the dominance of imagination. Though Francis Bacon conceded that in its proper sphere—not only poetry but also politics and religion—imagination might further Truth and the Good, he constantly worried that its encroachments on reason and science might corrupt both. The human mind, not content with the world as it is, "always compulsively hankers after something beyond" and fancies that nature corresponds to its own wishful thinking.[26] Bacon's attack on the false notions or Idols that barricade the mind against a reawakening of science implies that almost everyone succumbs to habit-forming dreams. Imagination must be kept in its place.[27]

Other philosophers went further yet. None raged against imagination more than Pascal. In the *Pensées* he calls it the "mistress of error and falsehood," the "haughty and powerful enemy of reason," and especially treacherous because it promiscuously mixes truth with its lies. Wise men are even more likely than fools to fall under its spell, which flatters their vanity and promises happiness far above reason. But worst of all, it cloaks its untruths in the guise of nature and custom, like the red gowns and ermines and fleurs-de-lis that wrap judges in the illusion of justice. The authority of every profession depends on a sort of playacting, which conjures belief with the right tone of voice or with dignified trappings. "Who dispenses reputation, who grants respect and veneration to people, to works, to laws, to the great, if not this imagining faculty? All the riches of the earth are insufficient without its consent." The show of things prevails over their substance. In this way "imagination governs everything"; it rules the world.[28]

The power Pascal ascribes to imagination also validates him as a hero, one of the very few who can resist its charms and stand up against the whole world for reason and truth. That role has suited scientists ever since. If most of society has been enslaved by collective fantasies, it needs to be liberated by the rare person who is not taken in. Hence Galileo owes his renown as the catalyst of the Scientific Revolution not only to what he discovered but perhaps even more to the obstinacy with which he supposedly clung to truth against his persecutors. "Nevertheless it moves." There is no evidence that Galileo actually spoke those words, but they remain an essential part of the man posterity has cherished. Scientists have a right to pride themselves on their refusal to be swayed by myths or orthodoxies, and on their determination to put all beliefs to the test. Yet they too sometimes subscribe to myths, such as Galileo's heroic, imaginary words. Today, as in the seventeenth century, the repulse of imagination provides a useful ideal and self-image for those who aspire to pure science. But then as now, good science was seldom pure; imagination as well as reason impelled it.

One way of restoring the balance would focus on aspects of early modern science that historians until quite recently have preferred to ignore: its heavy investment in the very mystifications that it was supposed to be dispelling. By now the outlines of such a challenge ought to be familiar, thanks to the important if controversial work of scholars such as Frances Yates.[29] Bacon, from this point of view, resembles a magus who draws on alchemical spirits to transmute nature and who "exalts the occult powers of the imagination."[30] Galileo cast horoscopes. Kepler was immersed in hermetic patterns of thought and the magic of numbers. Rosicrucian secrets lie behind the sudden revelations of Descartes. Astrology, witchcraft, spirits, and humors

pervade the medical practice of Thomas Browne and other physicians. New-ton spent much of his life investigating alchemy. And so on and so on. Whether or not we find these hints compelling, they do serve a purpose by making us put the fathers of science back in their own times and contexts, rather than judging them by how well they live up to what scientists now believe. The very word "science," one ought to remember, meant something different to those early explorers, who studied "natural philosophy," "natural history," "natural religion," and sometimes "natural magic."[31] Two centuries would pass before "science" ceased to stand for all fields of knowledge and became tied to nonhumanistic fields—specifically, to fields whose methods were assumed to bar imagination. So Galileo and Newton cannot be cat-egorized in any simple way as "scientists"; the concept as well as the word is anachronistic.[32] This book will often refer to early "science," for want of a better term. But the variety of activities that it examines should serve as a warning against any assumption that seventeenth-century thinkers devoted themselves to one all-encompassing discipline or to the scientific methods practiced today.

Whether or not the makers of the revolution dabbled in the occult, moreover, most of them were unquestionably masters of the arts. Leonardo's spectacular fusion of science (as it came to be called) and art prefigures the attainments of his successors, a century later, who used their gifts to reimagine what things might be.[33] Nature and art played equal parts in their work. When Milton refers to Galileo's sightings of the moon, he calls him "the *Tuscan* Artist."[34] *Artist*, a word that can imply a mastery of practi-cal science as well as of the fine arts, certainly fits the case. Galileo worked with his hands as well as his eyes. He excelled at *disegno* and could have made his living as a painter; an accomplished lutenist and singer, he pursued his father's interests in the theory of music and consonances; a sometime poet and inveterate writer, he claimed to have modeled his often dazzling prose on the style of Ariosto, his favorite poet.[35] Nor were these arts mere diversions for him; each of them contributed decisively to his discoveries in science. Kepler's great *Harmony of the World* (*Harmonice Mundi*, 1619) associates the composition of the solar system with recent developments in polyphonic music;[36] ingenious, punning poems, in his books and notebooks, reflect his love of playing with words and numbers; and the frontispiece he designed for *Rudolfine Tables* (1627) shows how much he could convey with pictures.[37] Descartes's first surviving work is a *Compendium of Music* (1618); in his youth he loved poetry and claimed that poets brim over "with precepts more weighty, more sensible, & better expressed than those found in the writings of Philosophers"; he studied painting and filled his books

with sketches that not only illustrate but embody his scientific theories.[38] Similar ties between science and art might be traced in the lives and works of Tycho Brahe, Francis Bacon, Christiaan Huygens, Robert Hooke, and a host of others. Their artistry breathes life into the projects for which they are known.

Above all, visions of what the world might be inspired their efforts. In the seventeenth century (if not beyond) the realms of imagination and science were usually not distinct, nor did natural philosophers simply discover images that later influenced poets and painters. Most scholarly studies assume a one-way traffic from science to art. The revelations of Newton's *Opticks*, Marjorie Nicolson persuasively argued, set off a wave of light effects in poems (as well as in pictures and music).[39] Yet imagination often came first. Thus Kepler embedded his most sophisticated picture of the moon in an allegorical *Dream* (*Somnium*) that he drafted in his youth and periodically revised throughout his life, and Descartes's lifework was predicted (he thought) by his interpretation of three vivid dreams during the night of November 10, 1619. Those dreams were not aberrations; Kepler's phantasmagoria encodes a secret history of his life, and Descartes believed that his revelations came from God (that is, the Being who sends signs to tell some lucky mortals what they are born to do). Nor did Descartes lack courage to inquire whether what he knew and what he was might be only a dream. Yet despite his cultivation of doubt, he asked his readers to imagine a new world, created from the laws of nature that he called forth.[40] Imagination validated science, in this new world; and science, imagination.

New worlds obsessed the age in practice as well as in theory. In the wake of Columbus, the European voyagers who found unheard-of lands across the seas and opened routes for trade and colonization also brought home a sense of previously unimagined possibilities. The earth contained varieties of people and things, flora and fauna, languages, gods, and natural wonders that the ancients had never known. Discoveries such as these redrew the map; the patchwork of terra incognita slowly filled in with global perspectives. At the same time the expansion of frontiers prepared the ground for intellectual adventures. The famous frontispiece to Bacon's *Great Instauration* pictures a ship that sails beyond the Pillars of Hercules, the boundary of the ancient world, and into uncharted waters of exploration and knowledge. Its motto, *Plus ultra*, helped to inspire the Royal Society, which itself was supposed to have been prophesied by another of Bacon's visions of a state "far beyond" present limits of learning, the *New Atlantis*.[41] Moreover, the past as well as the future seemed to offer rich veins that had yet to be mined—a renaissance of knowledge once known and now about to be brought again to light.

Though Bacon scorned Aristotelian idols, he too attempted to revive the wisdom of the ancients.[42] The time had come to reconceive both heaven and earth. As Tommaso Campanella wrote to Galileo in 1632, just at the moment when the *Dialogue on the Two Chief World Systems* came under attack, "This news of ancient truths, of new worlds, new stars, new systems, new nations, etc., is the beginning of a new age."[43]

Imagination Fills the Void

Campanella imagined other new worlds as well. *The City of the Sun*, the utopian dialogue he wrote in 1602 and published in Latin in 1623, describes a marvelous tropical commonwealth that anticipates a brave new European future. But Campanella's dreams extended further. As soon as he read *Sidereus Nuncius* he leapt to the conclusion (as did Kepler) that otherworldly creatures must inhabit those starry realms.[44] Few readers could refrain from building castles in the air; from the beginning, extraterrestrials peopled the Scientific Revolution.[45] As early as 1609, when Kepler put his *Dream* on paper, he viewed the moon through the perspective of its inhabitants, the "Subvolvans" (those who dwell on the hemisphere that always faces Earth). In 1638 John Wilkins published *The Discovery of a World in the Moone*, a habitable and inhabited world. Cyrano de Bergerac's lively fantasies of other worlds, in his *Voyages to the Moon and the Sun* (1656; 1662), mix scientific speculations, inspired by Descartes and Gassendi, with figures from classical mythology and history.[46] At the end of the century Christiaan Huygens, who discovered the ring of Saturn, left as his legacy *Kosmotheoros* (1698), an account of how rational beings on other planets perceive their worlds. And these are only a sample of the teeming hordes that crammed each corner of the universe, according to seventeenth-century suppositions.[47] If God had put mountains and deserts on the moon, he must have put mountaineers and nomads in charge there. A durable image, the Great Chain of Being, which pictures the universe as a plenum with no missing link, may well have influenced this tendency to fill space with life. And another set of discoveries, the microscopic organisms (descried by Hooke and Leeuwenhoek) inhabiting the air, the surface of a pond, and human bodies, also made it easy to imagine life in distant or invisible places.[48] From this point of view, most early scientists could no more conceive of an empty cosmos than early poets and painters could picture an empty landscape.

Yet imagination also struggled to tame the implications of these vast new open spaces. The Ptolemaic universe had long ago been civilized by poets, and Dante and Ariosto had effortlessly ascended to the moon on wings

of thought—impelled by Beatrice—or on a chariot like Elijah's, on which Astolfo passes through the ring of fire.[49] But the voyage proved harder for Copernicans to manage. In one of the most popular poems of the seventeenth century, *Adonis* (*L'Adone*, 1623), Giambattista Marino pays effusive tribute to his friend Galileo, an Argonaut of the telescope, whose explorations have emblazoned him forever in the stars. Marino had absorbed the *Starry Message*; he borrows some of its language in comparing the surface of the moon to that of the earth. Yet Adonis rides a chariot that flies through a "zone of fire" to the "sphere" of the moon, and "Cynthia" retains her Ptolemaic purity.[50] Lunar geography will not sustain such works of art. They need the resources of poetic tradition (Marino begs both Dante and Ariosto to aid him), the associations that had accumulated in the heavens through many generations, and above all the human interest that mythological figures confer on places and events beyond the reach of mortals.[51] In this respect the world had not been disenchanted. Even Christian poems deploy old gods, as Mercury holds the reins for Marino's Adonis and plays the role of astronomical cicerone. The moon, decked out with relics of the past, seems not a fearsome foreign wilderness but comfortable and oddly familiar.

Milton himself could not shake off that sort of enchantment. When he imagines the cosmos in *Paradise Lost*, majestically and sublimely, he takes in crystalline spheres as well as Jupiter's moons, the sapphire of Heaven's walls as well as spots on the moon and the sun; ancient and modern models are woven together. Milton was well informed; he had met Galileo and seems to have looked through telescopes and read some recent astronomy books.[52] Apparently the angel Raphael had also read them. He answers Adam's questions about the universe, in book 8 of *Paradise Lost*, with a brief version of Galileo's *Dialogue on the Two Chief World Systems*, comparing Ptolemaic or geocentric explanations with Copernican heliocentrism. But unlike Galileo he does not take sides, and in the end discourages Adam from choosing: "Heav'n is for thee too high / To know what passes there; be lowlie wise: / Think onely what concernes thee and thy being; / Dream not of other Worlds, what Creatures there / Live, in what state, condition, or degree."[53] The rebuke seems aimed not only at Adam but at all those dreamers who envisioned other worlds. Yet it also provokes some tension. As many readers have noticed, someone who is commanded not to think about something will find it very difficult to obey, just as someone forbidden to eat the fruit of one particular tree may keep wondering why. Perhaps Milton also harbors that tension. Putting words in Raphael's mouth, expounding world systems, tracing Satan's journey through space, exploring the highest heaven itself to understand and justify God's ways, he can hardly avoid bold speculations

about the nature of things beyond the ken of humankind. Nor can he help imagining what it might be like to visit other worlds, or to hang in a void.

The tension is most acute in Satan's journey through chaos. A "dark / Illimitable Ocean without bound, / Without dimension, where length, breadth, & highth, / And time and place are lost," that uncreated realm of anarchy and night defies astronomy; no such "wilde Abyss" appears in either the Ptolemaic or the Copernican system.[54] In imagining it, Milton draws his dark materials from the opening lines of Genesis and his beloved Spenser as well as from classical sources, especially the blind collisions of atoms in Lucretius's *De rerum natura*.[55] Yet precedents cannot throw light on the uncanny emptiness through which Satan must find his way, nor can they register his bafflement. This is a region where nothing makes sense, a waste outside the range of Hell and Heaven and the world of Creation. How then can it be pictured? Milton calls on all his resources. Clinging to Satan, the narrative explores the "vast vacuitie" through the assault on his senses: the confusion that clouds his eyes, the hubbub that peals in his ears, and above all, registered on his body, the warring elements that toss him up and down, as he "With head, hands, wings or feet pursues his way, / And swims or sinks, or wades, or creeps, or flyes."[56] Momentarily the devil becomes a clown; when high and low places lose their meaning, dignity also tumbles. But Milton's effort to imagine a featureless void is soon exhausted. In a short while the muddle and bedlam of chaos and night resolve into personified figures, Chaos and Night, who with their minions—Confusion and Discord among them—receive their ally Satan and purposefully direct his course to the frail world that he will bring down. Thus emptiness, within the poem, makes perfect sense. It can be caught in words, expressed by giant presences who understand the little world of human beings and have designs on them. Eventually, the poet discloses, Sin and Death will pave the way from Hell to Earth, allowing devils "easie intercourse" to mortals. Superseding chaos with Chaos, imagination reenchants the world. But the poem itself already builds that bridge, by making something out of nothing.

Natural philosophers as well as poets tended to shrink from conceiving a void. Whether or not Nature abhorred a vacuum, as Aristotle famously argued, most early seventeenth-century scientists certainly did.[57] The thought of emptiness was troubling not only for technical reasons but also epistemologically, theologically, and metaphysically. In his *Principles of Philosophy* (1644) Descartes stated categorically "that it is contradictory for a vacuum, or a space in which there is absolutely nothing, to exist."[58] A trick of language might tempt people to think that an urn was "empty" when drained of water, yet still it was full of air. Similarly, the cosmos, for Descartes, admits

no space without a substance, even though its "subtle matter" might be difficult to perceive. Hence he constructs a system with no missing parts, a plenum of ideas as well as of matter, in which simple thoughts and simple substances press on each other and join together to make a fully integrated world. Descartes believed that wholeness, or an explanation of everything, might be within his grasp, and that he could define it by means of clear and distinct ideas. Yet paradoxically his unwillingness to contemplate a vacuum required him to imagine a universe crammed with something that could not be seen, a hypothetical something outside the reach of any clear and distinct perception. When Descartes visited Pascal, in September 1647, they argued about the vacuum and subtle matter. A month later Pascal published *New Experiments concerning the Vacuum*, which ridicules those whose fear of the void compels them to fill space with invisible matter, a substance that exists only in their imagination.[59]

To illustrate his point, Pascal cleverly uses one of Descartes's own arguments against the possibility of a vacuum. People who believe that a box is empty because they cannot see anything in it have been deluded by their senses (as Descartes had said); but those who have been taught that there is no such thing as a vacuum are equally deluded, because their common sense has been corrupted, so that they fancy something where they see nothing.[60] Imagination has led Descartes astray, according to Pascal. An implicit self-reference lurks behind this passage. Many years earlier, building on Evangelista Torricelli's experiments with a column of mercury in an inverted tube (a *barometer*, as it came to be known), Pascal had persuaded his brother-in-law to carry such a tube up the Puy-de-Dôme, and the level of mercury dropped; this famous experiment seemed to show that the air that supported the column weighed less at the top of the mountain than at its foot. And since the mercury fell when deprived of air and surrounded by nothing, Pascal thought he had proved the possibility of a vacuum.[61] Mechanical means had contrived a mechanical effect, confirmed by mathematics and reason. Imagination had nothing to do with the case.

Yet Pascal himself was profoundly imaginative. Even the experiments that he relied on to replace illusions with hard evidence were sometimes suspected by Boyle and others of having been "mentally manufactured" rather than performed.[62] Such thought experiments were common at the time. But a deeper sort of imagination colors Pascal's whole worldview. If his natural philosophy joins in the task of disenchanting or mechanizing or quantifying the cosmos, his faith demands a leap of the soul: "The heart has its reasons of which reason knows nothing."[63] Like Milton, Pascal struggles to make sense of chaos. Looking into the immense new universe as into an abyss, he sees

that human beings are nothing there. "The eternal silence of these infinite spaces terrifies me."[64] As a mathematician Pascal is well acquainted with the infinitesimal as well as the infinite, and as a physicist he has a prophetic grasp not only of the vastness of the galaxy but of the infinite worlds that might be found within the confines of an atom. Placed between these abysses, he loses all sense of proportion. "When I consider the little span of my life, . . . the little space that I fill and even can see, engulfed in the infinite immensity of spaces that I do not know and that do not know me, I frighten myself and am amazed to see myself here rather than there."[65] This famous Pascalian moment of panic leads him eventually to peaceful acceptance of his middling human state between extremes, and to a surrender to God. Yet what lingers in the *Pensées* is a voyage of thought. Pascal imagines himself in the infinite spaces, and pushes his imagination so far that it becomes lost in macrocosmic and microcosmic reaches. Of course he does not belong there. But how can a mind imagine the cosmos except in reference to itself, the spaceship Self that hears the silence and sees the nothing and somehow expects them to recognize him? The eternal silence and infinite spaces would have no power to terrify unless a vision conjured them up. Hence testing the world also requires Pascal to test the limits of what he can imagine.

Most natural philosophers felt the same compulsion. Despite Donne's fears, the new discoveries did not reduce the world to a dead body. Instead they led to more and more ingenious efforts to imagine a cosmic spirit or life force, some way to make sense out of chaos. Most of all, philosophers searched for God's presence in nature. When Newton set down nature's laws, he quite explicitly kept God in mind, not only as a First Mover but also as an agent continuously involved in tuning his creation. Divine intelligence was "very well skilled in Mechanicks and Geometry" and knew how to make repairs—with comets, for instance.[66] It is always tempting for modern readers to interpret such statements as public relations, the tribute or tithe that scientists pay to the church. Hence the perpetual homage to God in the writings of Bacon, Kepler, Galileo, Descartes, Boyle, and Newton can be treated like static and quietly smothered. Another form of skepticism would view most early scientists as secret Deists, content to formulate the laws of a machine that needed no presence to run it. Despite Newton's active opposition to such mechanist views, Deists soon managed to accommodate his laws to their own creed.[67] Yet there is no good reason to doubt that seventeenth-century scientists believed what they said. Imagining God in nature was not a postscript for them, or an oath to secure a license, but an essential part of their vision of how the world functioned. Whether they thought, like Kepler, that they could read a part of God's mind through the

advanced geometry he wrote in the heavens, or like Pascal that God's grace was beyond any rational comprehension, again and again they testified, like Boyle, that studying nature itself was a form of worship. All of them found some image of God impressed on the world. At the limits of everything humans could know or discover, imagination managed to fill the void.

The Art of Science, the Science of Art

If this is true, however, one question remains: Why has the opposite story, the story that defines the Scientific Revolution as a systematic purging of imagination, been such an article of faith for so many people? The answer, I think, is that the story has been so useful. It serves both sides in a long historical debate: those who regard the early masters of science as heroes, casting out idols and marching along the straight road to truth, whatever the cost; and those who suspect the same masters of reducing the world to their own Flatland, a two-dimensional desert devoid of life. Right from the start both sides found ways of telling a story that fit their interests. Galileo, Descartes, and Newton were heroes of thought to many in their own times, because they allowed no dogma to corrupt their celestial, mathematical visions; and they provided models for the future. Yet other morals can also take over the story. Pascal was not the only one whom the new lifeless universe filled with terror. From Margaret Cavendish and Jonathan Swift to William Blake—to speak only of England—satirists reconfigured those heroes as deathly fanatics, ready to sacrifice everything to their obsessions. Resistance to the new philosophy proved to have a life of its own, evolving through changing times and circumstances. Eventually the story of a war between imagination and science became so powerful that it divided the world. We still are living in that story today; we still are invited to choose.

Yet neither version of the story rings quite true. When an impassable gulf divides scientific ways of thinking from the fables and visions of art, both sides seem diminished. Historically, any account of the early masters of science that wipes out imagination clearly distorts not only who they were but also what they saw. Astronomers who perceived the heavens constantly shaped and reshaped them into systems that matched the models in their minds. Thus Kepler clung to cosmic fantasies, arranging the orbits of the planets to accord with the five Platonic solids as well as with musical harmonies. Yet in the end these conceptions, which he never wholly relinquished, spurred him to discover three elegant laws that took the measure of the solar system. Fantasy and calculation are not opposed, for Kepler; they join in mighty acts of creation. Similarly, the great English naturalist John

Ray (1627–1705), who did more than anyone else to disenchant nature and substitute hard evidence for pretty stories that humanized flora and fauna, spent his life observing not only particular facts but also their ultimate meaning: *The Wisdom of God Manifested in the Works of the Creation* (1691). Patient investigations of what nature is prepare the ground for speculations about what it might represent. Again and again the work of scientists has resulted in new ways of imagining life and the world. This process is not an abnegation of science but part of science itself.

If the story of an eternal divorce between science and art diminishes science, moreover, it may have induced a still more damaging view of the arts. In retrospect, the triumph of the new philosophy has tempted humanists to lament their displacement from the center of culture and education. Donne pictures human history as a long, cataclysmic decline from the Garden of Eden to his own shrunken times, when even the heavens have fallen apart and colors have lost their luster; and two centuries later Keats would agree that cold philosophy could "conquer all mysteries with rule and line" and "unweave a rainbow."[68] Many historians and critics have sympathized with that dismay about the corrosive effects of reason. In the eighteenth century the first major history of English poetry, by Thomas Warton, suggested that "the fashion of treating everything scientifically" had stifled imagination, and since then a consistent strain of modernist and antimodernist thought has weighed the costs of disenchantment.[69] Even Max Weber betrayed mixed feelings about the replacement of magic by intellectualization.[70] Regrets like these often express a nostalgic craving for a supposedly simpler, more harmonious time, when unseen spirits lent a touch of poetry to everyday life. It is as if the chorus of petty gods in Milton's ode were wailing to return. Yet such views also patronize the arts, reducing them to a pathetic remnant of an earlier, outmoded stage of civilization.[71] Some artists enjoy their role as enemies of reason; their alienation from the modern world seems to connect them with primal, prehistoric depths of imagination, as if the Scientific Revolution had never happened. But their handiwork always exposes the grip of history that leaves its mark even on rebels, whose styles of defiance reflect the times that spur their discontent. Nor can artists ignore their own irresistible involvement with science. The history of the arts keeps pace with technical advances: the laws of perspective, the camera obscura, photography, film stock, computer imaging. In this respect one might argue that in practice science continually joins with art to reenchant the world.[72]

Yet no simple formula could ever account for the intricate interrelations between the new philosophy and imagination during the seventeenth century. If "science" did not yet refer to any particular way of thinking or

acting, then neither did "art." One reason why the meaning of the Scientific Revolution has been so disputed must be that it takes in so many different interests and fields. The relatively tidy history of astronomy, progressing from Copernicus to Newton, hardly resembles stories about what happened in mechanics, natural history, anatomy, microscopy, mathematics, chemistry, biology, geology, or the arts of agriculture and healing; and many new worlds had yet to be discovered. No single grid or mode of interpretation can hope to traverse the inexhaustible labyrinth of ideas. Nor did the thinkers who made the revolution always follow one path. Francis Bacon keeps shifting his shape, in this book, from chapter to chapter; he plays the part of a natural historian and poet, a life scientist, a scourge of error, a magus who fought against magic, a father of experimental methods, a genius who cut genius down to size, and incidentally both a defamer and an advocate of ancient wisdom. These roles may be inconsistent, but Bacon filled each of them ably during the ups and downs of his stormy career. At every turn he needed to match the world as it was with the world that he could imagine. Bacon tries to encompass all branches of learning.[73] Forever in motion, his story resembles that of the revolution itself.

The entanglement of scientific and imaginative ways of thinking was played out constantly not only in the new world pictures but also in individual minds. Few natural philosophers escaped it. Even those who inveighed against imagination often found themselves caught, like Pascal, in its web. Newton is a particularly interesting case. Disdainful of "fictions," he savagely spurned any speculation or flourish that might stray from unequivocal truth. Yet behind the marble face that he turned toward the public, "Immagination. & Phantasie & invention" inspired and troubled him.[74] The struggle between ideas of what might be and rational certainty is expressed most fully by his immersion in the mysteries of alchemy and theology. Newton brought to both the same intensity and depth of study that had determined the principles of optics and celestial mechanics; nor would he be content with mere conjectures. Nevertheless, his best efforts could not reach the incontrovertible answers he wanted so much to find. In mathematics a peerless intuition guides Newton's hand, and answers often come so fluently that they might be mistaken for nature's voice—though no one else could hear or translate her instructions. But the language of alchemy requires decoding from symbols or allegories that must be interpreted not only chemically but spiritually. This is the dark side of Newton's insight. Despite his zeal for calculation and demonstration, his mind roams freely through a realm of thoughts that stretch the bounds of possibility. When Newton denounced ungrounded suppositions, therefore, perhaps he was also arguing against a

part of himself. The unending clash of a wide-ranging imagination with stringent standards of proof does not undermine Newton's quest to bring truth to light. It is the very heart of that quest.

Nor did he or other philosophers ever stop dreaming. Whatever else it may have been, the Scientific Revolution was never an age unpeopled by visions and myths. The vein of mysticism in Newton responds to the revelations of Henry More, which draw in turn from the spiritualism of Jacob Boehme. But more important, the most advanced science often harbored imaginary agents and beings, like the spirits that guided the planets, according to Kepler, or the spirits of life in the body, according to Bacon. In context, the disenchantment, mathematization, and mechanization of nature might well be seen as rites of purification, making way for Christ (in Milton's version) or God the Pantokrator (in Newton's). Such rites defy the popular ideas and sentiments that shrink reality to *phantasia*—appearances registered on the senses. A deeper thinker was compelled to look for something more. Hence the effort to reconceive the universe in terms of geometrical figures or clockwork machines, as in the schemes of Galileo and Descartes, called on immense reserves of imagination. Science sometimes battled art, and sometimes depended on it. But whether the two were locked in combat or linked in arms, their relations furnish a key to what seventeenth-century scientists once thought and did. Those tensions and frictions and unions sparked new ways of seeing the world. It is time to explore them again.

❦ CHAPTER 2

What Galileo Saw

Two Fables of Sound and Seeing

The Afterlife of a Cicada

Sometimes the urge to speak in parables can descend on a natural philosopher, as on a poet or prophet. At the center of his polemical masterpiece *The Assayer* (*Il saggiatore*, 1623), Galileo clinches his argument by telling a story. "Once upon a time," it begins, "in a quite solitary place, a man was born blessed by nature with a very perspicacious brain and an extraordinary curiosity." Delighted by birds, he admires "the lovely artfulness with which at will they would transform the very air they breathed into various songs, and all surpassingly sweet." Then one night he hears another delicate song, and pursuing the singer discovers instead a shepherd boy "blowing into a piece of perforated wood and moving his fingers over the wood." Inspired to travel, the man encounters a boy who makes sweet sounds with a bow that saws sinews stretched over wood; a temple door whose hinges sing; a man whose fingertips draw melodies from the rim of a glass; insects who trill by beating or shaking their wings; and any number of other unlikely instruments. At last he comes upon an ultimate mystery: a cicada. He cannot silence it by closing its mouth or stopping its wings, nor do the scales that cover its body move. Perhaps the sound originates in the vibration of thin hard ligaments on its chest. He tries to break them with a needle. "Yet all was done in vain until, pushing the needle further in, transfixing the creature, he took away, along

with its voice, its life." The origin of the song remains undetermined; but the dead cicada cures him of his obsession. In later years, "when called on to tell how sounds were generated, he responded generously that he knew some ways, but that he firmly held that there could be a hundred others unknown and unforeseeable."[1]

Tactically the parable was brilliantly conceived, and its effect was stunning. In its immediate context, the tale distinguishes its wise and tolerant author from his opinionated adversary, the pseudonymous "Lotario Sarsi" (Orazio Grassi), whose effort to fix the comets in a path determined by systematic proofs and ancient authorities can only deny the bounty of nature and the limits of human understanding. Galileo himself does not pretend to know exactly what comets are. In fact he had never observed the three comets that kindled the controversy in 1618, and his hypothesis that they might rise like vapors from the earth is offered not as truth but merely as one possible explanation (he was right to be modest). *The Assayer* sets out to weigh the matter contained in Grassi's *Astronomical and Philosophical Balance* (1619) on a precise and delicate scale; it spends its energy detecting counterfeit arguments, not finding gold. The causes of comets, like those of the cicada's song, evade any final answer. But the story that Galileo tells is persuasive less as a formal argument than as a model of style or self-presentation. Its author commands the art of a virtuoso.

Galileo knew a great deal about the many ways that sounds are produced. His father, Vincenzio, a professional musician who took a special interest in relations between the theory and practice of music, had passed that interest on to his son, who was also an accomplished lutenist and singer. In 1588–89 Vincenzio set out to refute the classical theory that musical consonance is determined by precise numbers, rather than by a trained ear, and the experiments he conducted—perhaps assisted by his son—proved that the traditional mathematical ratios did not work in practice.[2] Technical and theoretical expertise support Galileo's fable. Yet he carries his learning lightly and ridicules pedantry with contemptuous *sprezzatura*. In *Galileo, Courtier,* Mario Biagioli has argued that the fable of sound "was the epitome of court culture itself," which took its pleasure in appreciating the wonders of nature, not in pinning them down.[3] An exercise in courtly condescension, *The Assayer* plays with its foe as it plays with ideas, and quotes Dante and Ariosto (Galileo's favorite poets) as tokens of its own literary finesse. Thus Galileo turns an astronomical dispute into something more personal, an affair of honor. Defending his reputation, he sketches a portrait of himself as a lover of song and story. An intellectual giant, the parable shows, can also be a man of the world.

When the book was published, it marked the high point of Galileo's career. Its reception seemed, one might say, almost too good to be true. The official imprimatur by Father Niccolò Riccardi not only certified the orthodoxy of Galileo's doctrine but also worshipped at his shrine, praising "the deep and solid reflections of this author in whose time I count myself fortunate to be born."[4] Then, while the book was still in press, heaven seemed to smile on it: Gregory XV died, and the Florentine cardinal Maffeo Barberini succeeded him in August 1623 as Pope Urban VIII. Barberini was Galileo's friend and fellow intellectual, who had written a Latin poem in his honor three years before and called him brother. This was an opportunity. The Academy of Linceans, which had encouraged and sponsored the work of its member Galileo, added the arms of the Barberini family to the frontispiece of *The Assayer* and dedicated the book to His Holiness as one who "has turned his heroic mind to the highest undertakings" and could be hoped in future "to continue favoring our studies with the gracious rays and vigorous warmth of your most benign protection."[5] The new pope responded in kind. He asked Giovanni Ciampoli, another Lincean, to read passages from the book at mealtimes; and he especially admired the fable of sound. The following spring (April 1624), when Galileo came to Rome, Urban VIII quickly granted him a private audience, the first of six friendly conversations. Galileo went back to Florence with a papal brief (written by Ciampoli) praising his merits and commending him as the pope's "beloved son."[6] He and his book had been blessed.

One reason that the fable of sound so delighted Urban VIII must have been that it seemed to reflect his own most cherished ideas. The pope did not care about the nature of comets. A man of letters, he took pleasure in the wonders that Galileo had found in the sky—who would have believed that there are spots in the sun?[7]—just as he relished gems of good writing. But the rights and wrongs of scientific debates meant little to him. All efforts to explain the ways of nature could only be provisional, he thought, because an omnipotent God might always have arranged things in some different way. The fable of sound exemplified that position. As time passed, the pope had recourse to the fable so often that it served as part of his creed, as if he had written it himself. In one conversation, when Galileo spoke of proving his cosmological theories, the pope "asked if God would have had the power and wisdom to arrange the orbs and stars differently in such a way as to save the phenomena that appear in heaven." If the answer was yes, as it must be, then the possibility of another arrangement must always exist. "You cannot say that this is the only way God could have brought it about, because there may be many, and perchance infinite ways that He could have thought of and

which are inaccessible to our limited minds." Galileo was overmastered by the lesson of his own fable. Augustinus Oregius, a theologian present at the conversation, took silence for acquiescence. "Having heard these arguments, that most learned man was quieted, thus deserving praise for his virtue no less than for his intellect."[8] In that still moment, unmarred by any rejoinder, the pope and his beloved son—both teacher and pupil—could imagine that they shared a sense of communion.

The silence did not last. Indeed, in retrospect it may have covered a colossal and fatal misunderstanding. What the pope interpreted as submission— was the reproach of systems and theories not Galileo's own?—Galileo seems to have interpreted as tacit permission to keep exploring God's manifold ways—if those included Copernicanism, so much the better. The rift would continue to grow. Eventually it would divide the whole world of learning, and the pope and the man he once had called his brother and son and friend would come to stand for cosmically opposite views of what could and should be known. Even today, the issues have not been settled. A host of scholarly studies have analyzed the "crime of Galileo" in every detail; nor have they all exonerated him from the charge of philosophical as well as political and theological misprision.[9]

Perhaps he even betrayed his own fable. The final break with Urban VIII, which delivered Galileo into the hands of the Inquisition, was set off by another version of the pope's favorite argument. Near the end of the *Dialogue on the Two Chief World Systems, Ptolemaic and Copernican* (1632), one speaker says, "I always keep before my mind's eye a very firm doctrine, which I once learned from a man of great knowledge and eminence"—clearly the pope. Could God, with his infinite power and wisdom, have caused the tides by some other means than the one proposed by "Salviati" and Galileo? Of course. Hence "it would be excessively bold if someone should want to limit and compel divine power and wisdom to a particular fancy of his."[10] The homage to Urban VIII, as well as the warning against bold dreamers who would circumscribe God's creative resources, was hardly casual. As a matter of fact it had been explicitly negotiated by the Vatican, which had stipulated that the *Dialogue* must terminate with such words, to "quiet the intellect." But when printed the book did not end there. As Urban VIII soon noticed, his doctrine of "epistemological modesty" was immediately rephrased or refined by another speaker, who points out that final answers would hinder "the exercise of the mind." Worse yet, the very firm doctrine itself had been put in the mouth of "Simplicio," whose name meant "simpleton," and perhaps, as Galileo's enemies murmured, was a stand-in for the pope. Urban VIII was outraged; his words had been twisted, the friendship was over. In

September 1632, a Special Commission reported to him, recommending that Galileo be indicted on the grounds, among others, "that he put the 'medicine of the end' in the mouth of a fool and in a place where it can only be found with difficulty, and then he had it approved coldly by the other speaker by merely mentioning but not elaborating the positive things he seems to utter against his will."[11] The charge confirmed itself. Galileo's doom had been decreed from on high.

What had gone wrong? No question in the history of the trials of science has been examined more thoroughly or has seemed so vital to answer. In 1979 John Paul II lent his own voice to the search, hoping that theologians, scholars, and historians "will study the Galileo case more deeply and, in a loyal recognition of wrongs from whatever side they come, will dispel the mistrust that still opposes, in many minds, a fruitful concord between science and faith, between the Church and the world." A "tragic mutual incomprehension," he added in 1992, had resulted in the "myth" of "the Church's supposed rejection of scientific progress."[12] But the wounds have not healed, nor has the case been closed. Despite John Paul's hopes, studies have reached no consensus on whom or what to blame: political circumstances, Jesuit machinations, church dogma in the Counter-Reformation, the patronage system, or Galileo's own intransigence and blunders.[13] Even as the Vatican began to relent and apologize for its errors, many historians of science turned against Galileo. Not only a heretic, they continue to say, he also promoted a pernicious view of scientific truth, insisting that he could decipher the mind of God. In this respect Urban VIII was right: the business of science is not to arrive at final explanations, but merely to "save the phenomena," offering hypotheses that a later time might always falsify and supplant.[14] Galileo remains on trial. Whether or not we accept this indictment, the question of what went wrong still casts its shadow over Rome and far beyond.[15]

No study will ever answer that question once and for all; at best we can hope to save a few more phenomena. But one place to look might be the fable of sound itself, a text whose meaning and implications have all too often been taken for granted. Perhaps it is not so simple. Like any parable, like Christ's own teachings, it offers a moral to which any listener can assent in his or her own way, but which in practice might lead to very different sorts of behavior. Galileo himself left no doubt about what he intended. Long experience had taught him one firm principle: "The less someone understands and knows [about intellectual things], the more insistently he wants to speak up; and on the contrary, the multitude of things someone recognizes and understands makes him slower and more hesitant to pontificate about something new." The positive Sarsi had exposed his own incapacity.

By contrast, Galileo knows where to stop: "The difficulty of understanding how the cicada's song is formed even when we have it singing to us right in our hands is more than enough to excuse us for not knowing how a comet is formed at such an immense distance."[16] A prudent seeker of truth will be content to ask some questions—or to propose a few new ideas. Thus Sarsi must stand in the dock; he is suspected of butchering nature by forcing his theories on it.

Yet Sarsi is not the protagonist of the story. If the man "blessed by nature with a very perspicacious brain and an extraordinary curiosity" can be identified with anyone, he must be Galileo himself, the great discoverer who has learned to be cautious. Nor does the killing of the cicada make him unsympathetic; instead his reaction adds generosity of mind to his other endowments. From Aesop to modern times, fables typically disseminate conservative folk wisdom about the dangers of wanting or risking too much: flies get caught in honey, scorpions lurk among the locusts boys snatch at, greed kills the golden goose. The fable of sound draws on the same pattern. But here the seeker does not pay for his excess, nor will the world miss one cicada. Rather, the moral is turned against less experienced, less humble reasoners. The storyteller confesses no weakness, and even his alter ego, within the tale, might be excused for his overreaching because, unlike the well-connected Galileo or his antagonist Grassi, professor of mathematics at the Collegio Romano, he comes from "a quite solitary place" where he has never heard a flute or violin or been instructed by more worldly guides. Brilliant and innocent, he learns his lesson. The pope himself might have offered protection to such a good soul.

Beneath the surface, however, the fable also harbors a tension it never resolves. Its protagonist first appears a lover of song, who raises birds as a hobby and prizes sweet sounds. Yet he readily sacrifices that pleasure to a consuming rage for knowledge; he wants to know how sounds are *produced*, not how or why they please. In this regard he lacks the courtier's insouciance. But more than that, he pursues a particular kind of knowledge. One of the most famous passages of *The Assayer* accuses Sarsi of being a slave to authorities, spellbound by written words and not the book of nature:

> Possibly he thinks that philosophy is a book of fiction created by some man, like the *Iliad* or *Orlando Furioso*—books in which the least important thing is whether what is written in them is true. Well, Sig. Sarsi, that is not the way matters stand. Philosophy is written in this grand book—I mean the universe—which stands continually open to our gaze, but it cannot be understood unless one first learns to comprehend

the language and interpret the characters in which it is written. It is written in the language of mathematics, and its characters are triangles, circles, and other geometrical figures, without which it is humanly impossible to understand a single word of it; without these, one is wandering about in a dark labyrinth.[17]

This argument has often been cited to mark a turning point in the history of science.[18] As well as rejecting the authority of Aristotle and other pillars of doctrine, it sets out a program of "physico-mathematics," redirecting natural philosophy—or reducing the book of nature—to the study of figures and numbers. Such calculations, unlike the fictions of Homer, Aristotle, or Sarsi, represent the essential truth about heaven and earth.[19] From this point of view, the quest of the fable could hardly stop at cataloging particular sources of sound. A curious and penetrating mind would surely want to understand the causes of these effects. At the end of the fable, when asked "how sounds are generated," the seeker deflects the question by replying that he knows only some of the ways. But Galileo himself wanted more. At the beginning and end of his life he pondered the mathematics of music, and either conducted or witnessed experiments that measured the ratios of vibrating strings or waves in water and air.[20] Sounds, no less than the tracks of comets, are composed of geometrical figures. And though the fable is not written in that language, it goes beyond fiction and tries to probe the essence of sound.

An inquisitor might notice a still more disturbing turn. Not content to listen, the seeker insists on taking apart the instruments that intrigue him. In this way he distinguishes appearances, or the manifestations of sound, from the physical properties or mechanisms that bring them about. When he hears music, for instance, it is not the notes and tones that fascinate him, but rather the engine that drives them: for instance, "that little iron reed that, hung between the teeth, in a strange way makes from the cavity of the mouth a resonance throughout the body, and from the breath a vehicle of sound." Later in *The Assayer*, Galileo explains his conception of sound. "Sounds are created and heard by us when—without any special 'sonorous' or 'transonorous' property—a rapid tremor of the air, ruffled into very minute waves, moves certain cartilages of a tympanum within our ear." What we hear, that is to say, depends entirely on our perceptions, not on something inherently "sonorous" that exists in the world outside us. "I think that if ears, tongues, and noses were taken away, shapes and numbers and motions would remain but not odors or tastes or sounds. These, I believe, are nothing but names, apart from the living animal"—just as tickling means nothing without an armpit.[21]

To a modern reader, such notions might seem not only inoffensive but banal. But Catholic readers at the time might smell a whiff of sulfur. Grassi himself sniffed out a deviation from church doctrine.[22] The issue of whether the senses perceived "real qualities"—heat, colors, or sounds inherent in material things, as Aristotle had said—or instead only impressions given various names, agitated the church far more than did any squabble on comets. It went to the heart of the doctrine affirmed by the Council of Trent, on which the church stood. An anonymous document found in the archives of the Holy Office by the historian Pietro Redondi, who used it as the centerpiece of *Galileo Heretic*, accuses *The Assayer* of subverting the Eucharist. The Council of Trent had decreed that the body and blood of Christ are really present in the consecrated host of bread and wine, as substance, not as symbol, while remnants of the bread and wine are merely accidents or properties of the senses. But Galileo, apparently an atomist and Democritean, seemed to have denied that distinction. If substances consist of particles (or shapes, numbers, and motions), then transubstantiation could not separate the holy substance from the accidental host in which it dwelt. Galileo's pursuit of truth had not saved the phenomenon of the real presence of Christ, according to this accusation, but rather implied that any phenomena might be subjective illusions.[23] Such speculations amounted to heresy. In 1625 the denunciation of *The Assayer* failed to convince the Holy Office, and the storm soon blew over. But later it would return and bring Galileo down.

To charge the fable of sound—the pope's own jewel—with heresy would certainly be strained. Yet the story did raise one problem that no amount of ingenuity could dispel: it called into question the innocence of perceptions. Right from the start, when Galileo pointed his telescope at the sky, the convulsions caused by the new things he saw there could always be justified by the detachment of an impartial eye. His sight might be keener than that of other observers, and his equipment was surely better than theirs, but the cliffs on the face of the moon, the myriad stars that dotted the Milky Way, and the moons of Jupiter were not the products of any theory; they could be seen, in the future, by anyone willing to look. Hence those who disbelieved the starry messenger—and at first they were many—would surely be brought round eventually, unless they denied the evidence of their own eyes. Galileo was right. Despite the initial resistance, many of his discoveries soon became self-evident parts of nature, or phenomena that had to be saved. But Copernicanism, and theories of tides and comets, were not self-evident. From this point of view, Galileo began to stumble when his eyes tried to pierce the unseen, as if one could look at objects and perceive them as geometrical figures, or atoms, or numbers. His sight would never again be innocent.

Yet the notion of pure perception itself is flawed. Even the eye of a lynx takes in only what the structure of its mind and vision allow it to see; it is always an interested eye, in search of its prey. The fable of sound carries a lesson that complicates epistemological modesty: to see things is to change them. The seeker who kills the cicada has gone too far, but that was his nature. As soon as he left home, his attention turned from song to the mechanics of sounds, and his perceptions sharpened until he could recognize not only sounds but their physical causes. In fact he was right about the origins of the cicada's song, though he never repeated the test. The logic of his inquiry induced a way of listening that identified music with waves and vibrations in air; substance and accident were only different names for one perception. Similarly, the gaze of the telescope, everyone knew, had forever stained the immaculate heavens, as surely as the needle broke the cicada. The Milky Way would never be the same; there was no going back. To see things is to change them.

Capturing Moons

In November 1609, when Galileo looked at the sky and began to change it forever, he took advantage not only of a spectacular new instrument but of an exceptionally well-trained eye. It seemed, in retrospect, that he had been preparing for this moment all his life. According to his first biographer, Vincenzio Viviani, young Galileo's "great genius and talent" for drawing (disegno) tempted him to make his living as a painter, until his father managed to dissuade him.[24] Viviani modeled the life on Vasari's "Life of Giotto" and showed the continuity of genius by fixing the date of Galileo's birth to coincide exactly with Michelangelo's death.[25] Many painters belonged to Galileo's circle, including Peter Paul Rubens, Artemisia Gentileschi, and especially the Florentine master Ludovico Cigoli, a fellow student and lifelong friend who shared Galileo's interest in astronomy and mathematics as well as disegno. These interests were linked; to picture the heavens, one had to know how to draw as well as how to see. In the controversy that followed Galileo's observations of the moon, Cigoli maintained that someone like Christopher Clavius, who was "without disegno, was not only half a mathematician, but also a man without eyes."[26] In this respect Galileo's eyes were superb. His wash drawings of the phases of the moon in 1609 display a refined and subtle mastery of chiaroscuro in which his brush makes the lunar surface come alive with piebald light and depths of shadow (see fig. 1).[27] Each phase is rendered with a technique that varies according to the particular moment of the cycle, and with a palette that moves from an intense white

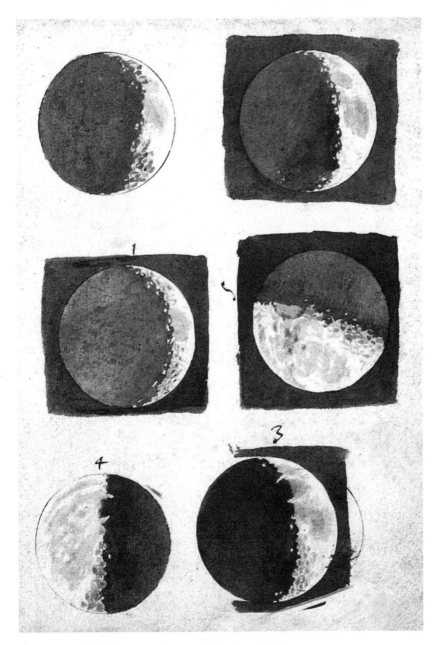

FIGURE 1. Galileo's wash drawings of the moon. Biblioteca Nazionale Centrale di Firenze, Gal. 48, f. 28r.

shimmer to mixed tinges of rusty red and brown. Together, the hand and eye collaborate in seamless works of observation and art.

Indeed, Galileo was gifted at using his hands. An early essay, *The Little Balance* (*La bilancetta*, 1586), tells how to make an improved device for determining specific gravities; and whether or not in his twenties Galileo did drop weights from the Leaning Tower of Pisa, as the story goes, he certainly did like practical experiments that tested how things really worked and Aristotle's theories as well.[28] He was a doer as much as a thinker. After he took the chair of mathematics at Padua in 1592, he spent much of his time inventing and making instruments to solve technological problems—for instance, a better quadrant to help gunners measure their targets.[29] This handiness would serve him well in 1609, when he first heard rumors about a new spyglass that seemed to bring distant objects near. At once, he later testified, he set out to build his own improved version.[30] "Sparing no labor or expense," grinding his own lenses to deepen the eyepiece and increase the power, he constructed an instrument that magnified nine times, and then another, a few months later, that magnified more than twenty. When this was finished, in November, he turned it toward the moon.

In a curious way, even a defect of vision may have contributed to Galileo's success. As he notes in *The Assayer*, early in his life "as a result of a certain affliction I began to see a luminous halo more than two feet in diameter around the flame of a candle, capable of concealing from me all objects which lay behind it." Eventually this aureole diminished, but never disappeared. As Stillman Drake points out, those so afflicted learn to shrink the halo by squinting through a small aperture such as a clenched fist or peephole, and this insight might have taught Galileo to stop down or narrow his convex lens with cardboard, so that the stars appeared sharp and distinct.[31] In 1609 he already knew how to compensate for the shortcomings of his eyes. To some extent, in fact, his instrument functioned like eyeglasses, correcting blurred vision. Not yet called a "telescope" (a word invented in 1611 to honor Galileo's "far-viewing"),[32] it was referred to in Italian as *occhiale* (from *occhio*, "eye") or in the Latin of *Sidereus Nuncius* as *perspicillum*, "something to see through." The obsolete English word *perspective*, used for magnifying glasses or concave mirrors, as in Shakespeare's "natural perspective" (*Twelfth Night* 5.1.209), conveys that sense of eyeing or seeing through. In any case Galileo's technical knowledge of the art of perspective clearly affected his vision.[33] Others did not at once see what he saw, and though poorly made spyglasses and obstinate ill will must have been responsible for much of this blindness, untrained eyes and a lack of know-how also helped veil the heavens. Galileo's acute mental vision enabled him to look harder and longer than

others. It is not accidental that, at the banquet where the word *telescope* was used for the first time, he was inducted into the small, select academy named after the eye of the lynx.[34]

Moreover, he also knew how to describe what he saw. As a narrative of discovery, *Sidereus Nuncius* evokes the new world of the heavens with words even more than with pictures.[35] Galileo took pride in his writing. An accomplished poet and literary critic, he studied the best Latin and Italian authors, and claimed that the influence of Ariosto was responsible for his own clear and graceful prose style.[36] Perspicuous language, he thought, could be trusted above the visual arts, which necessarily relied on illusions. Even in its title, *Sidereus Nuncius* announces a "message," a straightforward account of astonishing, distant sights unadorned by imagination. But pictures do not interpret themselves. Galileo expands on what he has seen not only through analogies between the things of heaven and earth—"This lunar surface, which is decorated with spots like the dark blue eyes in the tail of a peacock, is rendered similar to those small glass vessels which, plunged into cold water while still warm, crack and acquire a wavy surface, after which they are commonly called ice-glasses"[37]—but also by telling a story—the way that his observations developed and changed. The phases of the moon, and especially the sightings of the moons of Jupiter, occur less in space than in time. More than twenty pages, out of the fifty pages of the work as a whole, are devoted to the two months of observations during which Galileo came to realize that what he first assumed to be "fixed stars" near Jupiter were actually four "planets."[38] It is the sequence of pictures, not any one picture, that matters; and the dramatic effect depends on a process of thought, not on the naked eye.

Despite its air of objectivity, in fact, *Sidereus Nuncius* is a very argumentative text. Galileo's writing seems always energized by disputes and debates. For sheer polemics *The Assayer* stands out, but it is hardly alone in its contemptuous attack on lesser minds. Galileo swims in controversy like a fish in the sea. Even when he tries to temper his arguments by writing dialogues, most crucially in the *Dialogue on the Two Chief World Systems*, his diplomatic effort to give voice to opposing views tends to be unconvincing; the sop thrown to the Ptolemaic view of the world seems condescending when subjected to Copernican logic and scorn.[39] To some extent this polemical style reflects the tenor of a time that prized debate, a time when universities, like city-states, chose champions through public jousting. The arts were similarly contentious. In practice as well as theory, the *paragone* or quarrelsome comparison largely set the terms of evaluation.[40] Galileo was accustomed to taking sides. His most extended piece of criticism, *Considerazioni al Tasso*, offers a detailed commentary that pits the many faults of Tasso's "mannerism"

against the glories of Ariosto's classical art. Such "critical purism," Erwin Panofsky argued long ago, "may be said to be the very signature of [Galileo's] genius."[41] But a relish for combat often drives the purist to his extremes. In order to think about Ariosto, the critic needs a foil: Ariosto vs. Tasso, the treasure room vs. the *Wunderkammer*, truth vs. fiction or lies. The moon itself becomes the site of a debate, as Galileo perceives it.

Above all he argues that the moon resembles the earth. By observing the many small spots that sprinkle the lunar surface—"observed by no one before us"—he has reached the conclusion that "we certainly see the surface of the Moon to be not smooth, even, and perfectly spherical, as the great crowd of philosophers have believed about this and other heavenly bodies, but, on the contrary, to be uneven, rough, and crowded with depressions and bulges. And it is like the face of the Earth itself" (40). This inference, conceived in proud opposition to the crowd of ignorant philosophers, conditions Galileo's way of seeing as well as what he sees. When bright points appear in the dark part of the moon, then gradually increase until they join the luminous part, the reason is always already apparent. "Now on Earth, before sunrise, aren't the peaks of the highest mountains illuminated by the Sun's rays while shadows still cover the plain? Doesn't light grow, after a little while, until the middle and larger parts of the same mountains are illuminated, and finally, when the Sun has risen, aren't the illuminations of plains and hills joined together?" (42) Analogy and observation join here in one perception: the peaks of the earth at sunrise bear witness to peaks on the moon. In such descriptions, the boundary between what is seen and what is inferred seems to vanish. When Kepler responded to Galileo's new picture of the moon, what excited him most were exactly these demonstrations of earth-like features. Indeed, he acquiesced not only to the lofty lunar mountains that Galileo envisioned— and measured with surprising accuracy—but even more enthusiastically to the lunar seas and atmosphere that Galileo wrongly inferred from similar terrestrial analogies.[42] Nor could Kepler refrain from jumping to a further conclusion, that there must be inhabitants on the moon and probably on Jupiter too. Galileo, with his own eyes, had seen a new earth.

Yet how was that lunar earth to be pictured? Brought near by a telescope, the moon presents a dynamic visual challenge to its explorer. The problem of how to represent it depends on what the observer conceives it to be. Its shifting shapes, as it moves through so many phases, have marked it tradition- ally as an emblem of supernal fickleness: another name for mutability. At one extreme, there seem to be many moons—new moon, crescent, half-moon, gibbous, full—each with its own associations, auguries, and iconographical conventions. Invisible when new, and subject at times to eclipses, the moon conjures up a world of phantoms and illusions; and when it shines on earth, it

touches mortals with romance and madness.[43] And yet Diana vies with Pro-
teus: the image of the moon can also stand for spotless purity. One tradition
popular in Galileo's time linked the immaculate moon to the Immaculata or
Virgin Mary, *pulchra ut luna* ("beautiful as the moon," in a phrase from the
Song of Songs), who was pictured standing on a flawless, transparent sphere.[44]
The telescope dismantled that image forever, except as a relic of holy purity
superimposed on nature. But the eclipse of one iconographical convention
did not establish another. Cigoli's cratered and spotted moon, in the great
fresco he painted at Santa Maria Maggiore in Rome (1612), undoubtedly
derives from Galileo's lunar message. Yet Cigoli's maculate sphere, more suit-
able for the Woman of the Apocalypse than for the Virgin,[45] had little or
no effect on later artists. The Galilean earth-like moon defied conventional
otherworldly representations.

Nevertheless, what Galileo saw and what he drew clearly have a source
in what painters already had seen. The key was "secondary light": the light
reflected from a bright surface onto a surface that shines more dimly with a
radiance not its own. When Renaissance artists painted interiors, they often
exploited this effect quite brilliantly; and by analogy Leonardo, in a series of
notebook entries, reasoned that the *lumen cinereum* or "ashen light" that bathes
the shaded surface of the new moon must really be "earthshine," reflected
from the face of the earth.[46] Long afterward, in 1604, Kepler explained the
phenomenon at length in his *Optics*.[47] But Galileo makes this discovery his
own by combining the perspectives of an artist and an astronomer with his
personal observations. *Sidereus Nuncius* mocks philosophers who had attrib-
uted the ashen light to emanations from the moon itself, to a shine cast from
Venus or the stars, or to penetrating rays from the sun. Those theories are
childish nonsense. The truth is that "in an equal and grateful exchange the
Earth pays back the Moon with light equal to that which she receives from
the Moon almost all the time in the deepest darkness of the night." Still more,
understanding the role of secondary light refutes the anti-Copernican claim
that "the Earth is to be excluded from the dance of the stars"; "For we will
demonstrate that she is movable and surpasses the Moon in brightness, and
that she is not the dump heap of the filth and dregs of the universe" (55, 57).
A kind of terrestrial patriotism inspires the celebration of earthshine.

Galileo's seven sepia drawings—in brown ink diluted and diversified by a
series of washes—subtly convey the mutual dance of moonlight and earth-
light. A remarkable variety of contrasted shadings, filling the gaps between
pitch dark and absolute brightness (untouched white paper) with stipples
and mottled grays that look truly ashen, alert the viewer to the weakness of
eyes that perceive the moon only as something that shines. Here darkness
has its own iridescence and presence. Galileo is trying to see the moon as a

place, not merely an image.[48] Samuel Edgerton suggests that in these moon-scapes Galileo "has anticipated the independent landscape in the history of art. His almost impressionistic technique for rendering fleeting light effects reminds us of Constable and Turner, and perhaps even Monet."[49] Yet moon-scapes differ from landscapes; they are an alien light show, floating in space—less Constable than Rothko. Aside from the absence of fine detail, the faces that the moon turns toward the earth present an unearthly, dramatic line—a *terminator*—between light and dark, a line that Galileo can ruffle but cannot erase. Nor can the telescope finally close the distance between the perceiver and what is perceived. Galileo's pictures require a technique that will some-how make that remote and eerie circle resemble the earth. In particular, as an artist he needed to solve a problem posed by what he understood as well as what he saw: how to paint an apparently two-dimensional, flat surface in such a way as to suggest a third dimension of mountains, valleys, and seas. Formal perspective, at that distance, could only hint at this rugged terrain. But chiaroscuro and secondary light enabled him to bring the moon closer to home. No one before had ever captured the play of reflections that adum-brate heights and depths on the moon, and, by extension, allow us to think of the earth itself as a globe moving through space.[50]

These fine effects of light do not appear, however, in the pictures that illustrate *Sidereus Nuncius*. The striking differences between the original drawings and the printed illustrations, composed only months apart, provoke speculation. In 2005 the "discovery" of a set of watercolors of the moon, in a previously unknown copy of *Sidereus Nuncius*, electrified scholars who thought they had found a missing link. Unfortunately both the book and its pictures turned out to be forged.[51] Galileo supplied no link. Yet he clearly did intend to revise his first lunar sightings. A letter to an unknown cor-respondent (January 7, 1610) includes five sketches of the moon and four of craters, as well as verbal descriptions that he would repeat in his book.[52] Moreover, he probably made the printed illustrations himself. A roughness in the execution of the prints, which appear less skillful than the work of a professional engraver, suggests that they were etched; etching, an amateur's medium, would not have required Galileo to master the difficult technique of engraving.[53] In any event, the relatively coarse hatching inscribed by the burin cannot hope to reproduce the delicate gleam of washes. The pictures in *Sidereus Nuncius* are cruder than the earlier moonscapes in Florence, and its etchings flatten the depths envisioned by Galileo (see fig. 2).[54]

Yet the difference between the Florentine drawings and printed pictures may also expose a tension in what Galileo saw and wanted to show. From one point of view, he might have been painting a moonscape; but from another,

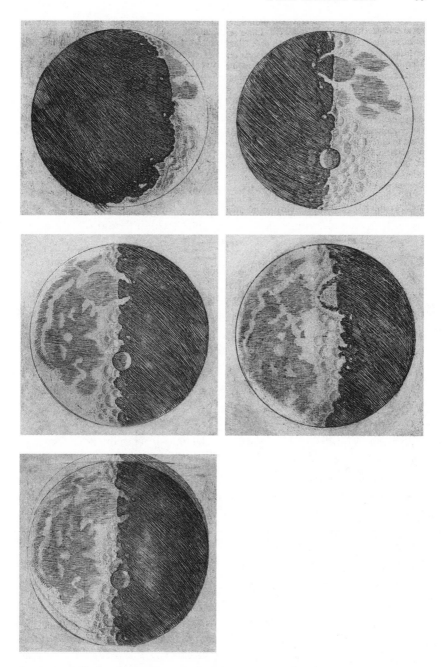

FIGURE 2. Galileo's etchings of the moon from *Sidereus Nuncius* (1610). Northwestern University Library.

he might have been making a map. Here another set of conventions or other ways of seeing and picturing come into play. Galileo was well versed in those ways. As a young man he gave two lectures at the prestigious Florentine Academy on the topography of Dante's Hell—its layout, location, and size[55]—and though he later stopped agreeing with Dante that the earth was the dump heap of the universe, he never lost his knack for visualizing how things are positioned and move in space. His mind's eye grasped so much, in fact, that historians still argue about whether some of his studies of motion were thought experiments or actually tested in practice.[56] He also taught cartography. The great age of voyaging and exploration had stimulated an age of increasingly sophisticated mapmaking, which proved valuable for military as well as colonial ventures. Several of Galileo's early inventions had military applications; and in an era of warring city-states the telescope itself quite soon excited interest in prospects for long-distance spying. If maps collected a store of useful knowledge for travelers, they also stirred thoughts of possession.

Galileo was not the first observer to chart the moon. Around 1600 William Gilbert, the great English philosopher of magnetism, drew a full sketch of the features he saw (or thought he saw) with his naked eye, including continents, seas, and islands. He even provided names; as might be expected from Queen Elizabeth's court physician, one island is called "Brittannia" [sic].[57] That sketch was not published until 1651, nor could Galileo have seen the primitive telescopic "map" of the moon that Thomas Harriot drew in July 1609. In any case those observers were baffled by what they dimly saw. When Sir William Lower reported to Harriot on what his "cylinder" had descried, he understood that he was looking at earthshine, not the man in the moon, but the rest was a jumble: "In the full she appears like a tarte that my cooke made me the last weeke. Here a vaine of bright stuffe, and there of darke, and so confusedlie al over." Only after Lower and Harriot read *Sidereus Nuncius* did they begin to appreciate how much more might be seen.[58] Galileo alone had comprehended the design of what he observed, and the honor of discovery belonged to him. Raw sightings and crude charts were not enough to make a Columbus or a Magellan; a true explorer had to open the way to a new world where others might follow.

The starry messenger opened that way. In terms of accuracy as well as artistic merit, the printed pictures take a distinct step backward from Galileo's first drawings. But a map is not, nor is it intended to be, the thing it represents. Instead of an illusion of reality, it offers a scheme of relations, in which the often muddled shapes and vistas that meet the eye resolve into intelligible and clearly distinguished marks and points. Maps, like names, contract the richness of the world into abbreviations and simplifications, and necessarily distort it.

The pictures in *Sidereus Nuncius* exaggerate what Galileo saw; they force the viewer to interpret some appearances as he did. Hence the ambiguous shades of the drawings now suggest discrete topographical features, while the "uneven, rough, and very sinuous" terminator calls attention to the depressions and bulges that Galileo envisioned. Still more dramatic is the very large and perfectly round "cavity" or crater that straddles the terminator just below the middle, as if it were the navel of the moon. Three of the five illustrations in *Sidereus Nuncius* highlight that spot. Yet no such feature appears in the earliest drawings. Perhaps Galileo remembered, from his sightings, the crater Albategnius; and perhaps, as Owen Gingerich suggests, he was registering its "psychological impact" rather than its true size.[59] Circles did cast a spell on Galileo. Alexandre Koyré remarks the obsession with circularity that tied him to older ideas of heavenly motions and may have kept him from recognizing Kepler's elliptical orbits.[60] But Galileo's text explicitly enlists the crater as "a very strong argument for the roughnesses and unevennesses scattered over the entire brighter region of the moon." Like a Bohemian valley enclosed in a perfect circle by very high mountains, the cavity is bathed in sunlight on the dark side of the dividing line between light and shadow (47).[61] Once again Galileo maps the earth onto the moon. The huge mountain range in the drawing marked "5," and the little study at the lower right of the first moon drawing, an elegant exercise in modeling depth through light and shade, seem trial runs for a more conclusive proof of what the artist meant to show. In print the crater is impossible to overlook. Its bold relief draws the eye and neatly balances the composition by placing a circular bowl within another circle, a tiny crescent moon within the moon. Like Wallace Stevens's jar in Tennessee, it makes the slovenly wilderness surround that hill—or rather, hole. Hence the crater functions, in several ways, as a *landmark*: a means of orienting the viewer; a proof of heights and depths on the land of the moon; a feature that no one else had discovered; a beacon engraved on a map.

In all these ways the landmark ministers to human needs, the rage for meaning and order. Whether or not Galileo saw such a crater, or something like it, he needed it to organize his pictures. The illustrations implicitly claim a right to heighten or even to tamper with the evidence of the eye. Artists have always enjoyed that prerogative, and Galileo was surely an artist.[62] But more important, he was an explorer, who had to communicate not only the reality of what he had found but also its significance and excitement. And like other explorers, he seems to have felt the special pride and privileges of ownership. As proprietor of the moon, he was responsible for keeping it up; other people must be instructed to see it in the right way. The text and maps offer a guide to the nature of the moon, not merely to its surface. Hence

Sidereus Nuncius too is a landmark. It represents a means of orientation, an urgent message that cannot be overlooked. Later explorers would see more and draw more accurate maps, but they could not share that sense of revelation. The first discoverer claims the right to name what he alone has seen, as Galileo names the moons of Jupiter "the Medicean Stars."

Glory and Darkness

Glory was certainly very much on Galileo's mind. The dedication to the little book begins with images of immortality, the monuments created by sculptors and poets to keep great names alive, and then moves on to the stars, where human ingenuity has contrived to translate "the fame of Jupiter, Mars, Mercury, Hercules, and other heroes" into incorruptible symbols. Henceforth a new hero, young Cosimo II de' Medici, will be emblazoned in the sky.[63] This master stroke of courtiership deflects attention from the observer to the divine and human grace that had inspired him. The Medici myth had long been tied to Jupiter, and Cosimo to the cosmos, so they were surely entitled to ascendance. All glory to the patron.[64] And Galileo duly won his reward, an appointment as Cosimo's philosopher and mathematician, as well as a highly lucrative nonteaching professorship at Pisa. A humble satellite could not ask for more.

If the grand duke's name was written on high, however, a secondary light shone intensely on his servant and former tutor:

> Since I was evidently influenced by divine inspiration to serve Your Highness and to receive from so close the rays of your incredible clemency and kindness, is it any wonder that my soul was so inflamed that day and night it reflected on almost nothing else than how I, most desirous of Your glory (since I am not only by desire but also by origin and nature under Your dominion), might show how very grateful I am toward You. (32)

These astronomical images, however fawning, extend the radiance of Cosimo to everyone in his orbit, as in the solar system itself. A similar appeal to family likenesses allows an unusually direct and daring assertion of Copernicanism: the "Medicean Stars" speed around Jupiter "with mutually different motions, like children of the same family, while meanwhile all together, in mutual harmony, complete their great revolutions every twelve years about the center of the world, that is, about the Sun itself" (31). Here the cosmos and the patronage system mirror each other, reflecting glory all around.[65] Indeed, the Medici name, according to Galileo, lends honor to the stars, and everyone who saw them in the future would murmur that name. But Galileo had christened them; he had changed the heavens, and henceforth would himself be a star.[66]

Nor would his life be the same. As more and more observers cast fresh looks at the skies, and reported and argued about the new things they saw there, Galileo's world also expanded. Even if he was not the first to identify sunspots, it was he who understood what they portended, "the Last Judgment of pseudophilosophy," as the immutability of the heavens shattered forever.[67] The *Letters on Sunspots* (1613) are decorous, by Galileo's standards; they condescend to lesser minds but do not savage them, nor do they claim to have solved every problem they raise. Yet no one could ignore their self-esteem. In the last of the letters, the author assumes something close to the royal "we" as he associates himself with human progress: "It seems to me, moreover, that we degrade our condition too much, not without offending Nature to a certain extent, and, I would almost say, divine Goodness—who, to help us understand His vast edifice, has granted to us 2000 more years of observations and vision twenty times as acute as what Aristotle had—by preferring to learn from that philosopher what he did not and could not know, rather than from our eyes and our own discussions."[68] Nature gave Galileo the telescope, and he will not insult her by inferring that her purposes—and those of Providence—might differ from his own. Such pride was justified, to be sure. In general he was right (though not about Saturn, comets, or tides), and his opponents were wrong. But more than that, he felt that he owned the skies. When he looked at sunspots, as when he first observed the moon nearby, he saw what no human being had ever seen before: not only earthshaking phenomena but also their meaning. For the moment he stood alone, uniquely relishing his vantage on the hill of truth. Moreover, he thought that he could look from there into the future, where new observations would confirm "the great Copernican system, to whose universal revelation we see such favorable breezes and bright escorts directing us, that we now have little to fear from darkness and cross-winds"—like the clouds and winds on the sun.[69]

Those breezes, like Walter Benjamin's storm called progress, were also irresistibly propelling the great explorer into the future, and they would leave destruction in their wake.[70] In 1613 Galileo did not foresee the strength of resistance to changing the heavens, nor the frailty of his protection. The wonderful confidence that prompted him to deliver opinions on everything that happened in the skies, and even to adjust the face of the moon in order to make a point, betrayed him in the end. Nor did his eyes retain their cunning. His sight began to fail in the 1620s, and by 1637, four years after his condemnation, he was completely blind. If the skies were no longer his domain, however, his mind's eye and memory flourished. His last and arguably greatest work, the dialogues on *Two New Sciences* (1638), returned to his early interest in the science of motion and mechanics. Drawing on experiments performed and imagined, it pioneered key principles of modern

engineering, and even includes a digression on sound that might have satis-
fied the inquisitive man in the fable.[71] The restless, lynx-eyed mind could still
see farther than others.

Yet the world that he saw had changed. The skies had come closer, and now
reflected the turmoil of earth itself; the authorities, not the explorer, owned the
moon. Galileo now saw what he had been told to see. In one of his final let-
ters, he insisted that the Copernican system must be false, on "the irrefragable
authority of Holy Scripture interpreted by the greatest masters in theology."
Experience had taught him again, as in the fable of sound, not "to pretend to
hamper God's hand and tenaciously maintain that in which we may be mis-
taken."[72] But geocentric systems like those of Ptolemy and his followers were
even *more* false, refuted by observations and the deductions of human reason.
At the horizon everything moved, and instruments could not measure whether
the earth or the stars were the source of that motion. The order of the heavens
had fallen apart; no one could be certain that what he saw there would stay.

A Fable of Seeing

Once upon a time, in a very high place, a man was born with amazing insight
and an extraordinary curiosity. In the evening he loved to look at the sky, and
with the eye of an artist he wondered at the order he saw there, the stately
procession of constellations, the moon and planets and stars, serene and beau-
tiful. They were so perfect, so different from his own world. Then one day
he walked off the beaten track and found a pair of twisted spectacles; and
when he put them on, they seemed to have been made for him. Suddenly the
heavens came near. The moon swelled above his head; the planets and stars
grew sharp and distinct. He felt that he could reach out and touch them. And
when he did reach out his hand he saw that its movements were in harmony
with those of the moon and the planets. They were his neighbors, no longer
distant and cold. Soon they became his other home. He knew they were like
the earth, rough restless places forever spinning, and he knew he was moving
too. That knowledge was power. He used that power to shape the sky into
new figures, no longer serene, but precise as a line or a circle; and what he
shaped, he saw. He liked the roving, unfamiliar sky that he had made. Then
he felt the earth shaking beneath him, and other people also felt it shake.
They started to look strangely at him. Rich landowners, who ruled that place,
told him that he had unsettled their property; they bound him and kept him
from moving. But still the earth shook, and still he gazed at the sky. And
even when he grew blind, he felt the earth shake, and he felt the sky move,
and knew he had changed them forever.

❧ CHAPTER 3

Kepler's Progress

Imagining the Future

I

The Six-Cornered Snowflake: Past, Present, and Future

As Johannes Kepler walked across the great Charles Bridge in Prague, one day in 1610, flakes of snow began to fall on his coat, and he suddenly noticed something remarkable: all of them had six corners and feathered radii, like tiny tufted stars. Why six, never five or seven? There must be a reason. Kepler loved puzzles, and this one arrested and fixed his wandering mind. He looked high and low for an answer—perhaps in heaven, from which those stars had descended, perhaps on earth. And since he was used to trying out his ideas by writing them down, he soon wrote a little book on the cause of that unaccountable figure.

Strena, Seu de Nive Sexangula (*A New Year's Gift, or On the Six-Cornered Snowflake*, 1611) is a self-confessed trifle. The title already brands the text as a present for Kepler's friend and patron Johannes Matthäus Wacker von Wackenfels, counselor at the imperial court, and the introduction plays on Wacker's special fondness for little nothings. Even the subject matter forwards the joke, since *nix*, the Latin for "snowflake," sounds in some German dialects just like *nichts*, or "nothing."[1] This book, the author insists, is no more than a droplet, as close to insignificant as any gift could be. Indeed, its final words, before "The End," are *Nihil sequitur*: "Nothing to follow." That prophecy did not prevent a number

of scholars, including Descartes, from picking up the thread that the book had laid down.[2] Nonetheless it remains obscure, unmentioned by many studies of Kepler.

Yet *The Six-Cornered Snowflake* might also be taken as an epitome of Kepler's work. In its search for the cause of a geometry inscribed in nature, an archetypal or divine mathematics, it follows in miniature the course of his quest for celestial designs, the geometrical patterns that shape the cosmos and underlie the harmony of the world. In its effort to bridge the gap between mathematical abstractions and the tangible, particular phenomena that bring them to life, it meshes with his revolution in astronomy, his stubborn refusal to separate the calculations of astronomers from the actual movements of physical bodies, stars, planets, the sun, and the earth. In its constant testing of theories, a habit of mind that launches one hypothesis after another and then relentlessly probes their faults, as Kepler dispels his own speculations on snowflakes, it draws on the method that he applied to celestial physics: the scrupulous, painstaking task of checking the numbers, and refusing to doctor them when they clash with his best ideas. In its oscillation between an ancient, animistic view of nature and progressive modern insights that often appear to be centuries ahead of their time, it recalls the "watershed" between old and new sciences where historians customarily place Kepler, with one foot in the universe of Pythagoras, Aristotle, Plato, Proclus, and Galen and the other in the emerging worlds of Copernicus, Galileo, Descartes, Newton, and Einstein.[3] And like all his writings, it offers not only evidence and deductions but also a glimpse of Kepler's own agile mind at work, which creatively strives to mirror the image in which it was made, the mind of God.

Moreover, the idiom of *The Six-Cornered Snowflake*, the quirky, personal style that is Kepler's trademark, at once serene and agitated, conveys at every point a sense of the distinctive way he imagines the world. That imagination is interactive; it looks for a soul and purpose like its own in everything that exists, in even a snowflake. In that respect his curiosity acknowledges no limits. He tries to see the universe from the varying perspectives of each of its parts, adopting the point of view of a comet, a dog, a plant, a moon dweller, or water vapor at the moment when it is translated into a dainty crystal. Most of all, his point of view moves through the heavens; it is heliocentric not only in theory but also through an active adjustment of vision, which peers into space like the Kepler Satellite of our own times. When Kepler discovered that the planets moved in elliptical orbits, against his own instinctive attraction to perfect circles as well as the unchallenged circular reasoning of all astronomers, the crucial turn was his decision to center his calculations on "the actual body of the sun."[4] He had to imagine, for the first time, a genuine solar system.

Kepler's lifework reflects that adjustment of vision. The *New Astronomy* (1609) originated in 1600 as "Commentaries on Mars," when the great astronomer Tycho Brahe tested his would-be assistant by assigning him to work out the notoriously difficult "theory of Mars," its path through space. Kepler expected to do this in a few months. Instead it took more than five years and required him to conceive two radically new models of motion, Kepler's first two Laws: planets move in ellipses with the sun at one focus; and in the plane of the orbit the radius vector (the line between the planet and the sun) sweeps out equal areas in equal times. But what held the system in place was a power or force (magnetic, he thought) exerted by the sun.[5] Mars did not guide itself. Even if some planetary intelligence or angel steered it, Kepler surmised, its route would be too complex for that intelligence to find its bearings. But the sun could orient it; and once that one great central power was put in charge, the task of computing and predicting the orbits became much simpler. For Kepler, who worshipped the sun as an image or symbol of God, this proof of its dominion was profoundly satisfying.[6] His imagination paid homage to it; and so did his calculations.

To enter the point of view of a snowflake presented a different sort of challenge, however. For one thing, the hexagonal pattern seemed to lack any useful function. In an age when it was supposed that everything in nature had been designed to serve some greater good, especially the good of human beings, such sports of nature needed to be explained. The laws of the solar system testified to a benevolent Creator whose geometry sustained order and life in the most economical way. But, as Kepler admitted, "no purpose can really be observed in the formation of a snowflake, nor does the six-cornered figure make the snowflake last long, or make a natural body into a well-defined, fixed, and durable form" (32). Here nature seemed to be *playing*, or at best contriving a pretty form to adorn ephemeral matter. In a remarkable image, Kepler compares the snowflake to Olympias (the mother of Alexander the Great), who when slain by assassins took care (according to Euripides) "not to fall ungracefully or shamelessly" (34). A graceful attitude redeems the death of each dispensable flake. This is imaginative, and certainly shows the writer, like nature, at play. Yet it also threatens to reduce the patterns of nature to a trivial game, if not to nothing.

Nevertheless, the player finds a principle, a shaping spirit or formative faculty (*facultas formatrix*), in the starlets that fall on his coat. Just as William Blake can see "a World in a Grain of Sand," so Kepler perceives a world soul at work in the snowflake: a spirit inherent in Earth itself, which "in accord with the internal state of each material or something external builds one thing or another" (34). This spirit or master builder provides a universal

rationale for all the puzzles and patterns of nature. At the same time, however, it conjures up a world of magical thinking, potentially hostile to science. The all-creating vital principle of form can account for the process by which anything is generated; Kepler resorts to the adjective *formatrix* twelve times in *The Six-Cornered Snowflake*. But its secret and mysterious power evades any possibility of a test or a proof. In this respect Kepler seems to follow the ways of ancient animists such as Lucretius, or the popular mysticism of Paracel-sus.[7] The search for a primal geometrical cause of the shape of a snowflake tempts him to posit a like-minded author or spirit, deliberately molding a form that expresses its own archetypal being. "Since it is quite certain that souls themselves incorporate quantities in their innermost essence—whether with or without physical matter, I will not debate—it is reasonable that they should incorporate shapely rather than rough quantities, and, if shapely, why not regular, solid shapes, since souls are not attached to surfaces but to solid bodies" (36). Hence the Earth-spirit replicates its favorite shape, the six-cornered octahedron, in the snowflake as in the diamond. Imagination has carried Kepler away. But immediately he recognizes his folly: "Am I now presenting the soul of the thrice-greatest animal, the globe of the earth, in an atom of snow?" (38). And providentially the snow again begins to fall, and when he examines the starlets "none of them was anything but flat" (38)—not three-dimensional octahedrons at all. So his mystical excursion has come to nothing.[8] Perhaps this reversal marks the essential spirit of Kepler. Devoted to flights of fancy and magical thinking, he also can turn on himself with skeptical matter-of-factness and rigorous logic.

Both sides of Kepler are involved in the stories he tells. *The Six-Cornered Snowflake* is far from a straightforward treatise. Like virtually all his publica-tions, it winds about and takes the reader into his hesitations and divagations and sudden changes of course. Even his major works often present their theses obliquely, in a stream of consciousness that dwells on the process of discovery, and the many missteps along the way, rather than on the results. It is characteristic of Kepler that his greatest insights, including the laws that changed the cosmos, tend to be introduced as outgrowths or digressions from some larger argument. *Mysterium Cosmographicum* (*The Secret of the Universe*, 1597), the book that made Kepler's name and attracted Brahe's attention, sets forth a theory that stunned and thrilled its author: the distances between the planets are proportioned to the five "Platonic solids" or polyhedra (the four-sided tetrahedron; the six-sided cube; the eight-sided octahedron; the twelve-sided dodecahedron; the twenty-sided icosahedron). That was why there could be no more than six planets; God had used geometry to build the solar system, and now his plan had been revealed.[9] In the long run, as more

planets swam into view, this wonderful idea would collapse. But in supporting it Kepler casually broached some incidental theories—the relation of the periods of the planets to their distance from the sun, and the power of the sun to move them—that would last forever.

Similarly, the *Harmonice Mundi* (*The Harmony of the World*, 1619) erects a magnificent edifice to demonstrate that all the universe obeys an unheard music, precise mathematical regularities or harmonies that not only derive from God but also show us an image of God the Creator. Yet the crowning touch, the Third Law, which laid a foundation for Newton—the squares of the periods of the planets are proportional to the cubes of their mean distances from the sun—is tucked away among the eighth of thirteen propositions in book 5, chapter 3. In fact Kepler discovered it only after most of the book had already been written. He weaves this revelation into a little story, with the aid of a quotation from Virgil's first Eclogue. For seventeen years he had been laboring on the observations passed down by Tycho, as the shepherd Tityrus had been held in place by his love for the nymph Galatea. But after she left him, Tityrus first saw Rome, thanks to "Freedom, who, though late, yet cast her eyes upon my sluggishness / ... Yet cast her eyes on me, and after a long time she came."[10] Kepler cleverly associates his delay in first seeing "Rome," the pinnacle of his research, with servitude to Tycho, and celebrates the exact day of his release from darkness, May 15, 1618, when his laborious star charts and beautiful theories conspired together and brought forth harmony.[11] Yet soon this particular vision closes. He turns back to his cosmic theme, and the book ends with a hymn to God and the conductor of God's orchestra, the sun.

There is no such climax in the story of *The Six-Cornered Snowflake*. It circles around to confessing, "This thing is not yet comprehensible to me" (42). Kepler lacked the tools to solve his problem. More than 300 years would pass before scientists were able to formulate a relatively adequate explanation: "The hexagonal symmetry of a snow crystal is a macroscopic, outward manifestation of the internal arrangement of the atoms in ice."[12] Kepler knew nothing, of course, about oxygen and hydrogen atoms, and in any case he doubted the existence of atoms, whose champions were likely to favor minute invisible material causes of all phenomena, rather than a foundational geometry that left nothing to chance. Yet he did acknowledge where an answer might be found. At the end of the book he shrewdly passes the problem on to metallurgists and especially to chemists, who will need to analyze what snowflakes are made of. This intuition proved to be quite prescient. Still more, Kepler had pioneered the science of crystallography. Almost a third of the little book consists of a long "parenthesis" or "preamble" that

considers the reasons why the six-cornered rhombus seems to provide the most efficient form for packing solid bodies together, as in the honeycomb or the pomegranate. This way of filling space, Kepler concludes, is the pattern that "God himself, creator of the bee, designed when He set down for it the laws of its architecture" (16–18). When equal pellets or congruent spheres, like cannonballs, are stacked for maximum density, they take the form of either face-centered cubic packing or hexagonal packing. "The packing will make the tightest fit, so that no other arrangement could squeeze more pellets into the same container" (14). Kepler's Conjecture was to become one of the most famous of all geometrical or mathematical problems. It resisted solution until 1998, when the mathematician Thomas C. Hales announced that he had confirmed it (assisted by computers and Samuel P. Ferguson).[13] Not for the first or last time, one of Kepler's asides turned out to found a field.

The full significance of *The Six-Cornered Snowflake*, moreover, may not have been realized yet. In a foreword to the 1966 edition, Lancelot Law Whyte contended that *"This essay is the first recorded step towards a mathematical theory of the genesis of inorganic or organic forms*, a theory which still lies in the future" (v–vi). Perhaps that future now looms even larger. Twenty-first-century science, Freeman Dyson predicts, will follow a track envisioned by the microbiologist Carl Woese, exploring the dynamic patterns of inorganic or organic forms. "This picture of living creatures, as patterns of organization rather than collections of molecules, applies not only to bees and bacteria, butterflies and rain forests, but also to sand dunes and snowflakes, thunderstorms and hurricanes. The nonliving universe is as diverse and as dynamic as the living universe, and is also dominated by patterns of organization that are not yet understood."[14] Though Kepler could hardly have anticipated the genetic codes and computer models that led to these new pictures of bees and snowflakes, the general line of thought might not have seemed strange to him. He had asked similar questions about the genesis of forms, or the wedding of geometry and creation, and his conjectures about the mathematical architectonics of nature often look fresh today. This is an ongoing conversation he helped to begin.

Nor would he have been surprised to learn that his ideas were still being talked about in the future. He was willing to wait for others to catch up to him; a hundred years might pass, he suspected, before the Third Law found the right readers.[15] But he also enjoyed the give-and-take of exchanging views or arguing with predecessors and contemporaries. A love of conversation pervades all Kepler's work. *The Six-Cornered Snowflake* begins by personally addressing its dedicatee Wacker, and finishes by asking "what an exceptionally clever man thinks" (44). Internally, the sense of dialogue

is sustained by frequent interjections: "You may ask how I know this ...," "Someone may think ...," "You might argue thus ...," "Someone else may object...". Soon after Kepler raises his opening question—why always six?—a crucial remark slides by in a flash. "When I had a conversation about this with someone recently, we first agreed that the cause was not to be sought in any material, but in an agent" (6–8). Kepler had many conversational partners in Prague. But it is also possible that the text is covertly referring to Thomas Harriot, the English natural philosopher, who had pondered these matters and might have shared his thoughts in correspondence long before the snowflakes had fallen on Kepler's coat. Had Harriot published his hypotheses, he might well have claimed a place as the founding father of several fields, including crystallography.[16] But Kepler cannot be fairly accused of concealing his debts. His speculations on snowflakes do not pretend to offer important, original theories. Instead they enter a social world and try to engage a few friends and readers in joint, open-ended detective work that will probably come to nothing. This play of mind should be its own reward; it keeps up the conversation.

Conversing with Galileo

A similar love of conversation sparks the historic little book that Kepler had published the previous year, his *Conversation with the Sidereal Messenger* (1610). Soon after Galileo's *Sidereus Nuncius* came out in March 1610, with its electrifying telescopic revelations, he sent a copy to the Tuscan ambassador at Prague, asking him to pass it on to Kepler and to solicit a written reply. Most other experts responded cautiously, and more than a few expressed hostility or doubts about what Galileo claimed to have seen. But Kepler greeted the book with praise and conviction, almost with ecstasy. By April 19, eleven days after receiving it, he dispatched a long letter to Galileo, and within a few weeks an expanded version of that letter appeared in print. This was a happy moment for Galileo. Amid the initial storm and controversy over his message, while its fate still hung in the balance, one of Europe's foremost astronomers, His Sacred Imperial Majesty's Mathematician, had publicly declared his belief in these marvelous sightings.

Kepler, as usual, makes his reactions into a story. He had first heard about the four new "planets" around March 15 from Wacker, who told him the news "from his carriage in front of my house."[17] Both men were overcome with intense astonishment and joyful laughter. But Kepler also felt anxious. Any increase in the number of planets would refute his favorite theory, the proportion between the six time-honored "celestial spheres" or planets and

the five Platonic solids; and as Wacker gleefully pointed out, Galileo's amazing discoveries also supported Giordano Bruno's speculation—strongly opposed by Kepler—that there might be an infinite number of other worlds.[18] Then the arrival of the book restored him to life. The new planets were actually Jupiter's moons, and easily accommodated to a closed solar system; they did not back the heresies of Bruno and Wacker. Kepler's relief casts a glow over his friendly tribute to Galileo.

At the same time the *Conversation* departs from the *Message* in every way. The two little books could hardly be more different in genre, substance, and style. Their opposition begins with the two titles. Galileo announces a message straight from the stars, a series of objective facts and descriptions that brook no dissent. These observations report exactly what he has seen, and even when he interprets the features he sees—for instance, by comparing the moon to the earth—he offers his views less as arguments than as clarifications. His spyglasses have brought the heavens nearer, and the heavens speak for themselves. To some extent the ambiguity of *nuncius*, which readers like Kepler often understood as "messenger" rather than "message," reinforces the sense of cosmic objectivity, as if the author as well as his message had descended as an ambassador from some unearthly, infallible realm. But Kepler chose another mode of discourse. His *dissertatio* is clearly not a thesis but a conversation *with* a fellow thinker, and it constantly brings other scholars and acquaintances into the circle of discussion. Wacker, Tycho, Michael Maestlin (Kepler's teacher), and many more have something to contribute. Nor does Kepler hesitate to veer from one topic to another, or to draw his own novel conclusions from Galileo's descriptions. Thus the large cavity, perfectly round, on the face of the moon, which Galileo had adduced or invented to show that its lights and shadows resemble Bohemian valleys surrounded by mountains, suggests to Kepler the "trained hand" of massive living beings who could be capable of constructing gigantic projects (28). (The way in which such round bowls do *not* resemble elongated Bohemian valleys also leads the Bohemian Kepler to guess that the moon might be porous.) Under the pressure of these conversational gambits, Galileo's firm message breaks down into aperçus.

The *Conversation* also thrusts Kepler's own work and ideas aggressively between the lines of the *Message*. Up until then he had not succeeded in getting Galileo's attention. In 1597, flushed with enthusiasm, he had sent copies of *The Secret of the Universe* to many qualified scholars, asking for their opinions; Galileo replied quickly and courteously that he looked forward to reading the book. This prompted an effusive letter from Kepler, who welcomed him as a fellow Copernican and implored him to share his thoughts.

But that did not happen. Galileo kept his thoughts to himself; nor did he later respond either publicly or privately to such major publications as Kepler's *Optics* (1604) and *New Astronomy*. In many ways Galileo should have been an ideal reader. Those works were full of rich calculations and speculations on topics that deeply concerned him, including atmospheric refraction, the way that the eye perceives images, lunar geography, the periods of the planets, and the cause of the tides. Yet he betrayed no sign of being interested, let alone influenced. Even after the *Conversation*, Kepler's attempts at correspondence were not reciprocated. Notoriously, his discovery of the elliptical orbits of the planets was never acknowledged by Galileo; and when Kepler conceived the design of an improved telescope in his pathbreaking *Dioptrice* (1611), with a long preface extolling the sidereal messenger, once again he heard nothing from Galileo (who privately complained that he did not understand this invention—and neither did Kepler).[19] There are many plausible reasons for such aloofness. Kepler's blatant Copernicanism, and his assumption that Galileo would want to spread the heliocentric gospel, could have been embarrassing to an astronomer who had to be careful about the political and theological consequences of such positions.[20] Kepler stirred trouble; he had too many bright ideas. Moreover, both temperamentally and intellectually the two were incompatible. To the practical-minded Galileo, who kept his feet on the ground even while scanning the heavens, Kepler must have looked like a zealot who kept his head in the clouds.[21]

From this point of view, the *Conversation* doubtless annoyed as well as delighted the man whose work it endorsed. Kepler's tone is deliberately playful. Unlike other debaters, he notes, he prefers to divert and amuse, not just to impress: "I seem by nature cut out to lighten the hard work and difficulty of a subject by mental relaxation, conveyed by the style" (5). Nor should a reader mistake his generous praise for fawning: "I do not think that Galileo, an Italian, has treated me, a German, so well that in return I must flatter him, with injury to the truth or to my deepest convictions" (7). Some readers, in fact, confused Kepler's freewheeling interrogation of the *Message* with an attack. That was surely wrong. But it might not be wrong to think of the *Conversation* as a good-natured act of revenge for years of neglect, a constant reminder that Kepler too has been discovering new things, and thinking, and writing. The *Message* had been a monologue, the record of one man's original observations. Kepler sets each of those observations within a context of past and present thought, and thus assimilates the new revelations to the collective endeavor of astronomers through the ages.[22] However remarkable, for instance, the telescope had been "announced" many years ago by Giambattista della Porta; and Plutarch and other ancients and moderns had

written about the spots on the moon.[23] These predecessors, Kepler insists, do not diminish Galileo's achievement. Rather, they lend him support by preparing the ground, so that skeptics ought to have faith in what he has done. And Galileo, whether or not he knows it, is strong because so many others stand with him.

Nor is Kepler himself the least of that band. The *Conversation* proper begins with Kepler thinking about Galileo; but what he is thinking about is what Galileo might think about him. Having just brought out his masterwork, the *New Astronomy*, "I supposed that among others Galileo too, the most highly qualified of all, would discuss with me by mail the new kind of astronomy or celestial physics which I had published, and that he would resume our interrupted correspondence, which had begun twelve years before" (9). But no. "Instead of reading a book by someone else," "my Galileo" has been exploring the skies. Kepler takes this in good part, not as an affront so much as an opportunity for "all lovers of true philosophy" to plunge into a new discussion—especially "since I had written on the same topic six years before" (11). The pleasantry carries an edge; the last part of the *Optics*, which Galileo obviously had not looked at, had specified the ways that better optical instruments could solve many astronomical problems. But Kepler prefers to construe the *Message* as an invitation to present his ideas, and to acquaint the messenger with some work he has missed. In this new partnership, the precision of the telescope, joined to the methods and measurements of Tycho and Kepler, will surpass what anyone could do alone. "Therefore let Galileo take his stand by Kepler's side" (22).

Perhaps it was just as well, all the same, that these partners would never meet. Each had his own entrenched ideas, and each his vanities. Though Kepler freely concedes that on some points the new discoveries have proved him wrong—for instance, he had believed that the density and blue color of air would obscure and distort distant things, so that "it was vain, I understood, to hope that a lens would remove this substance of the intervening air from visible things" (18)—he also corrects some of Galileo's mistakes. On irradiation, for instance, the statement in the *Message* that "the telescope removes from the stars their adventitious and accidental splendors" had already been refuted by a passage in the *Optics*, which had identified the widened retina as the agent of those splendors: "The telescope on earth does not remove anything from the stars in heaven, but it does take away from the retina whatever light is superfluous" (34). When Galileo claimed that the *Conversation* had approved "all the particulars contained in my book, without contradicting or doubting a single detail, even the smallest" (122), he was proving once more his lack of attention to what Kepler said.

He also needed to disregard the nature of Kepler's approval. Much of the *Conversation* is haunted by a phantom text, *The Dream* or *Somnium*, "a sort of lunar geography" first drafted in 1593 and rewritten in 1609, though published posthumously, with added notes, only in 1634.[24] Here Kepler imagines himself on the moon and charts its zones, its views of Volva (Earth), its seasons, and its inhabitants. This fantasy, minutely circumstantial, prepares the way for his embrace of Galileo's moon. Yet it also sets the terms of his agreement, or overagreement. The *Conversation* fills the space descried by Galileo with atmospheric and geographic details, and most of all with other living creatures. "I cannot refrain from contributing this additional feature to the unorthodox aspects of your findings. It is not improbable, I must point out, that there are inhabitants not only on the moon but on Jupiter too" (39).[25] A theological point supports this inference. Since everything created—even a snowflake—must have some purpose, the moons of Jupiter need to be explained. *Cui bono?* "For whose sake, the question arises, if there are no people on Jupiter to behold this wonderfully varied display with their own eyes? For, as far as we on the earth are concerned, I do not know by what arguments I may be persuaded to believe that these planets minister chiefly to us, who never see them" (40). Those moons must do someone some good.[26] Kepler's logic adds to the glory of Galileo, who has discovered worlds invisible to previous ages, and therefore new creatures, presumably, for God to look after. Yet it leaps far beyond the circumspect, workmanlike evidence that had inspired it.

Kepler leaps further still. Since no astrologer had known or calculated on these "planets," a skeptic might use them to deride astrology itself. That would have touched Kepler too, because his career, and the living he made, depended heavily on prognostications.[27] In practical terms, what the emperor Rudolf II wanted from his Imperial Mathematician consisted largely of astrological advice; and in 1608 a horoscope that Kepler prepared for an "anonymous nobleman" turned out to have predicted the brilliant future of the great commander Wallenstein, who later offered him patronage and promised to pay his debts.[28] But Jupiter's moons could hardly faze a prudent and legitimate astrologer. Kepler had consistently maintained that the influence of the stars had nothing to do with arcane rules and esoteric powers, which were no more than "horrible superstitions," but solely with "aspects"—angles "formed at the earth by the luminous rays of two planets." Such rays could shape and guide the activities of sublunary creatures, either by affecting their minds or by imparting to the soul some portion of the universal harmony of creation. "Obviously the planets themselves do not act on us, but their aspects become, by influence alone, bridle and spur for those

minds on earth that partake of the principle" (41). Perhaps Jupiter's moons might "coincide in the aspects," but their tiny rays could not accomplish much. They were mere satellites—a term that Kepler himself invented a few months later.[29] Therefore astrology was unscathed. But more important, humans need not feel diminished by the newly discovered worlds and their inhabitants. Aside from God's own shining symbol, the sun, "there is no globe nobler or more suitable for man than the earth," which orbits in the midst of the other planets and provides the best vantage to see them. "Let the Jovians ... have their own planets. We humans who inhabit the earth can with good reason (in my view) feel proud of the pre-eminent lodging place of our bodies" (46). Galileo had claimed that the phenomenon of secondary light refuted "those who claim that the Earth is to be excluded from the dance of the stars,"[30] but Kepler glories in taking his stand on a prime focal point. We have come a long way from the *Message*. In Kepler's eyes, the final significance of what Galileo has seen, or indeed its "aspect," is what it allows other human beings to imagine.

Above all, the *Conversation* tries to imagine the future. The palpable excitement of Kepler's prose reciprocates Galileo's restrained excitement, which trusts the facts themselves to stun the reader. But what the two men share, among so many differences, is a sense that they stand on the brink of new worlds—worlds of thought as well as heavenly bodies. For Kepler, whose thoughts have wings, these inspiring discoveries immediately raise the possibility of unknown creatures to meet or of voyages across the vast expanse: "As soon as someone demonstrates the art of flying, settlers from our species of man will not be lacking" (39). In years to come, many other writers would follow the path of the *Dream* and devise ingenious methods to journey to the moon and beyond.[31] Yet few rivaled Kepler's passionate commitment to exploring the universe and discovering its secrets. A modern reader, accustomed to take the inexorable progress of science for granted, might easily overlook the novelty of that commitment. Contemporaries of Kepler and Galileo still tended to believe not only in a geocentric cosmos but in a natural order whose boundaries had long been fixed—subject perhaps to a few minor modifications. Hardly anyone welcomed the signs of a rearranged sky and newfangled ideas. John Donne took a lively interest in the astronomical "new Philosophy," but to him it represented the inescapable downward spiral of history, decay and decline. When he refers, in *Ignatius His Conclave* (1611), to "*Keppler*, who (as himselfe testifies of himselfe) *ever since* Tycho Braches *death, hath received it into his care, that no new thing should be done in heaven without his knowledge*," the satire bites at the pride of the innovator (a short while later in Donne's fantasy, Copernicus, boasting that he has "turned the whole

frame of the world," will demand entrance to hell).[32] But whether we take Donne's joke as praise or as censure, Kepler deserves it. Extrapolating from Jupiter's moons, he already looks forward with joy to moons of Mars and Venus. He loves to watch the world of learning change.

II

Summing Up Kepler

When Paul Hindemith's eagerly awaited opera *The Harmony of the World* (*Die Harmonie der Welt*) opened at the Prinzregententheater in Munich on August 11, 1957, it represented a high point not only in the composer's career but also in public fascination with the life of its hero, Johannes Kepler. Hindemith had been working on the project, both text and music, for almost twenty years, and he had come to identify with his subject. A glittering audience, including many musical giants and more than 150 critics, attended the premiere, which was broadcast throughout Europe. After the long night of war and postwar gloom, the time was ripe for a major work to confirm the recovery of high culture. But despite a "stormy ovation" the event was far from an unqualified success; Theodor Adorno would later compare it to a state funeral. The critics yawned and carped, and in the long run their disappointment might be called a turning point for Hindemith, who has never quite regained his place as one of the leading composers of modern times. What was at issue was more than the fate of one opera; it was an interpretation of history, and in particular of the charge that music should express the underlying tensions of its age. For Adorno, an advocate of alienation and of Arnold Schoenberg, Hindemith's "affirmative ideology" had suppressed the essential tenor of the history of science since Kepler and marked the composer as a crass reactionary opposed to modern music.[33] And even those more sympathetic to an eclectic musical style seemed unsure that the work and its message spoke to their moment. Did it herald a possible future, or was it immured in the past?

To some extent the opera itself might be regarded as an allegory of this situation. The composer joins his hero in an obsessive quest for a harmony that forever eludes them. This absorption in Kepler dates to the 1930s, when Hindemith's textbook *The Craft of Musical Composition* framed rules for a tonal system of consonances and dissonances derived from nature. The extended major triad "is to the trained and the naïve listener alike one of the most impressive phenomena of nature, simple and elemental as rain, snow, and wind. Music, as long as it exists, will always take its departure from the major triad and return to it."[34] In aspiration, though not in its details, this

principle resembles Kepler's cosmic order. Yet natural harmony and order are not to be found on earth, except perhaps at times in musical inspirations or Kepler's mind. Confusion and frustration reign in Hindemith's opera, as attempts to seize power collapse in endless wars. The dreaming idealist Kepler bobs like a passive cork on an angry sea. Engulfed by characters who demand his allegiance, he dies with the word *vergeblich* (futile) on his lips; and no one understands him. Yet the opera ends with a mighty passacaglia, as all the characters return in a masque, transformed into heavenly bodies. As a dreaming chess player, exhausted by too many games, might translate people he knows into chess pieces on a board, so Kepler, or his departed spirit, arranges the companions of his life into an astronomical pattern like those that obsessed him. And at the same time these players take part in "God's chorale"—a harmony that remains beyond them, but into which they merge.[35] Like Goethe's *Faust*, Hindemith's *Harmony* concludes on a note of eternal striving, in which the struggle for truth is not so much resolved as absorbed into a major triad. Yet all this pageantry, with singers and dancers elaborately costumed to imitate the zodiac, accompanied by traditional musical forms, seems to point backward, to astrological mysteries and to a baroque aesthetic credo attuned to faith rather than progress. It is as if Kepler's laws mattered less than his dreams.

Hindemith's problem was not his alone. The question of how to imagine Kepler, both as an individual and as an emblem of the Scientific Revolution, has puzzled and energized many scholars and artists. To contemporaries of Hindemith and Adorno, who had lived through a Thirty Years' War of their own, the predicament of an intellectual at odds with the community where he was born, caught between murderous factions, and forced into exile seemed strangely familiar. Hindemith's tangled relations with the Nazis, who at one time embraced him and later cast him out, had tainted his integrity as an artist.[36] Hence his sympathetic portrait of a pure soul who wants to be left in peace and serve only his art reflects a high-minded self-justification. Similarly, with music as well as words, he expresses his own predicament as a modern composer, exploring new harmonies and forms yet captivated by an eternal tonality. The opera finds no exit from this impasse. Imagining Kepler, it revisits the dilemmas of its own time.

Science and scientists were also deeply involved in these conflicts. The idea of progress, so vital to the emerging field of the history of science in the mid-twentieth century, could be conscripted equally by Communists and Fascists as well as their enemies, and it might also be held responsible for the anomie and rootlessness of modern times. If Kepler was a hero to some, to others his curiosity had served to dismantle the order of things. In "To the

Planetarium," Walter Benjamin associates Kepler, Copernicus, and Tycho with an "exclusive emphasis on an optical connection to the universe" that broke from the ancient experience of communal, ecstatic contact with the cosmos. "It is the dangerous error of modern men to regard this experience as unimportant and avoidable, and to consign it to the individual as the poetic rapture of starry nights. It is not; its hour strikes again and again, and then neither nations nor generations can escape it, as was made terribly clear by the last war, which was an attempt at a new and unprecedented commingling with the cosmic powers"—a violent, imperialistic enslavement of nature.[37] Kepler can hardly be accused of neglecting the ancient ecstatic intimacy with the cosmos. Yet neither did he succeed in creating a new community, or a more harmonious relation to nature, that might mitigate the turmoil in which he lived. In practice his passivity largely disables Hindemith's opera, whose hero broods and is acted upon but very seldom acts. Such detachment implicates science itself. As the chorus points out, the disinterested pursuit of knowledge might lead to catastrophe: "The power of suns can be split, / To kill even more than before." Perhaps Kepler bears some responsibility for the world he has helped to make.

For historians of science, Kepler presents another sort of problem. The amazing advances that he brought about, converting Copernican insights into a full-fledged solar system and preparing the way for Newton's celestial mechanics, cannot be separated from his deep commitment to mystical fantasies and Neoplatonic forms. Charles Gillispie has compared the geometrical structure of Kepler's cosmos to a cathedral "embellished with gargoyles and figures of saints," and Kepler famously used a similar but more arcane image to introduce his Third Law: "It is my pleasure to yield to the inspired frenzy, it is my pleasure to taunt mortal men with the candid acknowledgment that I am stealing the golden vessels of the Egyptians to build a tabernacle to my God."[38] Raptures like these are not deviations from the essential Kepler but part and parcel of the way he thinks. Hence the brilliant mathematician in whose clockwork universe mankind still lives also pays homage to ancient wisdom and astrological charts. The "Great Tradition" of the history of science, which tracks a series of decisive innovations from the Scientific Revolution to the present day, has never quite managed a comfortable fit for Kepler.[39] From one point of view he plays the role of a founding father, a giant who, along with Galileo, transformed not only the standard model of the heavens but also the nature of science itself, which henceforth would search for laws inscribed in the language of mathematics and verified by evidence inscribed in the real world.[40] Yet from another point of view he represents an embarrassment to any triumphant narrative of

scientific progress. His idiosyncratic cast of mind, attracted to theories that often bordered on the occult and made little impact in his own time, strikes skeptical readers as the mark of "a tortured mystic, who stumbled onto his great discoveries in a weird groping."[41] Thus Kepler's work is often cited to deny the logic of any "Great Tradition."[42] The sheer bulk of his writing, moreover, invites discrepant views, depending on what has been cited; his scientific breakthroughs must be distilled from an incredibly rich and murky reservoir of inklings and eddies. Such writers are hard to place.

Contrasting ways of imagining Kepler come to the fore in accounts of his quarrel with Robert Fludd, the celebrated Oxford physician and hermeticist. In 1617, when Kepler was about to complete the major work on harmonics that he had conceived as long ago as 1599, he came across another study of universal harmony, the first volume of Fludd's *Inquiry into the Macrocosm and Microcosm*.[43] This rival theory had to be answered. An appendix to *The Harmony of the World* draws a sharp line between Kepler's method, founded on mathematics, and Fludd's reliance on ancient authorities and symbolism. "He takes great delight in topics which are hidden in the darkness of riddles, whereas I strive to bring topics which are wrapped in obscurity out into the light of understanding." Beginning with preconceived notions that picture man as a little cosmos and the cosmos as a magnified image of man, "Fludd erects his cosmic music" on principles of analogy and numerology. "Thus for him his conception of the cosmos, for me the cosmos itself, or the real motions of the planets in it, are the basis of the cosmic harmony."[44] Fludd quickly struck back with a point-by-point rebuttal, *The Stage of Truth* (*Veritatis proscenium*, 1621); Kepler replied in kind with an aggressive *Apologia* (*Pro Suo Opere Harmonices Mundi Apologia*, 1622); and Fludd had a spiteful last word in *Monochord of the World* (*Monochordum Mundi*, 1623). No truce was possible. Fludd, according to Kepler, was lost in enigmatic pictures and symbols, and Kepler, according to Fludd, had chased "quantitative shadows" that blinded him to essential qualities and first causes. Posterity would have to settle the quarrel. And until quite recently historians of science have not hesitated to render a verdict in favor of Kepler, the champion of modern scientific thought, who told a friend, "I hate all cabbalists."[45]

Yet lately many scholars have questioned that verdict. An essay by the Nobel Prize–winning physicist Wolfgang Pauli, "The Influence of Archetypal Ideas on the Scientific Theories of Kepler," reopened the debate, and since then its issues have seemed anything but simple. Drawing on Carl Jung's theory that archetypes or "primordial images" in the unconscious initiate the rational, conscious formulations of ideas, Pauli traces Kepler's natural philosophy to his fervent instinctive belief in the Trinity and its

image, the sun. "In Kepler the symbolical picture precedes the conscious formulation of a natural law. The symbolical images and archetypal conceptions are what cause him to seek natural law." From this perspective the dispute with Fludd seems less a matter of magic clashing with science—as Pauli points out, "Both Fludd's and Kepler's scientific ideas about world music have lost all significance"—than a clash of opposing archetypes. Kepler focuses on "the quantitative relations of the *parts*," Fludd on "the qualitative indivisibility of the *whole*"; the number three dominates Kepler's "trinitarian" worldview, the number four is the primal source of Fludd's alchemical, "quaternary" outlook; Kepler represents "the thinking type," and Fludd "the intuitive approach." And although Pauli concedes that "Fludd was always in the wrong" on specific points of astronomy and physics, he also finds the alchemical worldview compelling. Jung's studies of alchemy point to "a deeper unity of psychical and physical occurences," and the "uncontrollable interaction between observer and system" that affects all measurements in modern microphysics has dethroned "the detached observer of classical physics." Most of all, the idea of complementarity—the idea that light can be *both* particle and wave—suggests a synthesis of Kepler and Fludd, in which the quantitative and qualitative aspects of reality might be simultaneously embraced. In that respect Kepler's devotion to symbols does not disqualify his contributions to modern science but rather shows a direction it might well take in the future.[46]

The revival of interest in the impact of hermeticism and Neoplatonism on early modern science has also influenced views of Kepler. When Frances Yates discussed the controversy with Fludd, in *Giordano Bruno and the Hermetic Tradition*, she emphasized that Kepler, despite his disdain for numerology, "had carefully studied Pythagorean-Hermetic theory of world and soul harmony in the *Hermetica* and knew the tradition of religious Hermeticism." Later, with growing enthusiasm, she placed him in an alchemical circle: "Kepler's association with the Rosicrucian world is so close that one might almost call him a heretic from Rosicrucianism."[47] Most historians have rejected that correlation; they continue to regard Kepler's originality and independence of thought as far more important than any traces of the occult.[48] But this dispute, like the dispute with Fludd, may serve as a useful reminder of how many peculiar ideas circulated in Kepler's time. In an age when most causes of disease remained mysterious, and the air seemed full of spirits and demons, not microbes, the followers of Paracelsus were not unorthodox.[49] Physicians could hardly minister to the plague without resorting to metaphysical explanations; Galenic medicines were powerless against an astral scourge brought down on sinners.[50] Fludd, a respected physician patronized by James

I, sought remedies in astrology, which taught him to look to ethereal spirits for help. Magnetism (which also fascinated Kepler) showed that occult and hidden forces could move things in the absence of any apparent natural cause. Philosophers who distrusted magic might demand an explanation of such action-at-a-distance, as later skeptics would voice suspicion of Newton's mystifying gravity or Pauli's quantum physics. But magnetism proved itself in practice—as did ethereal spirits, according to Fludd.[51] Hence natural philosophy was threaded through with magic and metaphysics. Not even the best astronomer could be wholly immune from their spell. A modern reader should never forget that, modern as Kepler may seem, he lived in a world of strange ideas, a world we can never recover.

A Life of Allegory

The troubles of Kepler's life and times add other complications. The contrast between his personal search for harmony and the spectacular discord of both religion and politics in an age of Reformation and Counter-Reformation has been the organizing principle of several biographies as well as Hindemith's opera. It provides a central thread of Max Caspar's standard life, for instance, and also of James A. Connor's biography, *Kepler's Witch*, whose subtitle blocks out the theme: *An Astronomer's Discovery of Cosmic Order amid Religious War, Political Intrigue, and the Heresy Trial of His Mother.* Indeed, the interest of this intriguing personal story has sometimes displaced the natural philosopher or man of science. "It is the halo of his personality," Caspar argues in his preface, "which draws many under his spell, the nobility of his character which makes friends for him, the vicissitudes of his life which arouse sympathy, and the secret of his union with nature that attracts all those who seek something in the universe beyond, and different from, that which rigorous science offers."[52] A wealth of letters—six volumes in the collected edition—allows the spellbound reader to draw very close. No other great scientist or natural philosopher has ever left a fuller account of his thought processes, his uncertainties and changes of mind, his mood swings, or the difficulties of his daily life. Moreover, these musings and passions throw light on his methods. *The Six-Cornered Snowflake*, itself a sort of expansive letter, draws equally on personality and mathematics, and the spirits who transport a daemon to the moon in *Somnium* are conjured through the witchcraft of the narrator's mother. Kepler tempts readers to interpret his life as an allegory in which a series of accidents and adventures turns out to have been providentially inspired. In the introduction to book 5 of *The Harmony of the World*, his career becomes a prophecy fulfilled; "the finger of God" has guided him

to reveal "the very nature of things."[53] Retrospectively, his discoveries have converted apparent disorder into a fated winding path to truth.

This journey might also be read less positively as "sleepwalking." In Arthur Koestler's sweeping survey of early cosmology, *The Sleepwalkers*, Kepler exemplifies the peculiar logic of the creative process, whose operations often require a sort of "black-out shutter" that blinds the discoverer to obvious truths that might not fit his theory. "The history of cosmic theories, in particular, may without exaggeration be called a history of collective obsessions and controlled schizophrenias; and the manner in which some of the most important individual discoveries were arrived at reminds one more of a sleepwalker's performance than an electronic brain's."[54] Perhaps this diagnosis suits the disillusioned ex-Communist Koestler better than Kepler, who was not only supremely self-aware but also quite ready to falsify his own hypotheses. Consider the famous case of the "trivial" eight-minute gap between Ptolemy's and Tycho's calculations of Mars's position. After incredible labors in checking and rechecking those calculations (seventy times, according to Kepler!), he decided that the theory of the solar system itself would have to be changed. "Now, because they could not have been ignored, these eight minutes alone will have led the way to the reformation of all of astronomy."[55] Koestler rightly admires this stubborn refusal to bend the facts to a convenient geometrical scheme, but he goes on to argue that only a sort of "miracle," three crucial mistakes that canceled one another out, led Kepler to stumble on his Second Law. "It looks as if his conscious, critical faculties were anaesthetized by the creative impulse, by his impatience to get to grips with the physical forces in the solar system. . . . It is perhaps the most amazing sleepwalking performance in the history of science—except for the manner in which he found his First Law."[56]

Much of this analysis is specious.[57] Kepler certainly made mistakes, as he himself admitted, nor could he have anticipated the principles of inertia and gravity that his own work was reaching toward, but the way in which his intuitions leapt beyond cold calculation does not show that his reason was asleep. It shows only the complexity of any creative mind, the intricate twining of conscious and unconscious processes, which can entertain any number of odd ideas before settling on one that works. "The Imagination may be compared to Adam's dream," Keats wrote, "—he awoke and found it truth." Kepler, like Adam, believed that God had inspired his dreams. Yet that did not stop him from putting them to the test of repeated mathematical verification. Everyone dreams; but few have awakened like Kepler and found the truth.

In science, however, the process of waking can be prolonged for generations, if not forever. Nearly four centuries had to pass before the vivid dream

of Kepler's Conjecture was recognized to be true. Under the pressure of such reappraisals, the past keeps changing. As better telescopes and theories evolve, even an amateur like Koestler can see clearly—or thinks he can see—through the cosmic fog in which Kepler once struggled. Nor can anyone ever fully reenter Kepler's mind and world. Good historians of science all understand the danger of teleology, the smug pseudo-omniscience that judges each past idea in terms of its future success; but no historian of science completely avoids it. A few discoveries, like Kepler's Laws, live on, and scholars absorbed by the progress of science will always study how they came to be. Hence most of what Kepler thought and did appears irrelevant to his place in the pantheon—at best an interesting context for what he finally accomplished, at worst a series of outmoded distractions and errors. From this perspective, the function of histories of science seems to be to "normalize" his work, eliminating the peculiar features of imagination and style that make him different from anyone else. The pure, foundational Kepler, the crucial link between Copernicus and Newton, has very little in common with the eccentric writer of allegories and letters and poems. To read through his writings is to encounter an astonishing, often comic disparity between the great giver of laws and the unpredictable, often capricious, incredibly mobile human being who expressed himself day by day.

Visions of Progress

Yet Kepler himself had much to do with the teleological view of history that turned him into an icon of progress. Perhaps he even invented that view. In *The Birth of History and Philosophy of Science*, an aggressively titled edition and study of *A Defence of Tycho against Ursus*, Nicholas Jardine argues that Kepler's seminal work anticipates many later assumptions about science, in particular "the representation of theoretical progress as an ever more accurate and complete portrayal of the world."[58] Since the *Defence*, drafted in 1600 at Tycho's insistence, remained unfinished and unpublished, it can hardly have influenced subsequent epistemologies and histories of astronomy.[59] But Kepler continued to champion his vision of progress, in which the successive observations of astronomers since the Chaldeans had gradually been refined and at last had culminated in the cosmic truths unveiled by Copernicus, Tycho, and him. The *New Astronomy* leaves no doubt that Tycho's disciple has discovered secrets unknown to his master. *The Harmony of the World* not only claims to have completed and surpassed the insights of Proclus and all other geometers, but also maintains that the modern invention of polyphony has brought the harmony of the heavens down to earth: "Thus it is no longer

surprising that Man, aping his Creator, has at last found a method of singing in harmony which was unknown to the ancients, so that he might play, that is to say, the perpetuity of the whole of cosmic time in some brief fraction of an hour, by the artificial concert of several voices, and taste up to a point the satisfaction of God his Maker in His works by a most delightful sense of pleasure felt in this imitator of God, Music."[60] "The heavens themselves are singing polyphony," and human beings now join the choir.[61] Collectively, with a few skilled conductors like Kepler to guide them, over the ages they learned to keep time with God.

These signs of progress gratified Kepler's imagination. But they were largely theoretical and speculative, as well as controversial. In the end a far more practical work confirmed the advance of astronomy toward better pictures of the heavens. The *Rudolfine Tables* had been conceived by Tycho as the crowning achievement of a lifetime of meticulous observations and calculations, rising above the renowned but outmoded star tables of Ptolemy and Copernicus and inscribing his name (and his emperor's) in the skies.[62] But Tycho did not live to complete his lifework. In 1600 he took in Kepler to collaborate with him—or serve him—and when he died, on October 24, 1601, it was obvious that no other assistant was qualified to carry on the project. The task would engage Kepler for most of the rest of his life; it would prove to be his fortune and his bane. On the one hand, his role as Tycho's anointed successor brought him into the emperor's service, and in principle, if not always in fact, assured him a steady income and an international reputation.[63] On the other hand, it engulfed him in unending squabbles with jealous heirs, who preferred to regard him as Tycho's ungrateful and greedy lackey. Nor was Kepler ever convinced that the painstaking and backbreaking labor of compiling tables really suited his talents. "Don't sentence me completely to the treadmill of mathematical calculations and leave me time for philosophical speculations, which are my sole delight," he wrote to one correspondent.[64]

Still worse, he feared that he might be betraying as well as completing Tycho's commission. According to Kepler's own report, on his deathbed Tycho kept repeating, "Let me not be seen to have lived in vain." These poignant last words, addressed to Kepler rather than God, might be taken as encouragement to finish the tables. But Kepler interpreted them more generally as a plea to align his cosmology with Tycho's, rejecting Copernicanism and heliocentrism and embracing his master's solar epicycle and modified geocentrism: "On his death bed [he] asked me, whom he knew to be of the Copernican persuasion, that I demonstrate everything in his hypothesis."[65] Kepler would not do that. Again and again, in his later writings, he admits his profound debt to Tycho and then firmly distances himself from the

Tychonic system. If Tycho had not lived in vain, that was because he had enabled his successor to go far beyond him.

At the same time the *Rudolfine Tables*, when finally published in 1627, embodied complex, collaborative byways in the progress of knowledge. The project that Tycho had started was finished with tools and methods on which he had not reckoned. Immediately after his death, his heirs took charge of his legendary, unparalleled astronomical instruments, which in years to come were ruined and dispersed. Kepler's observations had to rely on less refined devices. But the telescope, when Galileo pointed it toward the sky in 1609, expanded the visible heavens beyond anything Tycho had seen; henceforth the cosmos would swarm with uncharted moons and stars. Another crucial discovery, John Napier's new logarithms, radically simplified astronomical calculations. To Kepler they seemed a gift from heaven, saving him years of labor.[66] The observations and notes he took from Tycho retained their value, thanks to their exceptional precision, but they would have to be accommodated to a new universe and a new Milky Way.

Kepler spelled out the principles of this new universe in his *Epitome of Copernican Astronomy* (1615–21). In the form of questions and answers, this massive textbook not only shows the superiority of heliocentric theories in explaining celestial phenomena, the rotation of the earth, and the irregular motions of the moon, but also demonstrates that the introduction of elliptical orbits can result in unprecedented, elegant calculations of planetary motions, without resort to epicycles and other time-honored fudging. Not even Copernicus, let alone Tycho, had dreamed of such a comprehensive theory. Mathematics, like astronomy, had progressed; at last the *Rudolfine Tables* could be completed.

Many vicissitudes still delayed publication, however. Patronage, war, and unreliable printers all stood in the way. By the time the volume appeared, the doomed Rudolf, its namesake and dedicatee, had been dead for fifteen years, and Kepler's hope for redress from Ferdinand II, the current emperor, was met with promises more than with payment. Meanwhile the Brahe family, who considered themselves the true patrons and owners of the project, claimed authority over the contents and profits. In the end Kepler himself would finance the printing. But perpetual warfare interfered with his plans. In 1626 a peasant army besieging Linz set a fire that destroyed the press where the printing of the book had already begun. Then at last, after Kepler found refuge and a printer in Ulm, the *Rudolfine Tables* went before the public in a handsome folio edition of a thousand copies (1627). The book marked an era in Kepler's life and in the triumph of the new astronomy.[67] The precision of the tables, bolstered by detailed instructions on how to use them, at

once made earlier calculations of events in the heavens obsolete. Henceforth every serious astronomer or navigator—or astrologer—would have to consult them. Nor could such accuracy have been achieved without the progress in theory for which Kepler had lighted the way. Here was the practical proof of his laws. Skeptics who previously had doubted or ignored him eventually steered by the tables, acknowledging that Kepler's outlandish ideas had worked. The solar system made better sense than ever before.

Even the author himself was impressed. The task that had weighed him down for so many years, distracting him from the speculations close to his heart, now seemed in retrospect the fulfillment of his theoretical as well as his practical labors. Quietly and modestly he joined the immortals. The frontispiece that he designed for the book (while concealing some of its details from Tycho's heirs) illuminates his view of the history of astronomy and of his place in it (see fig. 3). Verses titled *Idyllion*, by the Ulm poet Johann Baptist Hebenstreit, explain the symbolism at length.[68] Ten columns support the

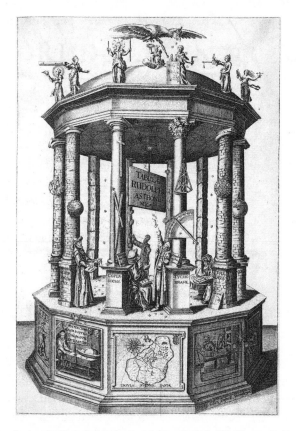

FIGURE 3. Frontispiece for Kepler's *Tabulae Rudolphinae* (1627). Lilly Library at Indiana University.

roof of a temple to Urania, the muse of astronomy. Architecturally as well as intellectually they represent the progress of Observation. Crude logs at the back, where a Chaldean uses his fingers to measure the distance between stars, yield to the basic bricks of the Greeks in the left and right foreground (Hipparchus and Ptolemy), until the circle is closed at the front and center, where Copernicus sits beside a solid Ionic pillar and Tycho, draped in ermine, leans on an imposing Corinthian column decked with his instruments. Copernicus holds out his hands to argue or plead for his system, but Tycho dominates the scene, pointing dramatically upward to a design, under the dome, of his personal geocentric vision, while his proud words *Quid si sic* (What if it is *thus?*) fly up like sparks around a dangling plaque: TABULÆ RUDOLPHI ASTRONOMICÆ. High above on the roof, a flock of goddesses personify the astronomical arts, including such newcomers as Logarithmica and Optica (nymph of the telescope). Higher still, a hovering Hapsburg eagle showers coins on the seekers below. A massive base is the foundation of the temple. Its panels display, at the center, a map of Tycho's island Hven, where he had first gathered his observations, and at the right a printing press (Kepler himself had paid for the type and paper and proofread the sheets). These images subsidize the progress of knowledge, which depends on patronage and material props as agents of change.

A panel on the left, however, slyly holds the key to the book as a whole (see fig. 4). In a cramped and dark little room Kepler sits at a table alone. He has been working late, by candlelight, which casts a shadow behind him, and his eyes fix us with a weary, somber gaze. The candle shines on a banner that abbreviates the titles of four of his major works. On the tablecloth he has jotted some numbers with pen and ink, and a few coins dropped from on high remind us of his poor rewards. This is a lonely scene. But another object on the table makes a bold, explicit claim: an unadorned model of the splendid roof and figures above. Without the help of others, this unsleeping craftsman has designed the current state of astronomical arts, incorporating some arts unknown to Tycho (the heirs were not shown this panel). A casual viewer might overlook this lowly footnote to the great temple. Yet Kepler, like a playwright who watches from the wings the mighty pageant he has created, witnesses that all this show would never have happened without him. Tycho's system, dimly figured above, could not have produced the *Rudolfine Tables*. Its true author sits below, and it is Kepler's system that will prevail.

That system proved its worth. On November 7, 1631, a year after Kepler's death, the transit of Mercury across the sun that he had predicted was observed by Pierre Gassendi. Earlier tables had miscalculated this transit by 5°, Kepler's by less than 10′.[69] Here was radical confirmation of the new laws and the

FIGURE 4. Panel from the frontispiece for Kepler's *Tabulae Rudolphinae* (1627). Lilly Library at Indiana University.

heliocentric worldview, a vindication of progress. In practical terms, there could be no more looking back to Ptolemy or Tycho. And philosophically the universe seemed more and more in accord with Kepler's geometrical idealism. Other astronomers had been content to save phenomena, with calculations that approximated, more or less, the timing of what happened in the heavens; but Kepler's effort to perceive the mind of God in patterns of celestial geometry was not only a grander ambition but saved phenomena better. Those phenomena, he was certain, obeyed real and demonstrable physical causes, and astronomers who understood the archetypes that formed the world had learned to grasp reality itself.

Nevertheless a gap of even eight or ten minutes rankled. Despite his pride in the *Rudolfine Tables*, Kepler was well aware of some discrepancies that he could not explain. The orbits of the planets and the moon, as well as the rotations of the sun and the earth, seemed subject to small, irregular "perturbations" that defied precise calculation. Evidently brute dumb matter did not

always follow archetypal rules.[70] In the last years of his life Kepler lost some of his confidence in the power of mind alone to comprehend the universe. Slight flaws in his computations suggested not only a need for more refined observations but also a possible limit to progress itself; perhaps some grain of fact would always fray the best laws that astronomers could conceive. The world in which Kepler struggled and suffered, a world of war, intolerance, betrayal, and pain, had frustrated his hopes again and again. That conflict between experience and high ideals provides the drama in any number of works, like Hindemith's, that try to imagine his life. But an internal conflict, a drama staged in Kepler's mind, may well be truer to what he himself imagined. His devotion to a geometrically perfect cosmos, composed of simple, everlasting laws, continually fell afoul not only of intractable numbers but of his own dynamic, unpredictable torrent of ideas. Nothing stays at rest in Kepler's prose. In this respect his eccentric flights of fancy are not digressions from the arguments and laws that he presents but wound into their substance. He thinks in archetypes, and then he thinks again, elliptically; he cannot resist one more bewitching insight.

At the end of *Somnium*, an imaginary voyage to the moon that incorporates an autobiographical allegory, Kepler provides one final twist, a characteristic confusion of realms. Rain on the moon blends into an earthly rattle of rain that wakes the author and wipes out the book that he has been reading in his dream. But when he awakes he finds a pillow over his head and blankets over his body. This chimes with an earlier moment within the dream, when the narrator Duracotus (a stand-in for Kepler) and his mother had covered their heads with their clothing, a rite that conjures up the daemon who will take them to the moon.[71] Draped in darkness, the dreamer and dreamed are one. But each of them mimics a real occasion, in October 1605, when Kepler and various courtiers had covered their heads with their coats to block daylight while viewing a solar eclipse. "How magically magical!" If fancies and dreams rely on a bit of strategic darkness, sometimes science also works best out of the light. Kepler's joke deliberately contrasts the illusion he has created with the smothered, all too real head from which it issued; now, as he puts it in the last sentence of *Somnium*, "I returned to myself."

The covert reference to the way he once observed an eclipse also hints at a deeper connection. In the preface to his *Optics*, Kepler had composed a small hymn to eclipses: "These *darknesses* are the astronomer's *eyes*, these *defects* are a cornucopia of *theory*, these *blemishes* illuminate the minds of mortals with the most precious *pictures*. O excellent theme, praiseworthy among all people, of the *praises of shadow!*"[72] Eclipses, he insists, are "the most noble and ancient part of astronomy," because they aroused observers in olden

times to formulate the first theories about the motions of the sun and moon. Moreover, the wonder of these strokes of darkness, like secret messages sent from on high, testifies to God's regard for the minds made in his image; the theater of nature, a secular scripture, not only inspires awe but also invites us to study God's works. This is true magic, according to Kepler. What begins in mystery, as in his dream, is destined to end, as in the sunlight of his notes, with science or revelation.

Yet still the shadows linger. No matter how far he has progressed, Kepler remains aware of secrets he will never understand. Even the cause of the six-cornered snowflake eludes him, nor could his calculations quite predict the motions of the planets. Something was always missing. At best he could add notes to his findings, as in *Somnium*, and then notes to those notes. Perhaps those second thoughts and that sense of radical incompletion, as much as his eternal laws, are Kepler's legacy; perhaps an uneasy recognition of how much is still unknown lurks in the very idea of progress. From one triumphant point of view Kepler, like John the Baptist, might herald a future glory. His destiny was to prepare the way for Newton's better laws and calculations, just as Copernicus (like Isaiah) prepared the way for Kepler and Galileo. But there were also tiny gaps in Newton's reckonings, and later in Einstein's.... The immaculate savior of science has never arrived. Meanwhile the influence of Kepler continues to grow—not only because of the progress he helped bring about, but also because his imagination so far outstripped what he could know for certain.

The Poetry of the World

A Natural History of Poetics

I

The Silence of Things: Lord Chandos and Francis Bacon

In Hugo von Hofmannsthal's famous little story *Ein Brief* ("The Lord Chandos Letter," 1902), a fictional alter ego, young Philipp, Lord Chandos, explains to his great friend Francis Bacon why he has abandoned his brilliant, budding literary career and stopped writing forever. Language itself has failed him; he is no longer able to utter words, especially abstract words such as "spirit," "soul," or even "body." This alienation from language has stamped the letter as a founding classic of modernism. Steeped in the profound unease of fin-de-siècle Vienna, just at the moment when not only words but the psyche and culture and music and art lost the sense of harmony that had sustained them, Hofmannsthal enters a disconnected and fragmented world, the world of the future.[1] Already a shadow looms across his path, a premonition of the death of literature that would haunt Paul Celan and Samuel Beckett and J. M. Coetzee.[2] Hofmannsthal wrote very few poems during the rest of his life. The things that spoke to him were frightened of words; they fled into drama and action.

Yet the letter is also dated, in more ways than one. "August 22, 1603," marks a crucial era in Bacon's career. Queen Elizabeth had died early that year, and when James I ascended the throne, Bacon's fortunes also began to

rise; on July 23 he was knighted (though Lord Chandos seems not to have heard). But more important, this was the period when he first drafted his plans for a new kind of natural history and a reformation of knowledge. "My ambition now I shall only put upon my pen, whereby I shall be able to maintain memory and merit of the times succeeding," he wrote to his cousin Sir Robert Cecil. A silence follows; after July, James Spedding, whose standard *Letters and Life of Francis Bacon* (1861) Hofmannsthal probably studied, finds no more letters until the next year. But Spedding imagines that "the intervening months were among the busiest and most exciting that he ever passed. For this is the time when I suppose him to have conceived the design of throwing his thoughts on philosophy and intellectual progress into a popular form, and inviting the co-operation of mankind."[3] Manuscripts attributed to those months of vegetation include Bacon's first naming of the "Idols" that breed fallacies in the mind, as well as of the "Great Instauration" of human dominion over nature.[4] Henceforth he would be obsessed with corruptions of learning.

Above all, words were not to be trusted. During the days when a loss of faith in language is supposed to have overwhelmed Lord Chandos, Bacon was founding a science on the same recognition, "that the subtilty of words, arguments, notions, yea of the senses themselves, is but rude and gross in comparison of the subtilty of things."[5] Thus language routinely wreaked havoc on human understanding. Not only did words, like a debased currency, reflect the mistaken and confused opinions of the vulgar, but "worse still, those faulty meanings of words cast their rays, or stamp their impressions, on the mind itself."[6] A few years later, in *The Advancement of Learning* (1605), Bacon would propose a method for healing the rift between matter and meaning. Yet even before then he had accused Aristotle, that enemy of sophists, of being himself a sophist, a mere monger of terms. Philosophers, no less than poets, spent their time spinning fables; they were the slaves of words.

One curious fragment, "The Masculine Birth of Time; or Three Books on the Interpretation of Nature" (*Temporis Partus Masculus*, 1602–3?), might almost have been designed explicitly to answer Lord Chandos's letter. Bacon fashions a monologue in which a sage instructs a young man to cast off ancient idols and schools and "to give yourself to me so that I may restore you to yourself." No longer will language be allowed to enslave the mind. "My dear, dear boy, what I purpose is to unite you with *things themselves* in a chaste, holy, and legal wedlock; and from this association you will secure an increase beyond all the hopes and prayers of ordinary marriages, to wit, a blessed race of Heroes."[7] In the future "masculine" science envisioned by Bacon, men will command all creation. But he also anticipates, in an uncanny

way, the problem that struck Lord Chandos dumb and that Hofmannsthal voices: "It is that the language in which I might have been granted the opportunity not only to write but also to think is not Latin or English, or Italian, or Spanish, but a language of which I know not one word, a language in which mute things speak to me."[8] Bacon too wants to learn that language and teach it to others; it will be the language of science.

Yet Bacon was also engaged in silencing things, or at any rate in preventing them from speaking too glibly. Perhaps he was even the source of Lord Chandos's aphasia. When Philipp remembers his happy early days as a poet, he conjures up a pre-Baconian world, a world in which he could disappear into things "and speak out of them with their tongues." No barrier separated nature from literature then, or from the self. Thus "the fables and mythic tales" of the ancients seemed "hieroglyphics of a secret, inexhaustible wisdom." Still more, "I lived at that time in a kind of continuous inebriation and saw all of existence as one great unity. The mental world did not seem to me to be opposed to the physical." Immersed in the sweep of life, the young poet drank nourishment from books in the same spirit as he drank sweet milk from cows of his acquaintance. "At other times I had the intuition that everything was symbolism and every creature a key to all the others, and I felt I was surely the one who could take hold of each in turn and unlock as many of the others as would open" (119–20).

In retrospect, the astounding confidence and enthusiasm of such a project might evoke a devastating irony. Yet in his own time Lord Chandos would have been expressing something quite close to received opinion about the meanings to be found in nature. The wisdom of the ancients, the unity of macrocosm and microcosm, the correspondence of the physical to the mental world and of things to symbols, were not the illusions of one young writer; they were the organizing principles of natural history itself. *Nosce te ipsum* (*Know Thyself*), the title intended for Lord Chandos's masterwork, conventionally implies that knowing oneself and knowing the essence of nature should be the same.[9] But it was just this point that Bacon set out to contest. "For the mind of Man is farre from the Nature of a cleare and equall glasse, wherein the beames of things should reflect according to their true incidence; Nay, it is rather like an inchanted glasse, full of superstition and Imposture, if it bee not deliuered and reduced."[10] The physical world must be protected from that warping mental enchantment. When Lord Chandos began to suspect that he saw things through a glass darkly, or that he was putting words in the mouth of nature, he became prematurely Bacon's best pupil. But at the same time he felt unbearably lonely. Despite his vast empathy for things, he could not talk to them, to other human beings, or to the past. A great conversation had ended.[11]

Nevertheless, most natural historians in Bacon's time continued to eaves-drop on the language of things. Flora and fauna in particular communicated meanings and morals freely to scholars, as in the three volumes of Ulisse Aldrovandi's *Ornithologiae* (1599–1603), the four volumes of Joachim Cam-erarius the Younger's *Collection of Symbols and Emblems* (1593–1604), and Edward Topsell's *Historie of Four-Footed Beastes* (1607). When Bacon surveyed the field in 1605, he found it riddled with "fables, and popular Errors: For, as things now are, if an vntruth in Nature bee once on foote, what by reason of the neglect of examination, and countenance of Antiquitie, and what by reason of the vse of the opinion in similitudes, and ornaments of speeche, it is neuer called downe."[12] And fifteen years later, in "A Description of a Natural and Experimental History of a Kind Fit to Serve as A Plan for the Basis and Foundations of the True Philosophy," he still assumed that a "true and active" natural history, as opposed to "mere opinion and the fictions of wit," did not yet exist.[13]

Perhaps he was underestimating how much had already been done. The New World discoveries of plants and animals hitherto unknown in Europe, and therefore untouched by antique fables or accumulated associations, had stimulated botanists and zoologists to describe with unprecedented accuracy and restraint what they or others had seen.[14] The Academy of Linceans, founded by the eighteen-year-old Federico Cesi in 1603, commissioned natural historical drawings of amazing refinement and beauty. Cassiano dal Pozzo, who sponsored and owned those drawings, wrote Cesi in 1625 that if Bacon "weren't living in England, I'd want us to make every effort to make him one of us."[15] But Bacon might not have been interested. "There is little point in the abundant wealth we find in natural histories of descriptions and pictures of species," he claims. "Such minute differences are nothing other than nature's sports and frivolities," sometimes attractive and delight-ful, but scientifically superfluous.[16] Bacon made no common cause with his contemporaries.[17] Devoted to his own experimental method, "the one and only method by which a true and practical philosophy can be established," he disregarded most continental investigations of natural history. Yet time was on his side. The next generation would embrace his method, and, at least in Britain, the revolution in natural history would be carried through in his name.[18]

Words, Things, Foucault

That revolution would forever separate words from things. In this respect, according to some recent historians of science and art, changing ideas of nat-ural history may have been even more influential than the better publicized

breakthroughs in astronomy and mathematics. It was not only ways of describing flora and fauna that changed, but the very perceptions that made such representations possible. The old world of nature could no longer be taken for granted. The radical difference between old views and new has been expressed dramatically and drastically by Michel Foucault in *Les mots et les choses* (1966). In his famous second chapter, "The Prose of the World," Foucault sets forth a sixteenth-century episteme based on similitude and resemblance, a world of knowledge in which the sign and its likeness coalesce, so that "nature and the word can intertwine with one another to infinity, forming, for those who can read it, one vast single text."[19] Through the play of sympathies and antipathies, things are ceaselessly drawn together or held apart, as the sunflower yearns for the sun, and the olive and vine hate the cabbage;[20] through a system of "signatures," the face of the world is covered with blazons or hieroglyphics that allow the invisible links between things to be read by visible signs, as the likeness of the walnut to the human brain tells an attentive observer that walnuts can prevent headaches. All knowledge thus consists of deciphering signs, whether through divination or erudition. "There is no difference between the visible marks that God has stamped upon the surface of the earth, so that we may know its inner secrets, and the legible words that the Scriptures, or the sages of Antiquity, have set down in the books preserved for us by tradition."[21] Indeed, the world itself is a language, already written. In the beginning, when Adam named the animals, the relation of words to things was transparent. Since then interpretation has been required to restore that original Text—to make everything speak. The sixteenth century, through endless, searching commentary, took on that task. But the Classical period, Foucault argues, dissolved the primal bonds between words and things. Today no memory recalls the living being of language; except at times, quite faintly, by way of an archaic "counter-discourse"—in Hölderlin and Mallarmé and Artaud and, one might add, in Hofmannsthal—through literature.

Foucault exaggerates. From a scholarly point of view, his brilliant formulations are vitiated by loose chronology, an eccentric and tendentious choice of texts, selective quotations and misquotations, forced and garbled readings, and a lofty indifference to what other, and sometimes better, scholars have said.[22] Yet a stubborn valid residue persists through all his overstatements.[23] One kind of evidence for the power of what Foucault calls the episteme or semantic web of resemblance or what William Ashworth calls the emblematic worldview or what Bacon called natural magic, consists of the heroic efforts required to deny or refute it. Much of the polemic of *The Advancement of Learning* directly confronts the speculative metaphysics and mystifications

that are assumed to dominate the learning of Bacon's time. "For as for the NATVRAL MAGICKE whereof now there is mention in books, containing certaine credulous and superstitious conceits and obseruations of *sympathies*, and *Antipathies* and *hidden Proprieties*, and some friuolous experiments, strange rather by disguisement, then in themselues, It is as far differing in truth of Nature, from such a knowledge as we require, as the storie of King *Arthur* of *Brittaine*, or *Hughe* of *Burdeaux*, differs from *Cæsars* commentaries in truth of storie."[24] True natural history should not beget more centaurs and chimeras.

Bacon is thinking of "degenerate" sciences, like alchemy and astrology, that feed on the occult. But he also implicates exactly those savants—for instance, Paracelsus, Della Porta, and Campanella—whom Foucault takes to speak for the age. They do not speak for Bacon; there is nothing he fears so much as being thought one of their party. Such fears were not unreasonable. Many modern scholars have argued that Bacon, despite his aim "to free the world from the domination of magic, . . . was finally entangled once again in its snares."[25] Yet Paolo Rossi, who wrote those words, eventually cast scorn on the picture of Bacon as a "transformer of hermetic dreams." "According to Bacon, man is not at the centre of secret correspondences; the universe is not a web of symbols that correspond to divine archetypes; scientific research in no way resembles an incommunicable and mystical experience."[26] Rossi brings back the father of modern science. Yet the very fact that such hard work was needed to banish the magi points to their refusal to go.

Like many arguments about revolutions in ways of seeing the world—the before and after of some turning point in attitudes and ideas—this controversy probably reflects not only differences of opinion but also differences in defining the object of study. Definitions of natural magic and natural history, let alone of emblematic and modern worldviews, are not set in stone. Before talking about the radical change in natural history, one needs to ask at least three prickly questions: Where? When? and What? (without ignoring who). They are not easy to answer. Even if the *where* is confined to Europe, for instance, quite different accounts might emanate from Rome, Amsterdam, Paris, and London (to take only a sample). Thus the sixteenth- and seventeenth-century pioneers examined by Charles Raven, in his classic study *English Naturalists*, play almost no part in Foucault.[27] The *when* seems even more fluid. Despite Bacon's strong attack on sympathies, similitudes, and signatures in 1605, that moment might be considered a high point, rather than the quietus, of the emblematic tradition. Emblem books like those of Camerarius poured from the presses, and they would retain their popularity for many decades to come.[28] Foucault's notorious unconcern for fixing causes and dates of epistemic change allows him to move freely through time.

Though he cites the appearance of Joannes Jonston's *Histoire naturelle* in 1657 as a landmark in which "all of animal semantics has fallen away," stripping beasts of the words that were once interlaced with them, that only signifies "the apparent enigma of an event."[29] Other dates might have been chosen as well; in fact Jonston's book was published in 1650.[30] Whenever.

Nor does the *what* escape similar transformations. "Natural history" is not a unified field or a term that explains itself; nature and history fit oddly and uncomfortably together. The old, archaic sense of "history," as Aristotle understood it, refers to "a systematic account (without reference to time) of a set of natural phenomena."[31] Yet many natural histories are anything but systematic. As conceived by Pliny the Elder (AD 23–79), whose massive *Naturalis historia* remained a standard guide throughout the Renaissance, the study of nature was historical in two ways: its facts were compiled and synthesized, without any rigorous inspection, from a great many earlier authors (almost 500, he claims); and those sources provide encyclopedic testimonies or narratives on which Pliny comments, beginning with stories about the universe. This unmethodical acceptance of "thinges weakely authorized or warranted" distresses Bacon, such history "being fraught with much fabulous matter, a great part, not onely vntried, but notoriously vntrue, to the great derogation of the credite of naturall Philosophie, with the graue and sober kinde of wits."[32] A better natural history would put aside such childish stories; its business would be truth, not entertainment. And ideally, according to Bacon, its language would be so plain that "the treasure-house of words" would be demolished, and words and things packed together like building materials, to "take up as little space as possible in the warehouse."[33]

Yet language would not surrender so quickly. One clue to what is at stake in rival versions of natural history might be the different timetables assigned to the replacement of one worldview by another. If 1657 constitutes one landmark for Foucault, another chapter singles out a text from 1605:

> *Don Quixote* is a negative of the Renaissance world; writing has ceased to be the prose of the world; resemblances and signs have dissolved their former alliance; similitudes have become deceptive and verge upon the visionary or madness; things remain stubbornly within their ironic identity: they are no longer anything but what they are; words wander off on their own, without content, without resemblance to fill their emptiness; they are no longer the marks of things; they lie sleeping between the pages of books and covered in dust.

In Cervantes's masterpiece, on this account, the estrangement of words from things becomes absolute. Henceforth the old dynamic of natural history, its

empire of signs, will belong to the madman alone, or to his ghostwriting double, the poet. "Beneath the established signs, and in spite of them, he hears another, deeper discourse, which recalls the time when words glittered in the universal resemblance of things."[34] It is because Lord Chandos no longer hears that discourse that he ceases to be a poet. But Bacon's refusal to hear it allows him to cast out the idols. As *Don Quixote* frees words from things, its companion volume of 1605, *The Advancement of Learning*, protects things from words, and prepares a future in which natural history will have no room for poets.[35]

The World of Poetry, the Mustard Seed

Eventually poets themselves would lament their eviction from the fabulous garden of nature. No story about the history of English poetry has proved more powerful and lasting than the turn epitomized by Hofmannsthal's letter and also subscribed to by Foucault: a vision of that seventeenth-century moment when things lost their magic and sealed a divorce from words. That story, already well established, runs through the first great *History of English Poetry* (1774–81), by Thomas Warton. Warton prefaced his history with two long dissertations, "On the Origin of Romantic Fiction in Europe" and "On the Introduction of Learning into England," and the opposition of romance and learning, or fancy and truth, sets a model for the work as a whole.[36] During the past two centuries, he argues, "the fashion of treating every thing scientifically" has advanced judgment over imagination. Warton is of two minds about this revolution, whose benefits of "much good sense, good taste, and good criticism" he approves, but whose long-term consequences he passionately deplores: the "colder magic" and "tamer mythology" of modern times have devastated "true poetry."[37] Like many poets of his generation, he idolizes the past, when imagination—or superstition—gave life to things. Their world is silent now.

Later histories of English poetry have regularly followed Warton's line. To an extraordinary extent they share not only his sense of loss but also his two minds.[38] Competing narratives about developments in poetry vie from the seventeenth century to the present. One is progressive, a story about good taste and refinement that gradually unsnarled the fantasies, hyperboles, and pedantries of early writers and brought the pleasures of verse to a far wider audience. The other is retrospective, a story about a failure of imagination and feeling that shrugged off any sense of wonder and turned the whole world into prose. Dryden, Pope, and Johnson are the heroes—or more often the villains—of the first story, and the Romantics—at least in their own eyes—the

heroes of the second, who restored the wonder of the world. But a fuller story would take account of the interpenetration of these two modes. Pope, for instance, thought of himself as upholding older poetic values against the benighted hacks of his own time, and the Romantic revolt against eighteenth-century verse not only harked back to earlier authors but also set out to bring a forward-looking purity to poetic language and a deeper sort of imagination to future poets. A similar doubleness of view impels the classic early twentieth-century modernists. As historians of poetry, both Ezra Pound and T. S. Eliot respond to the distant drum of ancient music—whether Li Po and Arnaut or Virgil and Dante—and prefer the traditional masters of verse to the insipidity or spilt religion of recent poetasters; but at the same time they are driven to reinvent tradition and Make It New. No one insists more strenuously than Eliot that a sense of history makes a writer "acutely conscious" of "his own contemporaneity," and that each new work of art forever alters the past. Yet Warton's lament over the conquest of fancy by truth still resonates in Eliot's regret about the seventeenth-century "dissociation of sensibility, . . . from which we have never recovered."[39] For classic modernists too, it seems, poetry fell from grace when things lost their magic.

Moreover, science must primarily take the blame. When literary historians revived the metaphysical poets, in the twentieth century, and elevated them to fixtures of the canon, they customarily charged scientific rationalism with having put an end to "the whole complex of physical and metaphysical analogies that had bound together man and his world and his Maker," according to Douglas Bush. "In the scientific and skeptical air of the later seventeenth century both poetry and religion were in danger of suffocation"; and though Bush concedes that "some persons might regard that as the final proof of maturity," he is clearly not one of those persons.[40] Neither was Marjorie Nicolson, long acknowledged the leading scholar of relations between science and literature. Despite her learned and sensitive studies of the ways that poets made use of such discoveries as Newton's optics, Nicolson regards the seventeenth-century rupture of the "Circle of Perfection" as an unmitigated disaster: "'Correspondence' between macrocosm and microcosm, which man had accepted as basic to faith, was no longer valid in a new mechanical universe and mechanical world." The prime instigator, or culprit, of this change was Bacon, who inveighed against the human tendency to impose regularities on nature. To him the notion that all celestial bodies move in perfect circles was no more than a fiction; nor did he accept the medical commonplace that four humors in the body, corresponding to the four elements, determine each person's temperament. Such doubts would quickly sap the life from poems. To understand the literature of the English

Renaissance, Nicolson concludes, we must "think as they thought before the 'Death of a World,' before the animate macrocosm and the living microcosm disappeared, and their place was taken by a mechanical clock and men with mechanical hearts."[41]

Nicolson's fervent embrace of the Circle, or what once was called The Elizabethan World Picture, is sparked by "filial piety" toward poets she loves—Donne, Herbert, Milton—and her urge to protect them not only from Bacon but also from "enlightened" critics like Samuel Johnson. Her defensiveness, however, often seems to extend to the poets themselves, who need protection from the centrifugal force of their own restlessness. Herbert, for instance, figures as a poet "who found shelter from the incomprehensible universe in faith," and whose most typical poem is "Content." Yet Nicolson's sheltered hero was in fact a good friend of the man who broke the Circle, whose *Advancement of Learning* he helped translate into Latin. And Bacon returned the favor when he dedicated his *Translation of Certain Psalmes into English Verse* (1625) "To his very good frend Mr. George Herbert": "The paines, that it pleased you to take, about some of my Writings, I cannot forget.... I thought, that in respect of Diuinitie, and Poesie, met (whereof the one is the Matter, the other the Stile of this little Writing) I could not make better choice."[42] The enmity that later critics would perceive between the ways of science and poetry evidently went unnoticed by these collaborators, who pay homage to God and nature equally.

The brilliant Latin poem that Herbert wrote in 1621 to honor the recently published *Novum Organum* shows how well he read the work of his friend. After searching for twenty-four lines for an image or phrase that will epitomize Bacon, it settles on a peculiar emblem: "in his natural Grain / A Mustard-Seed, bitter to Others, growing great itself" (*inque Naturalibus / Granum Sinapis, acre Alijs, crescens sibi*).[43] The little image stakes a mighty claim; as any Christian reader would know, it evokes Christ's parables of sowing, specifically Mark 4:30–32. The mustard seed represents the kingdom of God. At first it is tiny, "but when it is sown, it groweth up, and becometh greater than all herbs, and shooteth out great branches; so that the fowls of the air may lodge under the shadow of it" (King James Bible). How does this apply to Bacon? Herbert is clearly responding to Aphorism 116 of *Novum Organum*, which confides that the author does not expect to live to complete his work but instead will conduct himself calmly and usefully, "and meanwhile sow seeds of a purer truth for the generations to come."[44] Bacon's own kingdom has yet to come, and Herbert's last line calls on posterity to complete the portrait: "*O me probè lassum! Iuuate, Posteri!*" But the poem itself already envisions a new dispensation, where nature, divinity, and poetry will join in communion. Natural history

contains the seeds of faith, and as it grows it will find room for poets as well as all other creatures.

Herbert was a Baconian, it seems. Like his friend, he set out to protect the natural world from the tyranny of words and other idols. Suspicions of theory inform the new science as well as poems that respond to it. In recent decades, critics have tended to draw such poets outside the closed circle of faith and art and to place them firmly in a world of political and social turmoil. But for Nicolson the turmoil in the heavens was more important. The new cosmology broke the Circle of Perfection, and not even Shakespeare was immune; like Lord Chandos, he "ceased writing at the very time that the new Philosophy called all in doubt to his contemporary poet [John Donne]. Was that, I wonder, mere coincidence, or did Shakespeare, who always had his finger upon the pulse of his time, deliberately retire to a simpler life from a world and universe that were growing unintelligible?"[45] Poor Shakespeare! Evidently he could face the world and universe of *Lear* but not Galileo's moons.

Yet Nicolson's fixation on cosmology seems rather myopic. Did the circular heavens really provide a sanctuary, or crutch, for the poets she loves? The evidence of their poems suggests a far more complex response. Consider the single most important witness for the disruptive effect of the new philosophy, Donne's "Anatomie of the World" (1611). A classic of correspondence theory, it argues explicitly that *"Weaknesse in the want of correspondence of heaven and earth"* (in the words of a marginal gloss) has destroyed art. But the art of the poem itself depends on the violent drama of shaking spheres; on strained comparisons, hyperbole, and frantic nostalgia for a harmony that is now in its grave. Cosmologically speaking, Donne goes over the top. "The Sun is lost, and th'earth, and no man's wit / Can well direct him, where to looke for it. / . . . 'Tis all in pieces, all cohærence gone" (lines 207–8, 213). Yet this distraction is the enabling condition of the poem's own wit. The crumbling of correspondences, a decay that began in Eden with original sin, excites the ingenious, far-fetched metaphors that both manifest and repair the current broken state of man. Donne immerses himself in the new learning; like the earth itself, he moves.[46] In that respect he reflects his age, whose writers vibrate to breaking circles, to mutability, and to the discord that follows the shaking of "degree, priority, and place, / Infixture, course, proportion, season, form, / Office and custom, in all line of order" (Shakespeare seems to have relished Ulysses's picture of chaos).[47] These jarring images are not departures from the art of Spenser, Shakespeare, and Donne. At critical junctures they *are* that art.

Viewed in this way, Lord Chandos's crisis did not belong to him alone; it marks him as a poet of his time. Moreover, in looking backward at a world of

harmonies forever lost, he shares a point of view not only with poets but also with historians, including such unlikely confederates as Nicolson, E. M. W. Tillyard, C. S. Lewis, Foucault, Thomas Warton, and T. S. Eliot, who dream of an age when "The world itself was a 'metaphysical' poem," in the words of Joseph Mazzeo, created by God to arouse the wonder of men, so that in the eyes of the poet "the universe is a vast net of correspondences which unites the whole multiplicity of being."[48] The treasure-house of natural history proved especially rich in marvelous correspondences—or metaphors, analogies, and conceits—for poets to draw on, or to lament. Unfortunately, however, God, an inveterate punster, had written the world in riddles or secret code. Like the unity of many metaphysical poems, the unity of being had to be taken on faith.

Thus poets struggled to decipher the ingeniously cryptic Book of Nature and seldom agreed in their translations. Each Renaissance writer makes his own phoenix.[49] But it was just this competition, one might argue, that sparked a golden age of poetry. The metaphysical conceit expresses a tension, not an accord, between words and the things they can never directly name. Hence the art of similitudes burst with energy just at the moment when two epistemes collided (a moment that Foucault ignores on principle) or when the Circle broke, scattering images everywhere. As words were freed from things, they came to life. In retrospect, then, the poem that Lord Chandos was born to write was not the synthesis that would unite all being; it was the broken poem he coauthored with Bacon and Hofmannsthal, the Lord Chandos letter.

Nor did things really stop speaking. In 1600 and long afterward, natural history belonged largely to poets, whose business required attention not only to the human microcosm and cosmic macrocosm but also to everyday creatures and things: animals, flowers, rivers, trees, and even some stones. All of those talked incessantly, with voices lent from innumerable authors, from Homer, Ovid, and the Psalms, as well as from Aristotle and Pliny and other collectors of lore about the animal and vegetable kingdoms. Yet as natural history adapted to a disenchanted world, so did the language that writers put in the mouth of nature; the lyrics of birds, for instance, gradually stopped alluding to classical myths. When the cuckoo and the nightingale came face-to-face with Bacon, they hardly ceased their everlasting chatter. But those who translated their songs into English had to find words that dull-eared human beings could understand. Such words can tell us how to hear the language of creation, the constantly shifting pidgin that ornithologists share with birds and poets.[50] This is the natural history of poetics.

II

The Cuckoo and Nightingale Speak

What do birds say? In a state of nature—if such a thing were possible—they would speak for themselves, expressing their being, responding to the world around them, and conversing with all their fellow creatures, not least that creature man. "Here I am," the cuckoo says; it tells us its own name. And since its song arrives at the beginning of spring, the famous Middle English lyric that mimics its sound is a *reverdie* or joyous welcome of spring.

Svmer is icumen in,
Lhude sing cuccu!
Groweth sed and bloweth med
And springth the wde nu—
Sing cuccu!

Awe bleteth after lomb,
Lhouth after calue cu,
Bulluc sterteth, bucke uerteth,
Murie sing cuccu!

Cuccu, cuccu!
Wel singes thu cuccu,
Ne swik thu nauer nu!

Sing cuccu nu, sing cuccu!
Sing cuccu, sing cuccu nu![51]

(Spring has come in, / Loud sing cuckoo! / Seeds grow and meadows bloom / And the woods spring up now— / Sing cuckoo! // The ewe bleats after the lamb, / The cow lows after the calf, / The bullock leaps, the buck farts, / Merrily sing cuckoo! // Cuckoo, cuckoo! / You sing well cuckoo, / Don't you stop ever now! // Sing cuckoo now, sing cuckoo! / Sing cuckoo, sing cuckoo now!)

We do not know who composed this song, preserved by monks in the mid-thirteenth century; if it is a folk song, the folk who wrote it must have been skilled and clever.[52] Much of the cleverness involves the musical form, a round for six voices that circle each other and, exhorted by language, apparently never stop. The cuckoo is a very repetitious bird. "Cuckoo, cuckoo" is all it sings (at least in English), "Cryinge nothing but her oune name even vnto a tædious importunitie," according to one early modern guide.[53] Such monotony might express mourning or boredom—"bitter in

breast-hoard"—as in the Anglo-Saxon *Seafarer* (lines 53–55). But in "The Cuckoo Song" it stands for irrepressible vitality.[54] The spring is alive—at first with the blossoming of the outdoors, seed and meadow and wood, then with the barnyard chorus of sound effects as young ones wander away from their dams and the rising generation kicks up its heels, and finally, again and again, with the cheerleading cuckoo. Everybody sings. A remarkable redundancy of sounds—assonance, consonance, internal rhyme—links all these individuals together; for instance, "sed," "med," and "wde" intertwine, and the clicking *c*'s of "calue," "cu," "bulluc," and "bucke" echo the "cuccu" that presides over the glee. But the special trick of the song is the way that the bird and the human voices share the refrain.[55] "Sing cuccu!" might be addressed to the bird, encouraging it to keep on cuckooing, but it also might be asking *us* to join the chorus, to act like cuckoos, to sing our one song merrily and well, to sing eternally "cuckoo" and never stop. This is a very egalitarian note; it suggests that, caught up in the evergreen rounds and rites of spring, people are just as happy and mindless as the rest of creation.

That state of nature was only a fable, however; it soon became clear that not all creatures are created equal. By 1400, a sense of hierarchy informs the natural history of poets no less than the parliament or court. In "The Cuckoo and the Nightingale; or The Book of Cupid, God of Love," a poem long attributed to Chaucer and later translated into modern English by Wordsworth, the rabble and gentry clash.[56] The cuckoo is a *low* bird, authorities agree. In debate with the high-toned nightingale, a rival herald of spring, its song seems not only monotonous but also *lewd*, in the original sense of the word: ignorant, crude, ill-bred. One bird is a bumpkin and probably a Lollard, the other a noble soul. The words they voice define the gulf between them. He sings a "trewe and pleyn" vernacular; she trills courtly French jargon such as "Ocy! Ocy!"—which means "Kill!," she sweetly explains, since uncouth unloving creatures ought to be dead.[57] Plain song and speech reflect dishonor on the cuckoo. Moreover, they point to his ill repute in matters of love—*his*, because by convention the cuckoo is male, even when sowing his eggs, while the nightingale is female, even though it is males who strike up their mating songs in the spring.[58] Cuckoos, like other lower-class males, want only one thing, one note in sex or song, but nightingales, like other well-bred females, spend their time brooding on refinements of love, its beauty and its power to educate the heart. The bird who "spekest wonder faire" is a lady in plumage; she looks down on nature.

By the age of Lord Chandos and Bacon, the language of birds had little to do with nature; their chatter had been translated into human tongues with human purposes. According to books of natural history as well as poets, birds

spoke directly to people, conveying messages or warnings. Thus Edward Topsell reports the opinions of many learned authors on what the cuckoo *means*. For instance, "At this day in some Countreys when a man heareth first the Cuckoe, hee asketh her how many years hee shall lyve, and then after the quæstion hearkeneth to the nomber of the reiterated voices vttered in that place where hee first heard her, whereby hee maketh his coniecture of the leingth of his oune life, accountinge euery note or sound of the Cuckoe for a yeres life vnto himselfe. And this hee doeth very wisely."[59] We are not told how the cuckoo obtained this information, or for what reason a bird should know such things. Nor do these signs suggest a universe of correspondences. Instead they transform the world of nature into a personal, magical resource, where a cunning man can decipher secrets written only for him. And poets also heard their own names when birds talked to them. Natural history offered a treasury of conceits, in which things could be interpreted, like cryptograms, as signatures or marks of their human owners. In this way the Renaissance Book of Nature resembles a rhyming dictionary more than a bible; the key poetic catchwords are always already inscribed in flora and fauna, ready to pair with any mood or idea.

Philomel Talks to Poets

When most poets remembered the nightingale, therefore, they thought about poets, and mostly about themselves. Philomela leads her own life in myth and tradition, quite independent of the bird who is merely her earthly simulacrum, and writers often identify with her as the archetypal poet, long suffering, self-pitying, and unappreciated.[60] Thus the Elizabethan pioneer George Gascoigne, "who first beate the path to that perfection which our best Poets haue aspired to since his departure" (according to Thomas Nashe), explicitly compares "my case to that of fayre *Phylomene*, abused by the bloudy king hir brother by lawe."[61] This was no idle complaint; an illegal marriage had cooped the author in court cases, debtors' jail, and the army for more than a decade, and his books had been banned, in effect cutting out his tongue: "These flatterers, (in love) which falshood meane, / Not once aproach, to heare my pleasant song."

In *The Complaynt of Phylomene* (1576), the nightingale rehearses her own desolating story, her rape and mutilation by Tereus, but she also directs her fury against the enemies of skillful poetry and art. Why should she sing to them?

> For such unkinde, as let the cukowe flye,
> To sucke mine eggs, whiles I sit in the thicke?

And rather praise, the chattring of a pye,
Than hir that sings, with brest against a pricke?
Nay let them go, to marke the cuckowes talke.

This poet will sing in solitude, like Philomene, for an audience sufficiently
cultivated to tell the difference between "brute birds" and those of true feel-
ing and breeding.

For he that wel, *Dan Nasoes* verses notes,
Shal finde my words to be no fained thing.

Good nightingales have learned their art from Ovid (Publius Ovidius Naso).
Moreover, Ovid authenticates Gascoigne's own story, not only by providing a
classical source for Philomene but also by exemplifying the grieving, exiled
poet whose woes and words are anything but "fained." Both writers have felt
the thorn in the breast that, according to legend, provokes the nightingale's
song. The circle of poetry is thus complete; the myth of the bird confirms
the truth of the poet.

Gascoigne's identification with Philomene goes further still. His major
contribution to the natural history of poetics consists of a long and detailed
"expo[si]tion of al such notes as the nightingale dot[h] commonly use to
sing," as a marginal gloss informs us.[62] Not once but twice, the poem records
and explains the four distinct words pronounced by the song. This admira-
tion for the nightingale's variety was quite traditional. From ancient times
both naturalists and poets had marveled that so many different sounds could
emanate from one small bird. Thus Pliny devotes the bulk of his nightingale
lore to the endless ingenuity of her music. "In sum, she varieth and altereth
her voice to all keies: one while, ful of her largs, longs, briefs, semibriefs, and
minims; another while in her crotchets, quavers, semiquavers, and double
semiquavers."[63] But no one before Gascoigne had spelled out exactly what
she was saying. "Hir foremost note, *Tereu, Tereu*," recalls the savage Thra-
cian king who raped her and cut out her tongue. This sound was new, and
it would resonate through English poetry. Henceforth a man or woman of
letters who eavesdropped on the song might try to imagine, like T. S. Eliot
or Virginia Woolf, that birds were speaking Greek.[64]

Phylomene's second note, *fye* or *phy*, repeated thirty-two times in the next
sixty lines, "declares disdaine" for the "filthy lecher lewde" who befouled
her, and it also fits into her name. Next comes a learned disquisition on
"*Jug, Jug, Jug.*" Gascoigne associates the word both with Tereus, a "juggler"
(deceiver and trickster), and with Phylomene herself, as a "jugulator," who
cut the jugular vein of Itys, Tereus's son.[65] The fourth word, Nèmesis, is even

weirder. No one else (so far as I know) had ever heard that note in birdsong.[66] But the goddess of revenge aims less at Tereus than at Gascoigne himself, admonished to "Remember al my words, / And beare them wel in minde, / And make thereof a metaphore" for personal application. The conclusion expounds the moral: the poet's wrongful marriage has condemned him to be a wandering, hated bird who "howles and cries to see his children stray"; and he has learned his lesson.

> Beare with me (Lord) my lusting dayes are done,
> Fayre *Phylomene* forbad me fayre and flat
> To like such love, as is with lust begonne,
> The lawful love is best, and I like that.

As the poem ends, all the mythological apparatus converts to self-reflection, perhaps with some self-satisfaction: "My Lord shal do no wrong, / To say (*George*) thinke on *Phylomelâes song*." Every time he hears the nightingale, and still more when he writes about her, he will hear words that remind him of his own story. Indeed, he owns this bird, whom he has trained to sing to George.

Most Renaissance poets employed the same art; they made birds into words that spoke expressly to them. When Sir Philip Sidney compares himself to Philomela, for instance, he egotistically claims that his love-longing is worse than her rape, "since wanting is more woe then too much having."[67] The art of genre compels this perverse rivalry: in the duel between men and women that underlies the conventions of lovers' complaints, the "womanlike" bird must yield to the wounded man. Nature has nothing to do with the case. Edmund Spenser departed still further from nature. Images of nightingales flit through his early verse and haunt *The Shepheardes Calender* (1579) yet seem deliberately out of phase with the seasons. Indifferent to spring, his Philomel weeps in August through "wastefull woodes" and "gastfull grove," and mourns in November as winter deadens the world.[68] This bird cannot carry a tune of her own; she echoes the moods of the poet. And other poets also heard only what they wanted to hear. Brooding on the death of "Astrophill"—Sidney, the "phill" (or lover) of "astro" (Stella or star)—Matthew Royden projects his grief into the air.

> The birds did tune their mourning call,
> And *Philomell* for *Astrophill*,
> Vnto her notes annext a phill.[69]

Here singing seems identical with writing. Through the labored magic of words, the "Phil" of Philomell chimes with the "phill" of Astrophill, so

that the nightingale sings—or writes—another syllable into her call, recalling "Phillip." This terrible pun assumes the right of the poet to translate the language of birds. Philomell copies the notes of his heart and mind.

But what the cuckoo usually says is something else. When Shakespeare hears it cry its name in spring, at the end of *Love's Labour's Lost*, he cannot help recalling another word:

> The cuckoo then on every tree,
> Mocks married men, for thus sings he,
> > Cuckoo!
> Cuckoo, cuckoo! O word of fear,
> Unpleasing to a married ear![70]

Cuckoo and cuckold go together. That is because the cuckoo, as Chaucer had said, is "ever unkynde"—not only cruel but unnatural—since it does not hatch or raise its own kind but rather lays its eggs in the nests of other birds.[71] This practice is supposed to account for the word "cuckold," though many etymologists have noted the illogic of associating it with betrayed husbands instead of straying lovers. In any case, the song should jar the ears of Shakespeare's amorous swains, who have just flirted theatrically with marriage. The word is all the more ominous onstage because sung by "Ver"—that is, Vertumnus or Spring. A long-standing poetic tradition held that the first birdsong of spring would determine the lover's fate. A lewd cuckoo foretold jinxing and jilting; a nightingale's warble promised true, sweet love.

Thus Milton's first sonnet prays for the nightingale's favor:

> Thy liquid notes that close the eye of Day,
> > First heard before the shallow Cuccoo's bill
> > Portend success in love; O if *Jove's* will
> > Have linkt that amorous power to thy soft lay,
> Now timely sing, ere the rude Bird of Hate
> > Foretell my hopeles doom in som Grove ny:
> > As thou from yeer to yeer hast sung too late
> For my relief; yet hadst no reason why.[72]

The poet applies the classic debate between cuckoo and nightingale to his own situation. He also complains: evidently the bird of hope and love has kept missing its rendezvous with this young man, despite his allegiance to Love and the Muse. This poem is all about Milton. He wants the right bird to talk to *him*, in words he will understand because they quote earlier poems. Had Milton actually listened to birdsongs? Surely he had, in Italy as well as England. Yet nothing in his verse can prove it. Significantly, both Sonnet 1

and "Il Penseroso" entreat Philomel to "daign a Song" without any indication that she has complied.

> Sweet Bird that shunn'st the noise of folly,
> Most musicall, most melancholy!
> Thee Chauntress oft the Woods among,
> I woo to hear thy eeven Song.[73]

She is his soul mate; he woos her as if he were a lover whose gentle devotion, and craving to hear her, might compensate for the violation that forced her to hide. In the romantic vision of these woods, as in Ariosto or Spenser, Philomela poses as an enchantress (the older meaning of "Chauntress"), ready to reveal her human form at any moment. But mostly, of course, she serves as the poet's Muse, whose entreated song is already metamorphosing into his own.

The image of the poet as a solitary singer, a wanderer who haunts secluded places, shunning and shunned by the crowd, visible only by moonlight, a dreamer who lives in the past, communing only with night and the self, was not invented by "Il Penseroso," but its nightingale conveyed an irresistible sweetness and charm, and afterward it could not be forgotten. The generation of British poets who loitered at evening by groves and graveyards, after the 1740s, carried a precious volume of Milton's early verse in their pockets. It was the sweet bird they loved (they seldom loved women). What enraptured them most, however, was the history of poetry, not natural history. Already in Milton's time the birds who sang in poetry were usually quoting earlier poems rather than following nature. Yet naturalists might notice that something is missing: fresh ways of responding to aerial tones and timbres. Even the nightingale's "jug jug," a croak or warning call that interrupts the famous liquid crescendo, falls silent in Milton and his disciples.[74] A musical and melancholy bird must sing sweetly forever.

From Words to Things to Worlds: John Ray and James Thomson

As myths about nature faded, natural histories also began to shrink. By the late seventeenth century, words had lost much of their magic. Birds continued to sing in verse, to be sure, and any number of poets addressed them and identified with them. But poetic conventions drove the style, increasingly fatigued; young poets, like cuckoos, repeated one note, which they usually borrowed from Milton.[75] Nor did the naturalists supply new myths. In the great *Ornithology* (1678) compiled by Francis Willughby and John Ray, things prevail over words; all the old stories and signs are ruthlessly cut and replaced

by precise description: "The beam-feathers of the Wings are nineteen in number." Indeed, Ray can scarcely credit that cuckoos leave their eggs in other birds' nests; "Which thing seems so strange, monstrous, and absurd, that for my part I cannot sufficiently wonder there should be such an example in nature; nor could I have ever been induced to believe that such a thing had been done by Natures instinct, had I not with my own eyes seen it. For Nature in other things is wont constantly to observe one and the same Law and Order agreeable to the highest reason and prudence."[76] The order of nature leaves little room for signatures or wonders. Nor do the words of poets impress a good Baconian like Ray: "He that uses many Words for the explaining any Subject, doth, like the *Cuttle-Fish*, hide himself, for the most Part, in his own Ink."[77]

Thus natural history was no longer written for poets. Ray brings nightingales familiarly down to earth, securely fixed in a world of well-attested, ordinary facts. Even their songs are uninspired, learned from their elders or mimicked from other birds and sometimes from human beings. Similarly, whatever words they speak are parroted from overheard, unmagical human talk.[78] These are domestic birds; their habitat is mostly the cage, not the wild. Care and feeding dominate the article on nightingales in *Ornithology*, reflecting the "large London market in singing birds" in the late seventeenth century.[79] Ray and Willughby even tell readers the best ways to make nightingales sing. Poets resisted this domestication, of course. In "To the Nightingale" (1713), Anne Finch prizes her freedom: "Poets, wild as thee, were born, / Pleasing best when unconfin'd, / When to Please is least design'd." And in *The Seasons* James Thomson indignantly defends the birds "by tyrant Man / Inhuman caught, and in the narrow Cage / From Liberty confin'd, and boundless Air."[80] Women especially beat against the bars of their cage. A sense of isolation and voicelessness bonds Finch and Elizabeth Singer Rowe ("Philomela") with their nightingale sisters. But such poets were also reacting to the amused condescension of men who put them in their place. They know why the caged bird sings.

Yet the poetry of earth, like natural history itself, is never dead. In the long run, one might argue, the turn from words to things proved wonderfully fruitful; it inspired a new kind of nature poetry, so dominant that it came to seem identical with poetry itself. The fulcrum of this revolutionary turn was Thomson, whose influence on later poets can hardly be exaggerated. *The Seasons* brings to life not only Ray's perspectives on nature but also Sir Isaac Newton's "*pure intelligence*, whom GOD / To Mortals lent, to trace his boundless Works / From Laws sublimely simple."[81] The *Principia* marked an era in human history; for the first time, it seemed that a human being had glimpsed the few simple physical principles from which God had created the world.

Yet nature included more than celestial mechanics. Both theologically and scientifically, the principles of natural philosophy required a complementary insight into principles of natural history. John Ray had already formulated some of those laws, above all in *The Wisdom of God Manifested in the Works of the Creation* (1691). His studies of flora and fauna founded a new "Natural System" that revolutionized botany and zoology, and prepared the way for a "physico-theology" that would enable man to cooperate with nature in cultivating and civilizing the earth.[82] Later, in *The Moralists; A Philosophical Rhapsody* (1709), Anthony Ashley Cooper, the 3rd Earl of Shaftesbury, argued that naturalists, who understood systems of plants and animals, should be especially qualified to grasp the principle that "all things in this World are *united*."[83] Thomson takes up the task as scientist, philosopher, poet, and choirmaster of nature.

No poem matches *The Seasons* in its effort to survey and understand every aspect of the natural world. This poet does not want to leave anything out. Notoriously, *The Seasons* kept growing in every edition; "Winter," 405 lines when first published in 1726, swelled to 1,069 lines by 1744. But Thomson's claim to be the first, if not the best, of British nature poets is not so much a matter of size as of multiple, shifting perspectives. He looks at nature through the eyes of earlier poets, of farmers, naturalists, historians, astronomers, theologians, and landowners; he views each season from its beginning to its end, from high to low, from spreading plains to seeds beneath the ground, from bird to worm and sky to mire, "with a mind that at once comprehends the vast, and attends to the minute."[84] And though he rhapsodizes over what he sees, he also wants to tell the truth about it.

Thomson wrote about nightingales many times, in many poetic styles, from many perspectives. But one extended passage of "Spring" introduced a radically new way of hearing birdsong.

> Lend me your Song, ye Nightingales! oh, pour
> The mazy-running Soul of Melody
> Into my varied Verse! while I deduce,
> From the first Note the hollow Cuckoo sings,
> The Symphony of Spring, and touch a Theme
> Unknown to Fame, *the Passion of the Groves*. (lines 576–81)

Joined by the poet's verse, the nightingale and cuckoo are no longer rivals; they sing together. Thomson was not the first poet, of course, to recognize that sexual desire or courtship moved all kinds of birds to greet the spring.[85] But his song boldly pushes the theme to replace the old myths and repeal poetic tradition. The cuckoo is not ridiculing the cuckold, the nightingale

is not melancholy; one passion drives them both. Thus all compose a "harmony of mingled sounds" (a "symphony," in its original meaning). It is a heightened awareness of this harmony that so stirs Thomson—not only the possibility of writing verse that remains faithful to nature, verse in which birds obey their own instincts rather than human conceits, but also a sense of nature as a whole, connecting and uniting each part. Johnson's *Dictionary* cites the passage from "Spring" to illustrate "deduce": "To lay down in regular order, so that the following shall naturally rise from the foregoing." One by one, in Thomson's deduction, each bird joins the chorus that the cuckoo has started, until "the soul of love" fills all the air.

> The Thrush
> And Wood-Lark, o'er the kind-contending Throng
> Superior heard, run through the sweetest Length
> Of Notes, when listening Philomela deigns
> To let them joy, and purposes, in Thought
> Elate, to make her Night excel their Day. (lines 598–603)

This Philomela, unlike Milton's, will not be lonely or sad.[86] The social rituals of courtship drive her, and if her kind "in woodland solitudes delight, / In unfrequented glooms, or shaggy banks" (lines 644–45), the reason is that they can safely make a nest and family there. Thomson describes the mating dance, the gathering of moss and sprigs, the feeding and protection of the young, with unprecedented detail and precision. All these contribute to a love song that is at once ideal and scientific.[87]

Thomson prides himself on his devotion to nature; he puts no words in nightingales' throats. Yet he does put thoughts in their heads, as when Philomela "purposes, in Thought / Elate, to make her Night excel their Day." Anthropomorphic projections animate the animal kingdom of *The Seasons* and plump its poetic diction: "gay troops," "coy quiristers," and "tuneful nations" not only humanize but camouflage flocks of birds. Ever since the Romantics, readers have recoiled from those circumlocutions. Yet such phrases, however affected, do serve to affiliate birds with their fellow creatures, in quasi-human communities that suggest they are not so different from us. From one point of view, this might seem sentimental or condescending, as if the social relations of people provided a model for all creation. Compared to earlier views, however, the idea that animals have purposes and thoughts of their own seems distinctly progressive. When cuckoos and nightingales spoke words that only human beings could understand, their language implied that all the world had been designed to serve and speak to man, as cuckoos warn cuckolds and Philomela gives advice to George. Most people,

including poets, considered themselves the sole proprietors of the animal
kingdom as well as the earth. Thomson does not think so. His birds speak
to each other, not to people; they make their little plans, enjoy the pleasures
of companionship, and care unselfishly for their own families; they are living
beings, not hieroglyphics or emblems. Hence Thomson's conscience strains
at caging, hunting, or eating his fellow creatures, who all are part of God's
great plan of life. This sentimental vision made much of earlier poetry look
like a tone-deaf translation of nature into mere human words. And it also
helped change the world.

Thomson's vision would spread. Despite their quarrels with his poetic
diction, the great Romantics vibrated to his poetics of natural history. It
breathes again in Blake's "Vision of the lamentation of Beulah over Ololon"
(a "Song of Spring" directly responding to Thomson's),[88] in Wordsworth's
cuckoos and his "thousand blended notes of spring," in the "One Life" of
Coleridge and his nightingales, in Cowper and Shelley and Keats, and most
of all in John Clare, whose future was determined once and for all at the age
of thirteen, when the opening lines of Thomson's "Spring" "made my heart
twitter with joy," and he was hooked forever on the thrill of catching birds in
verse (in "The Progress of Rhyme" he would break all records by registering
at least twelve distinct notes of the nightingale—with four more scribbled
in the margin).[89] Nor could later writers and readers resist the encompassing
view of a presence that filled all nature: the spirit of Gaia or "th' informing
Author" who broods eternally over creation.[90] Many poets still cling to that
ecological vision.

Yet a part of the future also belonged to Lord Chandos. When words lost
their power over things, a new disquiet came into the world: the fear that
human beings might be a blight on nature, a windy pathetic static invading
its silence.[91] Today cuckoos rarely herald the spring. Recently, while visiting
the English countryside, I was unable to find anyone who had heard one. In
fact, according to ornithologists, the numbers of both cuckoos and night-
ingales have declined more than 60 percent in the last forty years—victims
of climate change and the loss of habitats in Africa and breeding grounds in
Britain.[92] Hence birdsong slowly departs from poems; we frighten away the
nightingales, and perhaps some day soon none will be left to sing. The disap-
pearance of things always haunted Rainer Maria Rilke; and more recently, in
the ambiguous phrase "After Nature," W. G. Sebald implied that descriptions
of the natural world now register an emptiness where things used to be.[93]
Even the spring might be changing. If so, the poetry of the world will have
to learn a new language.

"Look There, Look There!"

Imagining Life in King Lear

Invisible Signs

Sometimes the line between life and death seems imperceptible. "I know when one is dead and when one lives," King Lear insists, Cordelia's body cradled in his arms; "She's dead as earth." But his next words already expose the claim as pathetic bravado. "Lend me a Looking-glasse, / If that her breath will mist or staine the stone, / Why then she lives." Lear cannot trust his perceptions. Suffering has racked his senses as well as his brain, and his former confidence in telling what is true from what is false has broken down. Now death seems very nearly one with life. Only a series of physical tests can draw out their subtle distinctions: "This feather stirs, she lives" or "looke on her. Looke her lips, / Looke there, looke there."[1]

Moreover, the audience shares his uncertainty. Cordelia had not died in an earlier play, *The True Chronicle History of King Leir*, and those who first saw Shakespeare's version of the story might well have been shocked by this sudden blow.[2] And modern viewers, although they may know what is coming, can still feel the shock. One reason for the incredible power of this harrowing scene is our involvement with the illusion of hope as well as with pain. As spectators we view an actress who might still recover at any moment (anticipating Nahum Tate's version). Bodies do come to life on the stage. When the fallen Falstaff, after his bloated carcass has been memorialized by Prince Harry— "Poor Jack, farewell: / I could have better spar'd a better man"—suddenly

rouses and rises up, the wonderful coup de théâtre expresses the essence of theatrical magic. "To counterfeit dying, when a man thereby liveth, is to be no counterfeit, but the true and perfect image of life indeede."[3] The aftermath of every tragedy incorporates this moral; as life springs eternal, those who played dead come back, revived by applause. Against our better judgment, at the end of *Lear*, we are forced to look for invisible signs of life. A feather stirs, at least in imagination (the feather too is imagined, in most productions); Cordelia's lips undetectably quiver. "Looke there, looke there." Just at this instant Lear himself dies, though neither we nor Edgar can be quite sure—"He faints" is the first reaction. Father and daughter alike will come no more; five unbearable nevers block their return. But pronouncing "never" does not close the scene for Lear, who continues to talk and to hope. So long as imagination survives, the appearance of death need not be conclusive. Some other test might always uncover a lingering vital sign, encouraging us to look there.

These doubts were not Lear's alone. In Shakespeare's time, and long before and after, the line between life and death proved hard to draw. Pliny the Elder had told many stories about people who appeared to be dead and then revived. Later the great Duns Scotus (ca. 1265–1308) was reportedly buried during a cataleptic fit until a canny servant dug him out. Miraculous examples of resuscitation—the "Lazarus syndrome," as it is called today— were almost routine in early modern lore. "Many are the cases of men left for dead, or laid out on the deathbed; or carried off for burial, or indeed who have been actually buried, who have none the less come back to life again."[4] Even medical experts often felt baffled by such seeming life-in-death. When exactly did someone die? That was not easy to say. In January 1606, a month after *King Lear* was performed at court, Sir Everard Digby, convicted in the Gunpowder Plot, was hanged, drawn, and quartered. Afterward, "Here is the heart of a traytor!" the executioner cried, holding it up to the crowd; but what was left of Digby replied, "Thou liest!"[5] Or so the story goes. At the moment of indecision, no one could try a better test than Lear's. "The way to know whether a man be dead or not," according to John Ward, was to "lay a feather upon his lips; if it move he is alive, if not, dead."[6]

The public also witnessed these rites of passage. The ritual of the death watch, when friends and relatives gathered to take leave, offered many chances to observe the living ember as it flickered and went out. Long before he took orders, John Donne must have kept this last vigil, as in "A Valediction forbidding mourning":

> As virtuous men passe mildly' away
>> And whisper to their soules, to goe,
> Whilst some of their sad friends doe say,
>> The breath goes now, and some say, no.

On such occasions the priest had more to say than the philosopher or the physician. Practically speaking, death was no stranger, of course, not even to children; nor were the dying shuttled off to hospitals for their last rites.[7] But philosophies of nature struggled with definitions, largely in vain.[8] Michel Foucault has argued that living beings were first invented in the nineteenth century, at least in France;[9] and even if that audacious claim is oversimplified, it does seem true that what we call the modern "life sciences" originated then, when not only the meaning of "science" changed but also the meaning of "life." Biology came into being in 1802, as a word and a concept. Hence earlier ages seldom chose to define life as something "organic," in which an internal structural plan coordinates parts into a vital whole that is capable of development and growth. Instead they sought the principle of life in some mysterious essence—in heat or a humor or most often in breath.[10] Such an essence could not be seen but only imagined.

Bacon on Life and Death

Consider the views of Shakespeare's contemporary (if not alter ego) Francis Bacon. Issues of life and death preoccupied Bacon. In *De Sapientia Veterum* (*On the Wisdom of the Ancients*, 1609), a year after *Lear* was first published, he traced those issues to the dawn of natural philosophy. When Orpheus followed Eurydice to hell "to propitiate the infernal powers," he represented "philosophy personified," according to Bacon. "For natural philosophy proposes to itself, as its noblest work of all, nothing less than the restitution and renovation of things corruptible."[11] Bacon, like Orpheus, hopes to find harmonious ways to snatch life back from death; that is the ultimate aim of the revolution in science to which he devoted his life. The dream of prolonging life indefinitely, or even of conquering death, inspired much of the medical research of the sixteenth and seventeenth centuries, as it continues to do in our own times—at an accelerated rate.[12] Often that dream has proved deceptive. Notoriously, Bacon died at sixty-six when he caught a chill while pursuing his death-defying project (he was freezing a chicken); and Descartes, who saw no reason why he should not live to the age of a biblical patriarch, also caught cold and died of pneumonia at fifty-three.[13] Moreover, much of the search for an "elixir of life" derived from mystical or alchemical doctrines. Outdoing Orpheus, Paracelsus and his many followers believed that human bodies might be transmuted like metals in fire, with the ravages of age and illness burned away. Perhaps the Tree of Life that Adam knew could bloom again. But the fable of Orpheus might well yield another, contrary reading: all efforts to cheat death of its harvest run up against inescapable limits, and the urge to prolong life forever by art must lead to despair in the end.

Yet Bacon believes that human beings are capable of living for hundreds of years. Holy scripture assured him of it, and even after the Flood, when "men's lives had dropped to a quarter of their original length," the span of life approached 200 years. A Roman census in AD 76, recorded by Pliny, found numerous centenarians, including at least twenty who were 125 or older (*OFB* 12:197, 207). In recent times conditions may have changed, but longevity might still be restored, Bacon thinks, by healthy habits. Thus he is full of confidence that he can find ways to lengthen life. But unlike Orpheus or alchemists, Bacon relies on something more solid than wonder-working art: modern philosophy will far surpass ancient wisdom when it commits itself fully to facts it can prove and to the empirical method. Hence the tests for life that Lear devises—the looking glass, the feather—as well as his mistrust of the senses, so often deceived, fit very well with Bacon's program. "Neither bare hand nor unaided intellect counts for much; for the business is done with instruments and aids, which are no less necessary to the intellect than to the hand" (11:65).

At the same time, no one campaigned so hard as Bacon against confusing the sports of imagination with reason and truth. The revolution he called for begins with an attack on idols, above all Idols of the Theatre: "In my eyes the philosophies received and discovered are so many stories made up and acted out, stories which have created sham worlds worthy of the stage" (11:81–83). Like Shakespeare's lunatic, lover, and poet in *A Midsummer Night's Dream*, whose "seething braines" and "shaping phantasies" give form to airy nothing, the vast majority of pretenders to science had succumbed to "anticke fables" and "fairy toys" (5.1.3–17). Imagination, Bacon contends, strives to destroy the primal distinction between dead and living things. "Beeing not tyed to the Lawes of Matter," it "may at pleasure ioyne that which Nature hath seuered; & seuer that which Nature hath ioyned, and so make vnlawfull Matches & diuorses of things" (4:73). In plays and poetry, as in the madness of dreams, inanimate objects come to life; a joint stool may be taken for a woman. Such "high and vapourous imaginations" resemble the degenerate natural magic of alchemy, which fancies that "a fewe drops, or scruples of a liquor" could prolong life or restore an old man to youth. Bacon's project unmasks such theatrical resuscitations. A proper study of nature must work to keep idols in check.

Yet Bacon's own ideas of life seem highly fanciful, by later standards. In practice some of his theories fray the borders between dead and living things. The two Latin treatises he wrote on the topic, *The Ways of Death* (1611?)—*De Vijs Mortis*, first discovered in the 1970s—and *The History of Life and Death* (1623), are haunted by invisible and intangible spirits that inhabit all objects, whether inanimate or alive. "Every tangible body here with us"—even a

stone—"contains an invisible and intangible spirit which it overlays and as it were clothes."[14] In human beings two kinds of spirit, one vital, one lifeless, sometimes cooperate and sometimes part ways, with fatal results. Both are compounded of air and fire, but air predominates in the nonliving and fire in the living. The vital spirit (*spiritus vitalis*) serves as the "agent and workman" of the body, keeping its parts in motion and good repair, like a "vestal flame." But the more flighty "mortal spirit" (*spiritus mortuales*) struggles against its confinement and constantly tries to escape. When it succeeds, the body dies. Yet fire too can be deadly, when "the spirit, like a gentle flame, forever preda-tory, with the external air colluding with it—air which also sucks and dries bodies out—, at last destroys the workshop of the body and its machinery and instruments, and renders them incapable of doing the job of repair" (12:147–49). Spirits, like temperamental artists, can ruin as well as renew the dumb matter they mold.

Thus a good physician must imagine ingenious ways to keep spirits bal-anced and happy. Much of what Bacon prescribes seems directed toward the traditional formula of sound minds in sound bodies. Predictable, moderate regimens, untroubled by the tensions that tear Lear apart, should help to pacify the spirits. Hence diet and exercise should always avoid extremes. Similarly, the feelings and passions of the mind must be restrained: great joys diffuse the spirits and shorten life, "but joys recollected in tranquillity, or the consciousness of joys arising from hope or imagination, are good"; and the same rule of moderation applies to love. Nor should one think too much: "Admiration and idle reflection are wonderful for prolonging life, for they engage the spirits in business which pleases them, ... but subtle, acute, and sharp inquiry shortens life, for it wearies the spirit and preys on it" (12:265–67). Most metaphysicians do not live long, by Bacon's reckon-ing, but naturalists and rhetoricians, who contemplate interesting bits of the world or chase after "the brightness of words rather than the darkness of things," enjoy a pleasurable old age (even if words deceive them). In any case, so long as harmony and peace prevail, the particular course of life hardly matters. According to *Sylva Sylvarum*, "It conduceth unto *Long Life* . . . Either that *Mens Actions bee free and voluntary* . . . Or on the other side, that the *Actions of Men bee full of Regulation, and Commands within themselves*." An example of the former is "a Countrey life"; of the latter, "in *Monkes* and *Philosophers*, and such as doe continually enioyne themselves."[15] Freedom and self-restraint serve equally to frame a happy medium in which the spirits are content to stay at home.

Bacon also conceives some original last resorts. Both *The History of Life and Death* and the *New Atlantis* (1627) assume, for instance, that "life in dens and

caves where the air does not admit the Sun's rays can contribute to long life" (12:273). Air, when heated, preys on the body, "for ordinary air is a starveling, and greedily swallows them all up, spirits, smells, rays, sounds, and the rest" (12:357). But most of all it attracts nonliving spirits, whose airiness yearns to escape the gross body for company more like itself—like seeking like. Caves counteract this process. By excluding both sun and air, they snuff out the temptation of spirits to flee, and in this way they hold off death. Even history supports this principle, since in the past some men, such as anchorites, were very long-lived, "and these men generally spent their lives in caves" (12:273). To be sure, Bacon does not consider cave life practicable, except perhaps in the special circumstances of the New Atlantis.[16] Since "the duties of life are more important than life pure and simple," he cannot advocate remedies that involve "abandoning the offices of life" (12:241). Yet the regimens he does recommend for prolonging life—for instance, bathing the body in fat or oysters or egg yolks or blood—seem driven less by practice than by theory: the desiderata of closing the pores and cooling the overheated spirits in the blood. When speculating on ways to frustrate death, Bacon often succumbs to one of his own Idols of the Cave, where "men fall in love with particular sciences and reflections either because they fancy that they are their authors and discoverers, or because they have invested a great deal of work and become entirely steeped in them" (11:89).

One theory especially stimulates Bacon. As he ponders ways to delay or even reverse the natural journey toward death, he fastens on the strange resemblance of matter to living things. Both are informed by spirits, and both strive for a state of equilibrium or rest. Hence the two entwine like quarrelsome, grappling lovers, fatally coupled yet longing to part. Aging human bodies, Bacon says, "begin to suffer the torment devised by Mezentius, *that the living perish in the embrace of the dead.*"[17] This striking image suggests the intimacy as well as the antagonism of the two kinds of spirit. It might even be possible to wonder whether inanimate rather than vital spirits represent "the living" that want to escape the embrace of the dying body. Guido Giglioni, who argues that for Bacon "matter is alive," explores the paradox: "The life of animate beings (living spirits) seems to be, in fact, death; the inanimate beings' tendency to rest, which only for reasons of convenience we call death, is, in fact, life (the persistence of the lifeless spirits), or, if not life, at least a 'caricature or shadow of immortality itself.'"[18] At any rate, the permeable boundaries of life and death encourage efforts to find tangible, material things that might draw bodies in transit back from the brink. Bacon coaxes the quarreling lovers to put up with each other and mend a happy home.

By modern standards, however, Bacon's wildest leap is a confusion of realms: inanimate spirits can turn into living creatures. Sometimes generation

occurs without reproduction or seed. Since nonliving spirits, unlike the living, are bound to no cell or organ, they often intermingle with grosser matter, "as air is intermixed in snow or froth" (12:351). Hence they may cross over, or move up the chain of being. Spirits typically feed on matter, dissolving it into spirit that escapes (we know this because the object loses weight, as when metal rusts). But when the spirit comes across "obedient" parts that do not escape but follow its lead, "then indeed follows shaping into an organic body, the fashioning of members and other vital actions both in vegetable bodies as in animals" (11:349–51). In this way inanimate matter gives birth to life, as when maggots are spawned out of putrefaction. Technically this effect should probably not be called "spontaneous generation" (a nineteenth-century theory) but "equivocal generation" (the Aristotelian theory that life may be produced from things unlike itself; a theory that almost everyone in Bacon's time accepted).[19] At any rate Bacon—that father of modern science—believes in spirits that pass from lifeless to living things.

What is the evidence for such theories of life? Conjectures, anecdotes, and occult traditions. These grounds for belief depart so far from any logical inductive method that Graham Rees, the leading authority on Bacon's studies of life and death, once declared that he "fathered not one but two philosophies": the first, the utilitarian program for which he is famous; the second, the *speculative* philosophy that tries to sweep all phenomena into one theoretical net.[20] That division seems overstated. Though Bacon himself candidly admits, "I have not tested some of the points I shall make by experiment (for my way of life does not allow for that), but they are only derived with (as I judge) very good reason, from my principles and presuppositions" (12:241), he justifies this rush to print through "the exceptional utility of the matter," which is nothing less than "prolonging and renewing the life of man" (12:143). Everyone has an urgent interest in staying alive, and provisional knowledge is better than none at all; the future will sort out the truth of these speculations. In the meantime, the advancement of learning must cope with folk remedies and invisible spirits. Bacon's understanding of life and death is bounded by what he finds possible to imagine.

The Soul and the Body

What were the principal ways of imagining life in the time of Shakespeare and Bacon? A full answer would require a study not only of early modern medicine and literature but of the chemical and biological theories, going back to the ancients, that the world of learning continued to revolve and debate. Yet almost everyone accepted one tried and true definition: "Union and co-operation of soul with body."[21] In orthodox terms, that union constitutes

life. Philosophically, theologically, and medically, at least until the nineteenth century, it is neither the soul alone nor the body alone that defines living beings, according to doctors as well as priests, but rather the "subtle knot" or "vital chain" that holds them together. And similarly, death represents a parting, the moment when the knot snaps, and the soul takes leave of the body.[22] Despite the originality of Bacon's analysis of life and death, he too surveys two contrary forces knitted together, the soul and its mortal covering, and speculates on ways to keep them joined. Each living creature thus depends on a difficult and treacherous balance. Soul and body reconcile their differences, in life, and manage to hang together—for a brief time.

Yet the tension between them strained the imagination. Materialists were always tempted to reduce life to physical processes, and spiritualists were tempted to minimize death as a mere incident in the immortal journey of the soul. Nor could some thinkers help veering back and forth between the two poles. In his *Liber de Longa Vita* (1526?), Paracelsus confidently proclaims, "Life, by Hercules, is nothing else than a balsamite mumia, preserving the mortal body from mortal worms and from dead flesh, together with the infused addition of the liquor of salts." Yet elsewhere he no less confidently informs us that "the life of things is none other than a spiritual essence, an invisible and impalpable thing, a spirit and a spiritual thing."[23] To charge Paracelsus with inconsistency in these matters would only project on him the discords of his own and later eras. In his own mind any firm distinction between the corporeal and the spiritual betrayed a limited and superficial understanding of the true nature of the world; a good physician was always also a priest. However much the fusion of incompatible things might defy all logic, it was also, according to sages, the secret of life.[24]

Some sages tried to unravel the knot by expanding the reach of the soul. To the animist and the vitalist, there was no such thing as pure body: spirits inhabited and controlled all of nature. In that case a wholly inanimate matter would be a contradiction in terms. "There is nothing corporeal that has not a 'spiritual thing' hidden in itself," according to Walter Pagel; "hence to Paracelsus all things are alive—there is nothing that has no life hidden within itself."[25] Bacon, as we have seen, conceded that spirits in nonliving matter might generate life, and other theorists went much further and peopled the cosmos. In the Scholastic version of the celestial orbs that culminated in Dante's vision of Paradise, angelic orders moved the spheres, with a living intelligence derived from God. In Shakespeare's time Giordano Bruno refused to allow any boundaries to the presence and sentience of divine spirits: he perceived an infinite universe in which heavenly bodies were living beings with souls that guided them through space.[26] And even Kepler,

less heterodox, sometimes believed that intelligent spirits steered the planets. William Gilbert, the most famous natural philosopher in England, insisted that the loadstone had a soul: "As for us, we deem the whole world animate, and all globes, all stars, and this glorious earth, too, we hold to be from the beginning by their own destinate souls governed and from them also to have the impulse of self-preservation."[27] Such philosophic animism lent a color of truth to the popular superstitions, endowing dead things with life, that Bacon resisted yet sometimes seemed to endorse. Yet the refusal to recognize death had an obvious blind spot: it had to discount the nature of living creatures, whose bodies unmistakably decayed and perished. Gilbert's devotion to the soul of the loadstone leads him to look down on mere human beings, whose senses and organs condemn them to illness and error. Nevertheless, terrestrial creatures still felt attached to their bodies; they could not help imagining that death represented a fatal parting of spirit and flesh.

Finding ways to adjust the relations of body and soul preoccupied seventeenth-century thinkers.[28] Most natural philosophers began with Aristotle's distinction among three orders of soul: vegetative, sensitive, and rational.[29] For Christians, this threefold division explained not only what human beings shared with other creatures—plants had the same ability to grow, and animals had the same senses—but also what raised mankind above other creatures: the third, immortal soul. According to Bacon, "The spirit is the instrument of the rational soul which is incorporeal and divine" (12:377). Yet materialism always threatened such explanations. If the vegetative and sensitive souls were mortal—a mere "potential of matter," to use one common formula—then the third soul might be mortal too, or else so radically different that it had nothing to do with any physical process, not even with breath or spirit. During the seventeenth century, philosophers gradually lost belief in the first two orders of soul, the "natural" souls, and sought to replace them with bodily functions.

Pursuing this line of thought, Descartes proposed the most drastic solution: not only was the human mind or soul "in its nature entirely independent of body," but animals, having no mind or soul, were nothing but machines: "It is nature which acts in them according to the disposition of their organs. In the same way a clock, consisting only of wheels and springs, can count the hours and measure time more accurately than we can with all our wisdom."[30] This notorious argument has often been accused of reducing animals to insentient things, thus excusing their brutal treatment by smugly superior humans.[31] Yet Descartes's contemporaries were more troubled by the possibility that people also might be no more than machines.[32] "Life is but a motion of Limbs," Hobbes cheerfully argued, preparing the way for his Artificial Man.[33] It was such implications that Descartes sought to refute.

In order to champion the immortality of the human soul, he needed to exorcise or disenchant the natural world. Paradoxically, to the dualist most living beings only imitate life, like automata, while human beings, eternally thinking, remain alive after death.

In that case, however, the rational soul alone becomes the principle of life; it casts off its mortal rags like so many lendings. Even before Descartes, the mutual antagonism of spirit and flesh preoccupied not only theologians but also physicians. The sober medical advice of Bacon's *History of Life and Death* incorporates a sort of classic comic plot, in which restless rebellious spirits strive to escape from the house of their aging warder, until his defenses crumble and let in fresh air. Contempt for the threadbare patchwork of life was surely not Bacon's intention. Yet a slight shift of emphasis might transform death from a calamity to a release. The forced union of soul and body could seem absurd, to true believers, as if the essential person had been held for a lifetime in shackles. Andrew Marvell's "Dialogue between the Soul and Body" (ca. 1650) begins with the soul's complaint about the stranger to which it is tethered: "O who shall, from this Dungeon, raise / A Soul inslav'd so many wayes? / With bolts of Bones, that fetter'd stands / In Feet; and manacled in Hands." Similarly, the last words attributed to Descartes remained sublimely true to his convictions: "So, my soul, for a long time you have been captive; here is the hour when you ought to come out of prison and quit this body's burden."[34] The corporeal prison seems more than a metaphor, from such a perspective; it expresses precisely the state of a rational soul in this world.

Any number of poems and sermons contend that life itself is the prison. "Vex not his ghost, O let him passe," Kent pleads as Lear escapes; "he hates him, / That would upon the wracke of this tough world / Stretch him out longer" (5.3.288–89). In retrospect, existence has been a torture chamber for Lear and Gloucester, an ordeal from which they long to be delivered. Yet no Christian afterlife beckons; a ghost is not a soul.[35] As critics have always recognized, the play evokes a primitive, anthropomorphic state of mind in which not only the blasphemous Edmund but also the superstitious king acknowledge the rule of Nature. Lear takes the storm personally, as a direct reprisal by the "great Gods" for violation of the natural order. Even his oaths are pagan: "By all the operation of the Orbes, / From whom we do exist, and cease to be, / Heere I disclaime all my Paternal care" (1.1.109–11); and later, "Life and death!" (1.4.259). A pious audience might hear a phantom god tucked into that oath ("'s life and 's death!"). But life and death themselves seem the ultimate bounds of Lear's imagination. When his world falls apart, he can think of nothing more extreme than the terms imposed by nature on human beings—breathing and ceasing to breathe, the womb and the grave.

Nevertheless, his attitudes toward life and death are not consistent. At the beginning of the play, when Lear speaks casually if pompously about his will "to shake all cares and business from our age, / ... while we / Unburthen'd crawl toward death" (1.1.37–39), the royal "we" protects him from the sense of physical decay and helplessness in "crawl." The reality of what it means to die has not yet struck him. On the heath, as his wits turn, his understanding improves. The sight of "Tom" conveys the bare facts of someone "unburthen'd" against his will. "Thou wert better in a grave than to answer with thy uncover'd body this extremity of the skies. Is man no more than this?" (3.4.90–92). In the absence of any trappings, reduced to the state of "a poor, bare, forked animal," a human being might as well be dead, according to Lear. Yet the downward spiral, as "we" shrinks to "I," compels him also to wonder whether he might be something more than a body. Glimmers of a new consciousness shoot through the darkness.

The first result of this awakening is an overwhelming disgust. When Goneril reveals her contempt for her father, he responds by imploring the "dear goddess" Nature to curse her womb with sterility or with a tormenting "child of spleen"; one break in the natural order calls forth another (1.4.237–52). Rage at his unnatural daughters swells into revulsion at nature itself. At the peak of his madness, Lear visualizes women's sex as an embodied hell: "There is the sulphurous pit, burning, scalding, stench, consumption. Fie, fie, fie; pah, pah!" (4.5.121–23). But the disgust that preys on his mind extends to all bodies, including his own. When Gloucester offers to kiss his hand, he recoils: "Let me wipe it first; it smells of mortality" (4.5.126). Kings are not ague-proof, nor can they wipe off the foulness of flesh. In this revelation Lear comprehends that death is lurking inside him. It is that understanding that fuels his disgust.[36] More sensitive than he has ever been, and fastened to a dying animal,[37] he has become acutely aware that nature will always betray him.

Much of the power of the last acts of the play comes from its fluctuation between acknowledgment of the finality of death, and intimations of a life outside the natural cycle. As Lear's great rage is eased, he seems at once more frail and more indifferent to the world. His second awakening, in Cordelia's presence, prepares him to imagine a life outside time and decay, attuned to "the mystery of things." Lear's newfound acquaintance with mortality implies that he yearns for another mode of existence. Now that he knows he is confined in a body, he might be ready to envisage a soul.

The play itself turns here. Mortality had not been an issue in earlier versions of the story, in which both Lear and Cordelia survive their trials. But the shadow of death that infects Shakespeare's language prepares a different, darker conclusion. The suspense that slowly builds to the end of *King Lear*

involves not only whether the king and his daughter will die but also whether their deaths will have any meaning. Nor is the final question clearly resolved. The play allows radically different visions of soul and body, as different as the imaginations of G. Wilson Knight and Jan Kott.[38] It all depends on the lines and scenes one chooses to feature. Some critics elevate Lear to pure spirit, purged by sacrifices on which the gods themselves throw incense; others harp on images of an anguished and broken body. In the Christian readings that used to be gospel, death completes the work of redemption. Lear wakes to see Cordelia as a soul in bliss, and himself as a soul in purgatory or hell. These hallucinations transport him to another world. Even as they reflect his lingering madness, they also provide the first signs of his recovery, when he will be born again into a consciousness of grace and love, of blessing and forgiveness; he trembles on the brink of Christian faith.

In the profane and skeptical readings that counterbalance such pious optimism, however, death represents the last absurdity. The wanton gods kill people for their sport, and even Lear's death, according to William Empson, "is like a last trip-up as the clown leaves the stage," an effect of "shock and senselessness."[39] Kott's dark refashioning of *King Lear*, drawn equally from the Theater of the Absurd and from the bleak, atheistic totalitarianism of Eastern Europe, influenced a generation of Shakespearean unbelievers. Peter Brook's famous film (1971) drifts through a wasteland, where brute creatures struggle against each other and the elements as if the present were all that mattered, as if living and dying occurred without memory of the past or hope for the future. If life consists of nothing but physical substance and symptoms, as evanescent as breath, then a dog, a horse, a rat, prevail over Cordelia. The bare, forked animal caricatures a rational being; it cannot imagine a life outside the body.

Such readings tell us mainly, of course, about the minds and times that conceived them. Anxieties about the meaning or meaninglessness of life are problems that haunt modern critics. But they were also a problem in Shakespeare's time. Sir John Davies, for instance, endlessly worries questions of spirit, body, and soul in *Nosce Teipsum* (1599). This popular poem sets out to prove by argument the immortality of the soul. But something keeps getting in the way: the prevalence of spirits. Like Paracelsus, Bacon, or Thomas Browne, like virtually everyone who tried to imagine the processes of life, Davies assumes that various spirits drive the body, like wind in sails. Yet like the wind, those spirits sometimes sputter and die, which cannot be true of a perfect and incorruptible image of God. Soul "is a spirit, yet not like *aire*, or *wind*, / Nor like the *spirits* about the *heart* or *braine*." Instead it resembles angels, made of air but infinitely purer ("Some lovely glorious nothing," in

Donne's phrase).[40] Above all the soul is eternal. Among the many "great Clerks" with "litle wisedome" who have spun ridiculous theories, materialists agitate Davies the most: "These light and vicious persons *say*, / Our *Soule* is but a smoke, or aiery blast, / Which during life doth in our nosthrils play, / And when we die, doth turne to wind at last."[41] Such heretics lie, because the soul is more than a spirit; it is a distillation of spirit, a spark of celestial fire, a light that never can fail; and death is its true birth.

Wind, Breath, Air, and Spirit

Yet language itself resisted the distinction. Etymologically, most words for life incorporate puffs of air.[42] Latin *spiritus* means "breath," of course, and the first definition of "spirit" in Johnson's *Dictionary* is "Breath; wind in motion." Even the book of Genesis confirmed this derivation: "The LORD God formed a man from the dust of the ground and breathed into his nostrils the breath of life; and man became a living soul" (2:7).[43] Living creatures become more than dust when they are "inspired" to breathe in the quickening spirit, and they die, or "expire," when they at last breathe out. Similarly, animals are literally "breathers" (from *anima*, originally "breath of air" and by extension "breath of life").[44] Greek *pneuma* shares with *spiritus* a dual possibility of wind and soul. Anaximenes and other pre-Socratics identified air with the soul (*psyche* is another Greek word that can signify breath or air as well as soul), and Plato, in the *Philebus*, names breath as one of the four elements. Aristotle thought that *pneuma*, a kind of airy vital heat associated with soul, might be analogous to the *aether*, a fifth element or quintessence from which the cosmos and the stars were made.[45] Later, Galen attributed life to the respiration that distributes *pneumata* through the body.[46] Hence *pneumaticks*, in Bacon's time, could mean either "a branch of mechanicks, which considers the doctrine of the air" as a physical substance, or "in the schools, the doctrine of spiritual substances, as God, angels and the souls of men."[47] While theologians struggled with the metaphysics of these ethereal enigmas, natural philosophers sought some practical means to test them.[48] Eventually Robert Boyle's experiments on air would establish a "branch of mechanicks" that was almost entirely independent of occult explanations; yet he too referred to certain "supramechanical" gases as spirits and hoped to find an elixir to prolong life.[49] The soul itself must be an invisible substance, and thus akin to air.

Certainly the wind is alive in *King Lear*. "Blow, winds, and crack your cheeks! Rage, blow!" Lear's address to the wind, at first as a welcome destructive force that will crack nature's molds, then as a servile minister that does

his daughters' bidding, proclaims his gusting madness—"My wits begin to turn." Yet the audience shares his vision. The storm on stage, presumably as thunderous and flashy as the Globe's wizards of special effects could contrive, assails both ears and eyes. But the wind has to be imagined. A presence that cannot be seen and ruffles no clothes, it batters the head that conjures it up with words. No one can resist such personification; we all are assaulted; we shiver. But something more is also at stake. What the wind represents is a force that goes beyond nature. "Since I was man," Kent says, "Such sheets of fire, such bursts of horrid thunder, / Such groans of roaring wind and rain I never / Remember to have heard. Man's nature cannot carry / The affliction nor the fear" (3.2.44–48). Such winds exceed the petty trials of the earth; instead they undo creation. They recall the most ancient word for breath, the Sanskrit *Atman*, which came to stand for the World Soul or *Spiritus Mundi* from which all souls derive and to which they return. It is as if the injury done to Lear had infected the spirit that moves not only human beings but also being itself.

The uncanny relations among wind, air, breath, spirit, and soul preoccupied early modern physicians and philosophers as well as poets. In the famous "Digression of the Ayre" in *The Anatomy of Melancholy*, Robert Burton concludes that to cure melancholy, "the Rectification of aire is necessarily required." All over the world, experience confirms that "as the Aire is, so are the inhabitants, dull, heavy, witty, subtill, neat, cleanly, clownish, sicke, and sound."[50] Diseases of every kind, and plague in particular, were commonly attributed to malignant spirits that lurked and attacked through the air. And within the body, the circulation of air was equally crucial. When William Harvey discovered the circulation of the blood, he enthroned the heart as the seat of the soul: "The Heart of creatures is the foundation of life, the Prince of all, the Sun of their Microcosm, on which all vegetation does depend, from whence all vigour and strength does flow."[51] Later he would insist that blood itself was a more basic cause and locus of life, "the generative part, the fountain of life, the first to live, the last to die, and the primary seat of the soul."[52] Yet even then both spirits and air played a vital role; like Aristotle, Harvey identified the soul in the blood with the elemental substance of the stars. Robert Fludd, the hermetic philosopher and physician, welcomed the findings of Harvey, his colleague and friend, and used them to support his own extravagant associations of blood, as the vehicle of the spirit of life, with the ethereal spirit or cosmic Quintessence.[53] Air and blood shared a secret virtue to bring about long-distance healing. The material of the organic soul had been identified by Bernardino Telesio (1586) "with *spiritus*, the vapour refined from blood that was thought to fill the arteries and the nerves,"[54] and

such spirits might circulate through macrocosm and microcosm, through space as well as the body. Harvey himself, though skeptical about "incorporeal Spirits" outside the blood, associated the vivifying spirits dispensed by the heart with the evaporation and tempests generated by the sun.[55]

Bacon also thought that life could be prolonged by freshening the spirits in the blood. But for him the crucial element was always air: "The heart receives the most help and harm from the air we breathe, from vapours, and from our feelings" (12:301). The unknown powers of wind and air seem to fascinate Bacon, if not to obsess him. He began his "Natural and Experimental History" with a *History of the Winds* (1622), proposing a set of investigations to fathom and harness their might, and exploring their kinds, their causes, effects, and use in forecasting the weather. "The winds lend wings to the human race" by wafting ships, and like brooms they sweep the earth clean (12:19). In another work, *On Principles and Origins*, he concurs with Anaximenes, who "took Air to be the one principle of things. For if mass is to be taken into account in establishing the principles of things, air seems to occupy by far the greatest space in the universe" (6:213–15). Like other experimentalists, Bacon also devoted himself to weighing bodies, in order to measure the changes when spirit escaped. Later, the Royal Society set off a craze of weighing; Charles II, their patron, weighed himself frequently every day, "in order to observe the several emanations of his body." It was always tempting to go one step further and try to catch the soul in its passing or measure its wonderfully weightless ascent.[56]

One group of thinkers, in fact, devoted themselves to just such a project. The interplay of chemical and spiritual substances, and the liberation of the soul from the bodily shroud that concealed it, inspired the art of the magus. In his laboratory, base matter would be purged, and the pure gold of spirit would shine forth. Hence life and death often changed places; when bodies perished, souls came into their own.[57] The end of *King Lear* has been read as a gloss on this hermetic tradition. According to Charles Nicholl, Lear dies joyfully, "seeing Cordelia's breath. Breath and spirit are one and the same, so his last words are a vision of Cordelia's spirit issuing from her. . . . Nature, says Paracelsus, 'is not visible, though it operates visibly; for it is simply a volatile spirit, fulfilling its office in bodies.' Its office completed, itself revealed, it has no further need of the body. Cordelia's death is indeed 'the promised end': it makes the occult spirit manifest." And we who look on ought to share Lear's joy. "'Let us now rejoice together,' says the alchemist, 'for the reign of death is finished.'"[58]

The "mystical optimism" of this reading is far from persuasive, however; it assumes that not only Lear but the playwright and audience were bound

to respond like hermetic devotees. To the contrary, "the promis'd end," for Edgar, is "that horror," a devastating Last Judgment. The First Quarto excludes any possibility of joy; instead of Lear's repetitions of "look," it offers no more than "O, O, O, O"; and a moment later Lear's last words are "Break, heart, I prithee, break" (words that the First Folio assigns to Kent). Paracelsus himself might find it difficult to rejoice at this conclusion. And even if one were to argue that the Quarto and the Folio record quite different plays, the Folio also closes on a series of heartbroken notes: "Our present business / Is general woe." Both versions deny the least hint of a happy ending. Nor can anyone who is not deluded "see" Cordelia's breath or spirit. Lear's momentary happiness—if that is what it is—increases the pathos of his end, still gripped by self-deception. At the same time the play maintains a scrupulous detachment from any fixed opinion about what happens at the moment of death, let alone from any occult consolations. All that it shows is the futility of imagining that the process might be subject to human hopes and desires. Life comes and goes, mysteriously as the wind.

Imagining Death

Indeed, not knowing such things—not knowing when one is dead, and when one lives—marks an essential, repeated effect of *King Lear*. Death might be unimaginable, from the point of view of a creature immersed in life, but from another point of view, in which life itself resembles a dream, the mystery of death might be another sort of dream, or a simulacrum of life. When Gloucester falls from what he thinks is Dover cliff, he crosses into the "conceit" or imagination of death; and Edgar fears that the illusion might kill him: "I know not how conceit may rob / The Treasury of life" (4.5.42–43). When Lear awakes to see Cordelia, he knows that he comes from the grave, and "you are a spirit I know, where did you dye?" (4.6.42) These false, proleptic deaths prepare the limbo of the final scene. That Lear does not know whether or not Cordelia breathes, that we do not know just what Lear sees, temporarily holds the opposition of life and death in timeless suspense. This is the soul of the play.

The crucial difference made by such unknowing stands out when the final scene of *King Lear* is placed against one in another death-haunted play, Webster's *White Devil*. In some respects the episodes seem mirror images. Cornelia's wicked son Flamineo murders his virtuous brother Marcello, and the grief-stricken mother, a queen of denial, refuses to accept the finality of death. "Fetch a looking-glasse, see if his breath will not staine it; or pull out some feathers from my pillow, and lay them to his lippes—will you loose him

for a little paines-taking?"[59] Her wits and heart have cracked like Lear's; and Webster was surely remembering Shakespeare.

Yet in practice the effects of the two scenes are not at all alike. For one thing, the audience knows for certain that Marcello is dead; he has just been run through on stage. Perhaps even more conclusively, he has been given some parting words, in which he remembers that his evil brother, when an infant, broke off a piece of his father's crucifix; and Marcello goes on carefully to explain the moral: "This it is to rise / By all dishonest meanes. Let all men know / That tree shall long time keepe a steddy foote / Whose branches spread no [wider] than the roote" (5.2.23–26). The terminal rhyming couplet announces, far better than any stage direction, the moment of death. Hence Cornelia's denial seems perverse as well as pathetic. In her hysteria, she first threatens to stab the murderer, then lies to protect him. Nor will a corpse stay buried in this wasteland; her famous mad song raises the undead: "*But keepe the wolfe far thence, that's foe to men, / For with his nailes hee'l dig them up agen.*" What fascinates Webster is not the line between life and death but the persistence of death in life, which corrupts all it touches. The White Devil herself embodies this image. She breathes it out, as one of her assassins claims before he strikes: "O thou glorious strumpet, / Could I devide thy breath from this pure aire / When't leaves thy body, I would sucke it up / And breath't upon some dunghill" (5.6.207–10). Some bodily spirits were devils, according to medical experts. Those are the spirits that Webster knows best.

But Shakespeare seems much less knowing; the audience must draw its own conclusions about what it sees. This suspension of certainty even bears on what is often called the "moral" of *King Lear*. "Men must endure / Their going hence, even as their comming hither, / Ripenesse is all" (5.2.9–11). However profound, Edgar's maxim involves a classic ought / is ambiguity: "must endure" can mean either "ought to bear with patience" or "have to suffer." Perhaps old men *ought* to go hence stoically, but babies do not come hither that way; they have no choice in what they must endure.[60] Indeed, they have good grounds for crying. The earlier, companion passage in which Lear counsels the blinded Gloucester to be patient clearly takes the side of the babies:

LEAR. Thou must be patient. We came crying hither.
 Thou know'st the first time that we smell the air
 We waul and cry. I will preach to thee. Mark.
GLOUCESTER. Alack, alack the day!
LEAR. When we are born, we cry that we are come
 To this great stage of fools. (4.5.168–73)

Though Gloucester grieves at Lear's madness, the little sermon makes its point about the hardship and folly of life. "Wauling" and crying are perfectly apt responses to the world in which these characters suffer. In this context, the advice to be patient suggests little more than a death wish. Gloucester *must* endure till his troubles are over, as helplessly as a newborn child; the pain of coming hither will find relief only in going hence. And death, like birth, will happen, ready or not.

Is Lear ready to die, in fact, at the end of the play? Many critics have said so—none more strongly than Freud, in his brilliant essay "The Theme of the Three Caskets." "Let us now recall the moving final scene, one of the culminating points of tragedy in modern drama. Lear carries Cordelia's dead body on to the stage. Cordelia is death. ... Eternal wisdom, clothed in the primaeval myth, bids the old man renounce love, choose death and make friends with the necessity of dying."[61] Yet Lear does none of those things: he embraces love, rejects death, and dies while engaged with life. Evidently eternal wisdom is disobeyed. Nor does Lear, according to stage directions, carry Cordelia's "dead body"; Quarto and Folio agree on "*Enter* LEAR *with* CORDELIA *in his arms.*" The old man does not yet know the truth, and neither does any audience or reader who has not seen this before. Freud counsels an understanding of death, renunciation, and patience, and doubtless that is wise. But both Lear and the play expire on another note, an overwhelming exhaustion.

Meanwhile the lessons of life and death remain inscrutable. Notoriously, as Tolstoy bitterly complained, the play offers no final instructions or saving grace, nothing at all like Nahum Tate's ringing conclusion "That Truth and Vertue shall at last succeed."[62] Instead it lingers on the sheer duration of Lear's ordeal. Both Kent and Edgar follow the same train of thought: "The wonder is he hath endured so long. / He but usurped his life"; "The oldest hath borne most; we that are young / Shall never see so much nor live so long." The repetition of "so long" reminds us that this has been a very long play about a very long life. It is as if Lear had been absorbed into the age of the patriarchs, enduring and experiencing more than any younger character—or member of the audience—could ever comprehend. In this respect he is indeed ready to die, if only because he has passed beyond the normal span of human endurance.[63] Yet the immediate cause of his death remains obscure. Earlier in the scene the report of Gloucester's death fixed on his "flaw'd heart, / Alack, too weak the conflict to support," which "'twixt two extremes of passion, joy and grief, / Burst smilingly" (5.3.187–90); and perhaps a similar passionate conflict of joy and grief overcomes Lear. But we cannot be certain about his feelings at that last moment; even the Quarto

and Folio disagree. Nor can we see his last breath. As the audience watches, it becomes a double of Lear himself, hanging on imperceptible signs. Souls are passing, the end is approaching, but the meaning of this long journey, like the meaning of life, is left unresolved.

Yet the play converts that problem to a solution. In the final scene, theatrical and metaphysical knots are tied together. Theatrically, dying tends to be awkward, because the audience cannot be sure what it is seeing; a rigid actor might always rise up for one last swan song. Metaphysically, we cannot see or know when the soul leaves the body. Hence a tragedy asks us to look for what cannot be seen. Even the simplest, most undeniable fact in the world, the gulf between living and dying, turns out to baffle the senses. But it is just that invisible line—not knowing when one is dead and when one lives—on which the play finally turns. *King Lear* exposes, in the end, the idols of the theater, the illusions that cover the depths of what is unknown. Life hangs in the balance, as all of us imagine what death might be; and not a breath stirs.

The Dream of Descartes

The Book of Nature and the Infinite I AM

> This Science that plays in the mythology of modern times a role as majestic and as formidable as Progress itself, this Science that promised everything and denied everything, that raised above all things the absolute independence, the divine *aseity* of the human mind, . . . is not the true science, science such as it exists and is brought about by scientists, science submissive to things and to extra-mental reality. It is the Mid-Autumnal Night's Dream conjured up by a mischievous genius in a philosopher's brain—it is *the Dream of Descartes.*
>
> —Jacques Maritain

A Message Arrives

On the evening of November 10, 1619, in a stove-heated room in a provincial German village, something extraordinary passed through the mind of René Descartes. Almost everything about that episode is contested. Whether the crucial experience consisted of a rational process of thought or rather of three rambling dreams, whether that thought or those dreams contained the germ of all Descartes's future work, whether his ideas or dreams were empty or full of meaning, and whether the results of that day have proved to be a boon or disaster for Europe and the world have been debated for ages and never resolved.[1] Yet the search for what happened—so fugitive, yet so momentous—continues to fascinate scholars. It might hold a key to the origins of modern philosophy and science as well as the world they have made. Was Descartes dreaming, or was he supremely conscious?

The answer depends on which of two texts is favored. Descartes himself put great weight on the later text, the first book that he published. Not only did he write it in French, to address a wide audience, but he also gave it a title that expressed his ambition to conquer the world with logic: *Discourse on the Method of rightly conducting one's reason and seeking the truth in the sciences* (1637); and in the same volume he showed the fruits of his method in three scientific essays, on optics, meteorology, and geometry. That method evolved,

he insists, through rigorous, deliberate introspection. At twenty-three, he had already exhausted what books and travel could teach when "I resolved one day to undertake studies within myself too and to use all the powers of my mind in choosing the paths I should follow." His whole career would stem from that decision, according to part 2 of the *Discourse*. "At that time I was in Germany, where I had been called by the wars that are not yet ended there. While I was returning to the army from the coronation of the Emperor, the onset of winter detained me in quarters where, finding no conversation to divert me and fortunately having no cares or passions to trouble me, I stayed all day shut up alone in a stove-heated room, where I was completely free to converse with myself about my own thoughts."[2] It occurred to him first that the sciences contained in books, "compounded and amassed little by little from the opinions of many different persons, [never come] so close to the truth as the simple reasoning which a man of good sense naturally makes concerning whatever he comes across" (*PW* 1:117). And so he set out, "like a man who walks alone in the dark," to move from point to point with sure and simple steps until he found the way to certain knowledge. The method would take him there. From the thoughts he conceived in that room, firm principles grew, and "since beginning to use this method I had felt such extreme contentment that I did not think one could enjoy any sweeter or purer one in this life" (1:124). All of Descartes's achievements built on that first exercise of pure mind. As an intellectual autobiography, the *Discourse* identifies the story of the author's life with his discovery of the method.

Yet an earlier text tells a very different story. According to Adrien Baillet, who published the first major biography of Descartes (1691), the young philosopher kept a little notebook in Latin in one part of which, entitled *Olympica*, he recorded his dreams on that evening of November 10. Unfortunately the notebook has not survived, though it was cataloged as Item C in the inventory of papers Hector-Pierre Chanut compiled in Stockholm after Descartes's death (1650).[3] But Baillet offered a detailed French paraphrase of the dream entries, and some of his details are confirmed by notes taken by Leibniz in 1676.[4] Other evidence also argues for the reliability of these transcriptions. Abbé Baillet is known primarily as a patient, unimaginative compiler; he would have had no motive to invent Cartesian whimsies.[5] Most of all, the dreams that are rendered exhibit the features of actual dreams, not coherent, invented stories. They are propelled by peculiar associations, irrational anxieties, oddly intense perceptions, and sudden shifts of focus.[6] No one can verify their "accuracy," of course; at best we can hope for a faithful report of what the young dreamer remembered. Yet even in its sketchy form the *Olympica*, written in the heat of the experiences of which it gives tidings,

brings us closer to the fledgling philosophy of Descartes than do his later, mature recollections of method.

What do those dreams reveal? The first point, which must always be kept in view, is that Descartes was in a state of mind when everything, even his dreams, seemed charged with meaning. In Baillet's account, the contemplative reasoning claimed by the *Discourse* yields to a feverish agitation that "weighed on his mind, already depressed, so that it put him in a state to receive the impressions of dreams & of visions." Stripped of received opinions, he awaited the advent of truth; and a sign came. "He tells us that on the tenth of November sixteen hundred nineteen, having gone to bed *completely filled by this enthusiasm,* & completely occupied by the thought *of having found that very day the foundations of the wonderful science* [*la science admirable*], he had three consecutive dreams in a single night, which he imagined could only have come from on high."[7] Whatever that wonderful science might be, the sense of discovery thrills him and makes him tremble with premonitions. How could his dreams *not* have meaning? Interpretation is in the air; "the Genius that had excited in him the enthusiasm with which he had felt his brain seething for several days had predicted these dreams to him before he put himself to bed." Before, between, and after the dreams, therefore, he finds ways to explain them. Indeed, while still asleep, he states, he already began to interpret the last dream, and on waking calmly continued the same train of thought; consciousness and dreaming share a single inspiration.[8] "The Spirit of Truth," or God himself, had sent him these divinations. A rage of interpretation possesses Descartes.

That rage has also possessed Descartes's readers. Few have resisted the temptation to read the dreams as if they opened a window into the mind— or the subconscious. Even Freud, who cautiously declined to interpret the dreams on the grounds that he could not recover Descartes's own associations, could not help explaining two "symbols" in the first dream: the left side of the dreamer ("wrong or sin") and the melon ("a sexual fantasy").[9] Other analysts have proved far less cautious. In addition to a plethora of confident psychoanalytic readings, the dreams have been interpreted determinedly as mystic allegories and covert metaphysics.[10] From another perspective, some critics and philosophers find all the elements of mature Cartesian thought already present in the visions of that night.[11] At least three interesting books devote themselves entirely to solving the mystery. Gregor Sebba's *Dream of Descartes* construes the dream scenarios as a series of physical experiences and images that prefigure Descartes's most important ideas: the whirlwind foreshadows the vortex; the existential doubt of the dreamer, which culminates in a certainty that includes both his sleeping and waking states, predicts the

triumph over doubt in *cogito ergo sum*.[12] John Cole's *Olympian Dreams and Youthful Rebellion of René Descartes*, a thorough and plausible study, accounts for the dreams in terms of particular biographical associations: Descartes's guilt at rejecting his father's career, the law, and his joy at embracing the search for truth, encouraged by his friend Isaac Beeckman, that would guide the course of the rest of his life. Sophie Jama's *La nuit de songes de René Descartes*, an ethnological tour de force, traces the sources of the dreams to the popular traditions that surround Saint Martin's Eve, to Descartes's immersion in occult texts by ancients and moderns, and above all to the Pythagorean Y that John Dee and the Rosicrucians had proposed as the key to understanding the secrets of life.[13] What characterizes all these interpretations is a powerful impulse to crack the dream code, a message sent from the depths—or from on high—to be deciphered by the discerning expert. That impulse has always driven the study of dreams. Without it, Descartes himself would never have felt the urge to remember and write down his fragments of vision.

Yet the very strength of this need for interpretation might raise doubts about what it pries out. However tentative at first, each analyst eventually succumbs to his own theory. Descartes's initial puzzlement and zeal conclude in calm satisfaction when "the application of all these things turned out so well to his taste." Only one image, "the little portraits in copper-plate," remains to be accounted for, and "he looked for no further explanation after the visit that an Italian Painter paid him early the following day." Like fortune-tellers' cards, dream elements arrange the world around one person's destiny, and every item falls into place; if the painter had not visited, the head of a copper coin might well have sufficed. A skeptic might object that young Descartes was subscribing to a very primitive and superstitious theory of dreams. That would be true, of course.[14] But even modern interpretations of dreams seem enthralled by the appeal of *making sense*. As Wittgenstein observed in relation to Freud, there is an irresistible attraction to the notion that one's life has a pattern; and after analysis, "the dream appears so very logical."[15] A message always arrives at its destination.

Out of the Shadow of Dreams

In one respect, however, Descartes's rage for interpretation surely throws light on what happened that evening of November 10. Whether or not the dreams themselves make sense, the dreamer finds in them a reflection of who he is, and what he sees are images of his desire to break through. The book of poems that magically appears on his table is a portent of "Revelation & Enthusiasm, by which he did not despair of seeing himself favored." Many

commentators suggest that Descartes did not understand his own dreams. That raises the question of whether, before his interpretation, something already existed, some prior meaning, for someone to understand. Perhaps a dreamer owns the rights to his dreams. In any case, Descartes saw clearly that his last dream had revealed the future, "& it was only what ought to happen to him in the rest of his life." One might call this a self-fulfilling prophecy; divine sanction of the path he has chosen to follow not only confirms his way but also commands him to hold his course. But this external validation only reinforces the message conveyed alike by the dreams and interpretations, the wonderful news that all the universe is centered on himself. The amazing presumption that readers of Descartes have always criticized or admired, the self-absorption that founds the principles of philosophy on one man thinking, already flowers in that small stove-heated room, where "the treasures of all the sciences" lie open to him. Such confidence might be regarded rightly as divine. When, eighteen years later, the author of the *Discourse* brought back to mind the dawn of his new life, that turn into the self was probably what he remembered.

Nevertheless, the young Descartes's interpretations of his dreams can hardly be attributed to method. Despite or because of his conviction that he understands the true meaning of every symbol, he often draws on arbitrary or private associations. No one else would be likely to guess that the dream melon, for instance, signified "the charms of solitude."[16] When Baillet reports one final interpretation, "the clap of thunder he heard was the signal of the Spirit of truth descending on him to possess him," he adds that "this last imagination surely owes something to Enthusiasm; & it might incline us readily to believe that M. Descartes had been drinking that evening before going to bed."[17] In this case the interpretation strikes the biographer as even more fantastic or extravagant than the dream. Baillet quickly assures us that Descartes was in fact quite sober. But enthusiasm, as well as drink, confounds sober logic.[18] When the older Descartes pondered dreams in the *Discourse*, he argued: "After all, whether we are awake or asleep, we ought never to let ourselves be convinced except by the evidence of our reason. It will be observed that I say 'our reason,' not 'our imagination' or 'our senses'" (*PW* 1:131). Yet the young Descartes's interpretations of dreams are inspired by imagination.

One passage in particular marks this difference. At the moment at the end of his third dream when, still asleep, the dreamer already begins to interpret what he has seen, he decides that "the Collection of Poems entitled the *Corpus Poetarum* marked . . . Philosophy & Wisdom joined together." This insight leads to reflections—reported also in Leibniz's notes—on the superiority of the precepts of poets to those of philosophers. "He attributed this marvel

to the divinity of Enthusiasm, & to the force of Imagination, which brings forth the seeds of wisdom (which are present in the mind of all men like sparks of fire in flints) with much more readiness & much more brilliance too, than Reason could bring about in Philosophers." This passage has been ignored by many critics. Taken to heart, it would seem to preclude one major strand—perhaps *the* major strand—of Descartes's philosophical and scientific achievements: his effort to explain all laws of nature, from cosmology to the workings of the human body, through the application of mathematical and mechanical principles. Imagination has no place there—at least in theory.[19] To some extent the Scientific Revolution itself might be understood as a vast and sustained polemic against the dangerous prevalence of imagination. All the idols decried by Francis Bacon spring from that idol-making faculty, which deludes the mind into preferring subjective wishful thinking to objective truth. And Descartes's own project might be read as a similar breaking of idols.

The retreat from imagination culminates in the sixth of the *Meditations on First Philosophy* (1641). In a famous passage, Descartes maintains that pure understanding does not require the aid of imagination, and "besides this, I consider that this power of imagining which is in me, differing as it does from the power of understanding, is not a necessary constituent of my own essence, that is, of the essence of my mind. For if I lacked it, I should undoubtedly remain the same individual as I now am; from which it seems to follow that it depends on something distinct from myself." To *be* is to think, not at all to imagine. In understanding, he goes on to explain, the mind "turns towards itself and inspects one of the ideas which are within it; but when it imagines, it turns towards the body and looks at something in the body which conforms to an idea understood by the mind or perceived by the senses" (*PW* 2:51). The decisive Cartesian split between mind and body, a distinction that may have been conceived as early as 1623, grounds imagination in the body, along with the senses.[20] Nor can imagination *prove* that the body exists, as thinking proves the existence of the self. Hence a philosopher needs to resist the power of imagining, a faculty whose illusions will tempt him to false ideas not only of his own nature but also of the world.

Much of Descartes's mature philosophy derives from a similar struggle: an effort to answer the doubts raised by dreaming. Both the *Discourse* and the *Meditations* contend with one principal reason for doubt: our "inability to distinguish between being asleep and being awake." Imagination can rule the senses; perceptions in dreams and hallucinations are fully as strong as those in everyday waking life. Young Descartes was sure that the Spirit of Truth had inspired his dreams, but the older Descartes is less trusting; perhaps a demon

inspired them. Hence the vision that once provided certainty now provokes dark suspicions. In the *cogito* the philosopher reaches rock bottom: spectacular doubts are assuaged by spectacular faith in the ego. Yet many contemporaries were less impressed by the proofs on which Descartes built his system than by his rejection of all previous systems. Ironically, the thinker who regarded himself as the protector of certain and absolute belief was widely attacked as a skeptic.[21]

At the end of the *Meditations*, he tries to dismiss his former, exaggerated doubts. Now he notices a vast difference between sleeping and waking,

> in that dreams are never linked by memory with all the other actions of life as waking experiences are. If, while I am awake, anyone were suddenly to appear to me and then disappear immediately, as happens in sleep, so that I could not see where he had come from or where he had gone to, it would not be unreasonable for me to judge that he was a ghost, or a vision created in my brain, rather than a real man. But when I distinctly see where things come from and where and when they come to me, and when I can connect my perceptions of them with the whole of the rest of my life without a break, then I am quite certain that when I encounter these things I am not asleep but awake. (*PW* 2:61–62)[22]

The senses, memory, and intellect all confirm that these things are real; and God is not a deceiver. At this moment Descartes has fully emerged from the shadow of dreams.[23]

Yet imagination was not so easy to dismiss; for the rest of his life Descartes kept returning to it. His last philosophical work, *The Passions of the Soul* (1649), distinguishes two sorts of "imaginings," one formed by the soul, the other involuntarily by the body: "Such are the illusions of our dreams and also the day-dreams we often have when we are awake and our mind wanders idly without applying itself to anything of its own accord" (*PW* 1:336). This distinction allows the possibility of fully conscious, willed imaginings, directed by the soul. On that possibility, Descartes's whole enterprise of natural philosophy depended. In chapter 6 of *The World*, the most ambitious description of his system, he invites his readers to join him in a cosmic thought experiment: "For a while, then, allow your thought to wander beyond this world to view another, wholly new, world, which I call forth in imaginary spaces before it."[24] That imagined new world is the cosmos itself, as conceived by Descartes.

One might consider this formulation merely strategic. After the trial of Galileo, Descartes was keenly aware that his explanations of phenomena,

which often seemed to contradict the "truth" of scripture, must be presented only as hypotheses, devoid of truth claims. Hence his purpose, unlike that of overly subtle "Philosophers," "is not to explain the things that are in fact in the actual world, but only to make up as I please a world in which there is nothing that the dullest minds cannot conceive"[25]—a world imagined distinctly, with no contradictions. In this respect imagination can function didactically, as a means for teaching principles that might be used to fashion better tools; for instance, lenses or prostheses. In *Principles of Philosophy* (1644), designed to replace Aristotle in the curriculum, Descartes spells out his purpose:

> Just as for an understanding of the nature of plants or men it is better by far to consider how they can gradually grow from seeds than how they were created [entire] by God in the very beginning of the world; so, if we can devise some principles which are very simple and easy to know and by which we can demonstrate that the stars and the Earth, and indeed everything which we perceive in this visible world, could have sprung forth as if from certain seeds (even though we know that things did not happen that way); we shall in that way explain their nature much better than if we were merely to describe them as they are now, {or as we believe them to have been created}.[26]

God's creation must be left untouched. But Descartes presides over his own world, his own imaginative creation. Moreover, his thought experiment mimics one view of the Logos, the word or idea made flesh. In the Platonic tradition adopted by many Christian divines, God the demiurge formed the world, like an artist, bringing ideas to life and shaping man in his image. The creative imagination copies that process, as human artists strive to form a secondary world.[27] Of course they cannot make the word flesh; their thoughts exist only as thoughts. Yet such imaginings bring them as close to the Spirit of Truth, in Descartes's terms, as humans can come. *The World* represents that ideal.

Nor are those imaginings only a way of sheltering science from scripture. As scholars have repeatedly observed, Descartes's hypotheses about the fabric of the world, its reduction to certain effects of matter and motion, are radically metaphorical. The all-important vortex, for instance, can scarcely be conceived without referring to bodies that float on water, to currents and fluids and eddies and boats. Chapter 9 of *The World* includes a figure of two intersecting rivers, and asks the reader to keep that image in mind in order to understand the course of planets and comets, afloat on celestial matter. This

picture is more than an aid to thinking; it represents the conception itself (see fig. 5).[28] The image of the solar system as boats whirled about by water proved so irresistible, in fact, that good Cartesians held on to it for more than seventy years after Newton's rebuttal.[29] Unlike the impalpable law of gravity, fluid vortices appealed to the senses; everyone has seen water in motion. Moreover, to visualize the earth buoyed up by a cosmic current was not only easy but also profoundly comforting, a stay against the free fall of bodies through space. The Cartesian plenum sustains us on firm supports, unlike the Newtonian vacuum. Thus Cartesian science lends itself to popular, graphic models based on things seen every day. Descartes is masterful at finding analogies to illustrate his theories, as in his comparison of the action of light with the pressure of wine in a vat: our perceptions of light do not result from any inherent quality it has, but rather from the push of celestial matter against the eye.[30] What we experience as light, therefore, is something we make for ourselves. To object to such hypotheses on the grounds that they are based on images rather than facts would only reinforce Descartes's point: the world in its purest form, a world reduced by intellect to matter and motion alone, is not at all the rich and varied world we apprehend. What we see, what we sense, what we know, is a world we construct, a secondary, internal fabrication.[31]

FIGURE 5. Descartes's diagram of two intersecting rivers, illustrating the course of planets and comets afloat on celestial matter, from chapter 9 of *The World*.

The persistence of images in Descartes's mature scientific thought has often been regarded as a puzzle if not a scandal. For anti-Cartesians such as Jacques Maritain, those teeming images expose the sleep of reason, a demonic nightmare in which the spiritual life, suppressed by cold intellectualism, returns in distorted form to take its revenge on the unbeliever. In recent years some scholars have suggested that such attacks are based on a misunderstanding or a refusal to take account of the full range of imagination, its different types and meanings. No brief summary can do justice to the complexity of Descartes's views of what may be imagined or of his own imaginings.[32] Over the course of his career he kept refining his ideas, as his early embrace of *phantasia*—composite images or apparitions, like those seen in dreams—yielded to a definition of imagination as a mode of understanding or cognition that makes use of figures, and eventually to the distinction between imaginings that arise from the body ("corporeal imagination") and those willed by the soul ("intellectual imagination"). In these terms "images" could be useful, but only up to a point: they could not help the mind to comprehend the infinite, God, or the soul, and they were often prey to illusions and errors. But ideas conceived by the mind alone, without the crutch of images, might reach perfection. When Thomas Hobbes accused Descartes of having no idea or image of God, he was contemptuously dismissed:

> Here my critic wants the term "idea" to refer simply to the images of material things which are depicted in the corporeal imagination [*phantasia*]; and, if this is granted, it is easy for him to prove that there can be no proper idea of an angel or of God. But I make it quite clear in several places throughout the book, and in this passage in particular, that I am taking the word "idea" to refer to whatever is immediately perceived by the mind. . . . I think I did give a full enough explanation of the idea of God to satisfy those who are prepared to attend to my meaning; I cannot possibly satisfy those who prefer to attribute a different sense to my words than the one I intended. (*PW* 2:127–28)

At its best and most active, Descartes's imagination hopes to break the chains of the body and dwell among pure ideas.

The Eye of the Mind

Nevertheless, analysis cannot resolve the perplexities of Descartes's scientific worldview, at once opposed to imagination and yet highly imaginative.

At times his practice contradicts his theory; at times he changes his mind. Is thinking always tied to images? He strongly denies it, yet images materialize in his prose as regularly as dreams come in the night. There are many ways of accounting for such problems. Historically, the influence of Aristotle, who *did* consider thought to be impossible without the aid of mental images, continued to govern psychological and rhetorical views of imagination, even for thinkers who rebelled against him.[33] Similarly, traces of the long-established threefold division of life into vegetative, sensitive (or "animal"), and rational "souls" still linger in Descartes's anatomies of the body. Despite his explicit refusal to posit a vegetative or animal soul, he relies on "animal spirits"—"a certain very fine wind, or rather a very lively and very pure flame," produced in the brain—to run the human machine. And that "machine" itself is a vital image. The explanation of its movements depends on an extraordinary, prolonged comparison with "the grottoes and fountains in the royal gardens" in which external objects, for instance, "are like strangers who on entering the grottoes of these fountains unwittingly cause the movements that take place before their eyes."[34] Descartes cannot resist analogies that bring inanimate matter to life. Nor did he ever wholly lose the quasi-mystical sense of inspiration—the conviction that a divine Spirit of Truth had sent him images to guide his life—that marks his interpretation of the dreams of November 10.[35]

The ultimate knot in Descartes's scientific system, however, is bundled into his most famous insight, the division of mind and body. That rupture has never healed. By separating the realm of dead matter—the whole natural world—from the immortal and immaterial "thinking thing" (*res cogitans*), Descartes was able to construct both a universe and a body that functioned like clockwork. To be sure, he hoped eventually to put soul and body together again, perhaps with the help of the pineal gland: "Finally I must show you how those two natures would have to be joined and united so as to constitute men resembling us."[36] But he never finished that part of the "Treatise on Man." Nor have all the generations since then completed the work of uniting the ghost and machine. Refutations of the mind/body split are legion; they began as soon as the doctrine appeared, when "Objections" from various hands were published, along with replies, in the first edition of the *Meditations* (1641). From Spinoza's time to ours, whole schools of philosophy have been founded to answer Descartes, and any number of scholarly and popular books have proved, to their own satisfaction, where he went wrong.[37] Yet the problem, so often declared nonexistent, keeps coming back in new guises. The question of whether the operations of the mind or consciousness, for instance, are identical with particular physical states or events in the brain still stirs endless arguments, forever unresolved.[38] Whether or not the man in the

street is Cartesian, as Gilbert Ryle complained, the relation of mind to body seems one of the few current philosophical issues that haunt philosophers and laypeople alike.

The problem is rooted, of course, in language. When Descartes insisted that he took the word "idea" to refer not to images but to "whatever is conceived directly by the mind" (*tout ce qui est conçu immédiatement par l'esprit*), he could not help using a term that associates thought with a pregnant body, nor could he avoid construing the mind as a sort of spirit or person or agent. Our words for consciousness or inner states of mind unavoidably draw on embodied representations, like "inner" and "outer." For Hobbes, who was sure that "a man can have no thought, representing any thing, not subject to sense,"[39] an idea inaccessible to the senses must be at best incomprehensible, like God, or literally nonsense. Later, etymologists such as Horne Tooke argued that every word, including particles, derived from a concrete material cause or sensory impression.[40] Descartes himself may have contributed to that oversimplification with his emphasis on clear and distinct ideas, adapted by Locke to *sensible* ideas; could any idea be clear and distinct if it could not be pictured?[41] In any event, consistent dualism puts language under enormous strain. Describing what happens in the mind, the philosopher resorts to abstractions that always threaten to branch or break into images.

Descartes attributes such problems to intellectual laziness, since so many people "never raise their minds above things which can be perceived by the senses: they are so used to thinking of things only by imagining them (a way of thinking specially suited to material things) that whatever is unimaginable seems to them unintelligible" (*PW* 1:129). But higher thoughts prove them mistaken. Descartes's own view of language, as Chomsky maintained in *Cartesian Linguistics*, tends to equate the power of speech with an innate faculty, or with the rational soul itself. Unlike magpies and parrots, who utter words but "cannot show that they are thinking what they are saying" (*PW* 1:140), human beings form utterances in order to make their thoughts understood. Thus language mirrors the soul, and though it may refer to the body, the body cannot bind it. Even if this is so, however, the soul still requires some practical means of expressing itself; it depends on material words or images that clothe pure thought and allow it to pass into the sensory world and eventually into the thoughts of another mind. During that passage, contamination routinely occurs. As thought is transmuted to words and back into thought, the medium of language turns into the message, or specious images lure the mind into misunderstandings. "Oh! why hath not the Mind / Some element to stamp her image on / In nature somewhat nearer to her own?" Wordsworth lamented.[42] And even in that lament, the mind becomes identified with an image.

One possible escape from such linguistic contamination might be the purity of mathematics. Descartes's *Geometry* (1637), the cornerstone of his scientific studies, sets out to provide a basis for explaining all natural phenomena with the certainty of a mathematical demonstration. As early as March 1619, he had used mechanical compasses to develop a new tool of analysis, a series of well-defined plane curves that corresponded to well-defined algebraic equations. This discovery, which came to be known as analytic geometry, enabled him to think about mathematics in a new way, freeing number from spatial intuitions and conceiving algebra in terms of abstract entities.[43] Theoretically, such conceptions would represent pure intellect, unadulterated by the material objects of nature or the mixed modes of language. The idea that an infinity of points might be posited between any two other points plotted on the same curve, for instance, could never be visualized or reduced to an image, yet it stimulated further ideas in Newton and Leibniz, who invented the calculus. In this way mathematics could constitute a world of its own. But problems arose when Descartes turned to a mathematical physics, a set of ideas supposed to account for the world as it is. Now images must come back into play. To some extent the relation of abstract ideas to the world could be made comprehensible by assimilating algebra to geometry; that is, by representing numerical values as two-dimensional shapes, in a universe reduced to nothing but spatial extension. Imagination, working through the senses, would then convert these symbolic shapes into corporeal images, the world as we perceive (or misperceive) it. In Cartesian science, pure intellect can use hypotheses and symbols to elucidate material nature. Yet the process itself could never be pure; transmitting ideas, the mind eventually reverts to things grasped by the senses.

For many readers, in fact, Descartes's account of the world seemed true exactly because it inspired such persuasive pictures.[44] How does a magnet work? According to *Principles of Philosophy*, the earth itself is a giant magnet.[45] From the North and the South Poles, grooved particles of the first element (extremely tiny "subtle matter") whirl through and around the earth in "a kind of vortex." These particles, "twisted like the thread of a screw" in opposite directions, flow through "pores" in the earth or loadstone, hollowed out to admit one sort of thread and to bar the other. Hence the seeming attraction of iron to a magnet is actually the effect of matter tightly compressed, as "the grooved particles which emerge from both the magnet and the piece of iron expel the air between the two bodies."[46] No one can *see* this, of course, but Descartes provides diagrams in which the invisible threads and motions of subtle matter become clear and distinct (see fig. 6). In practice, such explanations depend on visual aids, not only as a means of persuasion

FIGURE 6. Descartes's diagram of magnetism, from *Principles of Philosophy* (1644). University of Chicago Library.

but as the main evidence for the theory itself; the idea and picture are one. Despite his suspicion of images, Descartes pursued science above all with his mind's eye, with farsighted visions of how things might be. In a peculiar way Cartesian science might even be called literal-minded, unable to credit theories it cannot visualize. Thus magnets do not "attract" iron, since attraction suggests some impalpable force that could span empty space; instead one kind of matter (grooved particles) replaces another (air), allowing no void or blank in the picture. Intellectually and visually, the Cartesian world is a plenum.

Cyrano's Make-Believe

When Descartes turns his mind to nature, therefore, he views it in terms of art as well as science.[47] A philosophy that captured the public would have to appeal to the senses, and illustrations were often remembered far better than the principles they set forth. As both a philosopher and a maker of pictures,[48] Descartes led a double life; ideas and pictures might always conflict and cause

trouble. Indeed, a few pictures almost cost the hero his life in Cyrano de Bergerac's *Voyage to the Sun* (1662). Suspected of heresy, "Dyrcona" (Cyrano) is seized by a mob of ignorant peasants, who leaf through his copy of Descartes's *Physics* (*Principles of Philosophy*). "When they perceived all the circles through which this philosopher has marked the movement of each planet, with one voice they howled that these were the rings that I traced to summon Beelzebub" (see fig. 7). In terror someone drops the book, which falls open to the page depicting the magnet, "where the little bodies that part from the mass to hitch on to the iron are represented as arms." Immediately one yokel swears that "that was the toad found in the trough of his cousin Fiacre's stable, when his horses died."[49] All shrink from the book in dread, and Dyrcona is hauled off to jail (from which he eventually escapes to the sun). Cyrano mocks superstition, of course; science and sorcery are alike to the rabble. But

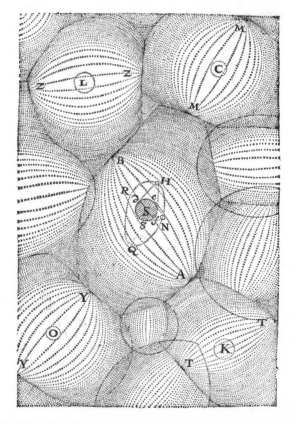

FIGURE 7. Descartes's diagram of the solar system, from *Principles of Philosophy* (1644). University of Chicago Library.

the trouble begins with pictures, where fine ideas descend to the realm of the senses, and stupid spectators impose their own illusions on things.

Yet intelligent readers also respond to the lure of imagination. Descartes is clearly one of Cyrano's idols, not so much for his philosophical and mathematical insights as for his ingenious images and machines. At the end of *Voyage to the Sun* the soul of Descartes arrives at a sort of solar Elysian Fields reserved for philosophers, the purest and finest of spirits.[50] Corporeal images as light as a breath fly straight to the soul, in that happy place, since "the mind is no longer entangled in a body formed of gross matter." Thus minds can perceive distant things and events; *dreams become real*, and imagination is "what your soul can see as surely as your eyes on a day when it shines." Cyrano plays with Cartesian themes, recombining bits of the *Physics* to make a new pattern.[51] In this whimsical science, Descartes functions as an enabler of fancies, or a sage who provides fresh ways of perceiving the world. Though Dyrcona does not mistake the picture of a magnet for a toad, his description does replace particles and screws with little bodies and arms; they make a better story. A hundred pages later the magnet returns, in an extended fantasy that mixes cosmology and physics with Ovidian metamorphoses. Now the bodies and arms belong to fierce lovers, like Pylades and Orestes: "The amorous ardor with which they couple is so sudden and so impatient that, after they have embraced all over, you would say that there is no grain of loadstone that does not want to kiss a grain of iron, nor any grain of iron that does not want to unite with a grain of loadstone" (1:295). In this punning image the loadstone or magnet (*aimant*) is literally loving (*aimant*). Such iconophilia has come a long way from Descartes. But perhaps his pictures had licensed a make-believe model of science, a world of ideas not yet explored and hypotheses not yet tested.[52]

Where Descartes reimagined the natural world as a set of machines, moreover, his disciple Cyrano liked to imagine contraptions.[53] Dyrcona is an inveterate inventor. He ascends to the sun in a box propelled by a transparent crystal icosahedron; when converging rays of light produce a vacuum in it, air rushes to fill the void, so that a tremendous wind from below lifts the box up. The outmoded principle here, that "nature abhors a vacuum," can hardly be attributed to Descartes, who argued that vacuums cannot and do not in fact exist (since the extension of space is the same as the extension of body or matter).[54] Yet Dyrcona, we know, has been reading Descartes's *Physics*, whose rules of motion and pictures of magnets might well have inspired his design. Later, when he lands on "one of those little worlds that fly around the sun (which mathematicians call spots)" (1:216), he draws on another passage from the same text, which had associated sunspots with the formation

of planets.[55] For Cyrano, Descartes's theories do not offer conclusions so much as points of departure. Thus the notorious Cartesian equation of animals with machines, lacking reason and soul, provokes a running series of jokes and reversals in which intelligent beasts—as well as some trees— on the moon and sun debate whether humans have souls. On the sun, the anthropocentric hierarchy turns upside down. After a parliament of birds has sentenced Dyrcona to death for the crime of being a man, a talkative parrot—Descartes's own example of a mindless mimic of words—saves the life of the condemned by remembering how often he used to maintain that birds can reason. The satire cuts deep: it subverts not only the beast-machine theory but also the implicit Cartesian pride that places humanity outside the natural order. It is precisely because human beings deny that they are like other creatures, in fact, that the sunbirds despise and revile them. By getting things exactly wrong, Descartes makes Cyrano's point.

At the same time, however, Descartes is a hero. One might say that Cyrano glorifies him for all the wrong reasons, converting him into an atomist, a skeptic, an Epicurean, and a freethinker—all positions that the philosopher himself explicitly repudiated. Yet still the image of a hero lingered, the type of a solitary explorer who voyaged bravely into the unknown. Once Descartes's mind had leapt into the cosmos, the moon and sun seemed much closer. Nor was this heroic impression at all far-fetched; it grew out of the author's own way of making ideas his own. The working title of the *Discourse on Method* was *A History of My Mind*.[56] Hence, for many later writers, the *Discourse* and the *Meditations* represented a new kind of first-person narrative: a prolonged soliloquy employing "the self-assured inner voice" in a quest that did not seek personal salvation so much as epistemological foundations.[57] Philosophy had joined with autobiography, refashioning a series of thoughts as a story. That narrative proved highly adaptable. Dressed in the proper style, it could accommodate Cyrano's adventures in science fiction, Scudéry's florid prose romances, the heroic tragedies of Corneille and Racine, and eventually the *récit* or logbook of Valéry's Monsieur Teste (Mr. Head).[58] In this regard Descartes's method and findings mattered less than his self-absorption. The thinking thing would live on as a hero, irrespective of what it had thought.

God's Book and Descartes's

Yet Descartes himself had dreamed of something far grander. Despite his turn from images to reason, he never abandoned the vaulting ambition expressed in the final dream of November 10. Two books had appeared unaccountably on his table: a *Dictionary*, which carried him away "with hope that it

might be very useful to him," and "a collection of Poems by various Authors, entitled *Corpus Poetarum* etc." Each book leaves something to be desired. The dictionary vanishes and reappears, but "he found that this *Dictionary* was no longer so complete as when he had seen it the first time"; and though familiar with the anthology, he cannot find some poems he is looking for, because "it was not the same edition as the one he knew."[59] Nevertheless these books bring him great satisfaction. Not yet awake, he begins to interpret the dream and "judged that the *Dictionary* could not be called anything else than all the Sciences gathered together; & that the Collection of Poems entitled the *Corpus Poetarum* marked in particular & in a more distinct way Philosophy & Wisdom joined together." This train of thought continues when he awakes, and "seeing that the application of all these things turned out so well to his taste, he was bold enough to persuade himself, that it was the Spirit of Truth which had wanted to open to him the treasures of all the sciences by this dream." Presumably even the incompleteness of the books reflects divine encouragement, since he has been assigned the task of making them perfect. If the dream did predict the future, and showed him "only what ought to happen to him in the rest of his life," what it predicted must be the books he would write—the books that set out to contain and control all the world.

Nor did he awake from that dream. No matter how much Descartes might shift from poetry to mathematics as the source of wisdom, or from enthusiasm and imagination to reason, he held to his purpose of universal knowledge. Slowly and deliberately, he would find the principles from which a creator could build the sum of things, both microcosm and macrocosm, a plenum with every element in its place. From the beginning this urge for completeness drove him. He could not stand the insinuation that anything might be missing in his system. When his earliest scientific friend, Isaac Beeckman, suggested in 1630 that he had taught Descartes something, the claim provoked an eruption of rage; it would have been like learning from ants and worms.[60] And four years later, when Beeckman disputed the theory that light "instantaneously arrives at the eye from the body which emits it," Descartes insisted that anything short of instantaneous transmission would mean that his entire philosophy would be "completely overturned"; he was so sure his theory was right that he could never agree on an experiment to test it.[61] From a scientific point of view, such confidence, or arrogance, exposes a fatal flaw in Descartes's introspective method. Yet his strength as a thinker demanded that total commitment. For those who believed in the Great Chain of Being, a single gap might destroy the whole fabric: "From Nature's chain whatever link you strike, / Ten or ten thousandth, breaks the chain alike."[62] Descartes's lifework, his own great chain of nature and mind,

obeyed a similar logic. In principle, each part of the world he had built was forever linked to the others.

Two complementary visions of wholeness meet in Descartes's ideal. The first is the well-established concept or metaphor of the Book of Nature.[63] During the Middle Ages, theologians regularly viewed creation as God's book, a companion volume to the Bible; the earth, the firmament, and living things all furnished models and lessons for scholars to read. Later, writers like Paracelsus often opposed this study of the world to mere book learning. A similar line of thought provides the climax to Descartes's account of his youth in the *Discourse*: "As soon as I was old enough to emerge from the control of my teachers, I entirely abandoned the study of letters. Resolving to seek no other knowledge than that which could be found in myself or else in the great book of the world, I spent the rest of my youth travelling, . . . and at all times reflecting upon whatever came my way so as to derive some profit from it" (*PW* 1:115). Experience is the great teacher; but more than that, true knowledge consists of reading the signs of nature. Words can deceive, and so can sensations, but the reflective mind can strike through appearances to the design of creation. The metaphor of the Book of Nature assures Descartes that the world is intelligible. Though no one but the Author can comprehend the whole, since only the Author is perfect, devoted reading should always have its reward, filling in one more piece of the puzzle. Perhaps that effort constitutes the truest worship of God, and explains why the human mind was created—for whom else could the book have been written? In any case it justifies a life dedicated to thought, a life spent in translating the world back into the simple ideas that made it.

If the world is a book, however, a book might also put a world together. Both the *Dictionary* and the *Corpus Poetarum* represent worlds *in nuce*: the first, "all the Sciences gathered together"; the second, "Philosophy & Wisdom joined together." These texts advise the dreaming Descartes to follow their way. The *Dictionary* kindles hope that it is designed to help him; the anthology reminds him of the Pythagorean choice between "Yes and No" (*Est & Non* [It is and it is not]), which he understands as Truth and Falsity. All the words, all the worlds, lie on his table, ready to be rearranged. Hence he conceives an ultimate book, a foundational text that will someday replace Aristotle. Under the influence of Neoplatonic ideas, some Renaissance theorists had embraced the metaphor of the poem as heterocosm or "second nature." The poet, a creator or maker of worlds, thus "produces another nature altogether, . . . and in this process even makes himself almost into another god."[64] Polemically the metaphor serves to exalt the poet. All other activities are bound to Nature as it is, as Sir Philip Sidney observes: "the natural philosopher thereon has his

name" and mirrors a brazen world, while "the poets only deliver a golden."[65] But Descartes refuses to let phenomena bind him. Incorporating the poet's power of creation, *The World* invites its readers to lose themselves in "the guise of a fable" or second nature, a wholly new, imaginary world. This new world will have its own laws of nature and even its own original myth or account of Creation. *Principles of Philosophy* elaborates that project. Although it concedes that what it has deduced, "the fabric of the entire World," may be uncertain, "compared to the absolute power of God," it ends by counting its reasonings among the number of "absolutely certain things." Indeed, "it will scarcely seem possible" for its demonstrations concerning material things "to be understood otherwise than as I have explained them."[66] Descartes is the god of his world; and what he has made is a book.

Yet the Book of Nature radically differs from the book that calls forth a new world. Above all, God's book is complete. Consisting of all creation, it offers unlimited vistas for the student to read, from the stars to what is beyond the stars, from the atom to that from which the atom is made; and whatever we see there has always already been written. But Descartes's book—*The World*, and the principles that explain it—can never be finished. He does not know enough, nor does he know what he has yet to learn. To patch the holes, therefore, he needs hypotheses. No one has ever been readier to provide them, or to create a whole hypothetical world. It was just this facility, in fact, that so enraged his successor Isaac Newton. There was nothing that Descartes could not explain, piecemeal, and sometimes in several contradictory plausible ways. His philosophy thus amounted to "nothing else than a system of Hypotheses," according to Newton, and "what certainty can there be in Philosophy which consists in as many Hypotheses as there are Phænomena to be explained."[67] In the *Principia* that overthrew Descartes's *Principia*, Newton famously declared, "Hypotheses non fingo" (I do not feign [or fabricate] hypotheses).[68] Nor did he pretend that his own great book, concluding with *The System of the World*, was anything like complete. To fix it would require not only his own revisions but also those of countless scientists in the unforeseeable future. The world of his book was only a chapter in God's great creation, the Book of Nature. To presume more would lead one to whirl in a vortex, the dream of Descartes.

Thus the dream circled back on itself. In the long run, the two versions of what occurred on November 10 came to seem analogues, not opposites: two visions of imaginary systems. Whether enthusiasm or method had produced the world of Descartes, it did not account for the world perceived and calculated by Newton. Of course Descartes had brought forth amazing insights, and he was a giant on whose shoulders Newton and others would

stand. But his book, like the flickering books in his dream, did not contain the certain knowledge it promised. Instead it survived as a work of imagination, a series of brilliant thought experiments. Even the crucial distinction between corporeal and intellectual imagination was vulnerable; to many thinkers, beginning with Hobbes, it seemed a way of begging the question of the mind/body problem, a way of assuming what had yet to be proved. Yet still the dream did not die. For Descartes, more than anyone else, had put the world in the custody of science. Henceforth the *Dictionary* and the *Corpus Poetarum* would yield their authority to a new kind of book, which, explaining everything through natural philosophy, could be mistaken for the Book of Nature itself.

In chapter 13 of *Biographia Literaria*, "*On the imagination, or esemplastic power*," Samuel Taylor Coleridge draws a famous—and famously difficult— distinction between the "primary" and "secondary" imagination. The primary imagination is held to be "the living Power and prime Agent of all human Perception, and as a repetition in the finite mind of the eternal act of creation in the infinite I AM"; the secondary, "an echo of the former, . . . dissolves, diffuses, dissipates, in order to re-create; or where this process is rendered impossible, yet still at all events it struggles to idealize and to unify."[69] This passage is usually glossed as a tribute to the creative imagination of great poets, and especially Wordsworth. Yet the chapter begins with another example: "DES CARTES, speaking as a naturalist, and in imitation of Archimedes, said, give me matter and motion and I will construct you the universe. We must of course understand him to have meant; I will render the construction of the universe intelligible."[70] Coleridge prefers a less materialistic philosophy, and goes on to praise the philosophic genius of Kant. But Descartes's name comes first; he had taken the lead. It was he whose finite mind had glimpsed the eternal act of creation; it was he who had dissolved the world in order to recreate it. Philosophers and poets share that ambition. According to Coleridge, the creative imagination unites them. Yet the initiative had long since passed to those who shut the books of poets and searched instead the infinite I AM. And all of that had begun with the dream of Descartes.

CHAPTER 7

A History of Error

Robert Fludd, Thomas Browne, and the Harrow of Truth

Doctor Fludd's Answer

Robert Fludd did not doubt in the least that he knew the meaning of truth. Whether he was arguing with some of the best minds in Europe—Johannes Kepler, Marin Mersenne, Pierre Gassendi—or with an obscure country parson, whether he was surveying the structure of the cosmos or the essence of a grain of wheat, his confidence in the rightness of his views remained unshakable and absolute. Whoever disagreed with his wisdom would cavil in vain: "It is not I, but the Spirit of truth, that assureth you thus much."[1] Ultimately such assurance stemmed from the authority of Christ, who had anticipated Pilate's question "What is truth?" simply by being himself, the Word revealed in body as well as in spirit: "My task is to bear witness to the truth. For this was I born" (John 18:37–38). Fludd bears witness to a similar fusion of matter and spirit, body and soul. When he wields "Truths goulden Harrow" against "thos gross clodds of Errour" thrown up by a skeptic who held that the alchemical elixir or Philosopher's Stone should be regarded only as a philosophical allegory, not as a physical substance, he parallels the sublimated elixir, material and earthly yet immortal and incorruptible, to the stones that became a pillow and house of God for Jacob and a source of water for Moses. Those stones existed equally in real and spiritual worlds, on earth and in heaven, like the resurrected souls whom Jesus had harrowed

131

from hell.[2] To doubt that such transubstantiations are matters of fact would be to doubt divine wisdom or creation itself.

The weapon-salve was one truth that Fludd made his own. In *Doctor Fludds Answer unto M. Foster, or, The Squesing of Parson Fosters Sponge, ordained by him for the wiping away of the Weapon-Salve* (1631), "the sharpe vineger of Truth" decisively extinguishes William Foster's inflammatory attack, *Hiplocrisma-spongus: or, A Sponge to Wipe Away the Weapon-Salve* (1631)—at least to Fludd's satisfaction. A controversy had already swirled around the salve. Attributed to Paracelsus, this magical cure involved an ointment that, when mixed with the blood of someone who had been wounded, and smeared on the weapon that had caused the wound, brought about a quick and sure healing, no matter what distance might separate the weapon from its victim. Such action-at-a-distance had been debated by many prominent physicians and chemical philosophers, including Andreas Libavius and Jean Baptiste van Helmont.[3] Fludd was especially devoted to theories of sympathetic attraction, which he associated with William Gilbert's famous treatise on the loadstone, *De Magnete* (1600). Hence an irresistible logic disposed him to embrace the weapon-salve. Although he claimed not to have used it in his own medical practice, he fiercely defended its efficacy, which had passed every test of truth.

How did Fludd distinguish truth from error? His tireless, embattled writings employ all the time-honored tests of his age. First, he invokes reliable witnesses who testified that the weapon-salve worked. An unimpeachable source, his own brother-in-law Sir Nicholas Gilbourne, "a man iudicious, religious and learned," had personally observed and administered several cures. In one instance Sir Nicholas had even proved the effect through a little experiment. A servant "was cut with his axe into the instep, so deepe as it could passe, and not cut it off." The next morning, by dressing that axe with the salve, Sir Nicholas put him at ease. But then he secretly struck off the ointment, and soon received a message that the servant had suddenly been wracked with pain. So the axe was anointed once more; immediately the pain ceased, and within seven days the man was perfectly well.[4] Another cure worked like a charm at a distance of twenty miles. And a thousand more were reported. If surgeons denied these wonders, the reason must be that such simple and painless healing had cost their trade a great deal of money. Only the right sort of witness could be trusted to tell the difference between truth and error.

The quality of witnesses is all-important to Fludd. He validates the testimony on which he relies through the rank and standing of those who provide it: "a Noble Personage in this kingdom of no mean descent, title and rank, among the English nobility," "a great Lord," "a Noble man of worth," an Earl,

a Cardinal, a Captain, a Knight, and among authors Bishop Anselm, "canonized a Saint." As evidence for the virtue of "the Sympatheticall oyntment," Lady Ralegh relates "that her late husband, Sir Walter Ralegh, would suddenly stop the bleeding of any person (albeit hee were farre and remote from the party) if he had a handkirchers, or some other piece of linnen dipped in some of the blood of the party sent unto him" (131). Such stories would matter far less in the absence of the great name that certifies them. Nor should they be mistaken for mere flummery, an empty show of name-dropping intended to impose on hoi polloi. In the time and milieu in which Fludd took up his case, authority and proof were near allied. Modern ideas of probability did not yet exist, according to Ian Hacking; all evidence was demonstrative, based on testimony rather than on inductive logic supported by hard facts and statistics. Hence "probability" then referred to whatever seemed worthy of approbation, whatever had the weight of authority behind it.[5] The luminaries who vouched for the weapon-salve personified truth; the doubting Thomases in thrall to circumstantial evidence had lashed themselves to error.

Moreover, Fludd demands respect for his own high position. The patrons of his work, he reminds his critic, include "our late King *Iames* of blessed memorie, and next three of the Reverend Bishops of the Land" (22). Much of the answer to Foster contrasts the credibility of the ignoble parson with that of the noble doctor, one a "self-conceited" nobody, the other the son of a knight. Defending his choice to present himself first as an Esquire instead of a Doctor, Fludd explains that "a Gentleman of Antiquitie is to be preferred before any one of the first Head or Degree." Foster may "snarle at my gentilitie," but a noble soul is far above such insults. "Would he thinke it decent in mee to revile him for his lownesse of birth or ignobilitie? For I know what he is: God forbid such an absurditie should come from my pen, much lesse to upbraid him with his gentilitie, if hee were a Gentleman indeed" (7).[6] Here the man of honor, while ostensibly refusing to stoop, grinds his opponent under his heel. A thinly disguised contempt for the low "Sponge-bearer" runs through the whole of Fludd's onslaught. He will not even concede that Foster is capable of manufacturing arguments of his own: "Hee talkes with *Mersennus* the Fryer his tongue, and therefore is but *Mersennus* his Parrat" (7). Marin Mersenne, the prominent French mechanist and self-styled "Christian philosopher," had already exchanged bitter words with Fludd, who considered him "a rayling Satyricall Babler" (18). But Foster was still more vulgar; he babbled in English rather than Latin. Even the language of *Doctor Fludds Answer*, demotic English, personal, blunt, and racy, reveals the author's scorn for his ill-bred foe. Bad taste alone would convict the parson of error; the dignity of Latin would be wasted on him.

In all these ways Fludd's argument reflects the view of truth and error that Steven Shapin formulates, the link between credibility and social standing. "In early modern culture the definition of gentility implied a conception of truth, just as the location of truth in that culture might invoke a notion of gentility."[7] Mersenne and Foster must be wrong, according to Fludd, not only because they reason badly but, still more, because they are not *civil*. No gentleman would roar and brag in such a fashion. In contrast, Fludd takes care to address his work to the "Courteous Reader." Yet more ingeniously, he proves his point by enlisting Mersenne's own friend, the great Pierre Gassendi, as an ally. Gassendi too had disagreed with Fludd in print, rebuking his devotion to alchemical mystifications. But these disputes had been within the pale of civil behavior. "As for *Peter Gassendus* I finde him a good Philosopher, and an honest and well conditioned Gentleman, just aswell unto his Adversary as friend, not passing beyond the bounds of Christian modestie" (18–19). It was all the more telling, therefore, that this good man had chided Mersenne for his extravagant vituperation. Fludd shows triumphantly "how this my honest dealing and morall forren Adversarie doth checke his uncivill friend, whose part he undergoeth, for his immodestie and small discretion: and next doth teach my home-bred Adversarie a great deale of manners or behaviour in writing against an Adversarie, namely, not to contend with foule and scandalous language" (16). Gassendi's civility exemplifies a proper attitude toward truth, which gentle hearts and good manners protect.

If authority provides one test of truth for Fludd, and gentility provides another, a third seems still more powerful: what he called *harmony*, or what is now called the coherence theory of truth, in which each belief is reinforced by being consistent with others. Fludd knows not only that the weapon-salve works but also *why* it works and, on "infallible grounds," its relation to everything else in the universe. There is nothing, it seems, that he does not know.[8] His philosophical key begins with the reciprocity of the Macrocosm—the World or Cosmos infused by the Holy Spirit—and the Microcosm—the little world of man, which is moved by the very same divine and incorruptible Spirit. Each element of this miniature universe, the human being, corresponds to some aspect of the greater world, as the beating of the heart, for instance, accords with the "proper macrocosmicall Sunne in Systole, and Diastole" (66). Hence true understanding depends on making connections and seeing the larger picture (Fludd's books are crammed with illustrations of his ideas).[9] Enormous confidence stems from this grasp of the whole, the *pansophia* of universal knowledge. Kepler, Mersenne, and Foster and other doubters may calculate odds or latch on to some puzzling detail, but that only proves how superficial they are, Fludd says again and again; only someone

acquainted with the Quintessence can comprehend the occult and hidden causes of things.

The causes of the weapon-salve exemplify this understanding. Fludd traces the sources of the cure back to the Spirit of the Creator. In human beings that soul or vital spirit is seated in the blood, from which all flesh and bones are made (Fludd draws his evidence from the Bible, especially Leviticus 3 and 17). The wound, an "unnatural action," violates this effusion of blood, so that the spirit withdraws. But the salve retrieves "the living fountaine of blood in the wounded" and thus refreshes the spirit. "And with what distance can his activity be limited, being that it is the spirit of the winds, and the soule of the lightnings, and the essence of the Sunne and starres of heaven?" (91–92). QED. From such an exalted perspective, the wonder of the salve can hardly be questioned. To be sure, an earthbound mortal such as Mersenne might find that this appeal to the sun and the stars had gone too far, perhaps as far as lunacy. But as a physician Fludd did not lack evidence. He was drawing, in fact, on one of the great discoveries of his time, the circulation of the blood, unveiled by his "esteemed compatriot" William Harvey. In *De Motu Cordis* (1628) Harvey had supported his thesis in terms very much like Fludd's: "So the heart is the beginning of life, the Sun of the Microcosm, as proportionably the Sun deserves to be call'd the heart of the world, by whose vertue and pulsation, the blood is mov'd, perfected, made vegetable, and is defended from corruption."[10] Fludd had witnessed Harvey's investigations, arranged the publication of his book, and endorsed his ideas in a book of his own on the pulse.[11] In this regard he was far more advanced than Mersenne and Gassendi, who refused to accept the circulation of the blood.

Yet Fludd also perverts the new theory. Harvey had dealt a deathblow to the Galenic division of arterial and venous blood, and ultimately to the dominant system of humors, the four bodily fluids whose proportions were supposed to determine the temperaments and health of human beings. But Fludd's Pythagorean cosmic vision, as well as his Galenic medical practice (which resorted to frequent bloodletting), found those divisions useful. Arterial blood carried the vital blood or quintessence, unlike the grosser venous blood; and the mystic, holy number four, expressed by the Tetragrammaton, composed a universal harmony, four elements and four humors, the Macrocosm and Microcosm in glorious concord. Thus Fludd takes from Harvey only what his own system can build on. The harmony and coherence of truth override any petty objections and always favor the theory that can absorb and account for everything that exists or might be imagined. Ultimately the weapon-salve is verified by its participation in the music of the spheres. Just as the chords of two lutes vibrate together in unison, so the

ointment and the spirit of the wounded man "evibrate & quaver forth one mutuall consent of simpatheticall harmony" (98). This is no metaphor for Fludd; it represents in miniature the Universal Monochord or God Himself, to which all things return. No truth could be more comprehensive.

Through all these tests of truth and error, *Doctor Fludds Answer* preserves a certain equanimity or even smugness. Nothing shakes the author's hearty conviction that he is always right. But much more seems to be at stake in another arena where he wars with Foster: the charge that the devil has inspired the weapon-salve. On this issue Fludd's rage boils over; he resorts not only to arguments but to threats. "And therefore I must tell this my English calumniatour, that there is a Starre-chamber to punish such abuses, and consequently, he may perchance heare of mee sooner than he doth expect, unlesse hee bridleth his slanderous tongue the better hereafter" (146). Foster's accusation touches Fludd where he lives, his assurance that his ideas harmonize with the Spirit of God, and he must stifle the damage before it spreads. Such repercussions are far more important to him than the question of whether or not the weapon-salve works. Foster himself had conceded the possibility, and Fludd understands that the efficacy of the cure can hardly outweigh the bane of sorcery. "The maine scope of the whole businesse is contained in this Question, which he proposeth thus: *Question. Whether the curing of wounds by the Weapon-Salve, bee Witchcraft, and unlawfull to be used?*" (26). Hence the burden of *Doctor Fludds Answer* (and presumably the reason why it had to be written) gives the lie to imputations of diabolical magic.[12] Fludd does not deny his attraction to hermetic mysteries, to "the verity in both the true Magick and Astrology" that "hath been falsely contaminated and abused by superstitious worldlings" (134). But he insists on the virtue of mysteries grounded in God and Nature, the white, divine magic.[13] Such magic is lawful, and it absolves him of the one error to which there could be no defense: the error of *heresy*.

All Fludd's passion goes into refuting that charge. He insists that the sages whose wisdom he shares, from cabalists and Neoplatonists to Paracelsus and the Rosicrucians, had done the work of God and spited the devil. He claims that his greatest adversary, the Jesuit Father Mersenne, had accused him of heresy in order to frighten him into deserting his faith and joining the Catholic Church. Above all, he identifies the miraculous effect of the weapon-salve with the miracles vouched for in scripture. Reversing the guilt by association with which Foster had smeared him, Fludd pleads a kind of innocence by association: the prophets, the apostles, and the Savior are all on his side. It would be blasphemy to impugn such heavenly champions. From this point of view, the real unbelievers are those who lack the insight to perceive the hand of God in every part of nature, in "all Acts

and operations, as well occult and mysticall, as those which are manifest and apparent unto sense: and therefore all Acts are instituted by God" (28). No error could be more fundamental than setting limits to God's power. Fludd never makes that mistake. In the final analysis the weapon-salve rewards a faith in providence, and the true believer who pays it respect is not engaging in heresy but revering the Lord. That is the truth on which Fludd rests his case.

Dark Woods and Open Daylight

> This same *Truth*, is a Naked, and Open day light. . . . Yet *Truth*, which onely doth judge it selfe, teacheth, that the Inquirie of *Truth*, which is the Love-making, or Wooing of it; The knowledge of *Truth*, which is the Presence of it; and the Beleefe of *Truth*, which is the Enjoying of it; is the Soveraigne Good of humane Nature.
>
> —Francis Bacon, "Of Truth"

Yet Fludd's belief in the weapon-salve was an error, according to some people at the time, and many more later. Evidently his four tests of truth were becoming vulnerable in the light of new discoveries and changing attitudes. Authority no longer intimidated savants such as Galileo, Bacon, and Descartes, who fearlessly set out to disable the grip of Aristotle and other oracles. A decade after Fludd flaunted his own gentility and the patronage of James I, doubts that the new king, Charles I, could be trusted to tell the truth would bring him crashing down. Reliance on harmony in the macrocosm and microcosm was trembling in the incoherent world conjured up by John Donne, a world of new stars and medicines that were out of tune with Fludd's great cosmic diapason. And although, in the same year as *Doctor Fludd's Answer*, the Inquisition summoned Galileo to answer the charge of heresy for which it would condemn him, expert judges in other parts of Europe were not persuaded that he had been in error. Error itself, apparently, might be regarded differently in different times and places. It was subject to history; and its nature kept changing.

Moreover, the current of history seemed to run counter to Fludd. During the seventeenth century an obsession with error took hold of natural philosophy and natural history, and his kind of magic came under attack. The Scientific Revolution might be imagined as a campaign against delusions like the weapon-salve. Long before Max Weber spoke about the disenchantment or demagicking (*Entzauberung*) of the world, enlightened Europeans had congratulated themselves on dispelling the phantoms that once had haunted science. Animism yielded to mechanistic explanations of nature; hermeticism

yielded to experiments and demonstrations. According to Keith Thomas, "the refutation of Robert Fludd's magical animism by Marin Mersenne and Pierre Gassendi" foreshadowed the dissolution of the union of magic and science.[14] Though common people might cling to their superstitions, an increasing number of educated people took pride in casting them off. Many scholars still agree with Basil Willey's conclusion that "the main intellectual problem of the seventeenth century" was "the separation of the 'true' from the 'false'," the great project in which Thomas Browne joined Francis Bacon "to clear away the vast deposit of pseudo-science and fantastic lore left over from the unscientific centuries."[15]

At the same time, the definitions of "true" and "false" went through radical alterations. Like the word "error" itself, which etymologically derives from "straying," the history of error turned away from the direction that it had steered through many centuries in Europe. Mistakes and blunders, the slips of the tongue and pen that intrude on any effort to set things straight, have been predictably constant, of course, so long as human beings have kept records; and scholarship historically involves the perpetuation as well as the rectification of such errata.[16] But these are relatively innocent lapses. Other kinds of straying once seemed so unforgivable that their consequences proved fatal. Long before Fludd, one might argue, the dominant form of error in the West was neither falsity nor ignorance but *heresy*, the charge that had preyed on his mind. For more than a millennium that accusation carried all before it. No mortal peril attended distortions of facts or ideas, but many people paid with their lives for swerving from creeds and dogmas.

Dante's great *Commedia*, from this point of view, might be regarded as an encyclopedic guide to error. The dark wood through which the pilgrim wanders in the first steps of canto 1 represents the savage world in which he is trying to live, and to escape he must find again "the straight way."[17] But the error that has led him astray is not so much lack of knowledge as a sinful disposition, embodied by the beasts that block his path. The straight way ought to be simple, to one of true faith and pure heart, yet dense and twisted byways detour the worldly traveler and lure him with false choices. Dante's journey represents a perpetual comedy of misunderstandings; again and again, throughout the poem, the wayfarer fails to comprehend what he sees and must be set straight. The pathetic ignorance of earthlings, so far removed from grace, drives both the plot and its lessons. Despite the poet's wonderful ability to comprehend all the varieties of human nature, he does not hesitate to render final, unsparing judgments about who must be damned or saved. At times he seems almost gleeful—or proud—about the blindness of his fellow creatures, as in the notorious elevation of the little-known pagan

Ripheus to a place among the saints of justice: "Who in the erring world down there would believe / that in this circle Trojan Ripheus / was the fifth of the holy lights?"[18] Dante mounts above the drifts of humankind. Released, however briefly, from that erring world, he submits to the higher power of a knowledge that sees the true state of things immediately, without any need for the circumlocutions of words. At the end of the *Paradiso*, when the clari- fied vision of the poet looks directly into the Eternal Light, he comprehends its mystery through love and faith, not reason. Error perpetually wanders, like endlessly forking heretical doctrines, but truth is one and the straight way leads the penitent home.

The dark wood returns at the opening of Spenser's *Faerie Queene* (1590), where the errant knight Redcrosse and his companions "wander too and fro in wayes unknowne," bewildered by "So many pathes, so many turnings seene," until they take a beaten path to "Errours den." A primal combat ensues. The "ugly monster," half serpent, half woman, swallows her brood of "a thousand yong ones, ... / eachone / Of sundry shapes, yet all ill favored," and wraps her "endlesse traine" around the knight. But adding faith to force, he strangles her so that "she spewd out of her filthy maw / A floud of poyson horrible and blacke, / ... Her vomit full of bookes and papers was." Belched forth, her spawn join the attack, "Deformed mon- sters, fowle, and blacke as inke," but they are harmless as gnats; and after the knight cuts off Errour's head, they lap up her blood until their bellies burst.[19] And so this fulsome allegory concludes; but what is its point? Doubtless Spenser takes aim at Satan and Catholicism, his usual paired targets. Yet the essence of Errour seems rather to consist of what she disgorges; she is so very prolific. The black poison she spews, the upchucked books and papers, the offspring black as ink, all mark disgust at the unrestrained, incontinent written—and printed—word. Una, Redcrosse's lady, is Truth because she is One; but Errour, containing multitudes, allows any black thing to have life. Significantly it is faith more than force, and certainly not sweet reason, that empowers the knight to choke her and exterminate her heresies. In fairyland no argument is required. One stanza compares the filthy spew of Errour to the monstrous creatures generated from the "fertile slime" of the Nile; later scholars might consider this image itself a perfect example of error.[20] But that sort of error, an innocent matter of fact, does not concern Spenser at all. Myths are his stock-in-trade and cause no harm, but the den of unclean beliefs cannot be tolerated, and any departure from the one true faith requires an urgent and ruthless response.

During the seventeenth century that equation of error with heresy is supposed to have changed forever—though Galileo might have thought

otherwise. Both Dante and Spenser had subscribed to one true faith, but the churches that defined their faith had broken in pieces and accused one another of multiple heresies. Una and Duessa were not always easy to tell apart. Who now represented the Truth? In the age of the printing press, it seemed that anyone who could read might have an opinion. Spenser was not the only writer who worried about the books and papers spewed by the monster Errour. An intense anxiety about the spread of print and heresy consumed the sixteenth-century guardians of dogma.[21] In 1527, when Robert Ridley, chaplain to the bishop of London, condemned William Tyndale's "common & vulgare translation of the new testament in to englishe," he hardly needed to pick out particular errors. The book itself was an error, precisely because it subjected the word of God to infirm minds, unfit to gaze directly at the sun. "Ye shal not neede to accuse this translation, it is accused & damned by the consent of the prelates & learned men, and comanded to be brynt both heir and beyonde the see, wher is many hundreth of theym brynt."[22] Nine years later Tyndale himself would be burned. Yet repression could not put an end to the lust for reading that print and Luther had started. At best, authorities might steer the common people to a Book of Common Prayer, or later to an English Bible sanctioned by the king. Eventually the prerogative of interpreting scripture in personal terms came to seem an Englishman's birthright.

Meanwhile new worlds were opening. Discoveries on earth and in the heavens, along with a new readiness (in Browne's words) "to stand alone against the strength of opinion; and to meet the Goliah and Gyant of Authority"[23] with the trust of a reasoning being in his own powers, made heresy less fearsome than illusion and untruth, the "idols" and "fallacies" identified by Bacon and Browne. Bacon sees error everywhere, and most of all in the mind: "Doth any man doubt, that if there were taken out of Mens Mindes, Vaine Opinions, Flattering Hopes, False valuations, Imaginations as one would, and the like; but it would leave the Mindes, of a Number of Men, poore shrunken Things?"[24] One kind of error especially troubles him: "the corruption of philosophy arising from *Superstition*, and admixture of theology." "This unhealthy mixture of things divine and human" debases both religion and science, and it leads to "the *Apotheosis* of error." Worse yet, it is "exceptionally gifted and exalted individuals," confident in their powers, who are most susceptible to the vanity of thinking that they can build a natural philosophy from sacred writings, "*seeking the living among the dead*."[25] Bacon's prime examples of such hubris are Pythagoras and Plato. But he also seems to be aiming at one of their modern disciples, his own contemporary and acquaintance Robert Fludd.[26] Fludd more than any had

drawn philosophy from scripture and from dark hermetic texts; he served as an ambassador of error.

Generations to come have acquiesced in that verdict. Whether or not the Royal Society was actually dedicated to carrying out Bacon's program, its engines of publicity declared that his attacks on superstition and authority had shown the way for its own experimental philosophy.[27] Joseph Glanvill took the title and inspiration of his encomium to the Society from Bacon: *Plus Ultra: Or, the Progress and Advancement of Knowledge Since the Days of Aristotle* (1668). *New Atlantis* had "*desired*, and form'd a SOCIETY of *Experimenters* in a *Romantick Model*" for later improvements of learning, and its author himself was transformed into a mighty romantic model, the great progenitor of the great instauration.[28] "*Bacon*, like *Moses*, led us forth at last," according to Abraham Cowley;[29] the seas of error had parted for him. Such writers are among the champions who star in the epic of modern times— heroic, inspiring. One story about the advancement of learning might sketch a steady progress, beginning perhaps with Bacon and marching forward in triumph for 400 years and beyond, with ignorance yielding more to truth at every successive stage. Or less imperiously, one might at least trace an edge of objectivity (in Charles Gillispie's phrase) through which reason and science, by the skin of their teeth, keep one step ahead of nonsense.[30]

Yet perhaps that heroic picture is too good to be true. Error is wonderfully resilient, and it endures and thrives. A generation after Fludd was "refuted," the weapon-salve came back to life, revived in powdered form by Sir Kenelm Digby, who pretended to have introduced it to "this Quarter of the World," and his book went through twenty-nine editions.[31] Nor have Fludd's ideas wholly lost their charm even today. Although the weapon-salve has gone out of favor, Frances Yates and other distinguished scholars have taken up the cause of "the Rosicrucian Enlightenment" and the contribution of occult and magical ways of thinking to the development of modern science. From this perspective an emphasis on particular errors can hardly detract from the undeniable power of hermetic philosophers, whose theories are spectacularly *coherent*. Their sweeping vision offers an opportunity to combine ancient wisdom with intuitions of a cosmic harmony, "a process which would return society to the idyllic unity lost in the remote past."[32] Thus the great quantum physicist Wolfgang Pauli seems personally drawn to Fludd. "Even though at the cost of consciousness of the quantitative side of nature and its laws, Fludd's 'hieroglyphic' figures do try to preserve a *unity* of the inner experience of the 'observer' (as we should say today) and the external processes of nature, and thus a *wholeness* in its contemplation—a wholeness formerly contained in the idea of the analogy between microcosm and macrocosm but

apparently already lacking in Kepler and lost in the world view of classical natural science."[33] Although Fludd could not cure bodily wounds, perhaps he could help to heal the psychic wounds of modern scientists like Pauli, whose rationality had blinded them to spiritual truths.

Nor does any simple distinction between truth and error account for the achievements of Bacon and Browne. A closer look at those pioneers of science tends to complicate what they stand for. What changed in natural philosophy between the sixteenth and seventeenth century was not so much a movement from the "false" to the "true," many scholars now agree, as a shift from contemplation of causes to a practical stress on results—in Peter Dear's terms, from knowing *why* to knowing *how*.[34] Even Fludd, despite his fascination with the *why*, put some impressive know-how into practice, as in patenting a method to produce a better and cheaper steel or in devising a functional memory system.[35] Bacon's polemic against the *why* went further. Traditional studies of "abstract forms" or "final and first causes," he argued, ignore the intermediate causes that alone can stimulate useful work. Worst of all, the search for primary qualities and occult properties in the end reduces all nature to atoms, "ideas which however true they may be, can do little for the good of mankind."[36] Only experience can guard against the recklessness with which philosophies perpetuate illusions of the mind. Hence unaided reason can never separate truth from error; all must be put to the test. Similarly, Browne sets aside "discursive enquiry and rationall conjecture" in order to explore instead "delightful Truths, confirmable by sense and ocular Observation, which seems to me the surest path, to trace the Labyrinth of Truth."[37] Within this labyrinth, error can often masquerade as a guardian spirit forever moving forward. Thus the open daylight of truth would have to contend with endless trials and shadows. In Browne the advancement of learning detours through byways where truth and error keep uneasy company together.

Doctor Browne's Deuteroscopy

> Some truths seem almost falshoods, and some falshoods almost truths; wherein falshood and truth seem almost æquilibriously stated, and but a few grains of distinction to bear down the balance.
>
> —Thomas Browne, *Christian Morals*

Thomas Browne was not at all sure that he knew the meaning of truth. Despite his enormous and sedulous learning, he understood that he had grasped only a tiny portion of the world and that a sense of the whole would always escape him. Hence the certainties of writers like Robert Fludd

or the legendary "Hermes Trismegistus" (Fludd's favorite guide) provoke a wry response: "To begin or continue our works like Trismegistus of old, 'verum certè verum atque verissimum est' [it is true, certainly true, and most supremely true], would sound arrogantly unto present ears in this strict enquiring age."[38] Yet Browne did know a great deal about error, to which he devoted much of his life. The first large folio of *Pseudodoxia Epidemica* was published in 1646, before he turned forty-one; revised and expanded editions appeared in 1650, 1658, 1669, and finally 1672, ten years before his death. Error kept coming back, and it was popular; the book "filled the kingdom with copies," according to Samuel Johnson.[39] Here readers could lose themselves in a wealth of bizarre and intriguing bits of information. Moreover, the miscellaneous organization, with brief entries or essays on any number of different topics—the loadstone, the elephant, mermaids, the age of the world, the blackness of Negroes, and whether or not the fruit that Eve and Adam ate was an apple—perfectly suited Browne's gifts. He was at home with error; he loved to wander through thickets of learning and follow his quarry through winding paths of digression.

A keen eye for oddities keeps Browne's restless mind in motion. With the zeal of a naturalist and archaeologist, over the years he collected a hoard of curios, ancient coins and medals and urns as well as plants and animals, alive or dead, including an eagle, whales' heads, and an ostrich. John Evelyn called Browne's house and garden in Norwich "a Paradise & Cabinet of rarities, & that of the best collection," and it is tempting to think of the *Pseudodoxia* too as a cabinet of curiosities, a private museum or portfolio of showpieces that invites us to rummage through his obsessions.[40] But curiosity cannot provide a test of truth or a principle for distinguishing harmless freaks of nature from dangerous false beliefs. Does the *Pseudodoxia* instruct its audience or merely divert it? That question hovers over Browne's hydra-headed and often whimsical investigations. Although he made his living as a physician, he offers very little medical advice, let alone prescriptions for curing the epidemic of popular errors. Indeed, he sometimes suggests that certain fallacies might be ineradicable, as with the superstition that those who pull up a mandrake root are doomed to die soon after; however ridiculous such a fear may be, "prepossessed heads will ever doubt it, and timorous beliefes will never dare to try it" (*PE* 1:146). *Pseudodoxia* has neither the will nor the power to straighten out the labyrinth it explores. Like error itself, it wanders, and the game it pursues does not resolve into any one unequivocal truth.[41]

Yet Browne was quite ready to cope with mysteries or enigmatic compounds of truth and error. That was his nature as well as the nature of all his kind: "Thus is man that great and true *Amphibium*, whose nature is disposed

to live not onely like other creatures in divers elements, but in divided and distinguished worlds."[42] Browne imagines himself as that *amphibium*. He associates the word not only with creatures like frogs who move between water and land but also with the passage from primal chaos to vital form— the principle of epigenesis, which according to William Harvey had generated the cosmos as well as human beings: "*Epigenesis*, in which an order is observed according to the dignity, and worth, and use of the *Parts*; where first a small foundation is laid, which at the same time while it doth increase, grows distinct, and formed, and so attains all its parts by degrees, according to their proper order, which are supergenerated, and born to it."[43] Here individuals reenact creation, from the moment of conception in the womb to the fully formed being to the unknown hereafter. It is as if for Browne the little world or microcosm of the self encompassed all possible forms of life, "not onely of the world, but of the Universe." The embryo or *amphibium* progresses from a "rude masse" without sense or reason through vegetable and animal states to "the life of men, and at last the life of spirits."[44] Browne relishes that perpetual transmigration. It marks his precarious balance between a number of worlds, to each of which he is drawn but in which he cannot permanently settle. He is poised between the ancients and moderns, between mysticism and science, between the active and contemplative life, between poetic appreciation of wonders and the new experimental methods. Even his celebrated prose style hovers between English and Latin, whose syntax and vocabulary he imports into a rich vernacular brocade (with stitches of Greek and Hebrew).[45] The *amphibium* dwells in the wide world as well as in England, in the past as well as the present.

In context, however, the image refers to one particular in-between situation of human beings, who consist of both body and soul: "We are onely that amphibious piece betweene a corporall and spirituall essence, that middle forme that links those two together, and makes good the method of God and nature, that jumps not from extreames, but unites the incompatible distances by some middle and participating natures."[46] Characteristically, Browne regards this middling position not with revulsion, as Hamlet and so many others do, but as a delight.[47] Participating in every possible state of existence, from the barely animate to the divine, the curious human being can find a piece of himself wherever he looks. The potential to view his life from more than one perspective doubles Browne's pleasure; the visible world engages his senses; the invisible world entices his reason and spirit. *Religio Medici* (1642), the work that made him famous, circulates happily among his roles as physician and man of faith, a reader of the book of God and the book of Nature, a lover of mysteries and matters of fact. Inhabiting so many

alternate selves, he is content to allow other people to differ from him. Charity is Browne's favorite virtue. "I cannot fall out or contemne a man for an errour, or conceive why a difference in opinion should divide an affection: for controversies, disputes, and argumentations, both in Philosophy, and in Divinity, . . . doe not infringe the Lawes of Charity" (RM 59).

Nevertheless, one sort of error does exasperate Browne: he cannot abide a narrow literal mind. Precisely because he imagines himself an *amphibium* in an amphibious world, caught "betweene a corporall and spirituall essence," he scorns those landlocked creatures, only half-human, who understand everything merely through their senses. Such creatures include the great majority of mankind. "If there be any among those common objects of hatred I doe contemne and laugh at, it is that great enemy of reason, vertue and religion, the multitude, that numerous piece of monstrosity . . .; it is no breach of Charity to call these fooles."[48] Much of the *Pseudodoxia* campaigns against one-sided views that overlook the invisible meanings of things. In this respect the book sets an example of how to read; it provides continual lessons for "attaining the deuteroscopy." Deuteroscopy, or the art of the "second look," is the heart of Browne's method. As a mode of biblical interpretation, it pursues the "second intention of the words," directing the reader to the spirit behind the letter of the text.[49] But Browne extends his method beyond "the Lecture of holy Scripture" to error in general. Whether the object of his scrutiny is a biblical passage, the picture of a grasshopper, or the bad luck foretold when salt is spilled, there ought to be more than one way to interpret its meaning.[50]

The need to take a second look accounts not only for Browne's principles of interpretation but also for much of his moral passion. Original sin itself, like Eve's fatal misunderstanding of Satan's words, began when "ænigmatical deliveries" were misconstrued by literal minds: "Your eyes shall be opened," Eve heard, without the subtext, to "discovery of your shame and proper confusion" (PE 1:24). Fallacies of one-sided reading lie at the root of "vulgar and senselesse heresies" as well as popular errors. Browne fears and loathes such tunnel vision. Historically, in modern England as well as ancient Israel, the scourge of *idolatry* haunts him, "men converting the symbolicall use of Idols into their proper worship, and receiving the representation of things as the substance and thing it selfe," so that the credulous multitude "may be made believe that any thing is God; and may be made believe there is no God at all" (PE 1:26, 29). Book 5 of the *Pseudodoxia*, "Of many things questionable as they are commonly described in Pictures," confronts such misreadings directly. Looking closely, looking twice, Browne uses his own literal mind and eye to correct the illusions of art; dolphins, for instance, are crooked in

paintings, but "in their naturall figure they are straight" (*PE* 1:370). Ultimately, however, his quarrel is with pictures themselves, insofar as they tend to make invisible essences into visible icons.[51] "The picture of the Creator, or God the Father in the shape of an old Man, is a dangerous piece, and in this fecundity of sects may revive the Anthropomorphites" (*PE* 1:429). When vulgar eyes regard such inventions as literal truths, they misplace their faith into factions that threaten both church and state. Corporeal idols stupidly shroud the spirit that cannot be seen.

The inability to comprehend more than one side is not only the source of most vulgar and common errors, according to Browne, but also the distinguishing mark of vulgar and common people. Such viewers will always be in error; though by chance they might stumble across some truth, first and last "they are incompetent judges" (*PE* 1:15). Even the title of the book suggests the writer's doubts about his readers. *Enquiries into Vulgar and Common Errors* served as the running head of editions in Browne's own time, and it also provided a subtitle in the Stationers' Register of the first edition. But it never appeared on a title page during Browne's life.[52] The original title page presents something else: *Pseudodoxia Epidemica: or, Enquiries into Very many received Tenents, And commonly presumed Truths.*[53] The Greek phrase itself would discourage vulgar and common people from coming too close to the text, or from hoping that their ignorance might be cured. "The people" are not the audience imagined by Browne, nor are they the source of the tenets he wants to correct. In fact he specifically writes for the "ingenuous Gentry" (*PE* 1:2; "ingenuous," as Johnson's *Dictionary* defines it, means "noble" or "freeborn," and the "gentry" are a "Class ... above the vulgar").[54] Browne is an unapologetic elitist: "Nor have wee addressed our penne or stile unto the people, (whom Bookes doe not redresse, and are this way incapable of reduction) but unto the knowing and leading part of Learning." Even the errors of hoi polloi are derivative, he assumes, like weeds that will wither "except they be watered from higher regions" (*PE* 1:3). Without such help from above, apparently the people would lack the wherewithal to generate their own mistakes.

This contempt for vulgar and common minds emerges from Browne's conception of truth. "For the assured truth of things is derived from the principles of knowledge, and causes, which determine their verities; whereof their uncultivated understandings, scarce holding any theory, they are but bad discerners of verity, and in the numerous tract of error, but casually do hit the point and unity of truth" (*PE* 1:15). The learned discover truth through proper theories, approximating the perfect Ideas of things in the mind of God. By contrast the common, illiterate people are slaves to their senses,

forever corrupted by appearances and original sin. "Thus the greater part of mankinde having but one eye of sence and reason, conceive the earth farre bigger than the Sun, the fixed Stars lesser then the Moone, their figures plaine, and their spaces from earth equidistant. For thus their sence enformeth them, and herein their reason cannot rectifie them, and therefore hopelesly continuing in mistakes, they live and dye in their absurdities" (*PE* 1:15). To see the sky correctly, one needs an encompassing theory.

The example is interesting here because, thanks to theory, Browne still saw the heavens largely through Ptolemy's eyes. "To make a revolution every day is the nature of the Sun, because that necessary course which God hath ordained it, from which it cannot swerve, but by a faculty from that voyce which first did give it motion" (*RM* 15–16). As Johnson points out, with post-Newtonian severity, "he never mentions the motion of the earth but with contempt and ridicule, though the opinion, which admits it, was then growing popular."[55] In many respects Browne was no advanced thinker. The basilisk and the unicorn revive in his pages. Moreover, his theory of error reserves a prominent place for Satan, who exerts himself everywhere to promote false opinions and who remains a powerful, living force in the world. Browne keeps his eye on the devil. A devout believer in witches, in 1662 he testified as an expert witness that three girls had been bewitched; and two women accused of bewitching them were hanged.[56]

Against this background, a reading of *Pseudodoxia Epidemica* throws plenty of doubt on Willey's argument that its "real drift" is to clear away the "fantastic lore" of the Middle Ages. Browne immerses himself in that lore. Did Adam and Eve have navels? Do Jews stink naturally with "an evil savour"? Will women, on Judgment Day, arise desexed?[57] Like Robert Burton, whose *Anatomy of Melancholy* (1621) kept growing like the *Pseudodoxia* in edition after edition, Browne seems arrested by every odd fact or idea. A fascination with arcana, and a fondness for many of the illusions he seeks to dispel, account for much of the charm as well as the bulk of the book. Nor have the wanderings of error decreased, for him or Burton, in modern times. The epidemic of false opinions that Browne diagnoses refers not only to some benighted past but also to a continuing plague, the corruptions brought about by skeptics and know-nothings—especially those pamphleteers whose "fruitlesse Rhapsodies" have done "not onely open injury unto learning" but "a secret treachery upon truth" (*PE* 1:53). In these new days, when instruments like the telescope and microscope have shaken Ptolemy's stars and riddled the stable surfaces of things, the wisdom of the ages must be defended. Despite his skepticism about received tenets, Browne clings to "the setled and determined order of the world" made by God. His earth does not move.[58]

Browne is by no means dogmatic. A sturdy common sense, as well as prodigious learning, informs his demolitions of folly (no, Jews do not stink, though of course they are nasty). Cutting "the great Climacterical year, that is, Sixty three" down to size, he demonstrates conclusively that its supposed effects depend on "arbitrary calculations."[59] In addition to all his book learning, moreover, he is willing to test theories through experiments and observations, in Bacon's spirit. As soon as he moves from the general causes of error, in book 1, to particular instances, in book 2, a long essay refutes the common opinion "that Crystall is nothing else, but Ice or Snow concreted" (*PE* 1:74). Good authors and good reasons argue against that opinion, but Browne goes further: among other trials, he covers glasses of water with an inch of oil in order to show that ice will not "concrete" without air.[60] Grand theories interest him less than attention to details. When he considers the weapon-salve (*Unguentum Armarium*), the "mighty principles" vouched for by advocates like Fludd impress him less than the practical virtue of keeping the wound clean: "It might be worth the experiment to try, whether the same will not ensue upon the same method of cure, by ordinary Balsams, or common vulnerary plasters" (*PE* 1:115). Browne stocks a clearinghouse of current, useful information. At times he seems carried away by the new world of knowledge, the burgeoning truth that will make posterity happy. Two fellow English physicians, Gilbert and Harvey, have brought eternal glory to the nation. In Gilbert's studies of terrestrial magnetism, "England produced the Father Philosopher, and discovered more in it, then Columbus or Americus did ever by it"; and Harvey, who discovered "the new and noble doctrine of the circulation of the blood," shines as "that ocular Philosopher, and singular discloser of truth."[61] Browne honors their explorations of the unknown.

Yet he also feels a deep sense of loss about what is passing. The war between ancients and moderns that would explode at the end of the seventeenth century brought to consciousness an anxiety about the nature of truth that already had troubled Browne. On the one hand, the seeker of truth could see its horizons expand every day. On the other, the purest truth reposed in scripture and the wise ancients, and most of the dicta that had accumulated through the centuries had covered that light with pseudodoxia—at least until recent times.[62] When Browne considers the delicate, controversial issue of whether both sexes pass their seed on to the embryo, as Lucretius had argued, or whether men alone supply the active principle of generation, as Aristotle maintained, he resorts to Genesis, not Harvey's ovist theory, to settle the case. Satan himself had inspired the Aristotelian or animalculist party: "For hereby he disparageth the fruit of the Virgin, frustrateth the fundamentall Prophesie, nor can the

seed of the woman then breake the head of the Serpent."[63] Error began with the Fall; "an invisible Agent," the devil, "playes in the darke upon us," and our own frailty tempts us to false speculations (*PE* 1:58). Hence, in the search for truth, discovery and recovery ought to be one. "The world, which took but six days to make, is like to take six thousand to make out: mean while old truths voted down begin to resume their places, and new ones arise upon us."[64]

Old truths would not surrender quietly. At the height of the war, Sir William Temple would famously argue that the ancients excelled the moderns even in science (though unfortunately the key works had been lost), and his secretary, Jonathan Swift, would satirize all modern religious sects (in *Tale of a Tub*) as blots and riders on the Father's Last Testament.[65] Such views may seem extreme, but they had long been orthodox in some fields of learning. The origins of scholarship itself are closely linked to textual editing, the effort of philologists to bring back the primal, uncorrupted written word, or perhaps even the thought or utterance that preceded writing—Homer and Socrates disentangled from scribes and Plato.[66] Similarly, etymologists tend to privilege the root of a word, as if the history of language manifested a falling away from authentic, original meaning.[67] In any case Browne is torn; false etymologies disturb him as much as foolish superstitions. If the recognition of error, from one point of view, confirms the progressive unveiling of truth, like the sun bursting forth from clouds, another perspective might show the encroachment of error on seasoned wisdom, like creepers strangling a tree.

The Rise of the Vulgar and Common

Meanwhile definitions of truth and error were shifting their grounds. The process by which *Pseudodoxia Epidemica* came to be known as *Enquiries into Vulgar and Common Errors* reflects a fundamental change in the organization of knowledge. Above all, authors began to take a new interest in what vulgar and common people actually thought. Browne, we have seen, was unpersuaded that they thought at all; "stuffed with errors," the multitude always threatened to drag their superiors down to their own blunt absence of mind. Nor was it easy for him to find evidence of what "people" believed. Though the *Pseudodoxia* records any number of errors that are "common conceits," it never once descends to any common person's opinions (I like to imagine Browne asking a servant whether Adam and Eve had navels). Written sources provide all the fodder, and illiterates by definition do not write. Yet in the course of the seventeenth century, as more and more people learned to read, print culture increasingly found room for vulgar and common opinions.

The vigorous pamphlet wars of the 1640s, at which Browne glances in his disdain for "the line of vulgaritie, and Democraticall enemies of truth" (*PE* 1:21), encouraged the barely literate to participate in the exciting and often subversive pursuit of reading. "Thomas Hobbes and Samuel Parker believed the Great Rebellion to have been 'chiefly hatched in the shops of trades-men'"[68]—booksellers most of all. This hunger for print affected the learned and unlearned alike. Moreover, not only readers but writers came from the ranks that Browne had considered outside the circle of knowledge. In 1682, the year that Browne died, John Bunyan, the meagerly educated son of a tin-ker, was by far the most popular author in England. The vulgar and common had mastered the art of passing along their vulgar and common opinions.

Hence a new kind of evidence opened vistas into the minds of "the peo-ple." Beginning with broadsides, some kinds of popular writing had always attempted to guess or calculate how plebeian audiences would respond. When Shakespeare wrote for the groundlings, he had to imagine not only the ways that rude characters would speak and act on the stage but also the ways they would be recognized by a rude public. Stephano and Trinculo outnumbered Prospero in the pit. Good playwrights knew the people for whom they wrote (if the Earl of Oxford did write the plays, at times he must have had to consult some lowly person like Shakespeare). And jest books had to know what made people laugh. But the rise of flourishing booksellers— "the trade"—in late seventeenth- and eighteenth-century Britain increased the stakes of catering to the public. A writer or businessman who could anticipate the wants of vulgar and common people could make a fortune. However much the learned might scorn a best seller like *Pilgrim's Progress*, it touched the lives of many who previously had not seen their own thoughts reflected in books.[69] At the same time, moreover, it gave erudite readers a chance to see—or think they saw—the beliefs of people with whom they might never have spoken. If Browne had been born a generation later, he might have been less ready to think that the vulgar had no minds at all.

The cause of the people was taken up with peerless energy by the first *philosophe*, the father of the Enlightenment, Pierre Bayle.[70] In the work that launched his career, *Pensées diverses sur la comète* (1683), Bayle aims at the very audience that Browne had rejected. "It is necessary to consider that here is one of those books written for the people and for those who do not make study their profession. It is known that persons of this order, not ordinarily reading much, are seeing for the first time, when they take the trouble to read a book, the most well-worn studies of which this book makes mention."[71] All works of the learned are grist for Bayle's mill, and his voracious reading consumes both ancient and modern accounts and opinions on comets. But

as a citizen of "the republic of letters" (a phrase he popularized) he comments on errors of every sort, on vulgar superstitions and scholarly blunders alike, and serves as a surrogate reader for those who lack the means to read or think for themselves. These reflections are full of mischief. When Browne touches briefly on comets, his gingerly remarks—"Whether Comets or blazing Starres be generally of such terrible effects, as elder times have conceived them, … is not absurd to doubt"[72]—remind us that some portents have biblical authority, and are not to be questioned. But Bayle is not afraid to question anything. According to him, God so detests idolatry that he cannot possibly have "made new stars glimmer in the sky from time to time in order to intimidate all the peoples of the earth and thereby to bring them without fail to all the acts of idolatry that each regarded as most appropriate to expiate their crimes." Superstition and fear, not comets, incite a credulous, frenzied mob "to sacrifice men in great quantities."[73] Readers who took such glances at idolatry, miracles, and persecution as a code for the militant arm of the Catholic Church were probably not mistaken; Bayle, a French Protestant refugee, was writing from the sanctuary of Rotterdam. But his skepticism about authority extends far beyond any settled position or sect. In his pursuit of error, learning itself goes on trial.

That pursuit culminated in the great *Historical and Critical Dictionary* (*Dictionnaire historique et critique*, 1696), a massive series of biographical essays. Here a thin line of information and narrative marches across the top of the page, while bulky footnotes below offer a perpetual commentary, both bibliographical and analytic, on the accumulated learned traditions that have encrusted knowledge with such heavy barnacles of folly.[74] Descartes had taught Bayle to doubt any dicta or dogma he could not prove for himself. Yet the pupil extended his master's suspicion of authority much further into the past, questioning historical accounts like so many contradictory and unreliable witnesses to be interrogated and broken down. In Bayle's pages truth is elusive, and even an honest witness is likely to be tainted by error; human incapacity seems still more damaging than original sin. Thus the epidemic of pseudodoxia, from an enlightened point of view, has descended through history, and makes no distinction between learned and common people.[75] Bayle's republic of letters was always already infected by fallacies, whether produced by erudite self-interest or by vulgar unconscious bias. In this respect, what a historian needed to explain was not how error had wandered away from truth but how any truth might be found.

Philosophy also was changing. The empiricist mode that began with Hobbes and Gassendi was grounded on efforts to comprehend cognition— the way that minds actually work. Thus knowledge itself depended less on

the status of facts, their absolute truth or falsehood, than on the sense impressions and memories that processed them. Even errors could prove highly instructive, because they revealed the peculiar inner workings of memory, its twists and deceptions. This put a new weight on vulgar and common ideas. The train of thought culminated in Locke. From one point of view, Tristram Shandy surely hit the nail on the head when he described *An Essay concerning Human Understanding* (1689) as "a history-book ... of what passes in a man's own mind," and went on to attribute the confusion of human beings to "dull organs, ... slight and transient impressions, ... [and] a memory like unto a sieve."[76] Had Tristram reflected on his own disastrous life and opinions, he might have gone a step further and called Locke's *Essay* a history of the *errors* that pass in a man's mind. Locke ends his book, in fact, by descending from understanding to error. "*Errour*," he claims, "is not a Fault of our Knowledge, but a Mistake of our Judgment giving Assent to that, which is not true."[77] Thus ignorance results from the tendency of the mind to cling to opinions against all probability, either through mistakes of reasoning or, far more frequently, through "*giving up our Assent to the common received Opinions*" learned in childhood and reinforced by passions or interests. Indeed, most of mankind, Locke says, "have no Thought, no Opinion at all," but merely stick to a party.[78] In this respect human understanding is not so much flawed as rare.

Thus error came into its own, in the wake of Locke's *Essay*. To guard against assent to false beliefs required new principles of education, as in *Some Thoughts concerning Education* (1693), and new ways to cultivate reason, as in Locke's last work, *Of the Conduct of the Understanding* (1706). Above all, the psychological sources of error—its logic, so to speak—began to make sense. Faults of knowledge were less important than the models and practices that guided thought. If people misconceived what they saw in the sky at night, for instance, the reason was not their slavery to sense impressions (as Browne had said) but rather their adherence to a false mental picture or episteme or gestalt. Therefore a teacher who wished to correct the error first needed to deduce the model on which it was based. The principle holds today. As studies repeatedly show, the majority of Americans do not know what causes winter and summer; they assent to the vulgar and common error that the earth is closer to the sun in the summer (except, apparently, in Australia). This is idiotic, of course, but it does have a kind of logic: a picture in the mind. And to correct it, as studies repeatedly show, simply stating the real cause will not be sufficient (a few weeks later, almost everyone will have forgotten that cause). Instead the model in the mind itself must be corrected. Locke knew that, as does every good teacher. But nothing is harder, as Locke knew and every good teacher knows.

Eighteenth-century thinkers also had trouble devising methods to straighten out errors. The problem was not so much tracking down the causes of vulgar mistakes as offering some means to avoid them. Locke is far more persuasive in showing how errors arise in the mind than in showing how reason can shield us; in view of the infinite wanderings of ideas and associations, his reliance on reason frequently seems pathetic.[79] Significantly, when Locke reaches for an example of a probability so great that no mind can resist it, the best he can do is the intelligent design of a Creator. Is it probable "that a blind fortuitous concourse of Atoms, not guided by an understanding Agent, should frequently constitute the Bodies of any Species of Animals"? "In these and the like Cases, I think, no Body that considers them, can be one jot at a stand which side to take, nor at all waver in his Assent."[80] But atomists did not agree, of course, and eventually Hume would expose the fragility of any unwavering assent to the Argument from Design.[81] Here faith masquerades as reason. Nor did later thinkers discover a better shield for the mind. By the time of *Tristram Shandy* (1759), errors—not only vulgar and common but also learned— seemed no aberration but rather the way of the world. Or as another work, published in the same year as *Tristram Shandy*, put the matter, "Perhaps, if we speak with rigorous exactness, no human mind is in its right state."[82]

Samuel Johnson's Truth

Samuel Johnson inherited and combined the perspectives of Browne and Locke. The learned traditions on which Browne drew influenced Johnson's fascination with scholarly quarrels as well as his prose, and Locke's psychological turn impressed him with the need to trace errors into the treacherous moonscape of the mind.[83] This combination was odd, in some respects. Browne's learning had made him disdain the foolishness of vulgar and common minds, while Johnson put his learning at the disposal of common readers; and the defects of understanding against which Locke had warned became the common coin of the minds that Johnson addressed. In Johnson's vision, as in Bayle's, pseudodoxia are far too prevalent to be an epidemic of any one time. Rather, they are the natural consequences of the way that all minds work, the product of that hunger of imagination which fills vacuity with misconceived atoms and shadows of meaning.[84] Hence Browne's eccentric and grand collection of errors is dumped, like so much bric-a-brac, on Locke's tabula rasa. In this regard Johnson's lifework might be defined as enquiries into vulgar and common errors. But the questions he pursues are not whether Adam and Eve had navels or whether Jews smell. Instead he keeps asking what you, dear reader, are thinking.

The *Pseudodoxia* was a work close to Johnson's heart. He quoted it frequently in the *Dictionary* (1755), and to some extent the *Dictionary* itself might be considered a supplement to Browne, since it "both displays vast stores of false opinion and seeks to explode them."[85] At one time he even thought about bringing the *Pseudodoxia* up to date, incorporating "BOYLE's and NEWTON's philosophy."[86] The foundations of knowledge required perpetual maintenance, to scrape away rust and rot. No one cared more than Johnson about rooting out error. Everyone who knew him remarked his devotion to "strict and scrupulous veracity";[87] a fanatic for truth, he will not concede that any untruth might be harmless. "No fraud is innocent," he wrote in his life of Browne, "for the confidence which makes the happiness of society, is in some degree diminished by every man, whose practice is at variance with his words" (*CM* 8). Hence readers need to be trained, not only to sniff out prevarications but also to guard against their own cast of mind when they color the truth.

Consider, for instance, the method of Johnson's short life of Browne.[88] A brief account of facts and dates provides a thread of narrative, and in accord with Johnson's principle that only those who knew a man intimately can mark the "minute peculiarities" that truly define him,[89] he quotes almost all the "minutes" by Browne's friend John Whitefoot. But most of the life consists of a subtle inquisition, anticipating—and usually disappointing—what readers will expect. Thus the opening paragraph tells us that the life has been written because "it was thought necessary to attempt the gratification of that curiosity which naturally inquires, by what peculiarities of nature or fortune eminent men have been distinguished, how uncommon attainments have been gained, and what influence learning has had on its possessors, or virtue on its teachers" (*CM* 3). Potentially this is already the stuff of satire. Although Johnson is hardly ridiculing Browne or the reader, his emphasis on curiosity about "peculiarities of nature," "uncommon attainments," and the virtue of teachers of virtue prepares us for many deflations, in which our curiosity will remain unsatisfied and our expectations of something extraordinary will come up against a man who is much like others. To presume that great authors lead wonderful lives may be quite natural, but such presumptions involve the reader in vulgar and common errors.

The urge to puncture wishful thinking runs through the life as a whole. When Browne claims that he never intended *Religio Medici* for the press, for instance, "having composed it only for his own exercise and entertainment," Johnson is very suspicious. "There is, surely, some reason to doubt the truth of the complaint so frequently made of surreptitious editions.... This is a stratagem, by which an author panting for fame, and yet afraid of seeming

to challenge it, may at once gratify his vanity, and preserve the appearance of modesty; may enter the lists, and secure a retreat" (*CM* 7–8); and such devices, Johnson concludes, are frauds that deceive the public. Similarly, the published debates between Browne and Sir Kenelm Digby, who flatter each other's faces and stab each other's backs, coauthor a fraud: "The reciprocal civility of authors is one of the most risible scenes in the farce of life."[90]

The passage that strikes Johnson most in Browne's writings inspires a skeptical reaction: "What most awakens curiosity, is his solemn assertion, that 'His life has been a miracle of thirty years; which to relate, were not history but a piece of poetry, and would sound like a fable'" (*CM* 11–12). Remarkably Johnson's quotation omits three crucial words: "would sound *to common eares* like a fable."[91] But "common eares" are exactly the issue; they must be protected from false inferences. Johnson, the champion of the common reader, cannot allow his readers to fall into error.[92] With ruthless literal-mindedness he challenges Browne's self-glorification. "There is, undoubtedly, a sense, in which all life is miraculous; ... but life, thus explained, whatever it may have of miracle, will have nothing of fable; and, therefore, the author undoubtedly had regard to something, by which he imagined himself distinguished from the rest of mankind" (*CM* 12). What can that have been? Browne's life in fact seems quite uneventful.

> What it was, that would, if it was related, sound so poetical and fabulous, we are left to guess; I believe, without hope of guessing rightly. The wonders probably were transacted in his own mind: self-love, cooperating with an imagination vigorous and fertile as that of Browne, will find or make objects of astonishment in every man's life: and, perhaps, there is no human being, however hid in the crowd from the observation of his fellow-mortals, who, if he has leisure and disposition to recollect his own thoughts and actions, will not conclude his life in some sort a miracle, and imagine himself distinguished from all the rest of his species by many discriminations of nature or of fortune. (*CM* 12–13)

Browne, like the astronomer in *Rasselas* who fancied that the weather obeyed his commands, thought himself specially chosen.[93] So do the rest of us, when we are lost in our own minds. But that way lies madness.

When Browne wrote that the miracle of his life "would sound to common eares like a fable," he was deliberately parting company with the mass of mankind. "The world that I regard is my selfe, it is the Microcosme of mine own frame, that I cast mine eye on"; and "Men that look upon my outside, perusing onely my condition, and fortunes, do erre in my altitude; for I am

above *Atlas* his shoulders" (*RM* 70). Here deuteroscopy reaches its peak. Taking a second look at himself, the amphibious Browne perceives that his corporeal existence or "masse of flesh" cannot circumscribe "the heavenly and celestial part" within him. Exalted in spirit, the writer towers above the sublunary world where vulgar and common people live their lives and fall into their petty errors. But Johnson brings him abruptly down to earth, and insists on conflating Browne's sense of revelation about his life with the factual record. To the literal-minded reader, the person who gazes into himself and the person seen by the world must ultimately be one. Browne himself might have thought such a reading a vulgar and common error. But Johnson will not permit imagination to set the terms of truth. Despite his admiration for Browne's remarkable learning and singular eloquence, he insists on reducing him to human size, on naturalizing or normalizing whatever might seem exceptional in his career. The otherworldly and superhuman are suspect; they feed the pride of error.[94]

Browne's story, as Johnson tells it, has few surprises. It is instructive precisely because the great man shares the common lot. By running together the reader's expectations about a miraculous life and the subject's claim to have led a miraculous life, the biography erases distinctions between high and low fellow mortals. No one is exempt from error. If Browne's life *had* been a miracle, it might have discouraged readers, bowed in the shadow of Atlas. What counts most finally, for Johnson and many others in his age, is not greatness but goodness. Browne was a good man, and a good Christian, and even if very few readers can aspire to his superabundant learning, everyone can respond to his passionate faith. Whatever we might have expected from the life, in the end it brings us back to ourselves. All of us, common and learned alike, stray from the one straight way, and our stories and errors at last are the same.

Johnson's domestication of error, his insistence that vulgar and learned fallacies do not differ *in kind*, represents only one historical moment. Soon error would veer off in other directions: for instance, the romantic creed, contra Johnson, that a man of genius like Shakespeare or Browne has power to transform any seeming error into a higher truth. But that moment also passed. As the world expanded and Western scholars grew better acquainted with other religions and cultures, belief in one unalterable truth became increasingly difficult to sustain. A new relativism, supported by findings in anthropology and biology as well as by explorations of the mind, eroded firm distinctions between what was universally valid and what might be right or wrong only in particular circumstances. Gradually the authority to judge truth and error in factual matters passed to natural history and natural philosophy, or what

now was called "science." Yet such authority is far from unproblematic. Even those scientists who reject Karl Popper's insight that falsifiability, not verification, is the criterion that differentiates science from pseudoscience tend to agree that theories keep changing and that the absolute truth about things may never be known.[95] Moreover, the burgeoning specialization of knowledge long ago sunk everyone, outside a few experts, in vulgar and common misunderstandings of science. Error is widely available, and truth must be sought in rare places, on a high hill or in a deep well, as the ancients said, where few people go.

Yet Johnson's revision of Browne still has some currency; it marks a turning point in attitudes toward error. When vulgar and common people were admitted to the social order of those who distinguish truth from error, they changed the basis of that distinction. Henceforth the health and functioning of the community would be the crucial issue. Johnson insists on the social *necessity* of telling the truth. On more than one occasion he borrowed a dictum from the *Pseudodoxia*: "The devils do not tell lies to one another; for truth is necessary to all societies; nor can the society of hell subsist without it."[96] Browne emphasizes the malignity of Satan, who twists truth into evil. But the need for people to trust one another is Johnson's essential point. In this respect the wanderings of error disastrously loosen the ties that bind society together. Mutual trust, though vulnerable to every liar and cheat, is all that safeguards each human being against a Hobbesian world of isolation and fear.[97] That is why Johnson cares so much about rooting out error.

Nevertheless, the harrow of truth has hardly retarded the fertile dissemination of error. Most people tend to believe what they want to believe; new classics of pseudodoxia, like *Protocols of the Elders of Zion*, spring up wherever they serve the interests of some party. Nor have recent techniques of communication succeeded in fostering trust. An optimist might point out that the amount of information has multiplied exponentially from each age to the next, but a pessimist, browsing the Web, might argue that the proportion of error to truth has remained more or less constant. Bacon's ideal of open daylight still proves elusive. And even today, at this very moment of writing and reading and texting, all of us are contributing, no doubt, not only to the advancement of learning but also to new histories of error. The epidemic continues. Yet even in hell, as Browne and Johnson contend, some modicum of truth survives, preserving just enough trust to enable devils—or people—to work together. Even a wanderer sometimes needs to come home.

The Century of Genius (1)

Measuring Up

The Otherness of Newton

In the preface to his monumental biography of Isaac Newton, *Never at Rest*, Richard S. Westfall deliberately stands apart not only from Newton but also from Samuel Johnson. A faithful narrative of any life can be useful, according to *Rambler* 60, because a common humanity unites us, so that we recognize ourselves in other people. "We are all prompted by the same motives, all deceived by the same fallacies, all animated by hope, obstructed by danger, entangled by desire, and seduced by pleasure."[1] Yet after more than twenty years of study Westfall can find no way to measure himself against Newton. "He has become for me wholly other, one of the tiny handful of supreme geniuses who have shaped the category of the human intellect, a man not finally reducible to the criteria by which we comprehend our fellow beings, those parallel circumstances of Dr. Johnson."[2] Newton seems more, or other, than human, a genius who at once defines and goes beyond the bounds of intellect.

He is not like us, he belongs to another species. Westfall's sense of Newton's irreducible otherness repeats a view already well established in Newton's own time. It was fixed forever by the Latin ode with which Edmond Halley introduced the *Principia* in 1687:

Arise, ye mortals, put aside earthly cares;
And from this recognize the force of a heaven-born mind,

From the life of the herd far and away removed....
Nor can any mortal come closer to touching the gods.[3]

Halley concedes that Newton is (just barely) a mortal. But the imagery of his ode draws freely on Lucretius' famous set of tributes to Epicurus in *De rerum natura*, which insists that its hero must be considered a god whose genius "surpassed the human race" (*qui genus humanum ingenio superavit*); and the same Latin phrase was later used to underwrite Roubiliac's heroic statue of Newton in the chapel of Trinity College, Cambridge.[4] Nor did other poets hesitate to call the great man "godlike." In an age when an "insuperable line, / The nice barrier 'twixt human and divine," barred mortals from rising higher in the Great Chain of Being, Newton alone ascended.[5] During his lifetime he was known as "the Genius of England," and after his death in 1727 no eulogist failed to note that he had already made one with the immortals whom he now joined. His place was high above, on earth as in heaven.

That reverence has never entirely faded. To be sure, modern scholars understand that "faults Newton had in abundance," not only as a person but as a thinker.[6] Westfall is not too intimidated to expose his demigod's scientific miscalculations as well as his petty grudges. But those are merely human faults, which qualify but do not shrink his superhuman stature. Most educated people, and also many with little education, still think of Newton as the type of an unsurpassed genius. In the words of a popular biography, he "discovered more of the essential core of human knowledge than anyone before or after. He was chief architect of the modern world."[7] Even Einstein, his sole competitor in the pantheon of scientific immortals, bowed down to his preeminence, perhaps with a touch of envy: "Fortunate Newton, happy childhood of science! ... Nature to him was an open book, whose letters he could read without effort. ... In one person he combined the experimenter, the theorist, the mechanic and, not least, the artist in exposition. He stands before us strong, certain, and alone."[8] Long after Newton's times and troubles have been forgotten, Einstein concludes, his great works remain. We can hardly imagine what the world might have been without him.

Einstein's praise draws on his own authority. Unlike Westfall, he conveys fellow feeling with Newton, through the brotherhood of solitary geniuses, and his admiration reflects a particular way of thinking about the Scientific Revolution and the history of science. That history, from his perspective, charts a progressive series of discoveries, or readings of the Book of Nature, and it is driven by a handful of great minds whose works and names furnish its chapters. Galileo, Descartes, and Newton, along with a select society of perhaps a dozen more, are Einstein's fathers and brothers. Moreover,

the public tends to share this point of view. Even a reader who does not understand what those great minds accomplished can grasp that their ideas changed the world.

Today, when many historians decisively reject historical narratives shaped around the lives of a few great men—"The lengthened shadow of a man / Is history, said Emerson"[9]—a similar narrative about the history of science might seem naive. But science, unlike most other human activities, can be regarded as a search for progressively better ideas or even for the true nature of things. "The history of science," according to Georges Canguilhem, "is the explicit, theoretical recognition of the fact that the sciences are critical, progressive discourses for determining what aspects of experience must be taken as real";[10] and it is not naive (though it may be mistaken) to credit some critical ideas to the particular minds that first conceived them, or to follow the development and modification of ideas through the relatively few minds that comprehended their implications and quarreled most deeply with them.[11] The calculus, which marks a period in the history of science, was first confined to the private thoughts of Newton and Leibniz, each of whom later believed that the other must have read his mind—or more likely his notes.[12] More positively, one might say, Einstein had to enter Newton's mind in order to go beyond it. This version of history follows great leaps forward; a giant mounts the shoulders of other giants.

The essential role of genius is so engrained in the history of science that even historians who resist the tide of progress have usually organized their narratives around dramatic breakthroughs. Thus A. N. Whitehead, whose influential *Science and the Modern World* (1925) warned that the triumphs of scientific materialism might be undermining the values by which most human beings have lived, finds the turning point in "the century of genius." Ever since then the European races "have been living upon the accumulated capital of ideas provided for them by the genius of the seventeenth century. The men of this epoch inherited a ferment of ideas attendant upon the historical revolt of the sixteenth century, and they bequeathed formed systems of thought touching every aspect of human life. It is the one century which consistently, and throughout the whole range of human activities, provided intellectual genius adequate for the greatness of its occasions."[13] A dozen names stand for the era as a whole: Francis Bacon, Harvey, Kepler, Galileo, Descartes, Pascal, Huygens, Boyle, Newton, Locke, Spinoza, Leibniz. And though Whitehead knows that his list is not exhaustive, the story he tells depends on the agency of a chosen few, those natural philosophers whose insights forever changed conceptions of nature. For him the culminating figure of the century is Newton, whose laws made possible the future

development of astronomy, engineering, and physics—indeed the modern world. His genius for abstract thought would succeed most of all in reducing nature to a version of his own mathematical schemes.[14]

The power of this narrative draws strength from many sources. First, it is simple. Like other stories, the history of scientific ideas comes alive when stocked with interesting characters, especially those we can look up to. The story of Newton and the apple—which he himself enjoyed telling—appeals to the imagination because it combines something ordinary, which anyone can recognize, with something extraordinary: a perception that no one had ever had before.[15] And even someone who, like most people, misses the point that Newton eventually grasped—not that apples fall, but that they obey the same law that holds the moon in place, since the mass of the earth attracts them and they reciprocally attract the earth—can appreciate the sudden shock of recognition. The identification of scientific discoveries with specific moments and persons oversimplifies but also humanizes the difficult operations of science. Moreover, it provides the history of science with a convenient principle of organization: the index. Histories may come and go, and vary with the assumptions and fashions and theories that shape them, but the great *Dictionary of Scientific Biography*, no matter how many editions it goes through, will always have a place for Isaac Newton. The number of pages devoted to him offers rough quantitative evidence of the size of his genius, and the narrative of his emergence from obscurity to fame and glory corroborates the importance of his work. In this way his life is a symbol: it represents the triumphant career of science itself.

The century of genius also affords the sense of an ending, with its mission accomplished. That is a second reason for centering history on Newton's insights. The "Great Tradition" of the history of science invokes an irresistible teleology, in which a series of geniuses, Galileo, Kepler, and Descartes (building on hints from Copernicus), formulate preliminary laws that eventually reach their ordained end in Newton's cosmic synthesis.[16] Many of Newton's own contemporaries subscribed to this view. As soon as the *Principia* appeared, Halley's ode announced that now we know "the immovable order of things / And the world concealed from former generations"; and when the great genius died in 1727, his mourners could rejoice that he had left "an universe complete!"[17] The monument erected near Newton's grave in Westminster Abbey congratulates the human race for having produced him, and Alexander Pope designed a dazzling epitaph for it: "Nature, and Nature's Laws lay hid in Night. / God said, *Let Newton be!* And All was *Light*."[18] Here the natural philosopher himself participates in the *fiat lux*, not only the primal light created by God but now an intellectual light as

well, thanks to the *Principia* and *Opticks*. God manifests intelligent design by conceiving Newton, a secondary Word, born as it happened on Christmas Day 1642, who comprehends God's plan. An iconoclast might point out that Newton's own revolutionary analysis of the light of the sun—that it is a heterogeneous mixture of differently refrangible rays—suggests by analogy that scientific illuminations result from the mingled insights of many minds, not from a single perfect source. Nor were Nature's laws thoroughly dark in the time of Galileo, Kepler, and Descartes, before the coming of Newton. Yet Pope's hyperbole expresses his confidence and satisfaction that nature has been shown to be intelligible, not only potentially but also by demonstration and verification. Future philosophers will merely fill in the details.

Nationalism also contributes to the celebration of genius. Civic pride, or chauvinism, supplies a third motive for focusing on indigenous greatness. In death as in life, James Thomson contended, Newton was "Britain's boast!," uniquely suited to inspire her youth: "O'er thy dejected country chief preside, / And be her Genius called!"[19] A tutelary deity, the spirit of the departed hero is appointed to watch over Britain, as Milton commissioned Lycidas to be "the Genius of the shore." Yet another meaning of "Genius" colors the passage: Newton's remarkable mind not only marks him as the first of Britons but also stands for the intellectual power of his nation when it is at its best—the envy of other nations. Although his discoveries now belong to the world, he lends special pride to the country he represents. "In Newton," David Hume wrote, "this island may boast of having produced the greatest and rarest genius that ever rose for the ornament and instruction of the species."[20] Other nations did not acknowledge this supremacy so quickly, in fact. In France, Descartes would long remain the epitome of a natural philosopher, nor were the countrymen of Galileo and Huygens so ready to concede that the British genius came first (though Germans did not unite around Kepler and Leibniz).[21] Voltaire wryly observed that when he traveled from Paris to London, he found that "the very essence of things has totally changed"; for instance, in Paris "light exists in the air," in London "it comes from the sun in six and a half minutes."[22] In Italy, still haunted by the fate of Galileo, the sun continued to circle the earth, at least in print, though privately astronomers knew better. Obviously some scientific perspectives are fostered by specific habitats or languages; when Galileo, Descartes, and Newton wrote accessible texts in the vernacular rather than Latin, they helped to bring the Scientific Revolution home. In any case the genius of such natural philosophers proved able to fill the role accorded in the past to warriors, rulers, and writers, as shining examples or myths of national greatness. Knowing that Newton was British increased, somehow, the patriot's self-esteem.

All the same, hardly anyone could understand him. Not only the general public but also good mathematicians confessed that Newton baffled and outstripped them.[23] Obscurity on this scale shadowed forth a kind of grandeur. The profundity or even incomprehensibility of the *Principia*, as later of Einstein's theories, confirmed that its genius occupied a separate sphere, outside the reach of groundlings. That is a fourth source of attraction to Newton's story; it was a mystery as well as a revelation.[24] To some extent it even had to be taken on faith. John Locke, deficient in geometry, "asked Mr. *Huygens*, whether all the mathematical *Propositions* in Sir *Isaac's Principia* were true, and being told he might depend upon their Certainty; he took them for granted, and carefully examined the Reasonings and *Corollaries* drawn from them, became Master of all the Physicks, and was fully convinc'd of the great Discoveries contain'd in that Book."[25] That effort pleased Newton, who liked to think that his methods and principles could reach beyond mathematicians—a notion that Locke himself supported in *An Essay concerning Human Understanding* and *Some Thoughts concerning Education*.[26] The two men became good friends and together pursued common interests in alchemy and theology.[27] But those were dangerous, secret studies, closed to the public. Newton could not afford to reveal his Arian, anti-Trinitarian convictions, which would have disqualified him for his Cambridge fellowship and later his appointment as warden and then master of the Mint. It was safer for him to cultivate the image of a reclusive, awe-inspiring sage, a sort of benign Dr. Faustus, whose thoughts were unfathomable. During Newton's long lifetime, it has been argued, the sense of wonder that had spurred inquiries into nature began to be replaced by an emphasis on the regularity and uniformity of natural laws.[28] The rule, not the exception, became the favored object of investigation. Yet Newton's mind itself proved a fresh source of wonder. Like the Revelation of John that so obsessed him, it seemed to hold a cryptic key to the future; and lesser minds could only struggle to follow his track to the stars.[29]

These stories are very compelling. Yet even in their own terms, as narratives or imaginative constructions, they raise doubts that are far from easy to quell. Two questions in particular demand attention. The first might be posed quite bluntly: even if Whitehead's handful of geniuses had never lived, would not the Scientific Revolution have happened in much the same way? Surely someone else would have discovered the moons of Jupiter, the elliptical orbits of the planets, the calculus, the law of gravity. All these discoveries were contested, in fact, by rival claimants, and the slow process by which the claims were sorted out might have proceeded more quickly without the egos and competitive instincts of great men. In any given age, ideas are in the air, not only in the minds of individuals. Whether one thinks that the Scientific

Revolution (if such a thing ever existed) resulted from paradigm shifts in a disciplinary matrix—that is, ideas shared by a community of specialists—or from changing social practices that shaped new kinds and definitions of knowledge, or from new philosophical, theological, and cultural issues and programs, or from expansion of the known world by chance discoveries (made possible by voyages and telescopes), or from any other set of circumstances, individual genius fades into the background. Perhaps it should stay there. The stories of exceptional men can be a distraction from the heterogeneous, collaborative activities out of which the history of science gradually emerges.

A second question challenges the very basis of such stories. Just what *is* genius? The meaning of that word cannot be taken for granted; it has shifted again and again, responding to different definitions of human nature. Over the course of Newton's life (1642–1727) the denotations and connotations of "genius" dramatically changed. Originally the word, whose root is Latin *genere*, "to beget," had signified a god who presided over the birth of some potentially remarkable person. In this respect it seems external to that person, not part of his or her essence; for example, one might speak of the good or evil geniuses who struggle over someone's soul. But more commonly, in the seventeenth century, "genius" referred to an inborn faculty or special talent.[30] Thus Newton *had* a genius for mathematics. This phrasing still suggests an accessory to the essential person, a gift bestowed. But eventually the word defined the person himself: contemporaries declared that Newton *was* a genius. Extraordinary mental power or pure intelligence was not a mere attribute of such a man, but his innermost self or birthright. By the mid-eighteenth century, when Johnson adjudicated the meanings of words, that sense of "genius" prevailed. The *Dictionary* (1755) includes the older definitions, but centers on "a man endowed with superiour faculties" or "mental power." And elsewhere Johnson sets aside "that particular designation of mind, and propensity for some certain science or employment, which is commonly called Genius. The true Genius is a mind of large general powers, accidentally determined to some particular direction."[31] To prove his point that a genius commands more mind than others, not simply a special aptitude, he chose an inevitable example: "I am persuaded that, had Sir Isaac Newton applied to poetry, he would have made a very fine epick poem."[32] In that event some other great man would have had to consummate the Scientific Revolution.

More important, competing definitions of "genius" upset the clear line of the story. Even Whitehead's "century of genius" depends on an equivocation: is its genius some presiding spirit of the age, the expression of ideas whose time has come, or does the distinction of the century stem from the presence of an unusual number of great individual minds? A good deal

hangs on the answer, since Whitehead's narrative is fashioned as a tragedy in which the modern world succumbs to scientific abstractions. Rhetorically his language often implies that "the genius of the epoch," itself an abstraction, produces and disseminates abstractions in its own image. But at other times he recognizes that individual geniuses are not confined to the common beliefs of their epochs, and that they might always depart from the general pattern he sees. In that case perhaps the modern world might still be saved from its fate through the efforts of great thinkers who resist the lure of science, and who refuse to be absorbed by any abstract spirit of the age. The final paragraph of Whitehead's book strives to rewrite the "tale" or "great adventure in the region of thought" that he has spun; he calls for "a renewed exercise of the creative imagination." The power of imagination, combined with reason, might yet reshape the future. In the long run, tyrants and conquerors are insignificant, "compared to the entire transformation of human habits and human mentality produced by the long line of men of thought from Thales to the present day, men individually powerless, but ultimately the rulers of the world."[33] For Whitehead, the only defense against the genius of the age is genius.

Yet the questions that counter the story of genius cannot be cast aside. Does the Scientific Revolution really depend on individuals, the insights of a few great men? And what does genius mean? Too many histories of science have built their narratives on facile answers to such questions, or on no answers at all. Perhaps that represents a failure of imagination. As soon as the questions are asked in earnest, they provoke quite other ways of imagining the revolution in thought, both as it appeared at the time and as it has been conceived ever since. It might prove worthwhile to take a fresh look at the stakes and the meanings of genius.

Challenging Genius: Copernicus, Tycho

In the beginning, Copernicus made the earth move. Whether or not the story of the Scientific Revolution still rings true, the story of the Copernican Revolution seems fixed in its orbit. Before the publication of *De Revolutionibus Orbium Cœlestium* in 1543, the sun, the planets, and the stars revolved around the earth, according to astronomers; afterward, in the course of a century of new calculations, our solar system was born, with the sun at its center; and finally Newton's universe confirmed the new astronomy. To be sure, one may question the phrase "Copernican Revolution." The full title of Thomas Kuhn's historic study, *The Copernican Revolution: Planetary Astronomy in the Development of Western Thought* (1957), anticipates the broader story that

he tells, encompassing three distinct meanings of the revolution: a reform in astronomical theory; some "radical alterations in man's understanding of nature," affecting many other sciences; and a focus on the "tremendous controversies in religion, in philosophy, and in social theory, which ... set the tenor of the modern mind."[34] Yet all these meanings originate in the work of one man, who gave the revolution, or revolutions, his name.

Does Copernicus really deserve to have so many meanings attached to his name? In some ways the designation seems very peculiar. The man himself could hardly have imagined his findings would reach so far. At the end of a life he had spent largely as a canon of the cathedral in Frombork (or Frauenburg), a city in northern Poland that he called "a very remote corner of the earth,"[35] he was prepared to die in obscurity, without exposing his work to public notice and charges of heresy. But decades earlier he had drafted a "Little Commentary" (*Commentariolus*, 1514 [?]) postulating that the earth moved around the sun, and he had made a few handwritten copies.[36] Slowly word of his ideas spread. In 1539 an enthusiastic young German astronomer, Georg Joachim Rheticus, pursued Copernicus to Frombork, became his disciple, published *A First Account* of the Copernican system, pushed him to finish his manuscript, and eventually brought *De Revolutionibus* to the press (1543). Even then caution prevailed. Copernicus himself supplied a defensive preface to the pope in which he claimed that he was only doing his duty as a mathematician: the blunders of earlier mathematicians had forced him to devise a better, more orderly system of astronomy in order to correct the ecclesiastical calendar. Worse was to come. When the book was published, Andreas Osiander, a Lutheran theologian and amateur mathematician whom Rheticus had trusted to look after the printing, inserted an unsigned, sanctimonious introduction that advised the reader that the work need not be taken too seriously, since it consisted merely of hypotheses.[37] Thus the revolution entered the world on tiptoe. In the event, its author did not have to fear its reception; he suffered a stroke and died as soon as the book appeared.

De Revolutionibus did not create an immediate stir, nor was it easy to read. Nevertheless it circulated.[38] Copernicus was a respected astronomer, and other astronomers admired his mathematical techniques and careful calculations. Although very few at first accepted the heliocentric thesis, they could not do without the astronomical tables he made possible.[39] He was "a second Ptolemy." Yet even that praise suggests the limitations of his achievement. Aside from the idea of a moving earth—an idea, he assured the pope, that he had found in many ancient authorities—his work seems relatively traditional, much closer to Ptolemy than to Kepler. As a proud mathematician, he believed or hoped that he had reformed the blatant inaccuracies of

conventional earth-centered systems, which had put together a "monster."[40] But his own system adopted the uniform circular motions and harmonious celestial spheres of the Aristotelian cosmos. In almost every way, as Kuhn has shown, *De Revolutionibus* fails to imagine the consequences of its transfiguring thesis.[41] Copernicus did not belong to the revolution he founded.

Nor was he, by most standards, himself a genius. Undeniably he was learned, painstaking, and gifted; and he certainly had a genius for mathematics. But without the energy and encouragement of Rheticus, his one disciple, he would probably have forever remained a mere footnote in the history of science—"no Rheticus, no Copernicus."[42] He did not foresee the challenging questions and answers that others would later extract from his work; he did not enlarge the universe or perceive that the sun was a star. Even his computations derive from Ptolemy's faulty latitude theory of the planets, and they are no more accurate than Ptolemy's in predicting planetary motions.[43] Copernicus lacked vision. Unlike his great successors, he seems to have had almost no sense that mathematical astronomy might correspond to what actually went on in the heavens. Only in one respect might he be considered a genius: "The highest praise of genius is original invention."[44] One great idea—not so much that the earth moved as that mathematics could *show* that it moved—brought Copernicus that high praise. Yet in general his power of invention was slight. One moral of his story might be that genius consists of what others make of it, in a collaborative, not an individual, effort. Another moral might be that genius depends on having the right disciple.

Each of those morals is tested by the next astronomer who is often labeled a genius, the stellar Tycho Brahe. In contrast to the retiring Copernicus, Tycho displayed all the trappings of greatness. A Danish aristocrat, he was brought up to serve his king and lead his country; and eventually, world renowned, he was treated with deference by an emperor as well as a king and rewarded with power such as no other astronomer had ever enjoyed. For more than twenty years, from 1576 to 1597, the land and people of the fabled island of Hven, near Copenhagen, belonged to him and his projects. When that dispensation soured, the Hapsburg emperor Rudolf II promised to underwrite his work and gave him a castle.[45] But Tycho's greatness was not restricted to worldly honors. A coherent story of the astronomical revolution might well be centered on him, displacing Copernicus. It was Tycho, for instance, who shattered forever the ancient crystalline spheres. His first book, *De Nova Stelle* (1573), demonstrated through observations of unprecedented accuracy that the bright light that had suddenly appeared in the heavens in November 1572 was both unmoving and incredibly distant—a new star (*nova*) in the realm of fixed stars, where supposedly nothing could

ever change and nothing new could happen. Later he proved that comets also went their own way in space beyond the moon, unimpeded by spheres. And ultimately the "Tychonic system" he invented, a forced wedding of Ptolemy and Copernicus in which the sun and moon circle the earth while the other planets circle the sun, discarded the spheres that Copernicus had accepted.

Most of all, Tycho looked at the heavens. Copernicus, like every other early astronomer, had based his calculations on very crude data, on rough approximations and charts only slightly improved since ancient times. Tycho refused to be content with such venerable inaccuracy. Uraniborg, the majestic observatory he built on Hven, was packed with elegant, prodigious instruments that he designed, the best the world had ever seen: a great mural quadrant fitted to a wall, a massive sextant, a giant celestial globe, a towering equatorial armillary positioned in an amphitheater, and many more.[46] But more important still, Tycho knew how to use them. Not only did he refine and calibrate his instruments until they tracked the planets and the stars with unexampled precision; he also registered what he saw at different times, observing the ever-changing configurations of the sky. The Atlas of the new astronomy, he bore the heavens on his shoulders.[47] Henceforth every cosmological theory would have to come to terms with his data. After he died in 1601, those data took on a life of their own. Johannes Kepler, entrusted and burdened with carrying through his master's project, would be their slave for more than twenty-five years, until the *Rudolfine Tables* were finally published in 1627; Tycho's name headed the title page, which called him the phoenix from whose ashes the work had sprung.[48] His great naked eye, his genius for observation, had redrawn the map of the sky.

Yet the new astronomy did not bear Tycho's name. Three circumstances beyond his control worked against the legacy he had hoped to leave. The first was the invention of the telescope. Eight years after Tycho's death, when Galileo turned his new spyglass toward the sky, the days and nights of naked-eye observation were suddenly numbered. The excellent data preserved by the *Rudolfine Tables* would remain valuable long after the secrets of the heavens began to yield to lenses more powerful than the eye; but even unskilled and impatient observers could now see a swarm of new moons and stars. By an irony of fate, the greatest of all designers of astronomical instruments, whose sightings had surpassed those of thousands of years, was soon himself eclipsed by relatively modest instruments. That was Tycho's peculiar misfortune.

Second, he turned out to have the wrong disciple. Rheticus had been so devoted to Copernicus and his system that he had made the world take notice. But Tycho and Kepler did not see eye to eye. Late in Tycho's life,

when he realized that someone else would have to carry on his work, he recognized that the talents of Kepler, a recent acquaintance, far surpassed those of Longomontanus and other assistants he might have preferred as successors.[49] But Tycho, reluctant to share his precious data, did not treat the younger man as an equal, nor did he succeed in converting him to the Tychonic system. Kepler had many theories of his own, and he wanted his master's data, not his ideas. When he reported the last words that Tycho kept addressing to him—"Let me not seem to have lived in vain"—he failed to offer any response, to acquiesce or console. Eight years later, in *Astronomia Nova*, he notes that immediately after their first meeting "I begged the master to allow me to make use of the observations in my own manner," but that Tycho put him off and "on his death bed asked me, whom he knew to be of the Copernican persuasion, that I demonstrate everything in his hypothesis."[50] In the event, the book mounts a devastating critique of that hypothesis; it ensures that Tycho, as a theorist, had indeed lived in vain.

The third, decisive reason why Tycho's system did not supplant Copernicus's, of course, is that it turned out to be mistaken. In the short term, it proved quite adequate at predicting the positions of the planets, and a majority of astronomers preferred its compromise with Ptolemy to the more radical heliocentric thesis. But in the long run Kepler's analysis could not be resisted. Ironically, the vindication of Tycho's data in the *Rudolfine Tables* was accompanied by Kepler's Copernican demonstrations, and by a further irony almost all of Tycho's discoveries fed Copernicanism by showing that Ptolemy needed to be replaced. In some respects, in fact, Tycho contributed more to the fall of geocentrism than all his predecessors had done, including the timid Copernicus. Yet his genius for observation, and still more for seeing through the fallacies of the old systems and crystalline spheres, could not rival the power of one idea, whose ramifications went far beyond what any one mind could conceive. The genius of the Copernican system endured, and it left Tycho's personal genius in the shade.

Collectively, these circumstances—the telescope, the reluctant disciple, the cosmic idea that did not work out—reduced Tycho's role in history to subordinate status. The future would recognize his undeniable greatness, but he would not be the protagonist of its grand story, the astronomical revolution that could not have happened without him. Such stories are driven by their last acts; they shamelessly follow the line of the lucky winner. Nor can that destiny be controlled by even the shrewdest management of a career. Tycho possessed, or manufactured, every advantage. In addition to his high social rank and powerful allies, he knew just how to make himself into a legend. His correspondents included nobles and courtiers as well as leading authors and

scholars, and he circulated his astronomical ideas by publishing (on his own printing press) one book that features his exchanges with a prince, Landgrave Wilhelm IV of Hesse-Kassel, and another book that interweaves an account of his career with descriptions and illustrations of his lifework, especially those awe-inspiring instruments.[51] These books were given to prominent patrons of the arts and sciences, in elegant presentation copies. Tycho had mastered not only the heavens but also the media of his time, and its channels for spreading fame. But times and the heavens were changing, and they were not on his side.

Nor did his eminence sustain a sovereign place in history. In a curious way, Tycho's brilliant career and artful maneuvers may well have diminished his standing as a genius. Adam Mosley's account of the Danish Atlas directly challenges "traditional grand narratives such as the 'Astronomical' or 'Copernican Revolution'" that focus on "a sequence of great individuals"; and it offers abundant evidence to justify a different kind of narrative, a history of communication that represents the *culture* of science. "In the final analysis," Mosley argues, even Tycho "was only one astronomer among many," and a better history would trace the practices of the astronomical community as a whole.[52] Whatever the merits of this argument, however, the example of Tycho also shows the limited reach of such communities. Mastery of cultural practices failed to preserve a perishable Tychonic system; soon Atlas shrugged, and Uraniborg crumbled.[53] Stories of genius tend to favor the lonely, isolated figure who struggles against communities that persecute or ignore him. It is not the worldly success of Galileo the courtier that holds the imagination, but rather the stubborn, imprisoned victim of dogma. Similarly, the self-abasing and troubled Kepler makes a better hero than lordly Tycho. The frontispiece of the *Rudolfine Tables*, described in chapter 3, covertly implies that reversal of fortunes: Tycho commands the stage, but Kepler underwrites and undermines it. The genius grasps the whole scene in which others are merely playing their parts, and he knows that his own time will come. A subversive moral deflates the picture of Tycho: an inclination to stand outside communities and shatter their codes is precisely the mark of genius.

Francis Bacon: The Genius of Tools

Nevertheless, no plausible history of science can ignore the contexts and practices that both provoke and enable individual efforts. Tycho relied on instruments that other people had invented; and better instruments scaled down what he had done. Genius, according to Johnson, cannot be *all*, but only a *part*. "Genius is nothing more than knowing the use of tools; but there must

be tools for it to use: a man who has spent all his life in this room will give a very poor account of what is contained in the next."[54] The Scientific Revolution was built with tools. Most leading natural philosophers, like Galileo and Descartes, were mechanically minded. They understood how to borrow and make and use tools, how to put together telescopes and pendulums and air pumps and houses. Despite their well-publicized differences, Robert Hooke and Isaac Newton were kindred spirits in one respect, their fabulous inborn knack for devising and building contraptions. Genius guided their hands as well as their minds. While still a boy, Hooke fashioned a model warship with tiny guns that fired; in middle age, while serving as curator of experiments and all-purpose mechanic of the Royal Society, he also found time to help rebuild London, not only designing buildings but also supervising their construction.[55] Newton the schoolboy was locally famous for "strange inventions," including numerous sundials and a toy mill run by a mouse; in his twenties he became internationally famous for the reflecting telescope he invented, grinding the mirror himself with novel techniques. When asked where he got his tools, he "said he made them himself & laughing added if I had staid for other people to make my tools & things for me, I had never made anything of it."[56] Imagining what tools might be, imagining what tools might find, constitutes an essential part of seventeenth-century genius.

Francis Bacon was not so good at making things. Yet more than anyone else he insisted that not even the greatest mind could accomplish much without tools. "If men really tackled work for machines with their bare hands, and without the help and force of instruments, in the same way as they have not hesitated to undertake work for the intellect with little besides the native force of the mind, there would have been very few things which they could have got going or mastered." Bacon doubts the efficacy of genius. For aeons the theories of Aristotle and Plato had dominated lesser minds, as they continued to do, yet their philosophies had long been stagnant. By contrast, "in the mechanical arts, however, we see that the opposite happens—which, as if they were partaking of a certain breath of life, grow and get better by the day." Such progress depends on drawing aid from other minds as well as from better tools. Hence Bacon insists on collaborative activities that anyone can perform, correcting the universal tendency of individuals to fall in love with their own ideas. "My view of the process of discovering the sciences is this: that little be left to sharpness and force of wits, but that wits and intellects be put on much the same footing. For in the same way that much depends on steadiness and practice if you want to draw a straight line or perfect circle by hand alone, and little or nothing if you use a ruler or compasses, so it is with the view that I take."[57] Significantly the instruments he names are

simple—ruler and compasses—not the sophisticated contrivances of Tycho, or later of Hooke and Newton. The legerdemain of a skillful hand or smoke and mirrors can always beguile the senses, but solid achievement follows the method of many hands in plain sight working together.

Bacon's fondness for tools and suspicion of individual genius would resonate through the future advancement of learning in England. The new empiricism of the 1640s and 1650s, culminating in the founding of the Royal Society in 1660, constantly paid him tribute. Indeed, in retrospect he seemed so peerless that he stood alone, as if he had become one of those revered ancients against whom he had warned. This was a danger; it contradicted his emphasis on equalizing talents and minds. Many of his followers were quite aware of this problem. Thus Thomas Sprat's *History of the Royal Society* (1667) carefully walks the line between idolizing Bacon and criticizing his shortcomings. "Methinks, in this one Man, I do at once find enough occasion, to admire the strength of humane Wit, and to bewail the weakness of a Mortal condition. ... He was a Man of strong, cleer, and powerful Imaginations: his Genius was searching, and inimitable. ... But yet his *Philosophical Works* do shew, that a single hand can never grasp all this whole Design, of which we treat."[58] In this way Bacon's legacy was divided. He had provided at once an example of genius and an object lesson of what it could not do.

R. H.'s Hall of Fame

Both sides of that legacy would be fleshed out by those who followed him. A generation weaned on Bacon took more than one leaf from his book. In September 1660, a year when many things were beginning or being restored, a curious work was published in London: *New Atlantis. Begun by the Lord Verulam, Viscount St. Albans: and Continued by R.H. Esquire.* Two giant figures preside over the text: Charles II, "so happily now returned," to whom an adulatory dedication is addressed; and Bacon, the master spirit. Continuing or recreating the *New Atlantis*, R. H. proposes a set of academies and universities modeled on Bacon's "Salomon's House," a utopian center of research dedicated to *"the Knowledge of Causes, and Secret Motions of Things; And the Enlarging of the bounds of Humane Empire, to the Effecting of all Things possible."*[59] At the same time, the new *New Atlantis* bows to a resurgent monarch whose laws will authorize and regulate all its activities.[60] Quite soon this vision seemed to come to life. The Royal Society, founded on November 28, 1660, self-consciously invoked Charles II, who would grant a royal charter in 1662 (though not the revenue the members wanted). In retrospect, *New Atlantis Continued* seems less a fantasy than a petition to

the king. It reconfigures a past ideal in order to mount a campaign for a possible future.

Yet the new, improved version of Bacon also magnifies some of the strains in what he conceived. After his death in 1626, when the first *New Atlantis* was published, his utopian program had been adopted by millenarians who viewed Bensalem and Salomon's House as harbingers of a literal Great Instauration, a Puritan golden age in which philosophy would realize God's plan, restoring the dominion of man over nature.[61] *New Atlantis Continued* takes up that dream with many cutting-edge tools, including "a rare *Microscope*, wherein the eyes, legs, mouth, hair and eggs of a Cheesmite, as well as the bloud running in the veins of a Lowce, was easily to be discerned."[62] But its grandest addition to Salomon's House consists of an elaborate Hall of Fame. Just before the end of his fable, Bacon had briefly described "two very Long, *and* Faire Galleries," one containing samples of "Rare *and* Excellent Inventions," the other decked with "Statua's *of all* Principall Inventours," including Columbus and Roger Bacon as well as unnamed local favorites. But R. H. expands the parade of moderns much further, recounting at length the triumphant initiation into the Hall of Fame of "the ingenious *Verdugo*," inventor of a fireproof or *salamandrine* paper. In present-day bustling England, room must be made for a clever young entrepreneur.[63]

At the same time, however, the cult of discovery marks a potential conflict of interest. Like any Hall of Fame, the gallery in Salomon's House sheds luster on its own establishment, collecting and enshrining heroes—or statues—who represent the ideals for which it stands. The absorption or conscription of individuals into a collective purpose, as in a scientific Leviathan, is one of Bacon's firmest principles. In the original *New Atlantis*, none of the members or luminaries of Salomon's House is named. Not even the magnificent Father of the House who describes all the features of its "true State" identifies himself; and almost all his sentences begin with *We*—e.g., "*We have also diverse* Mechanicall Arts, *which you have not*"; "*Wee have certaine* Hymnes *and* Services, *which wee say dayly, of* Laud *and* Thanks to God, *for his Marveillous* Works."[64] In many respects, in fact, Salomon's House resembles a religious order or secret society as much as a scientific institution, and it cultivates an air of mystery and wonder that individual names could only dispel.

New Atlantis Continued is far more personal. Its overture to Charles II places it in a particular moment of English history, and it reserves its greatest respect for pedigrees and persons. Here the Hall of Fame not only celebrates itself but also implicitly invites new applicants, the inventors whose clever ideas already seem to be transforming daily life. In every way initiates are recognized as *authors*; their works and fame will be published for all to admire.

Such publicity honors the individual more than the group. The new Hall of Fame is rich with modern names, immortalizing not only Magellan and Francis Drake and Michelangelo and Dürer but also Simon Stevin, J. Neper (Napier), Regiomontanus, Reinhold, Harriot, Harvey—and even a couple of fictional characters, Verdugo and one Thomas Boniger (inventor of flying chariots). It teems with genius and relishes the cunning and wit of those who stand out in a crowd. In Bacon's utopia, King Salomona, who reigned "*about 1900. yeares agoe*," founded Salomon's House, named after his counterpart, "*that* King *of the* Hebrewes *(which lived many yeares before him)*," to perpetuate the selfless study of God's works; and the founder is revered "*Not Superstitiously*," but as "*a Mortall Man*."[65] But in R. H.'s utopia, the current monarch inherits the name Salomona, descended from the founder "by a continued uninterrupted succession" without dispute; "for we conceive *Monarchy* the nearest to perfection, that is to God, the wise Governour of the Universe, and therefore best."[66] The lineage and name will never die. Thus history confers its blessing on a transmigrated king, whose divine right and perpetual rule reverse the fate of the Stuarts. In the ceremony that ends the work, the sick are cured not by new medicines but by Salomona's miraculous gift of healing. His hands are magic; only a special genius could wield such a tool.

Far beyond Bacon, therefore, *New Atlantis Continued* functions as a Hall of Fame that idolizes the great. Yet its own author is known only as R. H. Esquire, and attempts to identify him have been inconclusive.[67] A slim and dubious trail of evidence points to Robert Hooke. R. H., like Hooke, is a Baconian and Royalist who enthusiastically promotes "a Colledg of Light or *Solomons House* ... for the advance of learning"; he shares Hooke's interests in navigation and double-writing instruments and microscopes and flying machines; and his prose, like Hooke's, tends to run on from one idea or name to another without any summing up. Yet even if Hooke did not write the text, its wavering between the claims of the group and the individual reflects his own. In 1660 no one would have nominated him for a Hall of Fame. Though he had already worked with leading natural philosophers in Oxford, helping John Wilkins build a model flying machine, assisting Thomas Willis's chemical research, and above all collaborating with the great Robert Boyle on the air-pump experiments that culminated in Boyle's historic *New Experiments Physico-Mechanicall, Touching the Spring of the Air* (1660), Hooke could not yet claim the name of an author.[68] When he did publish a little tract, the following year, its title page gives Boyle pride of place: *An Attempt for the Explication of the Phænomena, Observable in an Experiment Published by the Honourable* ROBERT BOYLE, *Esq; In the XXXV. Experiment of his Epistolical Discourse touching the Aire, In Confirmation of a former Conjecture made by*

R. H. This time "R. H." identifies himself as Robert Hooke by signing "The Epistle Dedicatory" to Boyle; yet even then he looks up to his master as to the sun that inspired a fledgling eagle to soar. But Hooke would soon make his name. The Fellows of the newborn Royal Society were intrigued by his explanation of capillary action and asked for more experiments; and their lack of technical ability to perform them led to Hooke's appointment, in November 1662, as curator of experiments.[69] Henceforth his career and the activities of the Royal Society would be tangled together.

Yet Hooke's ambitions could not be confined to the group he served. His remarkable, indefatigable, and at first uncompensated efforts for the Society, which involved designing and carrying out at least three experiments each week, were accompanied by a torrent of his own speculations.[70] Often he did and said too much. The complications of his service appear most graphically in a brief prelude to the work that made him famous, *Micrographia* (1665). From the beginning the book had been intended to showcase the Society before the world. As soon as Hooke exhibited the peerless microscope he had contrived, members directed him to bring in observations, until "it was ordered that Mr. Hooke produce at every meeting of the Society one of his microscopical discourses, in order to their being printed by order of the Society."[71] The repetitions of "order" and "Society" underline the desire of the group to make the project its own. When the book was published, the Royal Society dominated its handiwork: its council "Ordered, *That the Book written by* Robert Hooke, *M.A. Fellow of this Society ... Be printed by* John Martyn, *and* James Allestry, *Printers to the said Society,*" and the title page features the Society's motto and coat of arms. But Hooke's address "To the Royal Society" acknowledges that he has not strictly followed its rules. Instead of avoiding any hypothesis not grounded in experiments, he admits that "there may perhaps be some *Expressions,* which may seem more *positive* then YOUR Prescriptions will permit: And though I desire to have them understood only as *Conjectures* and *Quæries* (which YOUR Method does not altogether disallow) yet if even in those I have exceeded, 'tis fit that I should declare, that it was not done by YOUR Directions." This author, both deferential and stubborn, maintains his independence from *you* and *yours.*

That independent spirit comes alive in *Micrographia*. If the bulk of the book consists of Hooke's "descriptions of minute bodies," made graphic by his expert, artful sketches, another substantial part displays his love of speculation. The famous blunt needle point and fuzzy period and bumpy razor edge with which the work begins are soon succeeded by a lengthy revision of his earlier explanation of capillary action, attributed to what he calls the "congruity" or "incongruity" of fluids with other bodies, or what we might now

call "surface energy."[72] In his tract Hooke had asked "whether this Principle well examined and explain'd, may not be found a co-efficient in the most considerable Operations of Nature." In *Micrographia* the principle takes wing; it accounts for magnetism, and probably light and gravity as well.[73] Similar bold conjectures run through the work as a whole. Thus some observations of colors in Muscovy-glass (or mica) set off a long inquiry into "the true causes of the production of all kind of Colours" (49), concluding with the hypothesis that "there are but two Colours," red and blue, corresponding to the two sides of "the *oblique* or uneven pulse of Light" (67)—a "deduction" that soon provoked a battle with Newton. And the final chapters leap from the microscopic world to the skies, with telescopic conjectures about "the *inflection*, or *multiplicate refraction*" of rays of light "within the body of the *Atmosphere*" (219) and about the surface and gravity of the moon. *Micrographia* insists on going beyond its mandate and delivering more than the Royal Society ordered. No reader can ignore the peculiar presence of Hooke. He yearns to be known as an author; he bids for a Hall of Fame.

❦ CHAPTER 9

The Century of Genius (2)
Hooke, Newton, and the System of the World

The Genius of Robert Hooke

Knowing where to place Robert Hooke has never been easy. Two contrary roles, the jack-of-all-trades who conducts experiments on order, and the visionary in quest of unseen causes, cohabit in his multifaceted career. Few scientists have left behind a more equivocal reputation. On the one hand, he has often been known as essentially a technician, a useful assistant to Boyle and other original thinkers, but someone whose ingenuity seldom rose to discoveries of his own. His major claim to fame, "Hooke's Law"—"the Power of any Spring is in the same proportion with the Tension thereof"— came out of his work with Boyle.[1] On the other hand, some champions of Hooke have long regarded him as one of the greatest natural philosophers of his time (and other times as well), who anticipated future developments in fields as various as meteorology, celestial mechanics, engineering, geology, and medicine. Thus his biographer Richard Waller remembered him in 1705 as "one of the greatest Promoters of Experimental Natural Knowledge, as well as Ornaments of the last Century (so fruitful of great *Genii*)."[2] In recent decades admiration for Hooke's achievements, along with an almost savage indignation at those who have underestimated him, has inspired a cluster of biographies and other appreciative studies. Two titles, *London's Leonardo* and *England's Leonardo*, along with *Restless Genius* and *The Forgotten Genius*, convey their tenor.[3] No longer a mere factotum, whom Sprat had barely

condescended to mention in his *History of the Royal Society* (1667), Hooke takes his place among the truly great.

The identification with Leonardo seems especially revealing. From one point of view, the two apparently had little in common. Quite aside from Leonardo's spectacular artistic talent, which certainly dwarfed Hooke's, the burst of his ideas was largely penned up in private notebooks, as opposed to the experiments and lectures of the English virtuoso, which on Baconian principles were supposed to be shared and exposed to public examination. Yet the heart of the comparison appeals to the incredible fertility of invention that these polymaths share, which spans any number of scientific pursuits and challenges standard divisions between theory and practice. Leonardo took all knowledge as his province; his hand and mind worked together; he was both thinker and workman; and the same might be said of Hooke. At the dawn of modern times, each of these artist/technicians aspired to realize the ancient myth of Daedalus, the artificer who soared beyond earthbound mortals.[4] And the parallel holds in another respect as well: despite some brilliant achievements, they carried through only a few of the fabulous projects they dreamed of. Their genius is reverenced not only for what they did but still more for the window they seem to hold up to the future, anticipating any number of later inventions and theories. Like Daedalus, they might have taught us how to fly.

The astonishing range and restlessness of Hooke's genius brim over in "The Method of Improving *Natural Philosophy*" (1666?), published in his *Posthumous Works*. Explicitly modeled on Bacon's *Great Instauration*, this treatise sets out, like *New Atlantis Continued*, to build on the guide or "Engine" that "the incomparable *Verulam*" started but "seem'd to want time to compleat."[5] Here Hooke attempts to predict "the search after Philosophical Truths" for generations to come. One passage (which cannot be short) will serve to exemplify how his mind works. Imagining how all the senses might be improved mechanically, as the microscope and telescope transform sight, he comes to the sense of hearing.[6] Perhaps "Otocousticons" (devices to amplify sounds in the ear) might overhear approaching weather or eavesdrop on enemy ships, or even listen to noises made by the planets. But such instruments might also descend to the tiniest sounds.

> There may be also a Possibility of discovering the Internal Motions and Actions of Bodies by the sound they make, who knows but that as in a Watch we may hear the beating of the Balance, and the running of the Wheels, and the striking of the Hammers, and the grating of the Teeth, and Multitudes of other Noises; who knows, I say, but

that it may be possible to discover the Motions of the Internal Parts of Bodies, whether Animal, Vegetable, or Mineral, by the sound they make, that one may discover the Works perform'd in the several Offices and Shops of a Man's Body, and thereby discover what Instrument or Engine is out of order, what Works are going on at several Times, and lies still at others, and the like; that in Plants and Vegetables one might discover by the Noise the Pumps for raising the Juice, the Valves for stopping it, and the rushing of it out of one Passage into another, and the like. I could proceed further, but methinks I can hardly forbear to blush, when I consider how the most part of Men will look upon this: But yet again, I have this Incouragement, not to think all these things utterly impossible, though never so much derided by the Generality of Men, and never so seemingly mad, foolish and phantastick, that as the thinking them impossible cannot much improve my Knowledge, so the believing them possible may perhaps be an occasion of taking notice of such things as another would pass by without regard as useless.

And the rush of ideas continues: experience encourages him to make some further trials, such as contriving "an Artificial Timpanum."[7]

Hooke's hands are all over this passage. The exuberant first sentence bounds from one thing to another with hardly a pause. Constantly moving, it renders the insides of engines and bodies and plants as sound effects, or gerunds— "beating," "running," "striking," "grating"—that remind us that watches, like verbs and people, function not as fixed parts but as actions in time. And the thought also never stops moving. This writer keeps leaping ahead, as if he could hardly wait to take notice of some other work in progress. Moreover, like the protagonist of Galileo's "Fable of Sound," he wants to handle whatever produces the sounds he hears. His fascination with mechanical devices, or the gears that make things tick, converts each organism into an apparatus with which one might tinker: "One may discover the Works perform'd in the several Offices and Shops of a Man's Body, and thereby discover what Instrument or Engine is out of order." To such an engineer, the whole world seems little more than a shop full of engines; nature itself inspires him to make machines.[8] And Hooke also reveals himself in the personal, even boastful, tone he adopts. In principle he intends to set rules for others to follow, in the collaborative spirit of Bacon and the Royal Society, where all sincere seekers of knowledge are supposed to be equal. But in practice he separates his own bold quest for knowledge from "the Generality of Men," who will not notice what he perceives (or imagines). Here and throughout Hooke's writings, the "one" who conducts experiments soon yields to an "I" who

defiantly refuses to rein in his imagination. What others think impossible will only spur him on to prove them wrong.

Yet the reach of the passage is thrilling. In a short space Hooke seems to foresee the inventions of later centuries: the stethoscope; sonar devices; the telegraph; the hearing aid. Dozens of similar creations course through his writings. Nor are these only idle conjectures. In many cases he provides detailed descriptions as well as sketches of possible contrivances, and often he hints that he has already produced a prototype—or might produce one if he had the time. Hooke was indeed very busy, too busy to focus attention on any one project. Hence a note of impatience, and sometimes frustration, accompanies his scattering of ideas, even when he seems inspired. Many readers have shared his dissatisfaction. Evidently he might have been robbed of credit for being the first to think of inventions or theories that others later developed. Suspicions like these consumed Hooke as he grew older. A passion for secrecy, quite unlike the Baconian ideal, began to characterize his dealings with other philosophers, until his own admiring biographer described his temper as "Melancholy, Mistrustful and Jealous."[9] As his wealth and fame grew, so did paranoia and ill health, doubtless agitated by the drugs he habitually used to experiment on himself.[10] One final project, "to repeat the most part of his Experiments, and finish the Accounts, Observations and Deductions from them," in the end came to nothing. Others would have to pick up the thoughts he had dropped.

Priority, Originality, and Luckey Hitts of Chance

In the meantime, priority disputes filled his days. The most famous of these was his long-standing series of quarrels with Newton, which began as soon as he read and reported skeptically to the Royal Society on Newton's historic letter "*containing his New Theory about* Light *and* Colors" (February 2, 1671/72). That debate would continue after his death in 1703, when Newton finally published replies he had written in 1675/76.[11] The claims and counterclaims produced by these exchanges, argued back and forth not only by the participants but also by scholars up to the present day, are too complex to allow any simple verdict. At times the rivals declared a truce or made concessions. At other times they ridiculed or tried to obliterate one another, as when Newton blue-penciled Hooke from the *Principia* or when Hooke told the Royal Society about "those proprietys of Gravity which I myself first Discovered and shewed to this Society many years since, which of late Mr Newton has done me the favour to print and Publish as his own Inventions."[12] In some ways the two were utterly incompatible—Hooke

the fox and Newton the hedgehog, Hooke the virtuoso and Newton the mathematician—in some ways all too much alike—too driven to admit that they might owe an idea to somebody else. When they came into contact, it sparked an electric recoil. Nor did they lack other foes, such as the great Christiaan Huygens, a rival to both. Such controversies thread through the story of Hooke's life.

In fact the natural philosophy of his time seethed with disputes about priority. Paradoxically the Royal Society itself may have ignited these competitions, because of the tensions in its ideals. In theory it advocated collaboration; in practice originality was what it prized, as in a worldwide Hall of Fame. Of all Hooke's enemies, the one he eventually most reviled was Henry Oldenburg, the first secretary and guiding spirit of the Royal Society, whom he came to suspect of plotting to destroy his reputation.[13] At first the two men had been allies and friends. Both were protégés of Robert Boyle, who donated them as a sort of gift to the Society, where they proved indispensable: Oldenburg as the enterprising administrator, diplomat, and publisher; Hooke as the philosopher and artisan who made things run. Their complementary skills and mutual efforts enabled the fledgling organization to survive its first hard times and ultimately flourish. Yet they were also at cross-purposes. Oldenburg, a Hanseatic German who was sent from Bremen to England in 1653 as an envoy to Cromwell and became attached to Boyle, always retained his continental ties. His correspondence with leading European philosophers kept him in touch with the latest scientific ideas; and *Philosophical Transactions*, the journal he founded in 1665, justified its subtitle: *Giving Some Accompt of the Present Undertakings, Studies, and Labours of the Ingenious in many Considerable Parts of the World*. In serving the Royal Society, therefore, he also functioned as a distributor or clearinghouse of "philosophical intelligence," forever spreading the word about new inventions. But not all inventors welcomed such exposure. Publicity might stir competition, encouraging others to follow a similar track or to ferret out secrets or even to steal them. At the height of his anger, Hooke looked down on Oldenburg "as one who made a trade of Intelligence," not only a monger of news but also a foreign spy.[14] When such a man spoke of "We and Us," "it is desired he would explain whether he means the *Royal Society*, or the Pluralities of himself."[15]

The same explanation might have been asked of Hooke, whose selves were so plural: did he represent the Royal Society or his own vainglorious interests? Clearly he was torn. Moreover, the free circulation of ideas seemed to him to trespass on the grounds of the Society, which might be regarded as a club of patriotic British citizens (and a few guests) whose information belonged to members only. Hooke's self-sufficient genius equated the go-between with

the double-dealer. Oldenburg had offended him by parleying with Huygens, who had invented a spring watch that Hooke thought stolen from his own design, and who had suggested that Oldenburg patent it. This looked like treachery. And even though the council of the Society rejected Hooke's charges, he never surrendered his grievance. He pursued it long after Oldenburg's death in 1677; and when in the aftermath he took over the duties of secretary and dominated the meetings of the Society, he allowed *Philosophical Transactions* to lapse, replacing it later with the sporadic *Philosophical Collections*. Temporarily he had won his battle against the "trade of Intelligence."[16] Yet in the long run Hooke's weakness at the business of publication, as well as his want of diplomacy, would cost him dearly. To the next generation, his resentment of Newton's fame seemed merely self-centered. The public monument of the *Principia* would cast a shadow over Hooke's carefully guarded secrets and theories.

Hence the Royal Society, which provided the stage where Hooke manifested his genius, turned out to be also the site of his ordeal. His lectures to the Society, in the years after the *Principia*, increasingly harp on two themes: his inventions and innovations in numerous fields, and the failure of younger men to credit or recognize him. He seems obsessed with questions of originality, and with the process by which imitators are enriched while "the first discoverer is dismist with Contempt and Impoverishment."[17] That obsession was not Hooke's alone. The fierce priority disputes of the late seventeenth century reflect a preoccupation with innovation and genius, as well as plagiarism and theft of intellectual property, that had been largely unknown in earlier ages.[18] To be sure, Galileo had not been modest about what he had discovered. The natural philosophers of his time also hungered for fame and wanted to be remembered, as in Tycho's last words, nor did they shrink from being rewarded and praised above other mortals. Yet public disputes about originality were rare. Thomas Harriot could surely have claimed that he had anticipated some of the discoveries of Galileo and Kepler, but he was content to leave that claim in private notebooks for future scholars to mine. Moreover, he lacked the resources to publish what he had done. There were as yet no institutions for coordinating and disseminating knowledge, no Royal Society and *Philosophical Transactions*, no Henry Oldenburg.

Most of all, originality itself had yet to be defined or glorified. Before the eighteenth century, when English borrowed the term from French, there was no such word, nor does it appear in Johnson's *Dictionary*.[19] More important, in early usage "original" seldom referred to modern ideas. Most scholars considered the Bible or the ancients as primal sources from which all later knowledge had been derived. When Galileo, Bacon, Descartes, and other

natural philosophers challenged that assumption, and above all the author-
ity of Aristotle, they set off a war between ancients and moderns that raged
for a century. It erupted again in 1687—the year of the *Principia*—when a
famous "Querelle" shook the Académie Française; and in 1690 Sir William
Temple brought the quarrel to England by contending, in *An Essay upon the
Ancient and Modern Learning*, that ancient sciences (now, unfortunately, lost)
had far surpassed modern achievements. Later, Temple's secretary, Jonathan
Swift, recast the war as farce in *The Battle of the Books* (1697), a mock-
epic clash between texts in the royal library. To Swift and other partisans of
ancient learning, "*the great Genius or Inventions of the* Moderns" suggested the
spider, which draws on itself alone to spin nothing but cobwebs. A better
ideal was the bee, which, pretending to no originality, brought home from
every corner of nature "Honey *and* Wax, *thus furnishing Mankind with the two
Noblest of Things, which are* Sweetness *and* Light."[20] From this point of view
the advancement of learning seemed an illusion. Slowly the moderns rallied
their forces, however, and the idea of progress took hold, as the seventeenth
century passed into the eighteenth, until originality became an indispensable
word, as natural as breathing.[21]

These skirmishes are directly related to Hooke's priority disputes. Few
natural philosophers have ever been more enthusiastic about the progress
of technology and science, or more concerned about their own original
contributions to it. That enthusiasm did not pass unnoticed. In Thomas
Shadwell's popular comedy *The Virtuoso* (1676), some of Hooke's words and
ideas are put in the mouth of the idiotic Sir Nicholas Gimcrack, who takes
great pride in his bizarre experiments (after Hooke saw the play, he growled
to his diary, "Damned Dogs. *Vindica Me Deus*. People almost pointed").
The ultimate insult arrives when Gimcrack is forced to admit that "I never
invented an engine in my life. . . . We virtuosos never find out anything of
use, 'tis not our way."[22] Such attacks took on a life of their own. Even as late
as 1726, when Swift published his notorious lampoon of the Royal Society
in book 3 of *Gulliver's Travels*, the absurd experiments of "*the universal Art-
ist*" implicate Hooke's all-embracing interests and quest for progress.[23] These
parodies were, of course, grossly unfair. Though "ancients" like Swift might
regard all modern inventions as useless, Hooke and his fellows had tirelessly
worked in the spirit of Bacon to bring about practical, useful improvements
in daily life: better eyeglasses, medicines, watches, and buildings. If they
did not succeed in their plans for flying machines, they were not wrong to
hope that future inventors would realize what they had dreamed. Yet the
satirists surely touched one vulnerable point, the pride of Hooke and other
champions of innovation. Priority disputes revealed the self-importance and

competitive urges that motivated the virtuoso, who panted for recognition. Hooke wanted the world to know that he was a genius.

To *prove* that one was a genius, however, was no easy matter. A single clever invention, such as Verdugo's fireproof paper, might earn a place in some imaginary Hall of Fame, but Verdugo might have been lucky rather than gifted. True genius had to aim higher, toward something universal: the law of gravity, for instance. Hooke's dispute with Newton, at times quite frantic, shows that he knew his immortality was at stake. A famous letter that he encouraged and assisted his friend John Aubrey to draft is addressed to posterity as well as to Anthony Wood: "This is the greatest discovery in nature that ever was since the world's creation. It never was so much as hinted by any man before. I know you will doe him right."[24] But Wood did not take up the cause.

Had Hooke been the first to discover the principle of universal gravitation? If so, his insight must be pried out of a lecture first delivered in 1670, *An Attempt to prove the Motion of the Earth from Observations*. Its amazing final paragraph hints that he has "discovered some new Motions even in the Earth it self, which perhaps were not dreamt of before, which I shall hereafter more at large describe," when "also I shall explain a System of the World differing in many particulars from any yet known." And the paragraph ends by passing the idea on to such as "are not wanting of Industry for observing and calculating, wishing heartily such may be found, having my self many other things in hand which I would first compleat, and therefore cannot so well attend it. But this I durst promise the Undertaker, that he will find all the great Motions of the World to be influenced by this Principle, and that the true understanding thereof will be the true perfection of Astronomy."[25] The claim of priority is breathtaking, and so is the sense of mystification. In retrospect Hooke seems at once to predict the rule that Newton's mathematical reasoning will formulate and to reduce it to mere calculation, a working out of something already conceived. But what *is* that something?[26] Though Hooke drops clues, including a conjectural inverse square law, he is not ready to show his hand; he lays claim to a secret, like the philosopher's stone, too precious to share. No wonder that Newton would later feel so defensive. A lien had been placed preemptively on his greatest idea, his System of the World; nor could he prove exactly what had or had not been in Hooke's mind. Two secretive and obstinate giants were headed toward a collision.

In any case, the evidence for Hooke's genius does not consist in any one idea, however great. It must be sought instead in the flood of original inspirations that passed through his mind and his hands, sometimes lingering, sometimes quickly straying. That kind of genius leaves many traces but no

deep, unequivocal track. Full of potential, it shows its power by constantly generating new thoughts in new fields, which may not take hold for centuries but sometimes unexpectedly turn out to be important. And yet its home is the shadow world of the mind, where images flicker into and out of life and do not always move a hand to sketch them or write them down.

The published version of the lecture in which Hooke announced his revolutionary System of the World begins with an extraordinary disclaimer: "No man is able to say he will compleat this or that *Inquiry*, whatever it be, (The greatest part of Invention being but a luckey hitt of chance, for the most part not in our own power, and like the wind, the Spirit of Invention bloweth where and when it listeth, and we scarce know whence it came, or whither 'tis gone."[27] The parenthesis, like the inquiry, never closes. Hooke cannot shape the course of his creations, even when they might shake the world. His sense of mystery anticipates Kant's famous verdict on genius: "If an author owes a product to his genius, he himself does not know how he came by the ideas for it; nor is it in his power to devise such products at his pleasure, or by following a plan, and to communicate to others in precepts that would enable them to bring about like products." And Kant then draws a logical conclusion: Newton was far too rational to be a genius.[28] When asked how he had made discoveries, Newton is supposed to have replied, "By always thinking unto them."[29] But Hooke's inventions came and went like the wind.

Nor did he often finish what he started. Even his best ideas kept being interrupted by duties and deadlines and projects. Perhaps Hooke did intuit the inverse square law, but there were also "many other things in hand"—by his own count, at least a "Centry" of "useful Inventions." Some of these were as practical as the method of forming arches in the shape of an inverted hanging chain, which Wren may have used in building St. Paul's Cathedral;[30] some as visionary as the equatorial quadrant or the spring-regulated chronometer, which later generations would develop; some as airy as the springy shoes designed to bounce the wearer twelve feet up.[31] But good or bad, the ideas kept coming, like the perpetual motion machine he once wanted to build. That capacity for invention, in which thoughts forever sought instruments to test or activate them, brings out the special nature of the virtuoso Hooke. Etymologically his genius occupies the space where *genere*, the seminal Latin root of "generation," branches to "ingenuity" as well as to "engineer." He did not make systems but things.

Moreover, he talked incessantly about them. Hooke's attachment to the Royal Society, which began not long after its founding and continued for forty years, despite his ill health, until shortly before he died in 1703, affected all his work.[32] The experiments that he was commissioned to perform

converged with his own thought experiments and devices, and all of them entailed reports and lectures. In the small world of the Society, Hooke's talents—and frailties—were always on display. Perhaps he was even too familiar a figure. Often brilliant, sometimes annoying, his genius could be taken for granted. If the Society was partly his creation, he was also its creature, as if the collective curiosity of its members assumed a visible form in what he did. Hence his prodigious talents, however respected, did not inspire awe. Few students came to his lectures, in his old age, and fewer still remembered the times when every week brought forth some new discovery or gadget. Hooke would forever hold a place in the Hall of Fame constructed by the history of science, but he had not shaken the world. For that a different order of genius was required.

The Making of Isaac Newton

First and last, mathematics made the difference. When Newton heard that Hooke was accusing him of having appropriated the inverse square law, he could not contain his rage: Hooke could never have understood the truth of the law, since he lacked the capacity to prove it. "Now is this not very fine? Mathematicians that find out, settle & do all the business must content themselves with being nothing but dry calculators & drudges & another that does nothing but pretend & grasp at all things must carry away all the invention as well of those that were to follow him as of those that went before."[33] Here Newton fumes not only on his own behalf but also as a member of a proud elite, those mathematicians who "do all the business." In his own eyes that group defines him, and it is closed to Hooke. Newton implicitly draws on a version of the history of science, of those who have gone before and are to follow, that traces a logical sequence of accurate calculations. Such a history will have nothing to do with mere virtuosi or those who concoct an unrelated series of clever inventions.

The culmination of Newton's version of science would arrive the following year, in *Philosophiæ Naturalis Principia Mathematica* (*Mathematical Principles of Natural Philosophy*, 1687), whose title itself declares that mathematics underlies the system of the world. In a brief preface to book 3, Newton observes that his principles are not "philosophical but strictly mathematical—that is, those on which the study of philosophy can be based. These principles are the laws and conditions of motions and of forces," or what would later be called celestial (as well as terrestrial) mechanics. None but "readers who are proficient in mathematics"—readers more adept than Hooke—are qualified to grasp them.[34] To explain how such principles account for the phenomena of

nature, Newton had "composed an earlier version of book 3 in popular form, so that it might be more widely read." But that would have led to misperceptions and "lengthy disputations" about the *cause* of the force that propels the planets.[35] Instead he traces its effects "*in a mathematical way*, to avoid all questions about the nature or quality of this force, which we would not be understood to determine by any hypothesis."[36] Hence the *Principia* translates the substance of its explanation into mathematical propositions. In the last analysis, the system of the world cannot be reduced to what common people can see or understand. Instead it obeys eternal laws that only mathematics is capable of expressing.

Newton had fashioned his views from a long tradition. Many years before, during an interlude in one of his quarrels, he had famously conceded to Hooke that others had influenced his own ideas on light and colors: "What DesCartes did was a good step. You have added much several ways.... If I have seen further it is by standing on ye sholders of Giants."[37] As many scholars have argued, the remark is probably less modest and gracious than it might seem, nor does it pronounce Hooke a giant.[38] Newton associates himself, most likely, with the inspired ancient philosophers "who made a *Vacuum*, and Atoms, and the Gravity of Atoms, the first Principles of their Philosophy; tacitly attributing Gravity to some other Cause than dense Matter," and thus preparing the way for a divine first Cause, which moderns such as Descartes and Hooke have ignorantly banished, "feigning Hypotheses for explaining all things mechanically."[39] As the apostle of those inspired ancients, Newton too partakes of the divine. Yet modern giants, despite their faults, had also helped to elevate him. From a mathematician's perspective, the progress of seventeenth-century philosophy had borne out Galileo's crucial insight, that the book of the universe "is written in the language of mathematics." A small number of giants—among them Copernicus, Kepler, Galileo himself, and Descartes—had learned to read that language fluently, and thus offered their shoulders to later mathematicians. This is the line of genius in which Newton takes his place.

Descartes, above all, provided a model. So much of Newton's work explicitly repudiates Cartesian principles that the two men might be considered implacable enemies, dividing the intellectual world between them. Thus Newton sets himself against Descartes's algebraic calculus, his theories of light and gravity, his separation of body and spirit, his vortices filling a plenum. Even the title of the *Principia* echoes and challenges Descartes's *Principia Philosophiæ* (1644), opposing Newton's focus on mathematics and "natural" philosophy to Descartes's investment in hypotheses—or what Newton called "fictions"—about the mechanisms that run the world.[40] Yet Descartes had been largely responsible for launching Newton's career. In 1664, when the

twenty-one-year-old scholar at Trinity College, Cambridge, fell under the spell of mathematics, it was *Géométrie* that opened and provoked his mind. "When he had read two or three pages & could understand no farther he ... begain again & got over three or four more till he came to another difficult place, & then began again & advanced farther & continued so doing till he not only made himself master of the whole without having the least light or instruction from any body, but discovered the errors of Descartes."[41] Newton was anything but a passive reader. Whetting his tools on Descartes, he immersed himself for two years—his *"annus mirabilis"*—in the most difficult problems of mathematics; and he did not emerge until he had gone beyond anyone else, all the way to infinity, and reinvented ideas of what mathematics could do.[42] He kept these findings to himself for many years. But eventually the secrets came out, and posterity would regard them as the ultimate example and proof of genius: something self-born and almost beyond comprehension. Not even Descartes had come so far so fast.

Nevertheless, in many ways Newton was treading in Descartes's footsteps. First he began by absorbing and overthrowing Euclid. Traditionally the *Elements* had provided a basis not only for mathematics but also for rational thought, establishing axioms whose demonstration trained the mind; the permutations of geometrical figures, of triangles, quadrilaterals, circles, and spheres, exemplified logic in action. But this was a limited language, restricted to what could be drawn by the ruler and compasses. Descartes had set out to expand the field by superimposing the methods of algebra, its symbolic language of abstract equations, on geometrical figures. In place of the classic conic section, his geometry featured the curve, which expressed the relations between lines in terms of coordinates that could be expressed in equations. *Géométrie* begins by asserting that "all the problems of geometry can be easily reduced to such terms that one need only know the length of certain straight lines in order to construct them."[43] This proud promise was vain, and Descartes failed to carry it through. But Newton took up the project, transcending classical geometry by reconceiving its lines as the tracks left by moving points, whose curving lines could be analyzed in terms of rates of flow, or "fluxions." *Géométrie* had led the way; it had given him "his first true vision of the universalising power of the algebraic free variable, of its capacity to generalise the particular and lay bare its inner structure to outward inspection."[44] A few further steps, incorporating insights about quadratures and infinitesimals, culminated in October 1666, when a tract that offered mathematical propositions "To resolve Problems by Motion" laid out the principles of a new method. Later it would be called the calculus.

That period of intense concentration and undeniable accomplishment still represents the epitome of what genius can do. But it also remains an enigma. What enabled Newton to leap so far ahead? Was the time ripe for him, or did his power of mind create its own reality, autonomous and timeless? Each rival theory of genius can find its own way to describe what happened. For Samuel Johnson, Newton's breakthrough might confirm that "the true Genius is a mind of large general powers, accidentally determined to some particular direction,"[45] as when Newton chanced to fall under the spell of *Géométrie*. Yet most admirers of Newton consider his attainments not accidental so much as fated. His peerless gift for mathematics was not simply a matter of "large general powers" but rather a specific transcendent potential always ready to seize its occasion. An accident might have cut that potential off but could never determine how far it might go. To be sure, he was fortunate in his time and place, and envied by his successors: "There could be only one Newton," Lagrange is supposed to have told Napoleon; "there was only one world to discover."[46] But the world was also fortunate to have found its Newton: someone uniquely qualified to understand it.

Nor could he be distracted from the questions he tried to answer. In every way Newton's genius was single-minded. What Cambridge provided during his formative years was less a community of scholars than a sanctuary that left him alone, free to pursue his interests without interruption.[47] Wordsworth, who felt an odd affinity with Newton, recorded a Trinity College tradition as well as a personal view in his famous lines on the statue "of Newton with his prism and silent face, / The marble index of a mind for ever / Voyaging through strange seas of Thought, alone."[48] The statue and the man converge in fancy, equally silent and closed to the world outside their marble, mysterious figures. Such genius makes its own laws. While working on the problems that consumed him, Newton wrapped himself in a cocoon of solitude; often he forgot to eat or sleep. Eventually, when he had exhausted the topic, at least in his own mind, he would rest and then turn to another, which might involve theology or alchemy. But mathematics served his genius best, because some problems yielded to his relentless attack and because his reasoning could be definitive, without any need to fabricate hypotheses or paper over heresies. After the trial of Galileo, Descartes had suppressed *The World*, and Newton shied from exposing his own arcane and nonconformist beliefs to the public. Even the controversies over his discoveries in optics and mechanics upset him and tempted him to withdraw from the glaring light of rival claims and publications. Only the business of mathematics—precise, obsessive, and most of all private—could furnish a refuge.

The System of the World

Nevertheless, Newton could not avoid the fame that descended on him. The excitement that carried Edmond Halley away when he urged and almost forced Newton to ready the *Principia* for publication, and that would also stir so many others, was not aroused only by dazzling and elegant mathematics.[49] It responded to something more, to something to which Descartes had devoted his life: the effort to construct a comprehensive system of the world. This aspiration had driven natural philosophers for more than a century, ever since the new philosophy called all in doubt. In the cosmos that Copernicus, Tycho, Galileo, and Kepler began to envision, Aristotle and Ptolemy no longer seemed competent to offer explanations of everything, yet only Descartes had made a plausible start at filling the void. Even the phrase "the System of the World" spoke of a promise yet to be performed. Ever since Kepler's three Laws, an elusive unified theory had seemed to hover just out of reach. When Hooke entered his claim to have discovered "a certain rule" on which to build "a System of the World," he hinted that the promised hour had come at last. Those were words that all philosophers except Cartesians had waited to hear. But Hooke had overreached. Someone else would have to make his words good.

Such hyperbolic claims did not come easily to Newton. Observations and propositions were his forte; he hammered out bold answers to difficult questions and usually left the implications for others to trace. In the letter that made him famous, "containing his New Theory about *Light* and *Colors*" (1672), he takes satisfaction not only in the absolute certainty of what he has found but also in his refusal to speculate about what he does not know: "Who ever thought any quality to be a *heterogeneous* aggregate, such as Light is discovered to be. But, to determine more absolutely, what Light is, after what manner refracted, and by what modes or actions it produceth in our minds the Phantasms of Colours, is not so easie. And I shall not mingle conjectures with certainties."[50] This is Newton's characteristic tone, proud, decisive, self-contained, and wary. Rhetorically he shuns hypotheses.

Even when, three years later, Newton sought to unlock the secrets of nature in "An Hypothesis explaining the Properties of Light discoursed of in my severall Papers," he denied that he cared "whether it shall be thought probable or improbable so it do but render ye papers I send you, and others sent formerly, more intelligible."[51] Some virtuosos could not understand his discourses unless he attached a hypothesis to them; so he would condescend to speculate. Hence he affects to disown in advance his first public attempt to make sense of the world through light and gravity and aether. "Perhaps

the whole frame of Nature may be nothing but various Contextures of some certaine æthereall Spirits or vapours, condens'd as it were by præcipitation ... ; and after condensation wrought into various formes; at first by the immediate hand of the Creator, and ever since by the power of Nature, wch by vertue of the command Increase & Multiply, became a complete Imitator of the copies sett her by the Protoplast. Thus perhaps may all things be originated from æther."[52] "Perhaps" begins and ends a flight of fancy. Significantly this all-embracing speculation seems drawn from alchemy far more than from mechanics. Freed from the severe constraints of absolute certainties, Newton exposes the "strange seas of thought" in which he had been voyaging for many years. Indeed, his reference to "the Protoplast" (first agent) may well hint at an Arian heresy, which regarded the Son as the mediator between the Father and the created world.[53] But Newton was hardly ready to share his personal beliefs; nor was he yet quite sure that he had found the truth. Most likely his unwillingness to stand behind his own hypothesis represents a genuine uncertainty, not merely a strategic precaution. He could not yet prove that the universe moved in conformity with his thoughts.

Moreover, a coherent system of the world required an author. As Kepler plumbed the harmonics of the solar system, he was inspired by the idea that he was glimpsing the mind of God. Descartes's mechanist explanation of everything in *The World* insisted that, as first mover, "God alone is the author of all the motions in the world,"[54] but his published writings defensively concede that his own system of the world *as it might be* is merely human, a tissue of suppositions. In Newton's time, the great "Christian virtuoso" Robert Boyle espoused a theology in which the study of nature served as a form of worship, because it contemplated God, the author of nature.[55] Ambitious natural philosophers, even those far more prudent than Galileo, could not avoid the theological implications of their world systems. Certainly Newton did not. Although he does not seem to have turned the full force of his mind to theology until the late 1660s, after he had transformed mathematics, it soon became his obsession, pursued with the same intensity and independence that marked all his serious studies. It remained so for more than a decade, until Hooke and Halley brought him back to cosmology and mathematics and prodded him to reconceive the world. Yet the first edition of the *Principia* draws no conclusions about the author of its system. God is almost entirely absent.

He was far from absent from Newton's mind, however. In a series of letters to Richard Bentley in 1692–93, Newton emphasized that God alone had authored the system of the world described in the *Principia* and that only God's eternal vigilance kept it in place. "When I wrote my treatise about

our Systeme I had an eye upon such Principles as might work wth considering men for the beleife of a Deity & nothing can rejoyce me more then to find it usefull for that purpose."[56] Twenty years later, a "General Scholium" appended to the second edition of the *Principia* declared, "This most elegant system of the sun, planets, and comets could not have arisen without the design and dominion of an intelligent and powerful being"—"Lord God *Pantokrator*," or "universal ruler." There is nothing equivocal about this repeated assertion that God rules all things and that all things testify to his presence; and the section concludes with one more endorsement of the argument from design: "To treat of God from phenomena is certainly a part of natural philosophy."[57]

Yet even at this moment of conviction, Newton will go only so far. The very next paragraph, which refuses to assign a cause to gravity, revolves around his most famous phrase, "Hypotheses non fingo" (I do not feign [or fabricate] hypotheses). The phrase has an interesting background. Newton had used the words before, most notably in Query 28 of the Latin version of the *Opticks* (1706), which anticipates the argument of the "General Scholium": "Does it not appear from Phænomena that there is a Being incorporeal, living, intelligent, omnipresent, who in infinite Space, as it were in his Sensory, sees the things themselves intimately, and thoroughly perceives them, and comprehends them wholly by their immediate presence to himself." This proposition, without a question mark, concludes a train of thought that rebukes philosophers for "feigning Hypotheses for explaining all things mechanically, and referring other Causes to Metaphysicks: Whereas the main Business of natural Philosophy is to argue from Phænomena without feigning Hypotheses, and to deduce Causes from Effects, till we come to the very first Cause, which certainly is not mechanical."[58] In Newton's mind, evidently, the first Cause he deduces—that incorporeal, omnipresent Being—is *not* a hypothesis, or is indeed a living refutation of all hypotheses concerned only with matter. In that respect Descartes's separation of matter from spirit had fatally set him on a false track. When the "General Scholium" follows its account of God the Pantokrator with a disavowal of hypotheses, therefore, it assumes that pure reason and truth, not fabrication and speculation, proclaim the divine first Cause. Implicitly the cause of gravity must be God. But Newton does not say that.

One reason may be that he feared to associate his great discovery in mechanics with a theology that might be disputed. Such fears were justified. David Gregory, who talked to Newton about a draft of Query 28, reports, "The plain truth is, that he believes God to be omnipresent in the literal sense," and that he thought of enlisting the ancients to support him:

"What Cause did the Ancients assign of Gravity. He believes that they reckoned God the Cause of it, nothing els."[59] But this presumed that infinite space is the sensorium of God, who presides over his creation as a percipient center or mind that at once receives impressions of all things that exist and impels them to move. The first Latin edition of the *Opticks* says that explicitly. But Newton soon backed down. Apparently he retrieved as much of the edition as he could and pasted another passage (the version above, with "as it were in his Sensory") over the more aggressive identification of space with the divine sensorium. One copy of the original, however, seems to have fallen into Leibniz's hands, who found the idea of the sensorium richly ridiculous: "Sir Isaac Newton says that space is an organ which God makes use of to perceive things by."[60] If gravity depended on the ever-present intervention of God, then the universe was no better designed than a watch that constantly needed rewinding. Surely the first Cause might have been more efficient. Hence reliance on the sensorium exposed, in Leibniz's eyes, the weak metaphysics that grounded Newton's physics. The system of the world began to tremble; a harsh debate ensued.

Yet Newton himself did not want to engage directly in that debate. When priority disputes broke out, as with Hooke on the inverse square law or Leibniz on the invention of the calculus, the situation was different. A challenge to his originality, or even a suggestion that others had thought as he did, touched the essence of his self-esteem, and he was hard to restrain. But the system of the world, which meant so much to his followers, could largely be left to them. Newton's genius thrived on certainties; he did not like to think of himself as someone who indulged in theories, and he preferred to husband rather than publish his work. When word of his genius snowballed and spread, he took no overt or active part in the process.[61] Despite his pride in his discoveries, Newton did not have much of a gift or inclination for explaining why they were significant. There was always something sequestered, if not uncanny, about his genius.

Thus the industry that grew around Newton, paraphrasing, interpreting, popularizing, and finally sanctifying his ideas, could mold his image as it wished, without descending to the merely human. Even the Royal Society, the site of his first public triumph in 1672, could hardly claim him as more than a token fellow, until thirty years later he lent it his own prestige by allowing himself to be elected president. Meanwhile a troop of enthusiastic champions and disciples—among them Oldenburg, John Collins, Halley, Bentley, John Craige, Roger Cotes, Henry Pemberton, and J. T. Desaguliers—gathered around his singular figure, bringing the new ideas home to the public.[62] The great man himself had no need to expose whatever he might privately believe.

One disciple, Samuel Clarke, spoke openly for Newton. Clarke, like Bentley, had given Boyle Lectures on natural theology (1704–5), and the following year had translated the *Opticks* into Latin. Moreover, he sympathized with Newton's unorthodox theological views, including Arianism.[63] The correspondence of Clarke and Leibniz in 1715–16 debated fundamental issues: the nature of the universe and God, free will, the vacuum and the plenum, miracles, and most of all the role of natural philosophy in fortifying religion.[64] When Clarke published these exchanges after Leibniz died, they became a central text for disseminating Newton's system of the world to a wide public, in understandable terms. Voltaire, who set Clarke with Newton among "the greatest thinkers and finest writers of their age,"[65] borrowed some of his arguments to eviscerate their common enemy Leibniz. Leibniz's Principle of the Best, which held that the world perfected by God must admit the greatest possible variety and plenitude, denied the existence of vacuums and atoms; but Clarke, and Voltaire after him, insisted that such reasoning would lead to the absurdity of a universe made entirely of pores, without any solid particles of matter.[66] Whatever the merits of this debate, it served Newton's purposes extremely well. Without committing himself to any explanation of gravity, he had delegated an active defense of his system to someone he could rely on, and at the same time he had put Leibniz in the embarrassing position of struggling to justify theories that were not fully worked out. When challenged by Leibniz, Newton had gently asked him to provide a better explanation of the world.[67] Now it was obvious, even to Leibniz himself in the moment before his death, that he had not succeeded.[68] Hereafter Newton's system would stand alone.

Nevertheless, he would not reveal the full range of his thoughts. Two texts, both called *The System of the World* (*De Mundi Systemate*), show how much he deliberately withheld. The first was originally intended to conclude the *Principia*, where it would use the mathematical principles of natural philosophy to "demonstrate the frame of the SYSTEM of the WORLD." Simply and directly, in Latin, it describes a heliocentric system held together by centripetal forces, explains the motions of the planets, the moon, and the tides, places the fixed stars at immense distances from the planets, and works out the trajectories of comets. When finally published in both Latin and English more than forty years later, a year after Newton's death in 1727, it immediately became the most accessible guide to his cosmology. But he himself had never published it. To avoid disputes and superficial responses, he reduced the text to mathematical propositions. Hence the altered "System of the World" that constitutes book 3 of the *Principia*, extensively revised in the second edition and again in the third, addresses a reader who has already mastered at least some of

the earlier mathematics. Such readers will certainly be rewarded for their toil, above all by grasping the power of the theory of gravity to calculate celestial motions. Yet Newton rigorously excludes any talk about the causes and implications of his theory, even those he had labored over in many canceled drafts, and proposed in searching discussions and correspondence. Even the first attempt at a more popular "System of the World" had stepped back from provocative claims: "It is none of our present business to explain the causes of the appearances of nature."[69] And it concludes with a set of mathematical problems and computations, without any summing up.

The Vision of Newton

In recent decades, when scholars have explored the range of Newton's interests and determined that his "system of the world" was only one small part of his lifework, the austerity of what he chose to publish has often seemed quite inexplicable. One leading authority, I. Bernard Cohen, confesses that he is perplexed.

> For Newton the system of rational mechanics (books 1 and 2) and the dynamics of the system of the world (book 3) were not ends in themselves but only parts of a unified general ordering of the universe that encompassed alchemy, the theory of matter, "vegetative" and other "spirits," prophecy, the wisdom of the ancients, and God's providence.... How could Newton have kept these considerations out of his *Principia* to such a degree that readers have had only the barest hint of their existence until our own times? Some years ago, I put this question to Frances Yates, the doyenne of studies in this area. She replied simply but very profoundly that, after all, "Newton was a genius." Who would not agree! We cannot expect a person of such creative genius to behave in an ordinary fashion.[70]

Here "genius" serves as an all-purpose explanation or "wonderful solution of all difficulties," like the *lusus naturae* in Swift.[71] Normal standards cannot apply to such a phenomenon, a sport of nature who proves that he is unique whenever he flouts what other people expect.

Yet Cohen and Yates ignore one salient point, that Newton safeguarded his reputation for genius precisely by suppressing any ideas and theories he could not confirm. In that respect he may have been wiser than modern scholars. When specialists recover the contexts of Newton's thought, in all its complexity, breadth, and confusion, their findings inevitably blur the hard, decisive mathematical truths whose force shook the world. Hence scholars who

comb his discoveries for psychological or metaphysical sources are always in danger of forgetting what matters, as if a falling apple could explain the law of gravity. From this perspective alchemy, despite its tantalizing cryptograms, is just another apple. Whether or not Newton's deep hermetic studies predisposed him to imagine gravity as action-at-a-distance, like Robert Fludd's beloved weapon-salve, the breakthrough he achieved depended on meticulous calculations, not magical thinking.[72] Meanwhile he preserved his secrets. That reticence was not the least of the traits that built his legend of genius.

The vision of Newton as a superior being was first designed, in fact, by Newton himself. The humility he expressed late in his life, most of all in the moving words he is supposed to have spoken a little before his death—"I don't know what I may seem to the world, but, as to myself, I seem to have been only like a boy playing on the sea shore, and diverting myself in now and then finding a smoother pebble or a prettier shell than ordinary, whilst the great ocean of truth lay all undiscovered before me"[73]—carries the weight of someone whom the world has glorified. Indeed, the words are literally worthy of Jesus. In Milton's *Paradise Regained* (1671), Satan had tempted the Son of God to become a natural philosopher. "Be famous then / By wisdom; as thy Empire must extend, / So let extend thy mind o'er all the world, / In knowledge, all things in it comprehend." The cunning rhyme ("extend" and "comprehend") converts the blank verse into an epigram fit for a braggart or devil. But the Saviour contemptuously rejects such studies: a scholar who "to his reading brings not / A spirit and judgment equal or superior, / (And what he brings, what needs he elsewhere seek) / Uncertain and unsettl'd still remains, / Deep verst in books and shallow in himself, / Crude or intoxicate, collecting toys, / And trifles for choice matters, worth a spunge; / As Children gathering pibles on the shore."[74] Newton—at least in his supposed self-portrait—agrees with that verdict. Although he may not have known he was echoing Milton, he consciously adopts the tone of someone who views the world and its concerns from a vast height, where even his own fame and acknowledged greatness shrink to trifles.[75] Like Jesus, he understands that a superior spirit need not seek approval from others. Hence his magnificent gesture of self-deprecation paradoxically raises him up. Lesser philosophers may think they have navigated the great ocean of truth, but Newton resists that temptation, because his definition of truth encompasses more. Competitive humility is the last resort of a saint, and of this natural philosopher as well.

Nor did he like to share his toys and trifles. The legend that Newton drew around himself left little room for other people. Whether through pride or paranoia, he cultivated a vigilant solitude in which his mind could spring,

unencumbered, from one discovery to another. Such intellectual confidence hardly required the sort of recognition that most scholars crave, through publication or social circles—though Newton certainly did want to be admired. But the attention that he attracted also carried a threat, a potential for disagreement and confrontation. Newton shrank from such scenes. In the fortress of his own certainty, he protected an insatiable ambition: not only that he be right, but that he be infallible. That was too much for anyone, even a genius, to ask. On those occasions when someone caught him in a mistake, therefore, he tended to ignore and sometimes tamper with the evidence. An infallible being endures no rivals. What Newton wants most, when his authority is challenged by Hooke, Leibniz, or Flamsteed, is not so much to vanquish them as to make them disappear—somehow to erase all traces of their existence. Even those who assisted or enabled his publications were seldom acknowledged in print. One mind alone fills the vacuum of his great works, which suspend the reader in an intense, demanding series of propositions, far from any hubbub of conversation.[76]

Thus Newton removes himself effectively from mortals and their concerns. In his last days, as he spun the stories about the apple tree and the boy on the shore, he was already disseminating pictures to be remembered.[77] Posterity would cherish these icons: the dreamer alone on the lawn, the seeker alone by the sea. They consecrate an eternal and cloistered thinker, distanced not only from any scandal or any intruder but also from the civic-minded master of the Mint and president of the Royal Society.[78] The great man has no peers. In this way, even when he was immersed in London life, Newton preserved a reputation as a being incomparable and singular. It was, one might say, a stroke of genius.

Indeed, the definition of genius would never fully recover hereafter from Newton's example. In his own time, one tribute after another insisted that he had reached the ne plus ultra, the ultimate human link of the Great Chain of Being—or perhaps gone beyond it. Once that might have been a sign of presumption or fearful ambition; no pride could be worse than that of a mortal who wanted to rival God. Yet Newton, unlike Milton's Eve, had always seemed obedient to codes of behavior.[79] Whatever he thought in private, he never touched the apple, at least in print. Still more, in the long run he doomed and dissolved the Great Chain of Being. A cosmos of visible plenitude, held together by uninterrupted, unbroken links without any gap, could not survive the new universe of vast empty spaces, a void with tiny particles that gravity invisibly held in place. In these terms genius broke the scale on which all human beings had been measured. The hierarchy of wit, ascending by degrees from fools below to prodigies on high according to each person's

special gifts, now yielded to a sense of "general powers." Newton's mind comprehended more than those of other people; like gravity, it somehow permeated everything and guaranteed an undivided whole whose presence governed every individual part. The size of what his powers of thought had grasped suggested an order of intellectual magnitude, a sum of mind almost too large to calculate.[80] He did not have a genius; he was genius itself.

When "genius" was remade in Newton's image, however, it subtly altered notions of what human beings are and what they can achieve. A god had always haunted the word, the spirit or daimon that inhabited men and governed their lives. But under the new mathematical dispensation those spirits were soon disenchanted and their powers dispersed among natural human talents. Socrates's daimon told him what not to do; it could foretell the future.[81] But Newton's consuming interest in prophecy, which occupied a great portion of his life, depended on endless calculations, as if the power of mathematics could fix the chronology of future times as well as of the past.[82] His genius was demonstrable and quantitative, a solid mass of intellect. Eventually its quotient represented what human beings could aspire to, not because gods possessed them but because their minds could build a universe that summed up the best of their thoughts.

Such genius also rearranged the history of science. Newton, like Kepler and others before him, believed that his laws had unveiled a small part of the mind of God, whose divine geometry opened a window into creation. Thus natural philosophy, as he told Bentley, aimed at "such Principles as might work with considering men for the beleife of a Deity," until it came to the very first Cause.[83] This doctrine supported a strong faith in progress, or a providential history of science that drew philosophy ever nearer to God. Yet there were also unintended consequences. Many historians have argued that Newton's mathematical principles contributed, against his will, to the rise of Deism and a secular worldview.[84] Blake's vision of him as a geometer god, effectively dethroning the one true God revealed by imagination, may be fantastic, but it expresses both the awe and the regret that many people have felt at the triumph of science. Even Pope's admiring epitaph might provoke similar qualms, since the light beaming from Newton, God's surrogate, illuminates Nature, not God. As an emblem of progress, the genius represents the power of the human mind to bend the universe to its conceptions, inventing new technologies and articles of faith of which religion never dreamed. A history of science based on such giant figures was bound to celebrate their individual achievements, whatever their creeds. Such histories of progress leap from mind to mind without assuming any first or final Cause. They venerate the human mind itself.

That way of writing history remains both credible and popular. Yet Bacon had foreseen the idolatry to which it pays tribute. The singularity of Newton's mental voyaging involves him deeply with the Idols of the Cave, the personal outlook that shapes the world as if it were a version of his own mathematical preoccupations. And the glorification of Newton reflects the Idols of the Tribe, when people confirm that man is the measure of things by granting authority to one of their own. A less idolatrous view of genius might return to the various, distinctive talents parceled out unequally among human beings. "One *Science* only will one *Genius* fit," according to Pope's conventional wisdom; "So *vast* is Art, so *narrow* Human Wit."[85] No one owns a permanent or all-embracing system of the world; Newton's gift for mathematics did not extend to the arts. Moreover, no mental power, however great, should be regarded as unique or superhuman. Blake, who thought that everyone carried an inborn spark of poetic genius, detested authorities who sought to impose their own sort of genius on others. A complete human being would delight in a "fourfold vision," four distinct ways of seeing and making the world, and those who saw things in only one way had locked themselves in mind-forged manacles. "May God us keep / From Single vision & Newton's sleep."[86]

A different vision of Newton's genius might also revise some traditional stories about the Scientific Revolution. Instead of reaching a peak with the giant who mounted highest, the progress of science would undergo many ups and downs, without any clear destination. Thus heroic visions of genius might break into different kinds and skills, or even into Hooke's lucky hits of chance. Or alternatively, a historian might imagine science as the product of any number of minds collaborating and entering into one another over time, until together they formed a single great mind or genius compared to which even the mind of Newton might seem no more than a drop in the ocean of truth. Shelley exalts that One Mind as an irresistible force and promise of reform, an idealism he associates with Plato and Bacon.[87] A history written on such principles would focus not on individual lives but on the collective achievements of each era. Whitehead's "century of genius," following Shelley's lead, sometimes comes close to that expansive sense of genius as gathering all that is best in an age. At one extreme, a history of the Scientific Revolution might record a series of new methods, facts, and ideas detached from any particular name. The moons of Jupiter would still be there if Galileo had not named them, and gravity would still exert its force if Hooke and Newton had not lived.

Yet still the vision of Newton casts its spell. It represents not only a model of what one human mind can achieve through prolonged and powerful

thought, but also something unfathomable: the otherness of someone who, as Westfall ruefully confessed, can hardly be measured on the terms or scale of fellow creatures. No one quite knows Newton. Even if one prefers the livelier, more open, and all-too-human genius of Hooke, the legend of otherworldly genius that Newton created cannot be annulled; it is so strong that generations to come will want to attack it. The wonder, the uncanniness, of such a genius corresponds to a moment when everything that people thought they knew about the world proved subject to change. Without it, the Scientific Revolution would be hard to imagine.

Revolution and Its Discontents

The Skeptical Challenge

Rejecting the Starry Message

At first most people did not see what Galileo saw. On the nights of April 24 and 25, 1610, a month after *Sidereus Nuncius* revealed the wonderful little stars around Jupiter, he tried to show them to a distinguished group of observers in Bologna; but when they looked through his spyglass, very few found those wonders. Giovanni Antonio Magini, the eminent astronomer who hosted the gathering, told Galileo that his instrument had deceived him. And even after Galileo received Kepler's enthusiastic testimonial, a few days later, many skeptics continued to resist the starry messenger and his message. Some tried and failed to duplicate his results; others, on principle, would not look at all. A host of correspondents, and more than one book, denied that Jupiter had or could have moons.[1] Galileo was exasperated. "What do you think of the chief philosophers of our gymnasium," he wrote Kepler, "who, with the stubbornness of a viper, did not want to see the planets, the Moon, or the telescope, even though I offered them the opportunity a thousand times?" Enchanted by old texts and indifferent to nature, "they closed their eyes against the light of truth."[2] Eventually the eyes of almost all those doubters would open to the truth of Galileo's moons. Yet he never reconciled himself to the blindness of people who did not see—or think—as he did.

Why were observers unable to see those moons? First of all, most lacked the skill; quite literally, they could not focus. Though Galileo had learned how to use his new, improved spyglass, stopped down to sharpen the image, its field of view was narrow and easily blurred by the slightest motion or breath.[3] Even experienced watchers of the sky, like Magini, were hard to instruct in the proper technique. And others, who made their own instruments and improvised their own ways of observing, perceived very different heavens. Galileo may well have been too quick to accuse those who doubted him of not wanting to see what in fact remained indistinct or invisible to them. But he was not wrong in suspecting many of malice. Magini, a rival astronomer, had reasons and motives for disbelief; and the ambitious young Martin Horkey, also present on that disastrous night in Bologna, later defamed Galileo so viciously that Magini himself was outraged.[4] Furthermore, the bold and proud dedication of Sidereus Nuncius, which did not hesitate to name the new Medicean stars as well as to proclaim the glory of their discovery, seemed calculated to inflame competitors. Galileo's remarkable self-assurance refused to admit the least hint of doubt about the accuracy of his instrument or the immortal significance of what he had found. Addressed specifically to "philosophers, and astronomers," the title page seems to throw down a gauntlet and dare them to disagree. No wonder that so many took up the challenge.

Another obstacle also blocked these "great and exceedingly wonderful sights":[5] in order to see them, many observers would first have to change their minds. The moons of Jupiter were unexpected. They fit no established cosmic theory or system, so that astronomers found no place for them and astrologers and theologians brushed them off. Nor was it only followers of Aristotle and Ptolemy, custodians of immutable celestial spheres, who knew that anything new in the heavens could not possibly be there. Many Copernicans were troubled too. When Kepler first heard about Galileo's discoveries, he was gripped by fear that these unknown "planets" would overthrow his own cherished cosmic scheme, whose tidy Platonic solids could accommodate no more than six planets. Reading Sidereus Nuncius restored him to life; the little moons would not affect his theory—or his astrology.[6] Hence he could accept Galileo's observations sight unseen. If things had not worked out so well, perhaps Kepler would have taken a much harder look. A less friendly reader, Francesco Sizzi, could hardly wait to prove that Galileo's additions to the solar system could not conceivably be real, no matter what the illusive spyglass seemed to show. In fact Sizzi himself, in the presence of Galileo, had gazed through the spyglass and seen a naked Jupiter, without one satellite. There is no reason to question his report. If the moons were invisible to him, the wasted effort need not be blamed exclusively on his poor

eyes, his obstinacy, or a defective instrument. Instead one might consider his theological *outlook*. As students of vision have repeatedly demonstrated, seeing something involves the mind as well as the eyes; we perceive only what we are prepared or accustomed to see. In this respect the moons of Jupiter lay outside Sizzi's horizon of expectations.[7] Many years would have to pass before most people were prepared to share Galileo's vision.

To share that vision, however, meant more than perceiving a few additional features of the sky. It also required a sense of excitement, a thrill like Galileo's own in recognizing that something essential had changed and that the universe would never again be the same. So long as the issue was nothing more than seeing the mottled face of the moon, the tiny stars that sprinkled the Milky War, or Jupiter's moons, Galileo knew that time was on his side. By 1615, when a "Letter to the Grand Duchess Christina" spoke out strongly for his views, he assumed that the facts could no longer be in dispute: "The passage of time has revealed to everyone the truths that I previously set forth." Only the "reckless passion" of his enemies, kindled by personal animus as well as theological fallacies, could account for their perverse refusal to accept what he had discovered.[8] Yet almost as grating were the indifferent onlookers who remained unpersuaded that what he had found was *important*. Even the marvelous spyglass—or "telescope," as it was christened to honor him in 1611—failed to impress them. Many confused it with the miraculous mirrors, supposed to make very distant objects seem near, that had been blazoned in ancient times and that Giovanni Battista della Porta claimed to have perfected in *Natural Magic* (1589).[9] Such prototypes familiarized the spyglass and reduced it to one more *perspicillum*, a device that was known to produce surprising spectacles and deceits. Perhaps the new moons were also clever illusions. In any case this sensational news might prove to be nothing new.

The critics were wrong, of course. But the attitude they represented, a disinclination to suspend disbelief about any radical innovation, withstood heroic efforts to change entrenched ways of thinking or seeing. One popular and influential work, Polydore Vergil's *On Discovery* (1499), attributed virtually every significant invention and discovery to the ancients; and not even revelations of the New World, which Polydore managed to disregard, could attract his attention or loosen his hold on readers. Historically, such obeisance toward the past sets the stage for the protracted, well-publicized quarrel between ancients and moderns. Since ultimately the moderns carried the day, they—and Galileo—had the last word. In retrospect, those who could not or would not admit the importance of the Copernican Revolution have been condemned to a historical graveyard. Yet not all the skeptics can be dismissed as willfully ignorant dogmatists. Some of them deserve

a place among the most intelligent and learned thinkers of their time: for example, Michel de Montaigne, John Donne, and Robert Burton. And their skepticism expresses much more than a reactionary response to the threat of progress. In many ways, one might argue, it exposes a critical tension within the new philosophy itself.

Under the Sun

Consider Montaigne. His credentials as a Renaissance man and corrosive skeptic can hardly be questioned. The widespread influence of his writings helped shake dogmatic certainties about truth and error or right and wrong.[10] The Old World could learn from the New, he thought; his famous essay "Of Cannibals" concludes that Europeans surpass "barbarians" in cruelty, since "there is more barbarity in eating a man alive than in eating him dead."[11] From one point of view, this open-mindedness might mark Montaigne as a quintessential modern. Yet the same ways of thinking ward off any claim that "novelties and reforms" in natural philosophy have established trustworthy knowledge. In the "Apology for Raymond Sebond" (1575–80), the motto "What do I know?" subverts Copernicus as well as Aristotle. "The sky and the stars have been moving for three thousand years; everybody had so believed" until a few ancients maintained that it was the earth that moved; "and in our day Copernicus has grounded this doctrine so well that he uses it very systematically for all astronomical deductions. What are we to get out of that, unless that we should not bother which of the two is so? And who knows whether a third opinion, a thousand years from now, will not overthrow the preceding two?"[12] A similar line of reasoning cautions against adhering to any new doctrine, whether in medicine, physics, geometry, or even geography. If a great man like Ptolemy mistook the limits of the world, why should we trust any present-day map?

A two-edged sword, this unsheathed skepticism cuts in opposite directions. Montaigne's undoing of "Natural Theology," which he himself had translated from Sebond's Latin, has often been taken as a rebuke to those who track God in the world, but it might better serve to undermine any firm belief in the stability of nature or nature's laws.[13] Pyrrhonism and relativism leave no knowledge safely standing. Aristotle had once represented the truth about nature on which the church and the philosopher could depend, and later corrections of Aristotle might try to replace his certainties with proofs that would last forever; but in the long run these too would fall. The same arguments that cast a cold eye on ancient authority could look down on modern mathematics. Moreover, ancient authors were Montaigne's companions.

Steeped in classical literature, he effortlessly combines his own experience with the wisdom he culls from their texts. Above all, that wisdom teaches him the folly of human presumption.[14] New theories may be entertaining, but no well-read person ought to be startled or captivated by them. Despite his suspicion of Aristotle's aura as "the god of scholastic knowledge," Montaigne does approve one maxim: "Aristotle attributes wondering at nothing to greatness of soul."[15] Superior souls refuse to be impressed by prodigies such as the "great and exceedingly wonderful sights" that Galileo would reveal to the next generation; and many followers of Montaigne made their indifference to new discoveries a point of pride. Yet the skepticism that was to shape the minds of such thinkers as Marin Mersenne and Pierre Gassendi also drove them to search for a "science without metaphysics"—provisional knowledge that did not claim to explain the final nature of things.[16] Philosophers, they thought, should be content with useful, pragmatic, more-or-less adequate systems of the world; they did not need to know ultimate truths in order to reason rightly about the phenomena grasped or composed by the senses. In this way Montaigne anticipated both those who attacked the new philosophy and those who saved it.

Montaigne did not live to see the telescope, which he might well have scoffed at as one more deceit of the senses.[17] But Donne was thoroughly acquainted with the new philosophy and with Galileo, "who of late hath summoned the other worlds, the Stars to come neerer to him, and give him an account of themselves."[18] Donne's imagination roamed freely among the odd and intriguing facts and fancies disseminated by traditional authorities as well as by present-day philosophers; all these could furnish materials for lively conceits. As a young man, he moved in advanced intellectual circles. He may have known Thomas Harriot, the English polymath who corresponded with Kepler and sketched the moon, from his own telescopic sightings, before Galileo had made it his own.[19] By 1610, Donne was certainly familiar with the leading English contribution to the new philosophy, Gilbert's *De Magnete* (1600), which extended its study of the loadstone into the motions of the earth and the cosmos.[20] Soon after Kepler's *De Stella Nova* (1606) appeared, Donne read it and absorbed its lesson that new stars or nova had exploded the ossified Aristotelian dogma of unalterable heavens.[21] Thus he was prepared for Galileo's message; *Ignatius His Conclave*, written when *Sidereus Nuncius* was still hot off the press, refers to its discoveries with clever and knowing asides. Clearly these new findings fascinate Donne. Yet he is also a skeptic. Although he does not deny the truth of what those starry-eyed philosophers have seen, their enthusiasm fails to infect him. Galileo's glasses may have brought the moon near, but wit and irony, Donne's own lenses, keep it at a distance.

Many habits of mind conspire against allegiance to the new philosophy as Donne perceives it. First, as a poet, he relishes difficult puzzles far more than hard facts. What interests him most about the reorganized modern heavens seems to be the bewildering theological questions they pose. *Ignatius His Conclave* begins with an out-of-body experience or *Extasie* in which the author wanders through the cosmos "to survey and reckon all the roomes, and all the volumes of the heavens, and to comprehend the situation, the dimensions, the nature, the people, and the policy, both of the swimming Ilands, the *Planets*, and of all those which are fixed in the firmament."[22] Galileo and Kepler map out this voyage. But it is not so much the idea of space travel that stirs Donne's imagination as the idea that other planets are peopled.[23] Bruno's heretical speculations had raised the problem of whether Christ had brought salvation to those planets as well as to Earth—a dangerous line of thought. Yet such problems do not provoke Donne to find a solution but rather tempt him to conjure up a metaphor or a poem. When the new philosophy clashes with biblical orthodoxy, the cognitive dissonance challenges him to wrap his mind around both:

> At the round earths imagin'd corners, blow
> Your trumpets, Angells, and arise, arise
> From death, you numberlesse infinities
> Of soules, and to your scattred bodies goe.[24]

Impossibilities attract this poet. The contradiction between the four-cornered earth in Revelation and the round earth of modern times, as well as the mind-bending perplexity of imagining how souls will reunite with bits and pieces of bodies at the Last Judgment, serve only to whet his appetite for paradox and poems. Nor does the actual roundness of the earth, or any knowledge of atomism, impede his metaphysical faith.

Moreover, he reduces cosmic discoveries to human dimensions. That is a second reason why he receives the new philosophy without conviction. All things in nature had been created by God, as scripture and science then agreed, to serve their master, man. In Donne's poetic and religious universe, the wonders revealed by Galileo and others mean little or nothing unless they cast light on the personal issues of love and salvation. The lovers of "The Canonization" extract "the whole worlds soule," so that the glasses of their eyes reflect the whole world; the lovers of "The Sunne Rising" tell the sun that since the world is contracted in them, he fulfills his duty by warming them alone. Again and again the microcosm of the self engulfs the macrocosm. Such megalomania should not be dismissed as a playful rhetorical flourish. It touches the gravest issues for Donne, the gulf between salvation

and damnation, the harrowing personal fate in the face of which the physical nature of the universe shrinks to insignificance. Each soul weighs more than Jupiter's moons.[25]

When Donne confronts the new philosophy directly and at length, in *The First Anniversarie: An Anatomy of the World* (1611), the current state of the heavens and earth is notoriously encapsulated in the death of one young woman. Coherence vanishes; the firmament is torn; the sun is lost; the earth encroaches on the sky. It is as if Elizabeth Drury's death, like the sin of Adam and Eve or the crucifixion of Christ, had power to shock the whole system of things and corrupt all nature. One might accuse Donne of a category mistake; if the poem had been written about the Virgin Mary, Ben Jonson told him, "it had been something."[26] But human perceptions hold the universe captive in these dark days, according to Donne: "We spur, we raine the stars, and in their race / They're diversly content t'obey our pace." When he refers to Copernicus, Galileo, and Kepler, he regularly accuses them of thinking that they are in charge of the heavens, not merely observers; in *Ignatius His Conclave*, Copernicus claims that he "was a Soule to the Earth, and gave it motion."[27] Delusions like these convict the new philosophers of self-satisfied pride. Yet they also reflect the poet's own imagination, where the world often seems no more than the fate of one person writ large.

What Elizabeth Drury represents most of all, however, is primal innocence, a spirit and body as free from sin as those of her counterpart, the immaculate Virgin. *An Anatomy of the World* exposes a universal decay, precipitated by the Fall and gathering force through the centuries until Donne's time, which has apparently lost its only surviving model of a pure soul. This inexorable, unstoppable decay provides the ultimate reason for Donne's skepticism about developments in natural philosophy. Each new discovery, which to Kepler had promised an age of awe-inspiring progress and to Bacon the possibility of recovering the golden age of mankind, confirms Donne's diagnosis of a world in its last throes. "Proportion," a word repeated nine times in the poem, has been disfigured or discarded, and all colors have faded. "The opinion of the Worlds Decay" was hardly original then. It was so generally received, according to George Hakewill, that his crusade against it amounted to a declaration of war against the learned and vulgar alike.[28] But Donne goes further: the advancement of learning itself, in a headlong reversal, turns into the best proof of decay. Whatever the mind of a new philosopher touches loses its life and shrivels to dust; spyglasses reconnoiter the heavens only to bring them down. Donne's skepticism heightens his interest in innovations precisely because they accelerate decay and draw the Last Judgment closer.

In the meantime the new philosophy also provides a rich source of amusement. *The Anatomy of Melancholy*, Robert Burton's masterpiece, delves into each byway of learning in pursuit of distraction. Burton, five years younger than Donne but far more settled in life—elected a student (or fellow) of Christ Church, Oxford, in 1599, he stayed there until his death in 1640— enjoys being a skeptic. "A Digression of the Ayre," included in the first edition of 1621, kept growing through four more editions during Burton's life and one more after his death, but he never made up his mind about the astronomical theories he recounted. Instead he asks endless questions while remarking that scholars differ on every point. All is in flux.

> There are that observe new motions of the Heavens, new Starres, *palantia sydera* [wandering stars], Comets, Clouds, call them what you will, like those *Medecean, Burbonian, Austrian* planets lately detected, which doe not decay, but come and goe, rise higher and lower, hide and shew themselves amongst the fixed starres, amongst the Planets, above and beneath the Moon, at set times, now nearer, now farther off, together, asunder; as he that playes upon a Sagbut by pulling it up and downe alters his tones and tunes, do they their stations and places, though to us undiscerned; and from these motions, proceed (as they conceave) diverse alterations.[29]

The long run-on sentence itself enacts the fitful movements it describes. At the same time, observers seem mixed with the things they observe. Who are "they" in the last two clauses? Are stargazers compared to a sackbut player who slides like a trombonist from note to note, or do the stars themselves alter their tunes and places? The far-fetched simile, involving the player as well as the music played, keeps both possibilities open. "Undiscerned" suggests that the stars are "they," whose stations are independent of any viewer; but "they" who conceive in the parenthesis are clearly stargazers. Burton will not commit himself to any firm decision about whether the new philosophy describes real motions in the heavens or perturbations in the minds of observers. At play in the fields of multiple texts, he brings the sky down to his study.[30]

Nevertheless, astronomical controversies do serve a useful practical purpose for Burton: by running riot in his head, they chase his blues away. *The Anatomy of Melancholy* delivers no final cure for the morbid fancies and fears that are its great subject, but it is full of remedies and placebos. Democritus Junior, whose name appears on the title page in lieu of Burton's, appreciates madness; he specializes in laughing at folly. The new philosophers wonderfully play his game. Building castles in air, astronomers exemplify not only

the obsessions of melancholy but also its pleasures.[31] Burton comprehends both. "A Digression of the Ayre" smiles at the many learned men who have invented and defended "absurd and ridiculous" things like the extravagant epicycles that they maintain to be real orbs: "For who is so mad to thinke, that there should be so many circles, like subordinate wheeles in a clock, all impenetrable and hard, as they faine, adde and subtract at their pleasure."[32] Once again the theorist mocked by Burton mistakes his own castles in the air for God's creation, as if a human hand had framed the clockwork universe. The epicycle is a perfect instance of the philosophy that entertains Democritus Junior. It exists only in the dreams of unworldly scholars, whose eccentric and wandering thoughts spin out cosmic gyrations in their own image.

Yet Burton himself is susceptible to wild flights of fancy. The notion of a plurality of worlds enchants him, especially since he expects the inhabitants of those worlds to share the madness of earth. Copernicus, Gilbert, and Kepler regard the earth as a kind of moon, according to Democritus Junior, and "if it bee so, that the Earth is a Moone, then are we also giddy, vertigenous, and lunaticke within this sublunarie Maze."[33] At the end of "A Digression of the Ayre," Burton launches into a torrent of speculations about the puzzles raised by new maps of the heavens. Both ancients and moderns lend him wings. Lucian's *True History*, along with Campanella's *Apologia pro Galileo* (1622) and Kepler's *Somnium* (1634), turned Burton's thoughts to the moon, where voyagers might find outlandish worlds, and he lived long enough to read John Wilkins's *Discovery of a New World* (1638).[34] But the "Digression" daringly pushes its space probe into transcendent realms of mystery. Pagans and other overreachers have wanted to "soare higher yet, and see what God himselfe doth." Where did he bide before the world was made? What are the limits of his power, and "why lets hee all things be done by fortune & chance?" Burton's daring finally frightens himself. "But hoo? I am now gone quite out of sight, I am almost giddy with roving about: I could have ranged farther yet; but I am an infant, and not able to dive into these profundities, or sound these depths, not able to understand, much lesse to discusse."[35] He folds his wings at last and comes down to earth.

In fact he had never committed himself to the emerging cosmology of his time. The conjectures that stuff the "Digression" draw on famous living astronomers but also on cranks as well as a great many ancients. Burton superintends a vast republic of print in which any opinion in any era often seems just as welcome as any other. In the last analysis he leaves decisions about the heavens to "stronger wits" and the future. Significantly, when Burton does admit a weak version of progress—"The day will perhaps come when things that are now obscure will be made plain through the labors of

succeeding ages"—he borrows Seneca's Latin to make the point.[36] Ancient philosophers may well have understood more than moderns do. God alone knows the truth, and "when God sees his time, hee will reveale these mysteries to mortall men, and shew that to some few at last, which hee hath concealed so long." Meanwhile knowledge ebbs and flows like the sea, or like the heavens themselves. A good skeptic shuffles his texts and moves on. In the end the "Digression" stoops to timeless wisdom. "When you have all done, as the Preacher concluded, *Nihil est sub sole novum.*"[37] There is nothing new under the sun.

Beholding the Nothing That Is

"Revolution," for Burton, still means that the world goes in endless circles; the idea that his age had brought about a "Scientific Revolution" would not have made sense to him.[38] A similar doubt persists today. "There was no such thing as the Scientific Revolution," Steven Shapin's popular survey begins, "and this is a book about it."[39] A paradox and a commonplace meet in that sentence. For more than two decades, historians of science have been expressing misgivings about "the Scientific Revolution" as a phrase and a "thing." Yet a great many of them continue to write about it. The term seems to retain its interest and even a certain glamour despite some determined efforts to hollow it out. Thus books intended to instruct the general public still adopt not only the phrase, as Shapin does, but also the assumptions on which it was based and which once seemed so firm: *The Scientific Revolution and the Origins of Modern Science,* and *The Scientific Revolution and the Foundations of Modern Science.*[40] Both titles acknowledge the influence of Herbert Butterfield's *Origins of Modern Science, 1300–1800* (1949), a text that is often credited, or blamed, with popularizing the view that the Scientific Revolution changed the world forever, "since it changed the character of men's habitual mental operations even in the conduct of the non-material sciences, while transforming the whole diagram of the physical universe and the very texture of human life itself."[41] Many readers still hold fast to that view, which seems as self-evident to them as the Preacher's wisdom once seemed to Burton. In the wake of Butterfield, the history of science took on the task of imagining, or demonstrating, what happened in the Scientific Revolution.[42] Yet later historians have often been inclined to imagine something else: that the revolution might never have happened, or that there was no such thing.

What accounts for such a dramatic reversal? To some extent the war has been fought over words. The meanings of "scientific" and "revolution" during the seventeenth century had little to do with the meanings and connotations

attached to them two centuries later, so that their fusion compounds an anachronism. Even Butterfield, on the first page of his book, referred to "the so-called 'scientific revolution'," a catchall term that he extended back to 1300. Moreover, the verbal anachronism sows the seeds of a more profound misunderstanding, the notion that early thinkers shared the interests and disciplinary concerns of future "scientists." Historians who focus on the Scientific Revolution are always tempted to regard it as a harbinger of things to come, as if the value of work in any field depended entirely on what some later generation made of it.[43] Such attitudes distort the complicated processes—the mixture of inherited assumptions, limited data, and the practices and instruments of the workshop—that shape the way that nature might be conceived at any given time. Still worse, whatever fails to fit the retrospective modern narrative is apt to be discarded. Notoriously, the alchemical and theological studies on which Newton spent most of his life remained invisible for centuries and continue to smudge the clear line of his cosmic achievements. When Betty Jo Dobbs, an expert on alchemy, considered the stock use of Newton as Final Cause or synthesis of *the* Scientific Revolution, she saw a teleological story that falsified the historical record as well as Newton's own valiant efforts to stem the tide of irreligion. The time had come, she thought, to cast aside Butterfield's model.[44]

A host of other arguments support that attack. One major problem is that the Scientific Revolution has proved so difficult to date. In Butterfield's reckoning it sprawled through 500 years, which seems a very leisurely course for any dramatic and drastic change. Perhaps the phrase represents no particular historical moment but rather a continuous, glacial shift in ways of thinking, going back at least to the Greeks and forward to our own times and beyond, as human beings redefine their world.[45] Nor is the *what* of the Revolution any easier to categorize than the *when*. So long as "science" refers to fields where the Book of Nature, as Galileo insisted, "is written in the language of mathematics"—fields such as physics, astronomy, and mechanics—a relatively coherent story can be told. But other fields—such as chemistry, biology, and medicine—seem to be written in other languages, and their stories obey very different patterns and sequences of historical change. From this point of view, the capitalized "Scientific" imposes a rigid uniformity on heterogeneous methods and operations. Moreover, it flaunts a twentieth-century bias, when all sorts of fields seemed to be ranked on a scale topped by physics, the "paradigm science" (a hierarchy that lately has been undermined by rising life sciences and the ascension of Darwin). And one more argument confirms the vulnerability of the old model. A number of scholars now propose that the decisive turn or era of change arrived well after the seventeenth

century: "The period 1760–1848 is a much more convincing place to locate the invention of science." Older historians, on this view, had dwelt on a revolution *within* science, which they conceived as a timeless, transcendent enterprise; but a better understanding of science would embed it in culture, as something "distinct and specific to our own region of time and space"—a product of the Age of Revolutions.[46] Both literally and metaphorically, the energy and electricity that power modern science played no part in the Scientific Revolution.

None of these arguments would be so persuasive, however, without the context in which they arose: a general skepticism toward Grand Theories or claims about the central role of science in history. Just as Galileo had to convince the skeptics of his time that his discoveries were not only real but also *exciting*, so twentieth-century historians of science tried to convey not only that something had happened in the seventeenth century but also that that something was supremely important. When Alexandre Koyré defined the Scientific Revolution in 1939, he declared that, by dissolving the cosmos and geometrizing space, it had brought about a radically new ontology—not merely particular insights, but a decisive "mutation" in human thought.[47] For better or worse, Galileo and his successors had transformed the very nature of things. A similar excitement pervades Butterfield's book, which begins by affirming its own importance: "Considering the part played by the sciences in the story of our Western civilisation, it is hardly possible to doubt the importance which the history of science will sooner or later acquire both in its own right and as the bridge which has been so long needed between the Arts and the Sciences." For a few decades that vast ambition seemed reasonable. The prestige of science, fortified by the stirring word "revolution," offered an opportunity for a young field, the history of science, to win a place among the disciplines and perhaps to revolutionize education. Thomas Kuhn's influential, best-selling books, *The Copernican Revolution* (1957) and *The Structure of Scientific Revolutions* (1962), implicitly and explicitly adopt Butterfield's program.[48] In academic circles, and far beyond them, the impact of the Scientific Revolution supplied a template, or "paradigm," for other historical narratives. The term "paradigm shift" soon came to be used so routinely, in the arts as well as the sciences, as to lose almost any particular meaning.[49] Yet even the controversies that swirled around this way of writing history confirmed the excitement that it provoked.

Long before the end of the century, that sense of excitement had faded. Whether or not there was such a thing as the Scientific Revolution, it was no longer the single story that gave the history of science its interest and reason

for being. Shapin begins his account with a few pages that explain why the encrusted, traditional views of Koyré and Butterfield will not be repeated by him; and Peter Dear's well-informed, up-to-date survey, *Revolutionizing the Sciences*, ignores them and Kuhn.[50] From a scholarly standpoint, Galileo's discoveries now seemed less an earthshaking convulsion than one intriguing event in a process with no definitive beginning or end. Nor did historians of science have any exclusive right to describe that process. As the heroic story of intellectual giants and shattered worldviews lost some of its magic, it yielded to a sociological emphasis on practices, institutions, and networks. Kuhn's own work came to look, through a rearview mirror, like a transition from grand narratives of change to a focus on the communities and situations that make change possible.[51] By the end of the 1980s, not only sociologists but also many historians and other scholars who studied science became associated with "constructivism": an outlook "which regards scientific knowledge primarily as a human product, made with locally situated cultural and material resources, rather than as simply the revelation of a pre-given order of nature."[52] This cast a different light on revolutions. If Galileo pictured himself as someone who had risen above the usual sphere of mortals, he made a mistake; nor had Newton uniquely revealed the truth about nature. Each of them depended on tools made by other people. That was the human condition that each occasionally denied to his cost.

Yet no new story has had power to replace the luster of the Scientific Revolution. While scholarship has flourished in two academic fields, science studies and the history of science, the teeming and sometimes compelling micronarratives they have produced still fail to cohere.[53] Constructivism, which once seemed so fresh, has run up against its own limits. One problem may be its adverbs: in the definition quoted above, "primarily" and "simply" function to impugn any truth about nature that might not be "locally" situated. Constructivists insist that science is "never pure";[54] the knowledge that it gives vent to is made or constructed rather than found, and hardly "the revelation of a pre-given order of nature." That phrase itself suggests a high-minded, timeless ideal, as if science purported to be a kind of religion. Scientists tend to resent the scare quotes of constructivist language, which hints that they are naive or self-deceived in their solid respect for facts and things and in their devotion to truth. Contemporary enemies of science can all too easily appropriate the argument that scientific views are merely relative and contingent.[55] Moreover, that argument has undermined the bridges between past and present, the sustained and continuous narratives on which historical thinking once depended. Not many years ago, in 1998, the "constructivist's bible" ended with a sentence full of promise: "Rather than regretting the

passing of the comforting old stories of scientific progress, we should there-
fore embrace with eagerness the prospect of entirely new ones."[56] But today
the prospect seems dimmer. Only one major story now rivals Butterfield's
fable of progress: the story of impending cataclysmic decline, in which scien-
tific knowledge brings on or fails to prevent the end of the world.

More modestly, any storyteller might find it almost impossible to imagine
"no such thing." The Scientific Revolution obstinately holds its place as a
term and an index of concrete achievements, and scholars may write it off
but cannot unwrite it. Even skeptics succumb to its gravitational pull. Shapin's
account of the no such thing he calls the Scientific Revolution deplores the
"fables and myths" that prop up its claim to fame, but he too has a story to
tell: a "cultural legacy," connecting the past to the present, that has identified
the modern natural sciences with "the *depersonalization* of nature" and the
production of "*disinterested*" knowledge.[57] Despite all efforts to take account
of contrary narratives, a conventional stress on mathematics and mechanism
provides the central thread of his story, and in the absence of "progress," the
notion of "inheritance" or "legacy" supplies a satisfying denouement. Per-
haps that narrative is less exciting, in a postmodern way, than the triumph of
enlightenment that once inspired many historians and their readers.[58] More
recent accounts have featured a host of subplots, above all the seventeenth-
century controversies that pitted natural philosophers against one another
and often left the issues unresolved. Hobbes's disputes with Descartes, with
Boyle, and with John Wallis, for instance, might each set the stage for a
lively scene in a play.[59] Yet the overriding drama, which still draws audiences,
involves a struggle against authorities who denied that there might be some-
thing new under the sun, and who refused to admit that things could change.
Galileo's persecution by the church continues to grip the imagination; even
scholars who question the rights and wrongs of the case contribute to the
sense of its importance. Hence the story of revolution has a life of its own,
not least when skeptics try to keep from thinking about it.

Nevertheless, imagining no such thing can be a useful way to enter the
minds of many seventeenth-century thinkers. A proliferation of doubts, a
skepticism that goes all the way down, a capacity to view the natural world
and the world of knowledge as empty of anything certain or solid, all clear
the ground for revolutions to come. "I realized that it was necessary, once
in the course of my life, to demolish everything completely and start again
right from the foundations if I wanted to establish anything at all in the sci-
ences that was stable and likely to last."[60] Descartes notoriously excelled at
imagining no such thing. Although in the end he did not doubt the existence
of God, reality itself might be questioned: "How do I know that he has not

brought it about that there is no earth, no sky, no extended thing, no shape, no size, no place, while at the same time ensuring that all these things appear to me to exist just as they do now?" These doubts proved too extreme for Descartes himself, who dispelled them with the thought that "God is not a deceiver."[61] Yet other philosophers and naturalists also began by questioning not only received opinion but even the reliability of everyday experiences. *Nullius in Verba*, the famous motto of the Royal Society, often extends its suspicions to *res* as well as to *verba*, envisioning no such "thing" as well as no adequate "words." When Bacon imagined an ideal student of natural history, he thought of a child who had yet to master his ABCs, and whose lack of experience perfectly matched his invaluable lack of erudition.[62] Nothing served better than a clean slate to prepare the advancement of learning.

Hence skepticism about the existence of the Scientific Revolution responds to a skepticism at the heart of the revolution itself. When Galileo, Bacon, Descartes, and Newton and their colleagues became the revered authorities on whose work modern science was built, they also became the targets for doubts like their own. Similarly, the idea of progress devours those who set it in motion. Kepler imagines a distant time when people will finally comprehend his laws, but not a time when the cosmos he knew will be absorbed into something he could not imagine. In this respect the methods and dreams of the Scientific Revolution extinguished themselves. Most of the answers provided then lasted only a while, but the spirit of questioning would go on forever. There is no end to this inquisition; it tears a hole in any attempt to close the book on seventeenth-century thinkers. A series of questions both constitute the Scientific Revolution and reduce it to nothing. Yet somehow it still seems important.

Imagining Something Important

What makes something seem important? At the beginning of his *Apologie for Poetrie*, Sir Philip Sidney remembers the lesson he learned from an ardent horseman, "that self-love is better than any gilding to make that seem gorgeous wherein ourselves are parties."[63] He proceeds, therefore, to aggrandize his own "unelected vocation," and argues that poetry surpasses all other sciences and arts, because the poet alone makes things even better "than Nature bringeth forth." This witty special pleading drives home a serious point. As Bacon would soon contend in *The Advancement of Learning*, the time had come to reexamine traditional kinds and classifications of knowledge, and those who had mastered a discipline had a stake in advancing its cause. Sidney was not the only humanist who thought that poetry deserved a very

high place in the ranks of learning—perhaps above philosophy and history.[64] Bacon acknowledged that view. But his own self-love steered him in another direction, toward a great instauration or new organon of learning, in which natural history would become the foundation of a true and active philosophy.[65] This was work fit for a king; and nothing could be more important.

That sense of importance pervades the minds that made the new philosophy. One might attribute it to the inflated self-regard of individuals: to Tycho's identification with Atlas, who held up the world; or to Bacon's grandeur as a temporary head of state; or to Galileo's arrogant combination of vision and blindness; or to Descartes's confidence that one man, thinking for himself, could accomplish more than all the schools; or even to Robert Fludd's belief that he knew everything worth knowing. But self-regard alone cannot explain the growing importance ascribed to natural philosophy and to its masters. The hierarchy of sciences was shifting too, in a long transition that would eventually deny the name of "scientist" to most scholars. In medieval universities, the curriculum had been headed by the quadrivium of mathematical arts—arithmetic, geometry, astronomy, and music—whose prestige depended largely on their serene uninvolvement with any practical reality. Mathematics, Aristotle maintained, had nothing to do with Plato's pure, supremely real Forms; instead it manipulated artificial, unchanging abstractions.[66] Hence Scholastic students of music learned harmonics, not music making, and students of astronomy learned to calculate heavenly ciphers, not to watch fluctuations in the sky. Profoundly unworldly, the mathematical arts bore witness to fixed and permanent rules: to numbers and their relations, to the movements of spotless, obedient spheres, to fine-tuned music that no one could hear. None of these, unlike the existence of mere mortals, was subject to fortune.[67] But seventeenth-century mathematics represented a changing world as well as heavenly revolutions. Its claim to importance depended on finding new things and actively unsettling the bedrock of what the schools once thought they knew.

Common knowledge itself, moreover, came under attack. The principles of natural philosophy, according to Aristotle, were based on experiences familiar and accessible to everyone. Stones fell because they were heavy; that was apparent to all. But Galileo had another idea, and he was willing not only to test it but also to found a new science on it. Whether or not he did drop two balls—one heavy, one light—from the Leaning Tower of Pisa to prove that they would fall at the same rate, by 1604 he had stated a law that refuted what Aristotle and everyone knew and prepared the way for modern mechanics and physics: bodies fall with a uniformly accelerated motion.[68] Common opinion was wrong, and it had been refuted by the

counterintuitive thoughts and actions of one individual. Eventually Galileo would confirm his findings in his last work, the dialogues *Two New Sciences* (1638), whose publisher marveled at the wonderful properties of motion, "none of which has been previously discovered or demonstrated by anyone"; this subject was "among the most important in nature."[69] Here two kinds of importance come together: the central place of motion in theories of nature, "an age-old subject," veers into something new through the insights of Galileo, who prides himself on having "opened a gateway and a road to a large and excellent science of which these labors of ours shall be the elements, [a science] into which minds more piercing than mine shall penetrate to recesses still deeper."[70] Motion makes the universe go round, but Galileo alone has transfigured it into a science.[71] Important subjects create and are created by important persons.

In some respects this way of making knowledge seems oddly personal. Most seventeenth-century philosophers denounced the old Scholastic emphasis on disputation, which reduced the principles of nature to debating points that a skilled sophist could turn to advantage, whatever the truth might be. Cooperation, not competition, would lead to the true advancement of learning, according to Bacon. Moreover, the growing ascendancy of mathematics, as in Galileo's studies of motion, provided explanations of phenomena that were quite independent of any human agent. People could no longer read signs of themselves in nature, and subjectivity had to be purged from credible observations.[72] At the same time, however, cults of personality sprang up around some central figures. Not many philosophers commanded the mathematical skills required for the new understandings of nature, and those who did, like Newton, seemed superior beings. The burst of new experiments also served to magnify some individuals. In theory a good experiment demonstrated a general truth and anyone could repeat it. But in practice most crucial experiments were performed in private—if they were performed at all—by virtuosi who wanted to test or prove some favorite thesis. Unlike the common experiences that once had verified what was known, these were singular events. Unsympathetic rivals often denied them. Had Galileo rolled balls down inclined planes? Had Pascal's brother-in-law ascended the Puy-de-Dôme to measure the height of mercury in a Torricellian tube? Had Boyle's air pump evacuated all the air and produced a vacuum? Had Newton's prisms settled questions about the true nature of light? Not everyone accepted the facts, let alone the hypotheses they were designed to prove.[73] Yet even those doubts reinforced the sense that such experiments were *exceptional*—bold and far-reaching, perhaps unique as well. Eventually both the events and the people who contrived them assumed a legendary importance.

If nature had been depersonalized, the persons who had solved some of its puzzles seemed more vivid than ever.

Nor were those natural philosophers unaware of their own importance. The new philosophy encouraged its practitioners to think that they could make the most of nature or even conquer it. As interest shifted from knowing *why* to knowing *how*, from causes to effects, the practical consequences of learning became apparent. If the world itself was a machine, then those who understood it could build better machines. In that case power would accrue to them. Bacon's utopia, the New Atlantis, is formally a monarchy, but the power behind the throne is Salomon's House, a scientific institute—"The Noblest Foundation, (as wee thinke), that ever was upon the Earth; And the Lanthorne of this Kingdome"—which is devoted to "the Enlarging of the bounds of *Humane Empire*, to the Effecting of all Things possible."[74] Already a man of learning could dream of a time when he might command an empire that embraced all human beings, and when monarchs would bow to him and his kind. At any rate philosophers felt authorized to imagine new ways of doing things and to devise their own methods to carry them through. "It is probably fair to say that every one of the new philosophical scientists thought he was a unique genius, despite many seemingly humble protestations to the contrary."[75] In this respect Newton's ostentatious modesty sets just the right tone: "I don't know what I may seem to the world" comes easily off the tongue of someone who knows quite well how much the world values his pretty pebbles and shells. He had written, after all, his very own *System of the World*; both socially and celestially, the world revolved around him.

The public also fell under the spell of importance. As the fame of Galileo, Bacon, Descartes, and Newton spread through Europe and beyond, a rich mythology enhanced their achievements, fostered by poets as well as by would-be heirs. These great men were *founders*, and those who came after acknowledged their debts. To some extent the leading natural philosophers had helped to create their own aura; intentionally or not, they managed to stand where the limelight would fall. Galileo's own writings directed Marino and Viviani in their efforts to inscribe him in the sky, and Bacon taught Cowley how to picture him as a new Moses, a guide to the Promised Land. Thus the modern view that credits such founding fathers with having forever altered perceptions of nature was already well established in the late seventeenth century. A clear track leads from Viviani's hagiography to the extravagant popular claims of our own time: "God created the world. Galileo re-created it."[76] This dramatic sense of importance may well be the most lasting legacy of the Scientific Revolution. Any number of books continue to tell the story of irreversible change, when a handful of inquiring minds

dismantled old authorities and old ways of thinking and brought what we now call science into being. Sometimes this story represents heroic and desirable progress; sometimes, a fatal rupture that has emptied life of its meaning. But the story itself endures.

Few narratives have had more power to account for modern history as if, in imagination, it made sense. From Faust to Frankenstein, the questing natural philosopher exemplifies not only what people fear but also what they want, the knowledge that carries them on a swift current into the future. Ostensibly these cautionary tales denounce the hubris of mad scientists, but a secret message is tucked inside: the lure of technological advances that might improve everyone's life. Faust invented the printing press (according to Heinrich Heine)[77] and paved the way to the World Wide Web; the children of Frankenstein have evolved into test-tube babies. Meanwhile the legendary status of early protoscientists grows. The spacecraft Galileo has explored the moons of Jupiter, and relics of Galileo rival those of saints.[78] The Kepler satellite, launched by NASA in 2009, has telescopically probed the Milky Way for signs of planets that might support extraterrestrial life. The names themselves speak of exploration and wonder, and those associations cannot be erased. Even more than the discovery of the New World, the discovery of a new universe and a new sense of human possibilities is a story so well established that those who challenge it can also take pride in doing something important. The meaning of modernity and the ways that modern people define themselves depend on the Scientific Revolution. If it did not exist—and perhaps it did not—its place would have to be filled by another story.

☙ APPENDIX 1

Galileo
The Fable of Sound

From *Il saggiatore* (*The Assayer*, 1623)

Through long experience I have observed—such is the human condition in regard to intellectual things—that the less someone understands and knows, so much the more insistently he wants to speak up; and that, on the contrary, the multitude of things someone recognizes and understands makes him slower and more hesitant to pontificate about something new. Once upon a time, in a quite solitary place, a man was born blessed by nature with a very perspicacious brain and an extraordinary curiosity; and for his amusement he raised several birds, enthralled by their song, and with the greatest wonder he used to observe the lovely artfulness with which at will they would transform the very air they breathed into various songs, and all surpassingly sweet. One night near his house he happened to hear a delicate sound, nor could he imagine what it could be other than some little bird, which he set out to catch; and coming to a road found a young shepherd who, blowing into a piece of perforated wood and moving his fingers over the wood, sometimes closing and sometimes opening some of the holes there, drew out from it those different voices, similar to those of a bird but produced in a very different way. Amazed, and moved by his natural curiosity, he gave the shepherd a calf to get that pipe; and retiring into himself, and considering that if he had not happened to come across that person, he would never have learned that

in nature there were two ways of forming sweet voices and songs, he decided to leave home, deeming he might be able to meet with some other adventure. And chancing the following day to pass near a little hovel, he heard a similar voice resounding within; and to establish whether it was a pipe or just a blackbird, he went inside, and found a boy occupied with a bow that he held in his right hand, sawing some sinews stretched over a concave piece of wood, and with his left supporting the instrument and moving his fingers over it, and without any breath thus drawing from it different and very sweet voices. Now what was his amazement! judge that if you partake of the insight and curiosity of such a person; who, seeing that he had happened on two new and totally unexpected ways of forming voice and song, began to believe that still others might have the power to exist in nature. But what was his wonder when, entering a certain temple, he looked behind the door to see what had made a sound, and realized that the sound came out of the hinges and couplings when the door opened? Another time, driven by curiosity, he entered an inn and, expecting to see someone who with a bow lightly touched the strings of a violin, saw someone rubbing the tip of a finger on the rim of a glass, prying out of it an extremely sweet sound. But when later he came to observe that wasps, mosquitoes, and flies did not, like his birds earlier, form voices with intermittent breath, but with very fast beating of wings sent out an incessant sound, how much his astonishment grew! so much as to shrink the conviction he had that he knew how sound is produced. Nor could all his experience up to then have been enough to make him comprehend or believe that crickets, although they do not fly, have the power, not through breath but through shaking their wings, to send forth such sweet and sonorous trills. But when he came to believe that it could scarcely be possible that there could be other manners of forming voices—after having observed, in addition to the ways already recounted, so many more organs, bugles, fifes, stringed instruments, of so many sorts, as far as that little iron reed that, suspended from the teeth, in a strange way makes from the cavity of the mouth a resonance throughout the body, and from the breath a vehicle of sound— when, I say, he believed that he had seen everything, he found himself more than ever turned back to ignorance and amazement when he happened to take in his hand a cicada, and neither by shutting its mouth nor by stopping its wings could he the least diminish its very high shrieks, nor could he see its scales or any other part move; until finally he lifted up the casing of its chest and saw underneath some hard but thin cartilages, and believing that the noise derived from shaking these, he was reduced to break them to make them quiet. Yet all was done in vain, until, pushing the needle further in, transfixing the creature, he took away, along with its voice, its life; so that even

then he could not ascertain if the song issued from there. Whereupon he was reduced to such diffidence about his knowledge, that when called on to tell how sounds are generated, he responded generously that he knew some ways, but that he firmly held that there could be a hundred others unknown and unforeseeable.

🎇 APPENDIX 2

Descartes's Three Dreams

From Adrien Baillet, *La vie de M. Descartes*, Book 2, Chapter 1

The search that he wanted to make for these means [of finding Truth] threw his mind into violent turmoil, augmented more and more by a continual exertion which he held to, without allowing walks or company to make a diversion. This exhausted him so much that fire took over his brain, so that he fell into a kind of enthusiasm, which in such circumstances weighed on his mind, already depressed, so that it put him in a state to receive the impressions of dreams & of visions.

He tells us that on the tenth of November sixteen hundred nineteen, having gone to bed *completely filled by this enthusiasm*, & completely occupied by the thought of *having found that very day the foundations of the wonderful science*, he had three consecutive dreams in a single night, which he imagined could only have come from on high. After he had fallen asleep, his imagination felt struck by the appearance of some phantoms who presented themselves to him, & who terrified him so much that, believing he was walking through the streets, he was compelled to shift to the left side in order to be able to advance to the place where he wished to go, because he felt a great weakness on the right side which he could not support. Ashamed to walk that way, he made an effort to straighten himself; but he felt an impetuous wind that carried him away in a kind of whirlwind that

made him take three or four turns on his left foot. Nor was it only this that terrified him. The difficulty he had in dragging himself along made him believe he was falling at every step, until having caught sight of a college open on his path, he went inside to find a refuge, & a remedy for what ailed him. He tried to reach the Church of the college, where his first thought was to go and offer his prayer; but becoming aware that he had passed a man of his acquaintance without greeting him, he wanted to turn back his steps to show him courtesy, & he was violently pushed away by the wind that blew against the Church. At the same time he saw in the middle of the college yard another person who called him by name in civil & obliging terms; and told him that if he wanted to go find Monsieur N. he had something to give him. M. Desc. imagined that it was a melon that had been brought from some foreign land. But what surprised him still more was to see that those who, together with that person, gathered around him for conversation were straight & firm on their feet; though he was always stooped & staggering on the same ground; & that the wind that had nearly turned him upside down so many times had greatly diminished. He awoke imagining this, & he felt at the same time a real pain, which made him fear that this was the doing of some evil genius who had wanted to lead him astray. Immediately he turned onto his right side, because it had been on the left that he had gone to sleep, & that he had had his dream. He made a prayer to God to ask to be protected from the evil effect of his dream, & to be preserved from all the misfortunes that might menace him in punishment for his sins, which he recognized might be grievous enough to bring down heaven's thunderbolts on his head; though he had hitherto led a life irreproachable enough in the eyes of men.

In this situation he fell asleep again after an interval of nearly two hours spent in assorted thoughts about the good & evil things of this world. There came to him immediately a new dream in which he believed he heard a sharp & shattering noise that he took for a clap of thunder. The fright it induced awoke him at the same moment; & having opened his eyes, he caught sight of a great many sparks of fire scattered through the room. The thing had already happened often to him at other times; & it was not very extraordinary, when waking in the middle of the night, for him to have enough sparks in his eyes to let him glimpse the objects closest to him. But on this last occasion he wanted to have recourse to reasons taken from Philosophy; & he drew conclusions favorable to his mind, after having observed, in alternately opening, then closing, his eyes, the quality of the sorts of things that appeared to him. Thus his fear dissipated, & he went to sleep again in a rather deep calm.

A moment afterward he had a third dream, which contained nothing so terrible as the first two. In this last he found a book on his table, without knowing who had put it there. He opened it, & seeing that it was a *Dictionary*, he was carried away with hope that it might be very useful to him. In the same instant he came upon another book under his hand which was just as new to him, nor did he know from where it had come. He found that it was a collection of Poems by various Authors, entitled *Corpus Poetarum* &c. Curious, he wanted to read something in it; & opening the book he came upon the line *Quod vitæ sectabor iter?* &c. [Which way of life shall I follow?] At the same moment he became aware of a man he did not know, who presented him with a piece of Verse, beginning with *Est & Non* [It is & it is Not], & which he commended to him as an excellent piece. M. Descartes told him that he knew what it was, & that this piece was among the Idylls of Ausonius to be found in the big Collection of Poets that was on the table. He wanted to show it himself to this man; & started to flip through the book, whose order & arrangement he prided himself on knowing perfectly. While he looked for the right place, the man asked him where he had gotten this book, & M. Descartes replied that he could not say how he had come to have it; but that a moment before he had handled yet another that had just disappeared, without his knowing who had brought it to him, or who had taken it back from him. He had not finished, when he again saw the book appear at the other end of the table. But he found that this *Dictionary* was no longer so complete as when he had seen it the first time. Meanwhile he came upon the Poems of Ausonius in the Collection of Poets that he flipped through; & not being able to find the piece that began with *Est & Non*, he told this man that he knew one by the same poet still finer than that, & that it began with *Quod vitæ sectabor iter?* The person entreated him to show it to him; & M. Descartes set himself the task of looking for it, when he came upon various little portraits engraved in copper-plate; this prompted him to say that the book was very fine, but it was not the same edition as the one he knew. He was at this point, when the books & the man disappeared, & were erased from his imagination, without yet waking him. What he found especially remarkable is that, doubting whether what he had happened to see was dream or vision, he not only decided while sleeping that it was a dream, but he also pursued the interpretation before breaking his slumber. He judged that the *Dictionary* could not be called anything else than all the Sciences gathered together; & that the Collection of Poems entitled the *Corpus Poetarum* marked in particular & in a more distinct way Philosophy & Wisdom joined together. For he did not believe that one should be so very astonished to see that Poets, even those who only make trifles, brim with precepts more

weighty, more sensible, & better expressed than those found in the writings of Philosophers. He attributed this marvel to the divinity of Enthusiasm, & to the force of Imagination, which brings forth the seeds of wisdom (which are present in the mind of all men like sparks of fire in flints) with much more readiness & much more brilliance too, than Reason could bring about in Philosophers. M. Descartes continued to interpret his dream in slumber, surmising that the piece of verse on the uncertainty of what kind of life one ought to choose, & which begins with *Quod vitæ sectabor iter*, marked the good counsel of a wise person, or even Moral Theology. On that, doubtful whether he was dreaming or musing, he awoke without emotion; & continued, with open eyes, the interpretation of his dream on the same train of thought. By the Poets gathered in the Collection he understood Revelation & Enthusiasm, by which he did not despair of seeing himself favored. By the piece of Verse *Est & Non*, which is the Yes & No of Pythagoras, he apprehended Truth & Falsity in human knowledge, & the profane sciences. Seeing that the application of all these things turned out so well to his taste, he was bold enough to persuade himself, that it was the Spirit of Truth which had wanted to open to him the treasures of all the sciences by this dream. And as what was left to explain was no more than the little portraits in copper-plate that he had found in the second book, he looked for no further explanation after the visit that an Italian Painter paid him early the following day.

This last dream, which had nothing in it that was not very sweet & very agreeable, indicated the future, according to him; & it was only what ought to happen to him in the rest of his life. But he took the two preceding for menacing warnings touching his past life, which could not have been as innocent before God as before men. And he believed that this was the reason for the terror & fright that had accompanied those two dreams. The melon that someone wanted to make a present to him in the first dream signified, he would say, the charms of solitude, but presented through purely human solicitations. The wind that pushed him toward the Church of the college, when his right side was bad, was nothing other than the evil Genius that was trying to fling him by force into a place where his intention was to go voluntarily. That is why God did not permit him to advance farther, & let him be carried away even to a holy place by a Spirit that He had not sent; though he was firmly persuaded that it had been the Spirit of God that had made him take the first steps toward that Church. The fright with which he had been struck in the second dream marked, to his mind, his inward monitor [*syndérêse*], that is to say, the remorse of conscience touching the sins that he might have committed during the course of his life up to then. The clap of thunder he heard was the signal of the Spirit of truth descending on him to possess him.

This last imagination surely owes something to Enthusiasm; & it might incline us readily to believe that M. Descartes had been drinking that evening before going to bed. As a matter of fact this was Saint Martin's Eve, on the evening of which it was customary to go on a spree in the place where he was, as in France. But he assures us that he had passed the evening & all the day in full sobriety, and that for three whole months he had not drunk wine. He adds that the Genius that had excited in him the enthusiasm with which he had felt his brain seething for several days had predicted these dreams to him before he put himself to bed, & that the human mind had no part in them.

❧ Notes

Preface

1. As Edgerton points out, Galileo can hardly have made "such careful pen-and-wash studies" while standing at the telescope "in a cold, windswept tower." He must have finished his pictures in the studio, "relying on remembered impressions, verbal notes, and hasty diagrams"; *Heritage of Giotto's Geometry*, 240.

2. Benson, "What Galileo Saw."

3. "Che son li segni bui/ di questo corpo"; *Paradiso*, 2.49–50. In the *Convito* (ca. 1305) Dante had attributed the spots to rare and dense matter, which Beatrice now rebuts by explaining that the spots "alloy" the virtue or divine radiance of the stars with the virtue of the moon.

4. Edgerton stresses Galileo's influence as a "perspectivist" in *The Mirror, the Window, and the Telescope*, 151–67.

5. I. B. Cohen, *Birth of a New Physics*, 188–89. Cohen elaborated his argument in "What Galileo Saw."

6. The reception of *Sidereus Nuncius* is discussed in chapters 2 and 10 below.

7. *Kepler's Conversation with Galileo's Sidereal Messenger*, 39. Kepler's response to Galileo is analyzed in chapter 3 below.

8. See Pormann and Savage-Smith, *Medieval Islamic Medicine*.

9. "The eye, in Galileo's new radical instrumentalism, is no longer the main point of reference for visual phenomena. . . . *The eye* mediates and distorts; the instrument provides the standard of trustworthy perception against which the eye should be judged"; Gal and Chen-Morris, *Baroque Science*, 93.

10. "Proverbs of Hell," Plate 8, *The Marriage of Heaven and Hell* (1790).

11. In *Theory of the Heaven* (*Thema Cœli*, 1612) Bacon refers to Galileo's discovery of "small wandering stars" near Jupiter but declares, "I do not mean to be bound by these things"; nor to affirm that planets orbit the sun; *Oxford Francis Bacon* 6:193 (hereafter cited as *OFB*). Rees concludes that according to Bacon "The Copernican theory offended common sense"; "Bacon's Speculative Philosophy," 124.

1. Introducing a Revolution

1. "On the morning of CHRISTS Nativity," lines 181–88. In a letter to Charles Diodati, Milton wrote that "we are engaged in singing the heavenly birth of the King of Peace . . . and the gods of heathen eld suddenly fleeing to their endangered fanes. This is the gift which we have presented to Christ's natal day. On that very morning, at daybreak, it was first conceived"; *Life Records of John Milton*, 1:213.

2. *Areopagitica*, 24.

3. See Revard, "Apollo and Christ."

4. "The story of the Scientific Revolution retains its hold, even on those schol-ars who have contributed to its unraveling. . . . It is a genuine mythology, which means it expresses in condensed and sometimes emblematic form themes too deep to be unsettled by mere facts, however plentiful and persuasive"; Park and Daston, "Introduction," 15. See chapter 10 below for a discussion of skeptical challenges to this "mythology."

5. H. Floris Cohen, *Scientific Revolution*, provides a rich analysis of critical per-spectives, as well as a spirited defense of the term and its importance. More recently, Cohen has challenged the argument of Park and Daston that "the Scientific Revolu-tion" was not a coherent enterprise but is rather "a myth about the inevitable rise to global domination of the West" ("The Age of the New," 15) by attempting to find coherent and comprehensive answers to the questions "*whence the onset, and whence the original staying power, of modern science?*"; *How Modern Science Came into the World*, xv. Horkheimer and Adorno, *Dialectic of Enlightenment*, offer a classic statement of the myth of domination; Butterfield, *Origins of Modern Science*, offers a classic statement of the importance of science in creating modernity. Huff, *Intellectual Curiosity*, argues that the Western European impact of the Scientific Revolution far exceeds its influ-ence on other civilizations.

6. "The growing process of intellectualization and rationalization . . . means that in principle, then, we are not ruled by mysterious, unpredictable forces, but that, on the contrary, we can in principle *control everything by means of calculation*. That in turn means the disenchantment of the world"; Weber, "Science as a Vocation," 12–13.

7. "Science as a Vocation", 16.

8. *Novum Organum* (1620), in *OFB* 11:78–111.

9. Jones, *Ancients and Moderns*, tells the story of Bacon's success. Doubt has been cast on the story by many scholars, including Hunter, *Science and Society in Restoration England*. "*Bacon-faced* generation" was coined by Henry Stubbe, a fierce critic of the Royal Society as well as of Bacon (Jones, 244–62).

10. Boyle sets out "the principles of the Mechanical Philosophy" in *The Ori-gins of Forms and Qualities* (1666) and "About the Excellency and Grounds of the Mechanical Hypothesis" (1674); *Works of Robert Boyle*, 5:305–35, 8:99–116. Standard historical accounts include Dijksterhuis, *Mechanization of the World Picture*, 287–491; and Westfall, *Construction of Modern Science*.

11. Mayr's influential book, *Authority, Liberty, and Automatic Machinery in Early Modern Europe*, explores the clockwork metaphor.

12. Aristotle, *De caelo* (*On the Heavens*), 292a18–21. Bruno: "The earth moves and so do the other stars, according to their proper local differences, in virtue of an intrinsic principle which is their proper soul. Do you think (said Nundinio) that this soul is sensitive? Not only sensitive (replies the Nolan) but also intelligent; not only intelligent as ours, but perhaps even more so"; *Ash Wednesday Supper*, 116. The Nolan, who represents Bruno himself, claims that stars possess not only the first two kinds of Aristotelian souls, vegetative and sensitive, but also *rational* souls.

13. Letter to Herwart von Hohenburg, Feb. 10, 1605, in *Gesammelte Werke*, 15:146. See Martens, *Kepler's Philosophy and the New Astronomy*, 81–82.

14. Thomas Hall traces the development of early biomechanics; *Ideas of Life and Matter*, 1:218–29.

15. *Discourse on the Method* (1637), in *Philosophical Writings*, 1:139–41. See chapter 6 below.

16. Galileo's earliest scientific work, *La balancitta* (*The Little Balance*, 1586), refines Archimedes's thoughts on floating bodies, and his first studies of motion (ca. 1590) use Archimedes to refute Aristotle. On Galileo's insistence that the universe is a book "written in the language of mathematics," see chapter 2 below.

17. Pascal, *Pensées* L418/S680, in *Œuvres complètes*, 2:676–81. Hacking analyzes the wager in *Emergence of Probability*.

18. A skeptical view of this historical division is offered by Latour, *We Have Never Been Modern* and *On the Modern Cult of the Factish Gods*.

19. *The First Anniversarie*, lines 205, 213. See chapter 10 below.

20. William Wordsworth, "Ode" (1807), lines 51–53, 56–57. After 1815 the title became "Ode: Intimations of Immortality from Recollections of Early Childhood."

21. Kavey, *World-Building and the Early Modern Imagination*, gathers a variety of essays on sixteenth- and seventeenth-century cosmogonies.

22. Aristotle defines *phantasia* in a much-debated section of *De anima*, 3.3. 428a–429a.

23. Park diagrams these separate faculties in "Organic Soul," 466. Most physiologists regarded imagination (or phantasy) as one of the three inner senses of the brain, along with common sense (which makes objects intelligible by appraising what the five outer senses perceive) and memory.

24. According to Sidney's *Apology for Poetry* (ca. 1583), Nature's "world is brazen, the poets only deliver a golden." Kemp surveys the shift from imitative to creative theories of art in "From 'Mimesis' to 'Fantasia'."

25. "Of the Powers of the Imagination," in *Complete Essays of Montaigne*, 68.

26. *Novum Organum*, in *OFB* 11:83–87. In *The Advancement of Learning* (1605) Bacon refers to imagination as an agent or *nuncius* like Janus, whose "face towards Reason hath the print of Truth."

27. Campbell emphasizes Bacon's "repression" of wonder; *Wonder and Science*, 71–77. Butler argues for a more nuanced view in which Bacon supports "the prudential imagination"; *Imagination and Politics*, 17–55.

28. "Imagination," *Pensées* L44/S78, in *Œuvres complètes*, 2:551–54.

29. Yates's influential studies include *Giordano Bruno and the Hermetic Tradition* and "Hermetic Tradition in Renaissance Science." Debus's popular introduction to the "new philosophy," *Man and Nature in the Renaissance*, stresses the impact of alchemy, astrology, and natural magic.

30. Rossi, *Francis Bacon*, 13. Rossi later dissociated himself from efforts to enlist Bacon in "the so-called 'hermetic tradition'"; "Hermeticism, Rationality, and the Scientific Revolution," 247–73.

31. Eamon, *Science and the Secrets of Nature*, documents relations between early science and magic.

32. The English word "scientist" was coined by William Whewell in 1833. Originally "science" meant "any art or species of knowledge," but by the eighteenth century it was often opposed to "art" and confined to "certainty grounded on demonstration" (Johnson's *Dictionary*). The modern identification of "science" with

"natural and physical sciences" became standard usage only in the late nineteenth century.

33. Kemp traces this legacy in *Seen/Unseen*.

34. *Paradise Lost*, 1.288.

35. Panofsky, *Galileo as a Critic*, 4–5; Peterson, *Galileo's Muse*, 13. Chiari's edition of Galileo's *Scritti letterari* includes poems and a play as well as critical essays. Heilbron, *Galileo*, translates and analyzes several poems.

36. See D. P. Walker, *Studies in Musical Science*, 34–62.

37. See chapter 3 below.

38. The quotation comes from Descartes's *Olympica* (1619); see appendix 2 below.

39. Nicolson, *Newton Demands the Muse*.

40. *The World*, 21–25. Descartes's complex attitudes toward dreams and imagination are analyzed in chapter 6 below.

41. "Salomon's House *in the* NEW ATLANTIS *was a Prophetic Scheam of the* ROYAL SOCIETY"; Joseph Glanville, *Scepsis Scientifica* (1665), quoted in the introduction to Sprat, *History of the Royal Society*, xii. Glanvill celebrates the Royal Society as "the *Great Body* of *Practical* Philosophers" in *Plus Ultra*, 148.

42. In *De Sapientia Veterum* (*On the Wisdom of the Ancients*, 1609), Bacon interprets the poetic fables of the Greeks and Romans as allegories that convey "the concealed and secret learning of the ancients."

43. Campanella to Galileo, August 5, 1632, in Galileo, *Le opere*, 14:367. In the same month, sales of the *Dialogue* were suspended; within a few months the book was referred to the Inquisition. Campanella had already published *A Defense of Galileo* (1622). Garin discusses the cultural context of Galileo's embrace of the new; *Science and Civic Life*, 75–116.

44. Campanella to Galileo, January 11, 1611, in Galileo, *Le opere*, 11:21–26. Cf. *Kepler's Conversation with Galileo*, 39.

45. Dick, *Plurality of Worlds*, examines the long history of speculations about life on other worlds. Crowe, *Extraterrestrial Life Debate*, 3–26, reviews the history of the debate, and also provides a source book.

46. See chapter 6 below.

47. Nicolson, *Voyages to the Moon* (1948), remains a standard account. Lambert, *Imagining the Unimaginable*, analyzes the metaphorical implications of interplanetary voyages.

48. See Catherine Wilson, *Invisible World*.

49. Dante, *Paradiso*, 2.19–30; Ariosto, *Orlando Furioso*, 34.68–70.

50. Marino, *L'Adone*, canto 10.

51. The classic study of such effects is Seznec, *Survival of the Pagan Gods*.

52. Duran, *Age of Milton*, examines Milton's knowledge of contemporary science. His efforts to steer between different cosmological models are analyzed by Svendsen, *Milton and Science*, and Edwards, *Milton and the Natural World*.

53. *Paradise Lost*, 8.172–76.

54. *Paradise Lost*, 2.891–94, 910. Nicholas of Cusa, Thomas Digges, and Giordano Bruno had envisioned an infinite universe outside fixed systems, but not a space or abyss unoccupied by God. Koyré, *From the Closed World to the Infinite Universe*, examines early notions of a cosmic void.

55. Spenser, *The Faerie Queene*, 3.6.36–38; Lucretius, *De rerum natura*, 2.62–293. Schwartz argues for the "goodness" of Milton's chaos; *Remembering and Repeating*, 8–39.

56. *Paradise Lost*, 2.949–50.

57. Aristotle's argument against the possibility of a void (*Physics*, 4.6–8.213a–217b) concludes that a body in a void would move at infinite speed, which cannot be. Philosophers later resorted to many other arguments; see Grant, *Much Ado about Nothing*.

58. *Principles of Philosophy*, 46. In earlier works Descartes had also doubted the possibility of a void in nature but had refused to rule it out absolutely. His arguments against the vacuum insist that space, like a body, is extended, and since it has dimensions, it must contain some substance. But he denies that "Nature abhors a vacuum," which would impose a purpose on a mechanical effect.

59. Pascal, *Œuvres complètes*, 1:356–57. Pascal extended his arguments in responses to Étienne Noël and in *Treatises on the Equilibrium of Liquids and on the Weight of the Air* (1654; published 1663); *Œuvres complètes*, 1:373–531.

60. *Œuvres complètes*, 1:364–65; cf. *Pensées*, ibid., 2:554.

61. *Œuvres complètes*, 1:436–37. Dear examines the status and interpretation of this "experience" in *Discipline & Experience*, 180–209. The issue was far from settled, however. Descartes claimed that he himself had suggested the experiment to Pascal, and that its results could be explained by "subtle matter" in the tube. In the 1660s, after Robert Boyle's air pump apparently produced a vacuum, a similar dispute broke out between Boyle and Thomas Hobbes, who denied the vacuum and believed that he himself had posited a kind of "subtle matter" before Descartes; see Shapin and Schaffer, *Leviathan and the Air-Pump*, 84.

62. "Hydrostatical Paradoxes" (1666), in *Works of Robert Boyle*, 5:189–91. Koyré elaborates the charge in *Metaphysics and Measurement*, 150–56. Cf. Kuhn, *Essential Tension*, 44–45.

63. *Pensées*, S680, in *Œuvres complètes*, 2:679.

64. *Pensées*, L201/S233, in *Œuvres complètes*, 2:615.

65. *Pensées*, L68/S102, in *Œuvres complètes*, 2:563.

66. Letter to Richard Bentley, December 10, 1692, *Correspondence*, 3–233–36. On the use of comets in renewing seas and fluids through "exhalations and vapors" as well as in providing "that spirit which is the smallest but most subtle and most excellent part of our air," see *Principia*, 926.

67. Brooke shows that Newton's authority could be invoked both against and for Deists; *Science and Religion*, 114–51. Janiak discusses the turning away of later "Newtonians" from Newton's own thought; *Newton as Philosopher*, 163–78. Cf. the legendary reply of the Newtonian Pierre-Simon Laplace when Napoleon inquired about the absence of a Creator in his system: "I had no need of that hypothesis."

68. *Lamia* (1820), pt. 2, lines 229–38.

69. Warton, *History of English Poetry*, 2:463. "Scientifically," for Warton, means the application of "speculation and theory to the art of writing." Studies about "the world we have lost" are far too many to enumerate, but see, e.g., Toulmin's *Cosmopolis*, which looks back to an ideal fusion of the natural and social orders that modern rationalism has torn asunder. Relations between the history of poetry and natural history are examined in chapter 4 below.

70. "Its resulting fate is that precisely the ultimate and most sublime values have withdrawn from public life. . . . It is no accident that our greatest art is intimate rather than monumental"; "Science as a Vocation," 30.

71. Thomas Love Peacock's clever essay, "The Four Ages of Poetry" (1820), advises poets to give up their anachronistic dreams and turn to the sciences. Shelley's spirited reply, *A Defence of Poetry* (1821), insists that science and poetry are complementary or intertwined: "Reason is to Imagination as the instrument to the agent, as the body to the spirit, as the shadow to the substance."

72. Cf. Arthur C. Clarke's famous "third law" in *Profiles of the Future*: "Any sufficiently advanced technology is indistinguishable from magic."

73. Edward O. Wilson pays tribute to Bacon as a hero of consilience and a "thoroughly modern man"; *Consilience*, 6. This claim is examined by several contributors to Solomon and Martin, *Francis Bacon*.

74. The phrase provides a heading in Newton's early notebook (1661–65), Cambridge University Library, MS Add. 3996, fol. 109r. Holton directs attention to Newton's fantasies; *Scientific Imagination*, 268–74.

2. What Galileo Saw

1. *Le opere di Galileo Galilei,* 6:280–81 (my translation; for the entire fable of sound, see appendix 1). Stillman Drake has translated *The Assayer* and, with C. D. O'Malley, documents by other participants in the dispute, including Orazio Grassi, Mario Guiducci, and Johannes Kepler, in *The Controversy on the Comets.*

2. See Palisca, "Was Galileo's Father an Experimental Scientist?," in Coelho, *Music and Science*; several contributors to that volume examine other aspects of Vincenzio's and Galileo's theory and practice of music. Palisca's many studies of Vincenzio's work include "Three Scientific Essays by Vincenzo Galilei," in *The Florentine Camerata*, 152–207. Settle discusses Galileo's pursuit of his father's investigations; *Galileo's Experimental Research*, 20–28. Galileo expounds his own theory of consonances at length in *Two New Sciences*, 96–108.

3. Biagioli, *Galileo, Courtier*, 301–2.

4. *Controversy on the Comets*, 152. Riccardi, an ally of the Medicis, became Galileo's friend and later, as master of the sacred palace (or Vatican secretary), served as an intermediary in Galileo's prosecution.

5. *Le opere*, 6:200–201; *Controversy on the Comets*, 153.

6. Redondi provides a chronology of the making and reception of *The Assayer; Galileo Heretic*, 36–51. For a fuller account of the Roman excursion, see Shea and Artigas, *Galileo in Rome*, 94–122.

7. "Respicimus nigras / In Sole (quis credat?) retectas / Arte tua, Galilaee, labes"; from "Adulatio perniciosa," quoted in De Santillana, *Crime of Galileo*, 156.

8. Oregius recorded the conversation, which probably took place in 1624, in *De Deo Uno* (1629). The translation in the text draws on those of Finocchiaro, *Galileo and the Art of Reasoning*, 10; and De Santillana, *Crime of Galileo*, 127n, 166.

9. Finocchiaro traces the later history of "the Galileo affair" in *Retrying Galileo*.

10. *Galileo on the World Systems*, 306–7.

11. Finocchiaro, *Galileo Affair*, 221.

12. Fantoli, *For Copernicanism and for the Church*, 367, 371–72.

13. Wootton reviews the scholarly debates and mounts a sustained argument that "Galileo was indeed a heretic" and, even worse, "disloyal and ungrateful" to Urban VIII; *Galileo*, 266.

14. Duhem, *To Save the Phenomena*, 104–12. Duhem approves the "truth" of which Urban VIII had reminded Galileo: experimental facts, even when numerous and precise, can never prove that a hypothesis is certain, since that would require that those facts had power to contradict all other imaginable hypotheses, a knowledge reserved to God alone.

15. In the acknowledgments in *Galileo Heretic*, Redondi thanks in particular Cardinal Joseph Ratzinger, "president of the Sacred Congregation for the Doctrine of the Faith" and the future Benedict XVI.

16. *Controversy on the Comets*, 237.

17. *Le opere*, 6:232; *Controversy on the Comets*, 183–84.

18. See, for instance, Shea, *Galileo's Intellectual Revolution*, 88–98.

19. Biagioli argues that Galileo's topos of the book of nature "was fraught with unavoidable contradictions," since the "open book of the heavens" inevitably came into conflict with the authority of another book, scripture; *Galileo's Instruments of Credit*, 220.

20. Drake, "Music and Philosophy," provides a succinct account of relations between Galileo's interests in physics and in music. See also Walker, *Studies in Musical Science*; and Peterson, *Galileo's Muse*, 149–73.

21. *Le opere*, 6:349–50; *Controversy on the Comets*, 311. Gal and Chen-Morris argue that Galileo intends to discredit Grassi's reliance on parallax and other observations of "the unaided eye"; *Baroque Science*, 80–97. See also Butts, "Some Tactics in Galileo's Propaganda."

22. "Lotario Sarsi," *Ratio Ponderum Librae et Simbellae* (Paris, 1626).

23. For a much fuller exposition, see Redondi, *Galileo Heretic*, esp. 157–65. The document itself (G3) is translated on 333–35; it misrepresents the position of Galileo, who did not refer to anything "subjective." Few scholars have accepted Redondi's claims for its importance; see esp. Ferrone and Firpo, "From Inquisitors to Microhistorians." Sharratt provides a balanced view of this issue; *Galileo*, 148–49. A similar document found in the archives of the Holy Office in 1999 is analyzed by Artigas, Martínez, and Shea, "New Light on the Galileo Affair?" It appears to be "a direct sequel" to G3 (Redondi's document) but was written many years later (1631 or 1632).

24. *Le opere*, 19:602.

25. Segre, *In the Wake of Galileo*, 112–22. Bredekamp develops the theme of Galileo as a "new Michelangelo" in *Galilei der Künstler*, 13–24.

26. *Le opere*, 11:168. Bredekamp relates Galileo's skill at drawing to his lunar observations in "Gazing Hands and Blind Spots," and provides much more evidence throughout *Galilei der Künstler*.

27. Edgerton throws light on Galileo's knowing artistry in "Galileo, Florentine *disegno*." Righini concludes that Galileo was "a remarkably faithful recorder of his visual experiences"; "New Light on Galileo's Lunar Observations," 76.

28. Viviani, Galileo's biographer, originated the anecdote about the Tower of Pisa. Lane Cooper, *Aristotle, Galileo, and the Tower of Pisa*, pokes fun at the mythographers who later inflated that unsubstantiated story.

29. Galileo's early inventions are surveyed by Drake, *Galileo at Work*, 1–49.

30. Reeves questions and amends this account in *Galileo's Glassworks*. See also Shea's and Bascelli's introduction to *Galileo's "Sidereus Nuncius" or "A Sidereal Message*," 1–18; Van Helden, "Galileo and the Telescope"; and Biagioli, "Did Galileo Copy the Telescope?"

31. *Galileo at Work*, 148. Dupré contends against Drake that Galileo learned about pinholes "on the basis of notes of Leonardo"; "Galileo's Telescope and Celestial Light."

32. See Rosen, *Naming of the Telescope*.

33. See Edgerton, *The Mirror, the Window, and the Telescope*, 151–67.

34. Rosen, *Naming of the Telescope*, 31. Galileo's relations with the Academy are explored by Freedberg in *Eye of the Lynx*.

35. See Winkler and Van Helden, "Representing the Heavens," 207.

36. Panofsky, *Galileo as a Critic of the Arts*, 4–5. Bredekamp emphasizes Galileo's distaste for Mannerism in literature as well as in the visual arts; *Galilei der Künstler*, 42–62.

37. *Sidereus Nuncius or The Sidereal Messenger*, 43. Page numbers in the text refer to Van Helden's translation.

38. Galileo's later refinements of his observations of the satellites of Jupiter are discussed by Swerdlow, "Galileo's Discoveries with the Telescope."

39. Moss analyzes the rhetorical problems of Galileo's dialectic; *Novelties in the Heavens*, 264–67.

40. Kristeller discusses the *paragone* in "Moral Thought of Renaissance Humanism."

41. *Galileo as a Critic of the Arts*, 11.

42. *Kepler's Conversation with Galileo*, 23–31. Kepler's relations with Galileo will be discussed in chapter 3. By 1632 Galileo—or his spokesman "Salviati"—had become far more cautious about comparing the moon to the earth, and particularly about claiming that there was water on the moon; *Galileo on the World Systems*, 108–11.

43. Montgomery, *The Moon and the Western Imagination*, examines lunar effects in literature and art from antiquity through the seventeenth century. Lambert discusses both Ariosto's whimsical excursion to the moon as the repository for everything lost on earth (*Orlando Furioso*, canto 34), and the "rhetorical imagery" of Galileo's pictures and descriptions of the moon.

44. The tradition, and Galileo's effect on it, have been thoroughly studied by Reeves, *Painting the Heavens*.

45. In "The Virgin and the Telescope," Booth and Van Helden point out that the moon could also be interpreted as a sign of corruption, especially in the context of chapter 12 of the book of Revelation.

46. See Reeves, *Painting the Heavens*, 29–32.

47. Kepler, *Optics*, 263–68.

48. Bredekamp concludes that Galileo's drawings of light and darkness on the face of the moon enabled him to recognize that he was viewing reflective surfaces and shadows, and thus prepared him to describe the moon's topography; *Galilei der Künstler*, 137–46.

49. Edgerton, *Heritage of Giotto's Geometry*, 245.

50. Both Jan van Eyck and Leonardo da Vinci had pictured mottled details on the face of the moon, and Leonardo argued that variations in those details were caused by lunar clouds and seas; *Notebooks of Leonardo da Vinci*, 154–68. But neither artist evokes a third dimension.

51. The forgeries were concocted by Marino Massimo De Caro, a well-connected Italian bibliophile and thief who later confessed to these and other misdeeds. Bredekamp endorsed the forged book and pictures in *Galilei der Künstler*, 149–216, a claim disputed by Gingerich, "The Curious Case of the M-L *Sidereus Nuncius*," and supported by Shea, "Owen Gingerich's Curious Case." Bredekamp's case was elaborated in detail by him and other scholars, including Paul Needham, in *Galileo's O* (2011). But sharp-eyed studies by the British scholar Nick Wilding exposed the forgery, and analyses of the dubious copy of *Sidereus Nuncius* by Gingerich, Wilding, and himself led Needham to admit, in 2012, that he had been wrong in accepting its authenticity in 2011. See the reports in *PhiloBiblos* (online), June 17, 2012, and *New York Times*, Aug. 11, 2012. Nicholas Schmidle's *New Yorker* article provides a thorough account of the scandal, including an interview with De Caro.

52. *Le opere*, 10:273–78. In *Galileo Makes a Book*, vol. 2 of *Galileo's O*, Needham provides a meticulous and thorough review of the documents pertaining to *Sidereus Nuncius* (notwithstanding his mistaken endorsement of the forged "New York edition").

53. Bredekamp, who argues with persuasive evidence that Galileo etched the prints, points out that a good engraver would have tapered the ends of the wavy lines that mark the moon's topography; *Galilei der Künstler*, 191.

54. Whitaker reproduces the Florentine drawings and printed illustrations, correlated with modern photographs of the moon, in "Galileo's Lunar Observations." Johns compares "Galileo's own" lunar images in *Sidereus Nuncius* to those in three subsequent unauthorized editions, and concludes that "the painstakingly crafted verisimilitude of Galileo's original drawings had been significantly eroded"; *Nature of the Book*, 22–23; but this confuses the drawings with the etchings printed in the first edition.

55. *Le opere*, 9:29–57. The lectures were given in 1588. As Peterson points out, Galileo later realized that his scale model was faulty; *Galileo's Muse*, 227–33.

56. See Dear, *Discipline & Experience*, 124–50.

57. Whitaker prints his own reduced version of the sketch in "Selenography in the Seventeenth Century," 121. On Gilbert, see also Whitaker, 44–48, as well as Montgomery, *Scientific Voice*, 207–12. Montgomery makes a strong case that "Galileo drew the moon according to certain conventions of pictorial rhetoric in late Renaissance mapmaking" (226), but does not distinguish the original drawings from the versions printed in *Sidereus Nuncius*.

58. Whitaker, "Selenography," 120–23; Montgomery, *Scientific Voice*, 212–19. Roos, *Luminaries in the Natural World*, associates Gilbert and Harriot with the "desacralization" of the moon.

59. Gingerich, "*Dissertatio cum Professore Righini et Sidereo Nuncio*," 86. The four drawings of lunar craters in Galileo's letter of January 7, 1610, anticipate the huge crater he etched; see *Galileo's "Sidereus Nuncius*," 21–24.

60. Koyré, *Newtonian Studies*, 67–68. Koyré, Panofsky, and Aby Warburg could not persuade Einstein, however, that Galileo's blind spot resulted from an aesthetic

predilection (see Bredekamp, "Gazing Hands and Blind Spots," 184–86). Hallyn contends that "Galileo's predilection for circular forms may be based on his verification of their efficacy" rather than on aesthetics; *Poetic Structure of the World*, 222.

61. Galileo had never been to Bohemia; his description could have derived from an Italian edition of Ptolemy's *Geography*; *Galileo's "Sidereus Nuncius,"* 24–25.

62. "The art of *disegno* in which Galileo was so well trained not only meant drawing accurately but also arranging objects to suit the purpose of the exercise (our idea of 'design'). In Baroque art a drawing or painting was always a reference to something; it always illustrated a theme or text"; Gingerich and Van Helden, "From *Occhiale* to Printed Page," 260.

63. Galileo originally called the moons *Cosmica Sydera* or "Cosmic Stars," punning on Cosimo and "cosmic." But when the grand duke's secretary preferred the less ambiguous *Medicea*, it was pasted over *Cosmica* on the title page of the book.

64. On the mythology of the Medicis and the rites of patronage, see Biagioli, *Galileo Courtier*, chap. 2.

65. The honor paid by Galileo attracted the eyes of other would-be luminaries. Henri IV of France soon asked him to name the next star he discovered Henri, and French and Austrian astronomers named sunspots *Borbonia Sidera* and *Austriaca Sidera*; see *Galileo's "Sidereus Nuncius,"* 98n.

66. Shea, "Galileo and the Church," notes the discomfort of theologians, who believed that God, rather than mortals, had named the stars.

67. Galileo to Federico Cesi, May 12, 1612, in Drake, *Galileo at Work*, 183. "Unlike *Sidereus nuncius*, *Observations on Sunspots* was not merely an account of the phenomena (*istoria*) but also an indication of the true character of the universe (*dimostrazioni*)"; Heilbron, *Galileo*, 191.

68. Galileo and Scheiner, *On Sunspots*, 294.

69. *On Sunspots*, 296.

70. Benjamin, "Theses on the Philosophy of History," 257–58.

71. In the dialogue on the first new science, "concerning the resistance of solid bodies to separation," Salviati proposes "reasons for marvelous things in the matter of sounds," which entrances Sagredo, "as one who is delighted by all musical instruments"; *Two New Sciences*, 96. Clavelin, *Natural Philosophy of Galileo*, surveys Galileo's contributions to mechanics.

72. March 29, 1641, in Drake, *Galileo at Work*, 417. Galileo's repudiation of the Copernican system in this letter has disturbed many readers; it may very well be ironic.

3. Kepler's Progress

1. *New Year's Gift*, 7. Page numbers in the text refer to Hardie's edition, in which the Latin text faces an English translation. *The Six-Cornered Snowflake*, translated by Bromberg, also includes the Latin text as well as comments by Owen Gingerich and Guillermo Bleichmar and a poem, "The Six-Cornered Snowflake," by John Frederick Nims. Translations in the text are my own.

2. Descartes described various structures of snow crystals, accompanied by detailed drawings, in the essay on meteorology appended to his *Discourse on Method* (1637). Hooke's *Micrographia* (1665) makes use of a microscope to amplify

and complicate earlier sketches of the "infinite variety of curiously figur'd *Snow*" (91).

3. Koestler's popular history of astronomy, *The Sleepwalkers*, dramatizes that "watershed" with his customary flair: "A.D. 1600 is probably the most important turning point in human destiny after 600 B.C. Astride that milestone . . . stands the founder of modern astronomy, a tortured genius in whom all the contradictions of his age seem to have become incarnate: Johannes Kepler" (22). The section on Kepler was later published separately in paperback as *The Watershed*.

4. Kozhamthadam examines the shift from circle to ellipse; *Discovery of Kepler's Laws*, 199–245.

5. This theory, derived from William Gilbert's famous *De Magnete* (1600), is analyzed by Stephenson; *Kepler's Physical Astronomy*, 111–18.

6. Burtt's classic essay calls attention to Kepler's worship of the sun; *Metaphysical Foundations*, 44–49.

7. Pauli maintains that "Kepler's ideas reveal quite unmistakably the influence of Paracelsus and his pupils"; "Influence of Archetypal Ideas," 157. But Lancelot Law Whyte suggests that Galen is the primary source for Kepler's "formative faculty"; *New Year's Gift*, 57–63.

8. Aït-Touati observes that "in the snowflake [Kepler] saw the structure of the universe revealed," but does not mention his repudiation of that claim; *Fictions of the Cosmos*, 1.

9. "'The Earth is the circle which is the measure of all. Construct a dodeca-hedron round it. The circle surrounding that will be Mars. Round Mars construct a tetrahedron. The circle surrounding that will be Jupiter. Round Jupiter construct a cube. The circle surrounding that will be Saturn. Now construct an icosahedron inside the Earth. The circle inscibed within that will be Venus. Inside Venus inscribe an octahedron. The circle inscribed within that will be Mercury.' There you have the explanation of the number of the planets"; *Mysterium Cosmographicum*, 69. The rela-tion of Kepler's polyhedra to Plato's *Timaeus* is analyzed by Field, *Kepler's Geometrical Cosmology*, 1–16, 171–76.

10. "Libertas, quae sera tamen respexit inertem, / . . . respexit tamen et longo post tempore venit"; Virgil, *Eclogues*, 1.27, 29. A venerable interpretation associates this story with Virgil's own trip to Rome to appeal to Octavian to restore his con-fiscated farm.

11. *Harmony of the World*, 411. "Harmonics," emphasizing the science and math-ematics of sounds, might be a more accurate translation of *Harmonice*.

12. B. J. Mason, "On the Shapes of Snow Crystals," in *New Year's Gift*, 53. But in many respects the morphology of snow crystals remains a puzzle. "So here we sit at the beginning of the twenty-first century and we cannot yet explain exactly why snowflakes are as they are"; Libbrecht, *Snowflake*, 57. Recent investigations suggest that microbes inhabit each snowflake, affecting its shape.

13. See Szpiro, *Kepler's Conjecture*.

14. Dyson, "Our Biotech Future," 6.

15. "Whether [the book] is to be read by the people of the present or of the future makes no difference: let it await its reader for a hundred years, if God Him-self has stood ready for six thousand years for one to study him"; *Harmony of the World*, 391.

16. Harriot's acute speculations on close packing go back to manuscripts of 1599. What survives of his correspondence with Kepler in 1606–7 is concerned with optics, however, and not crystallography; *Gesammelte Werke*, vols. 15 and 16. As Shirley points out, Harriot, though flattered by Kepler's attention, "was reluctant to reveal too much of his original experimental results, particularly since it appears that he had some plans for publishing them for his own credit"; *Thomas Harriot*, 386.

17. *Kepler's Conversation with Galileo*, 10. Page numbers in this section of the text refer to this book.

18. Koyré analyzes Kepler's "rejection of infinity"; *From the Closed World to the Infinite Universe*, 58–87.

19. Drake, *Galileo at Work*, 237–38. Feyerabend argues that "Galileo was only slightly acquainted with contemporary optical *theory*" or the principles of telescopic vision, and that his knowledge of optics was far inferior to Kepler's; *Against Method*, 80–82, 99–100.

20. McMullin contrasts Kepler's positions with Galileo's; "Galileo on Science and Scripture," 299–302.

21. In the *Dialogue on the Two Chief World Systems* (1632), published after Kepler's death, Galileo's only reference to Kepler expresses his surprise that such a great philosopher could have been so wrong about the tides: "Although he had a free and penetrating intellect and grasped the motions attributed to the earth, he lent his ear and gave his assent to the dominion of the moon over the water, to occult properties, and to similar childish ideas"; *Galileo on the World Systems*, 304. Ironically, Galileo's explanation of tidal motion proved to be quite mistaken, while Kepler had anticipated Newton's correct theory.

22. Spiller argues that the *Conversation* "is structured around tension between Galileo as an observer and Kepler as a reader"; *Science, Reading, and Renaissance Literature*, 119.

23. *Conversation*, 14–18. As Kepler recognizes, Della Porta's fanciful devices draw on "natural magic" rather than proper lenses. Reeves, *Galileo's Glassworks*, disposes of these supposed predecessors. Galileo had met Della Porta, whose comedies may have influenced his own unfinished play (if not his optics); see Heilbron, *Galileo*, 86–88.

24. By the time Kepler died in 1630, the notes were five times as long as the text they glossed. Rosen discusses the circumstances of publication in the introduction and appendices to *Kepler's Somnium*, 7. Lambert, *Imagining the Unimaginable*, compares Galileo's perspective on the moon with Kepler's.

25. The Kepler satellite was launched by NASA in 2009 with the mission of searching the universe for planets that might support life. Kepler himself did not believe that the stars were other suns, however, and his own speculations about extraterrestrial life are limited to the solar system.

26. Kepler's argument echoes Plutarch's *On the Face in the Moon*, in *Moralia*, 157. Later Kepler translated that text from Greek into Latin, filling in some of its gaps, and appended it to *Somnium*. "Every time I reread this book by Plutarch, I am exceedingly amazed and keep wondering by what chance it happened that our dreams or fables coincided so closely"; 31–32.

27. On Kepler's complex involvement with astrology, see Simon, *Kepler astronome astrologue*; and Rosen, "Kepler's Attitude toward Astrology."

28. See Caspar, *Kepler*, 338–45.

29. See Rosen's note, in Kepler, *Kepler's Somnium*, 76–77.

30. *Sidereus Nuncius*, 57.

31. Nicolson's classic survey, *Voyages to the Moon* (1948), has been supplemented by Montgomery, *Moon and the Western Imagination*, and Parrett, *Translunar Narrative*.

32. *Ignatius His Conclave*, 7, 15. See chapter 10 below. Donne slyly (mis)quotes a sentence from Kepler's *De Stella in Cygno* (1606). In a note written in the 1620s, Kepler surmises (probably wrongly) that the anonymous author of *Ignatius His Conclave* had seen an early manuscript of the unpublished *Dream*; *Kepler's Somnium*, 38–41, 212–13. The two men met briefly in 1619 in Linz, though apparently Kepler never realized that it was Donne who had attacked him; see Bernstein, "Heaven's Net."

33. Adorno, "Postludium." Blumenfeld, "'Ad Vocem' Adorno," analyzes Adorno's polemic against Hindemith, and Lessing, *Die Hindemith-Rezeption*, provides a detailed critique of Adorno's unconditional attack.

34. Hindemith, *Craft of Musical Composition*, 1:22.

35. Bruhn argues that Kepler's death finally brings about harmony by transcending life's limitations; *Musical Order of the World*, 203–7.

36. Kater describes the plight of Hindemith, whom he describes as "the reluctant emigré"; *Composers of the Nazi Era*, 31–56.

37. Benjamin, *Reflections*, 92–93. Schubert, a leading Hindemith scholar, considers this passage a key to the opera, which represents the Hegelian *Entzweiung* (rupture, estrangement) of an ordered cosmos.

38. Gillispie, *Edge of Objectivity*, 39; Kepler, *Harmony*, 391. See Exodus 12:35–36, 25:1–8. "Egyptian vessels," in this context, refers to Ptolemy's *Harmony*, reclaimed as a building block for Kepler's temple.

39. As H. F. Cohen points out, Koyré, who played a major role in defining the "Great Tradition" of the Scientific Revolution, never accepted Kepler as a central figure in it. "Although Koyré greatly admired Kepler's achievement, and in particular his mathematical conception of nature, he had little use for him in his overall schema of things," since "Kepler regarded the universe as finite"; *Scientific Revolution*, 82.

40. "As Archimedes' axioms are the foundation of the mathematical science of statics, so Kepler's laws were to become the foundation of the mathematical science of celestial mechanics"; A. R. Hall, *From Galileo to Newton*, 81.

41. I. B. Cohen, *Birth of a New Physics*, 132.

42. "Individual scientists embrace a new paradigm for all sorts of reasons and usually for several at once. Some of these reasons—for example, the sun worship that helped make Kepler a Copernican—lie outside the apparent sphere of science entirely"; Kuhn, *Structure of Scientific Revolutions*, 152–53.

43. *Utriusque cosmi maioris*. Fludd's *Inquiry* went through many stages; a final volume was published in 1621.

44. *Harmony of the World*, 503–8. Fludd's criteria of truth are examined in chapter 7 below. H. F. Cohen, *Quantifying Music*, analyzes Kepler's speculations.

45. Caspar, *Kepler*, 292. This influential biography was first published in German in 1948; Gingerich supervised a corrected and expanded edition of the translation by Hellman (1993). Caspar's account of the quarrel marvels at "the flood

of astrological, alchemical, magical, cabbalistic, theosophic, mock mystic, and pseudoprophetic writings which held the intellects in a spell" among Kepler's foolish enemies (291).

46. Pauli, "Influence of Archetypal Ideas," 171, 204–12. Westman, "Nature, Art, and Psyche," provides a searching analysis of Pauli's essay. Other articles in *Occult and Scientific Mentalities*, the volume edited by Vickers, also cast light on the quarrel; see esp. Vickers (95–163) and Field (273–96). Meier's edition of the Pauli-Jung letters, *Atom and Archetype*, includes Pauli's other studies of Kepler and an interpretive essay by Beverley Zabriskie. On the relations of Pauli's ideas to Jung, see also Lindorff, *Pauli and Jung*; Gieser, *Innermost Kernel*; and Miller, *Deciphering the Cosmic Number*.

47. Yates, *Giordano Bruno*: 444; *Rosicrucian Enlightenment*, 223.

48. See Vickers, "Frances Yates and the Writing of History." The issues are debated by many of the contributors to Bonelli and Shea, *Reason, Experiment, and Mysticism*. According to Shea's introduction, "Kepler offers a particularly fascinating case study in the pitfalls of historical interpretation" (8).

49. Clark, *Thinking with Demons*, has documented the close relations between demonology and early modern science.

50. Dekker, *Plague Pamphlets*, gives a vivid account of the horrors of the plague and the ineffectual efforts of divines and doctors to combat it. Wear examines medical responses to plague; *Knowledge and Practice in English Medicine*, 275–349.

51. For Fludd's advocacy of one occult cure, the weapon-salve, see chapter 7 below.

52. Caspar, *Kepler*, 13. Caspar's love for his subject, it should be added, did not keep him from probing analyses of Kepler's scientific writings. Caspar's biography has guided most later treatments of Kepler, including Hindemith's and Koestler's as well as Banville's atmospheric novel, *Kepler* (1981).

53. *Harmony of the World*, 391.

54. *Sleepwalkers*, 11. Cf. Paul de Man's claim that "a certain degree of blindness is part of the specificity of all literature"; *Blindness and Insight*, 141.

55. *New Astronomy*, 286.

56. *Sleepwalkers*, 330, 333.

57. Useful correctives to Koestler's analysis include Curtis Wilson, *Astronomy from Kepler to Newton*, and Voelkel, *Composition of Kepler's "Astronomia Nova."*

58. Jardine, *Birth of History and Philosophy of Science*, 290. Jardine provides a text and translation of the Latin *Apologia*.

59. Ursus's published attack on Tycho (1597) includes a flattering letter from Kepler, who had not read the work. Later Kepler sent a long letter of apology to Tycho. But Tycho would not accept Kepler as an assistant until he agreed to write a refutation of Ursus's charges. Kepler's *Defence* (*Apologia*) was first published in 1858.

60. *Harmony of the World*: 447–48. Walker concludes that this comparison marks "a real causal connexion," not only a metaphor; *Studies in Musical Science*, 61–62.

61. Stephenson, *Music of the Heavens*, 184. "Once heaven has been cast as the page of a well-staffed polyphonic score, the planets may be perceived as executing a cosmological composition in six parts"; Heller-Roazen, *Fifth Hammer*, 129.

62. As Mosley points out, the *Tables* were only a part of Tycho's plan for an *Opus Astronomicum* that would describe his techniques and cosmology; *Bearing the Heavens*, 119–26.

63. Kepler's modest annual salary of 500 gulden was largely hypothetical; throughout his life he struggled to collect it from the imperial treasury, and at his death the arrears amounted to 12,694 gulden, a debt that his heirs never recouped; Caspar, *Kepler*, 363.

64. Caspar, *Kepler*, 308.

65. *New Astronomy*, 157. Tycho hypothesized that the sun and moon circle the earth, while the planets circle the sun. Max Brod's intriguing and unreliable novel on Tycho (1916) interprets his last words perversely as a disinterested espousal of "the true law"; *Tycho Brahe's Path to God*, 288. Ferguson, *Tycho & Kepler*, tells the story of the fraught relationship, and Gilder and Gilder, *Heavenly Intrigue*, manufacture a case that Kepler poisoned Tycho.

66. When Kepler belatedly came across Napier's *Description of the Admirable Table of Logarithms* (1614), he characteristically wrote a book that reconceived it on the basis of Euclidean arithmetic: *Chilias Logarithmorum at Totidem Numeros Rotundos* (1624–25).

67. See Gingerich, *Great Copernicus Chase*, 123–31.

68. *Tabulae Rudolphinae*, in *Gesammelte Werke,* 10:15–26. Arnulf, "Das Titelbild der Tabulae Rudolphinae," throws light on the sources and allegorical finesses of Kepler's intricate design.

69. See Gingerich, *Eye of Heaven*, 340–42, 379–87.

70. Martens discusses "the threat to the perfectibility of astronomy"; *Kepler's Philosophy*, 169–72. Aughton, *Transit of Venus*, describes the British astronomer Jeremiah Horrocks's improvements over Kepler's calculations.

71. *Kepler's Somnium*, 14, 28–29.

72. *Optics*, 16.

4. The Poetry of the World

1. The situation and significance of Hofmannsthal are analyzed perceptively by Schorske, *Fin-de-siècle Vienna*, 15–22, 304–19; and Broch, *Hugo von Hofmannsthal and His Time*, 117–25.

2. Coetzee's novel *Elizabeth Costello* concludes with a letter by "Elizabeth," the wife of Lord Chandos, in which she begs Bacon to save them from revelations more intense and disturbing than words can express—for instance, the visionary, horrifying scene (in Hofmannsthal's story) in which Lord Chandos feels himself filled with the death throes of poisoned rats.

3. *Letters*, 3:80–82.

4. On the origins of Bacon's revolution in natural philosophy during this period, see Farrington, *Philosophy of Francis Bacon*; and Zagorin, *Francis Bacon*, 25–73.

5. "Valerius Terminus: Of The Interpretation of Nature," *Works of Francis Bacon*, 3:242.

6. "Thoughts and Conclusions on the Interpretation of Nature," in Farrington, *Philosophy of Francis Bacon*, 81.

7. Farrington, *Philosophy of Francis Bacon*, 72; his italics. For the original Latin, see *Works of Francis Bacon*, 3:538–39.

8. Hofmannsthal, *Lord Chandos Letter*, 127–28.

9. Sir John Davies's famous poem *Nosce Teipsum* (1599) is divided into two parts: "Of Human Knowledge" and "Of the Soule of Man." Bacon knew Davies and wrote a friendly letter to him on March 28, 1603. See *Works of Francis Bacon*, 3:65.

10. *Advancement of Learning* (1605), in *OFB* 4:116.

11. In *Back to Nature*, Watson argues that "nostalgia for unmediated contact with the world of nature" (5) drives much of the art of the late Renaissance.

12. *Advancement of Learning*, in *OFB* 4:63.

13. "A Preparative to a Natural and Experimental History" (1620), in *OFB* 11:453.

14. Ogilvie, *Science of Describing*, explores the reach and variety of sixteenth-century naturalists.

15. Quoted by Freedberg, *Eye of the Lynx*, 76—a book lavishly illustrated with Lincean drawings.

16. *OFB* 11:457.

17. "In truth, Bacon's attitude seems to have had little impact on naturalists before the era of the Royal Society. If his presence was felt before then, it was so subtle as to be, shall we say, occult." Ashworth, "Natural History and the Emblematic World View," 324.

18. The "Bacon-faced generation" is a central concern of Jones, *Ancients and Moderns*. See also Levine, "Natural History and the History of the Scientific Revolution."

19. *Les mots et les choses*, 49 (*Order of Things*, 34). Foucault borrows a phrase from Hegel's aesthetics, "the prose of the world," which had previously been adopted by Merleau-Ponty in *La prose du monde* (posthumously published, 1969).

20. *Les mots et les choses*, 39. In the French text, though not its English translation, Bacon is cited as the authority for mutual attractions between things (43).

21. *Les mots et les choses*, 48 (*Order of Things*, 33).

22. Huppert documents most of these charges in "*Divinatio et Erudito*: Thoughts on Foucault." Rossi exposes other errors by Foucault in *Logic and the Art of Memory*, xxiv–xxvi.

23. Ashworth supplies many concrete examples to back Foucault's position. "Michel Foucault has suggested that [the] search for similitudes and resemblances was the principal guiding episteme for all of Renaissance thought, and, in the case of Gesner's natural history, he was absolutely right"; "Natural History and the Emblematic World View," 306.

24. *OFB* 4:89.

25. Rossi, *Francis Bacon*, 35. The book was first published, in Italian, in 1957.

26. Paolo Rossi, "Hermeticism, Rationality, and the Scientific Revolution," 257, 259.

27. John Ray (1627–1705), whom Raven credits with having put an end once and for all to the emblematic worldview "as a serious interpretation of life" (*English Naturalists*, 47), is mentioned by Foucault only as a late example of a new episteme, Cartesian mechanism (140).

28. See Ashworth, "Natural History and the Emblematic World View," 311–16. In 1632, Henry Reynolds insisted that the ancient poets had commanded "the mysteries and hidden properties of Nature"; "Mythomystes," 1:162. The persistence of occult interpretations of nature is stressed by several of the contributors to Debus and Walton, *Reading the Book of Nature.*

29. *Les mots et les choses,* 140–41 (*Order of Things,* 128–29).

30. Ashworth, who agrees that Jonston marks a watershed, also notes the inaccuracy of the date; "Natural History and the Emblematic World View," 317–18, 330.

31. *OED,* s.v. "history." Cf. Aristotle's *History of Animals,* which begins by describing and comparing the parts of animals, not their origins.

32. *Advancement of Learning,* in *OFB* 4:26. Cf. Italo Calvino, who recommends *Naturalis historia* as "a guided tour of the human imagination. An animal, whether real or imaginary, has a place of honor in the sphere of the imagination. As soon as it is named it takes on a dreamlike power, becoming an allegory, a symbol, an emblem"; "Man, the Sky, and the Elephant," 329.

33. *OFB* 11:457.

34. *Les mots et les choses,* 61–63 (*Order of Things,* 47–49).

35. Sewell argues that Bacon's attack on "poetical ways of thinking" about natural history was a betrayal or distortion of his true character, revealed in *On the Wisdom of the Ancients* (*De Sapientia Veterum,* 1609), "as a dark, riddling, emblematic poet, struggling with a metamorphosis of his own thinking and of man's power over the universe"; *Orphic Voice,* 61.

36. On the structure and critical principles of Warton's *History,* see Lipking, *Ordering of the Arts,* 352–404.

37. Warton, *History of English Poetry,* 2:463.

38. E.g., Lewis, *Discarded Image* (1964). Parker stresses the cost of Augustan literalism, a "triumph" that brought about an impoverished "re-invention of nature"; *Triumph of Augustan Poetics.*

39. Eliot, *Selected Essays,* 4–5, 247. "Spilt religion" is T. E. Hulme's definition of Romanticism.

40. Bush, *Science and English Poetry,* 44. For a response to Bush, see Lipking, "Gods of Poetry."

41. Nicolson, *Breaking of the Circle,* xxi–xxii.

42. *Works of George Herbert,* xl. Summers spells out the "remarkable similarities" between Herbert and Bacon; *George Herbert,* 97–99, 195–97.

43. "*In Honorem Illustr. D.D. Verulamij, Sti Albani, Mag. Sigilli Custodis post editam ab eo Instaurationem Magnam*" ("In Honor of the Gift Offered by the Illustrious Verulam, St. Albans, Keeper of the Great Seal, after Publishing His Great Instauration"); Herbert's *Works,* 436–37. The title dates the poem (first published in 1637) during the high-water mark of Bacon's career in 1621, between January 27, when he became Viscount St. Albans, and May 1, when his impeachment on charges of bribery took away the Great Seal. Bacon had delivered a presentation copy of part 2 of *The Great Instauration* to Cambridge, for which Herbert, as Public Orator, offers official thanks.

44. *OFB* 11:175.

45. *Breaking of the Circle,* 149.

46. See chapter 10 below. Donne's energetic engagement with the cosmography of his time has been explored by Coffin, *John Donne and the New Philosophy*, and Empson, *Essays on Renaissance Literature*.

47. *Troilus and Cressida*, 1.3.86–88.

48. Mazzeo, *Renaissance and Seventeenth-Century Studies*, 54–55.

49. The appendix to Chester's *Loves Martyr* (1601) includes "Diverse Poeticall Essaies" on the phoenix and the turtle by Shakespeare, Jonson, Chapman, Marston, and "Ignoto," who provide dissimilar and often enigmatic versions of the pair. "*The Phœnix Analysde*," by Jonson, comments ironically on the slippery emblem: "Now, after all, let no man / Receive it for a *Fable*, / If a *Bird* so amiable, / Do turn into a Woman. // Or (by our *Turtles* Augure) / That *Natures* fairest Creature, / Prove of his *Mistris* Feature, / But a bare *Type* and *Figure*"; *Loves Martyr*, 186.

50. Bevis, *Aaaaw to Zzzzzd*, supplies a lexicon of words attributed to birds, and Burroughs, *Birds and Poets*, offers a brief survey of poetic birdsongs.

51. British Library, Harley MS 978, fol. 11v. In the manuscript, line breaks are indicated only by capitalization and bar lines (in the musical notation), and punctuation is limited to dots (or puncta) that separate phrases. The page is reproduced by Hirsh, *Medieval Lyric*, 36.

52. The English words are interlineated with a Latin hymn, which also fits the music. W. P. Ker assumed that the Latin came first, so that the Cuckoo song "is the result of deliberate study"; *English Literature Medieval*, 75. Ezra Pound supposed that "Dr Ker has put an end to much babble about folk song by showing us *Summer is ycummen in* written beneath the Latin words of a very old canon"; *Literary Essays*, 92. A note to Pound's "Ancient Music"—"WINTER is icummen in, / Lhude sing Goddamm"—repeats that misinformation, which may have inspired his riposte; *Personæ*, 116. But the English is written *above* the Latin, and no evidence indicates that it was based on an older canon. Boklund-Lagopoulou concludes that "it is easier to see this poem as a popular song than it is to imagine it as the written composition of a learned poet"; "*I have a yong suster*," 46.

53. Topsell, *Fowles of Heauen*, 244. Modern ornithologists observe one variation in the cuckoo's cry, its "chuckle" or "so-called change of tune, when the note is triplicated"; Coward and Barnes, *Birds of the British Isles*, 208. This variation is artfully exploited by Handel when he mimics the song in "The Cuckoo and the Nightingale" (Organ Concerto no. 13).

54. As early as Hesiod (eighth century BC?) the cuckoo represented the joy of spring: "When first the cuckoo cuckoos in the leaves of the oak tree, / Giving delight to mortals on the boundless earth"; *Works and Days*, lines 486–87.

55. For a fine analysis of this effect, see Reiss, *Art of the Middle English Lyric*, 8–12.

56. Symons's anthology, *Chaucerian Dream Visions*, includes the text as well as an extensive survey of criticism and scholarship. In 1897 W. W. Skeat convincingly removed the poem from the Chaucer canon; *Chaucerian and Other Pieces*, lvii–lxi. Skeat attributed it to Sir Thomas Clanvowe, but lately most scholars conclude that Sir John Clanvowe was the author.

57. Baird describes the medieval "bird of violence" who cries "oci"; *Rossignol*, 18–23. Lee Patterson argues that the poem subordinates truth telling to the discourse and social practices of the court, and that *ocy* "encapsulates in a single word the

absolutist ideology that is at the center of courtliness"; "Court Politics and the Invention of Literature," 23.

58. "The nightingale in Provençal and Old French lyrics is almost exclusively male," as Pfeffer points out (*Change of Philomel*, 157); indeed, it sometimes has a penis. But by Chaucer's time the nightingale in English poems is almost exclusively female.

59. Topsell, *Fowles of Heauen*, 240–41. Topsell also recounts an "old Apologue" (unidentified) in which a cuckoo and nightingale ask an ass to judge "which of them sange the sweetest notes." The ass decides in favor of the cuckoo, but the nightingale appeals to Man, who reverses the judgment: "Amonge Asses great talkers are best esteemed, but amonge wisemen sweete songs and wise sayings are better accompted then lowde bablinge and importunate exclamations" (244). Mahler composed a song on this theme in *Das Knaben Wunderhorn*, with the ass (or donkey) as *critic*.

60. Nagy, *Poetry as Performance*, explores relations between nightingales and poets, particularly in oral poetic traditions dating back to Homer.

61. Gascoigne, *Complete Works*, 2:177. "Philomene" (for "Philomela") is a transcriptional error with a long history. By the time of the *Carmina Burana* (thirteenth century) *philomena* was the generic word for "nightingale."

62. *Complete Works*, 2:198. See 2:179–80 and 198–203. Austen suggests that this exposition may have been added when the poem was revised in 1576; *George Gascoigne*, 166.

63. *Pliny's "Natural History,"* 113. In his commentary on Ovid (1632), Sandys contends that Philomela's "infinite variety" is "more than natural," since she develops skill by competing with other birds as well as through schooling by her elders; *Ovid's "Metamorphosis,"* 300. The nightingale's incredible capacity for learning songs has been experimentally verified by Hultsch and Todt, "Learning to Sing," 101–5.

64. Eliot contrasts "Tereu" with "Jug Jug" in *The Waste Land*, lines 203–6. John Lyly, whom Gascoigne influenced, coupled "jug" and "tereu" in *Campaspe* (1584). Prouty (*George Gascoigne*, 262) cites Pausanius (*Description of Greece*) as recording the cry of "Tereus," but I do not find it there. In Greek the nightingale usually sang "Itu, itu!," supposedly a reference to Itys, although Aristophanes' *Birds* plays variations on "tio"; see Pollard, *Birds in Greek Life*, 42–43, 165. Baird suggests that in "Axe Phebus aureo," a song from the *Carmina Burana*, the lines "Philomena querule / Terea retractat" (commonly understood as "Philomena retracts her complaint of Tereus") might be translated as "Philomena retracts her complaining cry, 'Terea'"; *Rossignol*, 6–7. Garrod says it was Gascoigne "who first, so far as I know, isolated from among the notes of the Nightingale the *Tereu* which later poets have made so tiresome to us"; *Profession of Poetry*, 150.

65. Deriving *juggler* from *jugum* (yoke) is a plausible error; the English word actually derives from the Latin *joculator* (joker). "Jug, jug" had long been a familiar nightingale's cry, at least to the "dirty ears" of those who did not want to understand why Philomel was crying (*The Waste Land*, lines 99–103).

66. Keilen argues that "only by estranging this most familiar convention of Latin literature, and by framing Latin eloquence as animal sounds, can English poets turn the categories of eloquence and literature to new uses and claim the nightingale as the symbol of their vulgar kind of writing"; *Vulgar Eloquence*, 101.

67. "Certain Sonnets" (1581?) 4; Sidney, *Poems*, 137. Brown analyzes many adaptations of Philomela's story, including Gascoigne's, in which the violence and latent homoeroticism of the two sisters induce anxiety in male writers; *Ovid*, 85–121.

68. *Shorter Poems*, 145, 188, 192. Cheney argues that "the 'Nightingale' is a sign of the poet relying on his divine art to free himself from the cycle of nature"; *Spenser's Famous Flight*, 99–100.

69. "An Elegie, or friends passion, for his *Astrophill. Written vpon the death of the right Honourable sir Phillip Sidney Knight, Lord gouernour of Flushing,*"lines 190–92. First printed in *The Phœnix Nest* (1593), the poem was included in *Astrophel* (1595), a collection of elegies for Sidney headed by Spenser (to whom it has sometimes been wrongly attributed). According to Thomas Nashe, Roydon "hath shewed himselfe singular in the immortal Epitaph of his beloued *Astrophell*"; *Works*, 3:323.

70. *Love's Labour's Lost* (1594–95), 5.2.882–86.

71. Chaucer, *Parlement of Foules*, line 358. See Acworth, *Cuckoo and Other Bird Mysteries*, 144, 171–72.

72. First published in Milton's 1645 *Poems*. Most scholars assign the sonnet to Milton's early twenties, but Annabel Patterson hypothesizes that it may have been written after his marriage in 1642, when the cuckoo's song might have posed a threat of cuckoldry; "That Old Man Eloquent," 33.

73. "Il Penseroso," lines 62–65.

74. Fowler notes Aristophanes's accurate rendition of the crescendo, ending in "totobrix"; *Year with the Birds*, 163. Coward and Barnes hear the crescendo as "pew, pew" and the croak as "kur kur"; *Birds of the British Isles*, 282–84. The nuances of a nightingale's song are brilliantly captured by Richard Crashaw's "Musicks Duell," published the year after Milton's 1645 *Poems* but far less influential.

75. "Hear how the Birds, on ev'ry bloomy Spray, / With joyous Musick wake the dawning Day! / Why sit we mute, when early Linnets sing, / When warbling *Philomel* salutes the Spring"; Alexander Pope, "Spring" (1709), lines 23–26. The first line of Milton's first sonnet refers to "yon bloomy Spray." Pope claimed to have written his pastorals in 1704, when he was sixteen.

76. *Ornithology of Francis Willughby*, 98.

77. Ray, *Wisdom of God*, 339. On the "anti-marvelous" bias of Baconian naturalists, see Daston and Park, *Wonders and the Order of Nature*.

78. *Ornithology of Francis Willughby* records a long anecdote from a guest at an inn who hears caged nightingales, after midnight, "talking one with another, and plainly imitating mens discourses"; they repeat a coarse argument between the tapster and his wife and even chant a prediction of future wars, presumably from overhearing "the secret conferences of some Noblemen and Captains" (221).

79. Thomas, *Man and the Natural World*, 111.

80. Thomson, "Spring," lines 703–5. This passage responds to Virgil's *Georgics*, 4:511–15, which compares a nightingale whose nest has been robbed of her young to Orpheus, mourning the lost Eurydice. But Thomson focuses on the bird herself, whose despair not only explains why nightingales wail but also conveys a political and ecological indictment of "tyrant Man." Chalker analyzes Thomson's debt to Virgil; *English Georgic*, 90–140.

81. "Summer," lines 1560–62. When Newton died in 1727, Thomson interrupted work on "Spring" to compose a long memorial poem. As Nicolson has shown in *Newton Demands the Muse*, the *Optics* inspired some dazzling effects of light and color in Thomson's poems.

82. Raven's *John Ray* still sets the standard. McKillop, *Background of Thomson's "Seasons,"* provides the best introduction to Thomson's scientific and philosophical views.

83. Shaftesbury, *Characteristicks*, 2:162. On the natural affections of animals, see his "Miscellaneous Reflections": "We are to believe firmly and resolutely, 'That other Creatures have their *Sense* and *Feeling*, their mere *Passions* and *Affections*, as well as our-selves'" (3:129–30).

84. Johnson, *Lives of the Poets*, 4:103.

85. On lines 580–81 of "Spring," Sambrook notes, "A theme not entirely unknown to fame; cf. Addison's Latin verses in *Spectator* 412." Those verses confirm the point that male birds, in their courtship, respond to the colors of their own species: "The Black-bird hence selects her sooty Spouse; / The Nightingale her musical Compeer, / Lur'd by the well-known Voice: the Bird of Night, / Smit with his dusky Wings, and greenish Eyes, / Woos his dun Paramour." (This English translation comes from the 1744 edition of *The Spectator*.) But Addison's acknowledgment of sexual attraction (or attraction to beauty) within each species is not the same as Thomson's universal chorus.

86. In "A Hymn on the Seasons" (1730), Thomson emphasizes that the "sweet bird" is praising God: "when the restless day, / Expiring, lays the warbling world asleep, / Sweetest of birds, sweet Philomela! charm / The listening shades, and teach the night his praise!" (lines 77–80). In nature, neither the bird nor night is melancholy; unhappy human beings project their own woeful associations on them. This correction of Milton, both naturalistic and theological, anticipates the argument of Coleridge's conversation poem "The Nightingale" (1798).

87. These are Ralph Cohen's terms in a fine analysis of this part of the poem; *Unfolding of "The Seasons,"* 51–66.

88. "Thou hearest the Nightingale begin the Song of Spring"; Blake, *Milton a Poem*, Plate 31, line 28.

89. *John Clare by Himself*, 10; *Poems of the Middle Period*, 3:500.

90. Thomson: "Spring," line 860.

91. Goodman analyzes the figure of "noise" in Thomson, which she associates with uneasiness about the unseen people ignored by history; *Georgic Modernity*, 56–66.

92. See the conservationist Danäe Sheehan in *The Observer*, April 23, 2011.

93. Sebald, *After Nature*. Cf. Durs Grünbein, "To Lord Chandos: A Fax from the Future," in *Bars of Atlantis*, 72–74. Merchant argues that the "mechanistic analysis of reality" brought about the death of "living animate nature": "In 1500 the parts of the cosmos were bound together as a living organism; by 1700 the dominant metaphor had become the machine"; *Death of Nature*, 288. To speak of the early Renaissance world as "organic" seems anachronistic, however; the notion of "a living organism" did not exist before the late eighteenth century. Nor did the reciprocity of macrocosm and microcosm and the perception of nature as female constrain Renaissance men from exercising absolute dominion over nature, or from oppressing women as

well as other creatures. And Merchant's own acute comments on the vitalism of Leibniz and Newton, who "bequeathed" us "the world in which we live today" (275), tend to undermine her opposition of that world to "the world we have lost." The evidence of poetry suggests instead a growing ecological awareness.

5. "Look There, Look There!"

1. First Folio, 5.3.234–37, 285–86. These words do not appear in the First Quarto, where Lear's speech closes with "O, O, O, O." Line numbers in the text refer to *The Oxford Shakespeare*.

2. *King Lear* was probably first performed in 1605, although not published until 1608. In Holinshed's *Chronicles* (1577) and other likely sources for Shakespeare, Cordelia and her husband restore Lear to his kingdom, and after his death two years later she reigns in Britain; but after five years the sons of her sisters depose her, and she takes her own life. *The True Chronicle*, performed in the 1590s and published in 1605, ends happily with the reconciliation and victory of Cordelia and Lear.

3. *I Henry IV*, 5.4.102–3, 115–17.

4. *The History of Life and Death (Historia Vitæ & Mortis)*, in *OFB* 12:339; volume and page numbers in the text refer to this edition. Bacon cites the case of Duns Scotus as well as instances in his own time.

5. Aubrey, *Brief Lives*, 1:223–24.

6. John Ward's *Diaries* (1648–79), quoted by Haycock; *Mortal Coil*, 18.

7. On the art and ritual of dying, a standard study is Philippe Ariès, *Hour of Our Death*. On English customs, see Cressy, *Birth, Marriage, and Death*, and Houlbrooke, *Death, Religion, and the Family*. "The place where most people were ill was the home," according to Wear (*Knowledge and Practice in English Medicine*, 24), who estimates that "Of a thousand babies born alive, around a hundred and sixty would be dead by the end of their first year" (12). Dobson, *Contours of Death and Disease*, provides extensive demographic data about mortality in early modern England.

8. As late as 1661, a dialogue by Thomas Hobbes expressed his doubts: "B. But when is it that we can truly say of a man that he is dead, or which is the same thing, that he has breathed out his soul? For it is known that some men taken for dead have revived the next day when exhumed. / A. It is difficult to determine the point in time in which the soul is separated from the body." "Hobbes's *Physical Dialogue*," trans. Simon Schaffer, in Shapin and Schaffer, *Leviathan and the Air-Pump*, 373.

9. *Les mots et les choses*, 275–81. After Cuvier, Foucault argues, "Life is no longer what can be distinguished more or less certainly from mechanisms; it is what grounds all the possible distinctions among living beings [*les vivants*]" (281).

10. The prehistory of biological thought is excavated by Roger's classic study of eighteenth-century life sciences, *The Life Sciences in Eighteenth-Century French Thought*. Treviranus introduced the term "Biologie" in 1802. According to the *OED*, the word *biology* first occurs in English in 1813. Thomas S. Hall surveys efforts to answer the question "What is life?" in *Ideas of Life and Matter*.

11. "Orpheus; or Philosophy"; *Works*, 6:720–21.

12. Dubos, *Mirage of Health*, offers a critique of utopian hopes to restore the garden of Eden. More recently, the psychological and financial costs of technologies

that strive to prolong life by radical means have been examined by economists and philosophers as well as physicians. "These days, many hospitalized patients die only when a doctor has decided that the right time has come. Beyond the curiosity and the problem-solving challenge fundamental to good research, I believe that the fantasy of controlling nature lies at the very basis of modern science"; Nuland, *How We Die*, 259. John Gray, *Immortalization Commission*, examines post-Darwinian efforts to reassert the possibility of eternal life, an occult project often related to science. Jonathan Swift's classic satire of the Struldbruggs, *Gulliver's Travels* (1726), pt. 3, chap. 10, mocks the naive illusions of those who feed a "keen Appetite for Perpetuity of Life."

13. Haycock, *Mortal Coil*, 1–5, 39–41.

14. *Novum Organum*, in *OFB* 11:347. On Bacon's conception of spirits, see Walker, "Frances Bacon and *spiritus*"; Rees, "Frances Bacon and *spiritus vitalis*," in Fattori and Bianchi, *Spiritus*, 265–81; and in the same volume, Fattori, "*Spiritus* dans l'*Historia vitae et mortis* de Francis Bacon," 283–323, which includes a concordance of Bacon's use of *spiritus*.

15. Bacon, *Sylva Sylvarum*, 75. The *OED* cites Bacon for the definition of *enjoin* as "to impose rules on oneself."

16. In the utopian *New Atlantis*, Salomon's House, an institution dedicated to "the finding out of the true Nature of all Things," contains "large and deepe Caves" used for "*Prolongation of Life*, in some *Hermits* that choose to live there, well accommodated of all things necessarie, and indeed live very long."

17. *OFB* 12:147. The Etruscan king Mezentius, "scorner of the gods," killed his victims by binding them face-to-face with dead bodies (*Aeneid*, 8:485–88).

18. Giglioni, "Hidden Life of Matter," 142.

19. On Bacon's place in the history of theories of procreation, see Thomas Hall, *Ideas of Life and Matter*, 1:237–38. In 1668, Francesco Redi showed that maggots do not arise spontaneously in rotten meat but are produced by eggs laid by flies. But the theory of spontaneous generation was not refuted definitively until Louis Pasteur's experiments in 1859.

20. Rees, "The *De viis mortis* and the speculative philosophy," in *Francis Bacon's Natural Philosophy*, 20–32. Rees moderates this view somewhat in his introduction to vol. 6 of the *OFB*: "Francis Bacon's natural philosophy may be viewed as a single philosophy with two aspects or as two philosophies each with its peculiar character" (xxxvi). For an answer to Rees, see Zagorin, *Francis Bacon*, 118–20.

21. The first definition in Johnson's *Dictionary* (1755). Illustrative quotations begin with *King Lear*—"On thy *life* no more. /—My *life* I never held but as a pawn"—and *Antony and Cleopatra*—"She shows a body rather than a *life*, / A statue than a breather."

22. "That subtile knot, which makes us man"; John Donne, "The Extasie," line 64. "Death broke at once the vital chain, / And free'd his soul the nearest way"; Samuel Johnson, "On the Death of Dr Robert Levet," lines 35–36. In *The Passions of the Soul* (1649), Descartes maintains that the standard view of death is a serious error: "the soul takes its leave when we die" only because the body has already died; *Philosophical Writings*, 1:329.

23. Paracelsus, *Hermetic and Alchemical Writings*, 2:323; 1:135. Weeks sets Paracelsus's ideas about spirit and matter in the context of contemporaneous religious debates (see esp. *Paracelsus*, 108–14).

24. On the physican as priest and magus, see Debus, *Chemical Philosophy*: 1:96ff.; and Webster, *Paracelsus*.

25. Pagel, *Paracelsus*, 117.

26. Contrasting views of Bruno's cosmology are offered by Yates, *Giordano Bruno and the Hermetic Tradition*, and Gatti, *Giordano Bruno and Renaissance Science*.

27. Gilbert, *On the Loadstone* (1600), 309.

28. Garber provides a useful survey of theories of soul and mind in Garber and Ayers, *Cambridge History of Seventeenth-Century Philosophy*, 1:759–95.

29. *De anima*, 2.3. Des Chene, *Life's Form*, examines Scholastic versions of Aristotle's distinctions among souls.

30. *Discourse on the Method* (1637), in *Philosophical Writings,* 1:141. Descartes reexamined his view of animals, both theologically and anatomically, on many occasions. Clarke analyzes his various arguments in *Descartes's Theory of Mind*, 71–77, and more broadly in *Descartes: A Biography*, 331–36.

31. See Rosenfield, *From Beast-Machine to Man-Machine*.

32. "The problem is less that he makes animals into mere machines, but rather that animal faculties are capable of so much that the line between animals and human beings becomes blurred"; Gaukroger, *Descartes' System of Natural Philosophy*, 215.

33. *Leviathan*, 9.

34. "Ça mon âme, il y a long temps que tu es captive; voici l'heure que tu dois sortir de prison et quitter l'embaras de ce cors." This is the version of Claude Clerselier, in *Œuvres de Descartes,* 5:482.

35. Elton associates Kent's word with "the pagan ghost, or *umbra*"; *"King Lear" and the Gods*, 258. The complexity of relations between "spirit" and *"anima"* or "pure spirit" in the Middle Ages is examined by Jean-Claude Schmitt; *Ghosts in the Middle Ages*, 25–27, 196–200.

36. McGinn, *Meaning of Disgust*, argues that disgust reflects the consciousness of human beings that life depends on organic processes that carry the stain of corruption and death.

37. W. B. Yeats, "Sailing to Byzantium," line 22. Yeats often associated himself with Lear. In "Lapis Lazuli," he insists on the ultimate "gaiety" of Lear and other tragic figures.

38. Knight, *Wheel of Fire*, 177–206, and "Soul and Body in Shakespeare," in *Shakespearian Dimensions,* 3–21. Kott, *Shakespeare Our Contemporary*, 101–37. Cf. Spurgeon, *Shakespeare's Imagery*, 338–43.

39. Empson, *Structure of Complex Words*, 150.

40. Davies, *Poems*, 134. Donne, "Aire and Angels," line 6.

41. Davies, *Poems*, 167. These lines may glance at members of the Northumberland circle, especially Thomas Harriot, whose doctrine *ex nihilo nihil fit* ("Nothing is made of nothing") contradicts Davies's position that God "didst *Mans-soule* of nothing make" (*Poems*, 123); see Jacquot, "Harriot, Hill, Warner," 108. But Davies's main source on theories of the soul seems to be La Primaudaye, especially "Of the bodie and soule"; *French Academie*, 1:19–27.

42. Sanskrit *prana* and Chinese *ch'i*, for instance, both signify "life force" as well as "breath."

43. King James Version. In Hebrew "breath" of life is *neshamah*, and the living "soul" is *nephesh*. The Hebrew word *Ruach* can mean "breath," "wind," or "spirit."

Abrams surveys the traditional use of such ancient words as metaphors in *Correspondent Breeze*, 25–43.

44. Louis Delatte, Suzanne Govaerts, and Joseph Denooz trace the entangling and separation of *spiritus* and *anima* in Fattori and Bianchi, *Spiritus*, 55–62.

45. *On the Generation of Animals* (*De generatione animalium*), 736b30–737a1. Freudenthal surveys opinions on this much-disputed passage; *Aristotle's Theory of Material Substance*, 106–30.

46. See Thomas Hall, *Ideas of Life and Matter*, 1:104–5, 115–16, 155–63.

47. Johnson's *Dictionary*. To illustrate *pneumatical*, Johnson cites Bacon: "All solid bodies consist of parts *pneumatical* and tangible; the *pneumatical* substance being in some bodies the native spirit of the body, and in some other, plain air that is gotten in." In this free translation, the interchangeability of "intangible" and "pneumatic" is warranted by Bacon himself, who refers to "intangible or pneumatic bodies" (*Novum Organum*, in *OFB* 11:353).

48. Putscher, *Pneuma, Spiritus, Geist*, details the historical relations between theological and scientific understandings of spirit.

49. Boyle's early *New Experiments Physico-Mechanical, Touching the Spring of the Air and its Effects* (1660) examines opinions on breathing, air, and life, including Paracelsus's view "that there is in the Air a little vital Quintessence," but draws no firm conclusion; Boyle, *Works*, 1:287. Haycock reviews Boyle's research on chemical and alchemical processes that might rejuvenate diseased or aging bodies; *Mortal Coil*, 60–74.

50. Burton, *Anatomy of Melancholy*, 2:58–59.

51. *De Motu Cordis* (1628) in *Anatomical Exercises*, vii.

52. Quoted by Thomas Hall, *Ideas of Life and Matter*, 1:246.

53. On Fludd's weapon-salve and its relation to Harvey, see chapter 7 below. Debus analyzes Fludd's views on spirits of the blood and air in "Harvey and Fludd."

54. Katharine Park, "Organic Soul."

55. Harvey, *Anatomical Exercises*, 59.

56. In a chapter entitled "Concerning Weight," Sir Thomas Browne reports experimental evidence refuting Pliny's well-known claim that "men weigh heavier dead than alive"; *Pseudodoxia Epidemica*, 1:315. On Charles II, see 2:917–18.

57. Robert Fludd ("Rudolfo Otreb") mounts a vigorous defense of Rosicrucian teachings on life, death, and resurrection in *Tractatus Theologo-Philosophicus* (1617).

58. Nicholl, *Chemical Theatre*, 217–18.

59. *White Devil*, 5.2.38–41. The play was first published in 1612, four years after *Lear*.

60. Cf. Bacon's essay "Of Death" (1625): "It is as Naturall to die, as to be borne; And to a little Infant, perhaps, the one, is as painfull, as the other"; *OFB* 15:10–11.

61. Freud, *Collected Papers*, 4:244–56.

62. *Tolstoy on Shakespeare*; Nahum Tate, *The History of King Lear* (London, 1681).

63. "A man would die, though he were neither valiant, nor miserable, onely upon a wearinesse to doe the same thing, so oft over and over"; Bacon, "Of Death," in *OFB* 15:10.

6. The Dream of Descartes

1. Maritain's attack on Descartes (*Dream of Descartes*, 29), first published in 1920, is amplified by the contributors to Sweetman, *Failure of Modernism*.

2. *Philosophical Writings of Descartes*, 1:116 (hereafter cited as *PW*). Volume and page numbers in the text refer to the Cambridge edition.

3. *Œuvres de Descartes*, 10:7–8.

4. Notes by Baillet, Leibniz, and Descartes himself are edited by Hallyn, along with studies by various hands, in *Les Olympiques de Descartes*. Cole translates the relevant portion of the notes; *Olympian Dreams*, 25–29. Aczel, *Descartes' Secret Notebook*, argues that Leibniz deciphered Descartes's great secret: influenced by Kepler's cosmological model based on the five Platonic solids, he had been the first to discover the principles of topology.

5. Cole makes a strong case for the fidelity of Baillet's transcriptions; *Olympian Dreams*, 41–48. But Richard Watson, who thinks that "in many cases Baillet just makes things up," suspects that he "greatly embellished the dreams"; *Cogito, Ergo Sum*, 97, 113. Cole provides a facsimile of Baillet's chapter (book 2, chap. 1 of *La vie de M. Descartes*) on the dreams as well as his own translation of the dream sequence; *Olympian Dreams*, 32–40.

6. Recent clinical studies of sleep and dreams have described three distinct sleep conditions, each with its own kind of dreams: sleep onset, REM (rapid eye movement), and NREM (non-REM). Descartes's dreams seem to fall into those three types. The first, which is lengthy, dramatic, bizarre, and full of movement, characterizes REM; the second, a night terror that shocks the dreamer awake, matches one pattern of NREM sleep; the third, in which prior associations return in sleep, and the dream and waking states blend together, seems to occur at sleep onset. Hobson, *Dreaming*, provides a simplified survey of modern research.

7. My translation. Unless otherwise noted, all quotations in this chapter are drawn from Baillet's account of the dreams, translated in appendix 2.

8. Self-conscious states of dreaming are analyzed by two essays in Barrett and McNamara, *New Science of Dreaming*: David Kahn, "Metacognition, Recognition, and Reflection while Dreaming" (1:245–67); and Jennifer Michelle Windt and Thomas Metzinger, "The Philosophy of Dreaming and Self-Consciousness: What Happens to the Experiential Subject during the Dream State?" (3:193–247).

9. Leroy, *Descartes*, 1:89–90. Freud's letter on the dreams was written at Leroy's request.

10. Gouhier, *Les premières pensées de Descartes*, argues that the dreams are actually "thoughts" or allegorical fictions that warrant esoteric interpretations. Paul Arnold associates the dreams with *The Chemical Wedding of Christian Rosencreutz* (1616), a Rosicrucian classic (see Richard Watson, *Cogito, Ergo Sum*, 133–34). Von Franz provides an elaborate Jungian reading; "Dream of Descartes," 55–147.

11. Poulet provides a brilliant, tendentious close reading that links the dreams not only to Descartes's philosophy but to his "entire being"; *Studies in Human Time*, 72. According to Marion, "the *cogitatio* is awakened in the dreams of 1619" by Descartes's ability to think in his dreams, or "think dreams," "his consciousness being freed from affections"; *Cartesian Questions*, 19.

12. Sebba, *Dream of Descartes*, 54–56.

13. Jama's bibliography of studies of the dreams, though incomplete (for instance, it omits Sebba), cites eighty-five items. Clarke's account of the dreams in *Descartes: A Biography* (58–63) draws freely on Jama.

14. Harris suggests that Descartes's later theory of dreams marks a crucial turning away from the earlier mode of the "epiphany dream"; *Dreams and Experience*, 85–90.

15. Wittgenstein, *Lectures & Conversations*, 51.

16. According to Poulet, "In the language of the period, 'charms of solitude' and 'charms of nature' are equivalent expressions. The charms of solitude are nothing other than those proposed by the sensuous nature, the ensemble of which, fecund, succulent, compact and multiple at the same time, is indeed very well represented by this fruit"; *Studies in Human Time*, 60–61. Gabbey and Hall offer many possible interpretations of the melon, and favor the view that it represents the sphere of the cosmos or "a complete world of knowledge"; "Melon and the Dictionary," 662.

17. The date of the dreams, Baillet points out, "was Saint Martin's Eve, on the evening of which it was customary to go on a spree"; *La vie de M. Descartes*.

18. Gaukroger suggests that Descartes was undergoing "a mental collapse of some kind," and that his thoughts on method "came to symbolize his recovery from this"; *Descartes: An Intellectual Biography*, 111.

19. Influential accounts of the Cartesian banishment of imagination include Whitehead, *Science and the Modern World*; Dijksterhuis, *Mechanization of the World Picture*; and Heidegger, *What Is Called Thinking?* In an impassioned series of essays, the poet Durs Grünbein argues that Descartes, as "the quintessence of the free subject, the autonomously thinking and acting human being," was the progenitor not only of modern science, through a cognitive "I" that masters the world, but also of modern poetry, through a poetic "I" immersed in language; *Descartes' Devil*, 84–87.

20. Rodis-Lewis, *Descartes*, 57–58.

21. In Popkin's *History of Scepticism*, successive chapters are entitled "Descartes: Conqueror of Scepticism" and "Descartes: Sceptique Malgré Lui." See also Curley, *Descartes against the Sceptics*.

22. In an appendix on "Dreaming," Bernard Williams defends Descartes's claim that when we are awake, we can tell that we are awake; *Descartes*, 309–13.

23. Flanagan discusses Descartes's efforts to distinguish dreaming from wakefulness, and concludes that "Descartes got both the problem and the solution right"; *Dreaming Souls*, 174.

24. *The World*, 21. According to Gaukroger, when Descartes applies mathematics to the corporeal world "the contents of the intellect and the contents of the world must both be represented in the imagination"; *Descartes' System of Natural Philosophy*, 220. *The World* (1633) was abandoned after Galileo's condemnation and was not published in Descartes's lifetime. It consists of two parts, the *Treatise on Light* and the *Treatise on Man*.

25. *The World*, 24.

26. *Principles of Philosophy*, 105–6.

27. Platonic influence on Descartes's cosmology is viewed skeptically by Catherine Wilson, "Soul, Body, and World"; and by Cottingham, "Plato's Sun and Descartes's Stove," in *Cartesian Reflections*, 292–318.

28. *The World*, 38–39. Cf. *Principles of Philosophy*, 96, 117–22.

29. Newton mounted a full-scale attack on the "absurdity" of Cartesian vortices in an undated manuscript on gravity, *De Gravitatione*, in *Philosophical Writings*, 12–39. But as late as 1752, Bernard le Bouvier de Fontenelle, who had published the first biography of Newton in 1728, defended vortices in *Théorie des tourbillions cartésiens*.

30. *Optics*, Discourse One (Light), *PW* 1:154–55

31. See Gal and Chen-Morris, *Baroque Science*, 37–51. Baigrie argues that the images provided by Descartes are cognitive thought experiments rather than representations of anything in the world: "Descartes' illustrations are to be seen as two-dimensional models of how things might work, and not what they look like"; *Picturing Knowledge*, 116.

32. These issues are explored in good studies by Sepper (*Descartes's Imagination*) and Schouls (*Descartes and the Possibility of Science*). Clarke emphasizes that for the later Descartes "imagination is a cognitive faculty and, like any other instrument, it may be used properly or improperly"; *Descartes's Theory of Mind*, 81.

33. Alan R. White, *Language of Imagination*, mounts a sustained attack on the prevailing doctrine that imagination is coextensive with imagery.

34. *The World*, 105, 107. In the Royal Gardens at Saint-Germain-en-Lay, visitors stepped on tiles that activated mechanisms in the shape of gods or monsters. The rational soul, in Descartes's simile, presides over the waterworks like an alert fountaineer. Salomon de Caus, *La raisons des forces mouvantes* (Paris, 1624), had amply explained and illustrated the designs of grottoes and fountains.

35. On Descartes's continuing belief in the power of inspiration—"An inner joy has some secret power to make Fortune more favourable"—see his letter to Princess Elizabeth, October or November 1646 (*PW* 3:296–97).

36. *The World*, 99. For the functions of the pineal gland, see 142–60.

37. E.g., Ryle, *Concept of Mind*; and Damasio, *Descartes' Error*. Arguments about Descartes's dualism and the mind/body problem are so extensive that modern philosophy might be considered a series of footnotes to the issues he introduced. Some clarification of Descartes's own views is offered by Machamer and McGuire, *Descartes's Changing Mind*.

38. Opposing views are well expressed in the debate between Changeux and Ricoeur, *What Makes Us Think?*

39. "Of the Consequence or TRAYNE of Imagination"; *Leviathan*, pt. 1, chap. 3.

40. See Aarsleff, *Study of Language in England*, 44–72.

41. In *Principles of Philosophy* Descartes states that "all the things which we clearly perceive are true" (15), and subsequently refers to clear and distinct *perceptions* rather than to *ideas*, which might involve illusory images.

42. *The Prelude* (1850), 5.45–47.

43. This formulation draws on Gaukroger, "Nature of Abstract Reasoning."

44. Lüthy, "Logical Necessity," points out that Descartes's extensive use of visual aids or "iconography" was an innovation in natural philosophy that accounts for much of his influence on the natural sciences.

45. The globe of the earth is represented as a great magnet or loadstone in book 6 of Gilbert's *De Magnete* (1600), which Descartes acknowledged as his source.

46. *Principles of Philosophy*, 243, 265.

47. According to Dear, in the mechanical philosophy exemplified by automata and endorsed by Descartes "the distinction between art and nature was dissolved by

fiat"; "Mechanical Microcosm," 123. Stone, *Tables of Knowledge*, compares Descartes's and Vermeer's modes of representing thought.

48. The figures conceived by Descartes were prepared for print by his friend and editor Frans van Schooten the Younger, a Dutch mathematician and artist. Baigrie offers some interesting speculations about Descartes's acquaintance with Dutch painters, though it is not true that Rembrandt was apprenticed to Frans van Schooten's father; *Picturing Knowledge*, 88.

49. Cyrano de Bergerac, "Les états et empires du soleil," in *Œuvres complètes*, 1:180–83. Unfinished at Cyrano's death in 1655, this sequel to the *Voyage to the Moon* was first published in 1662.

50. Descartes's apparition suggests that this section of *Voyage to the Sun* was written just after his death in 1650. According to Vartanian, *Voyage to the Sun* contrasts sharply with Cyrano's previous work "by finding its inspiration wholly in Descartes"; *Diderot and Descartes*, 56.

51. *Œuvres complètes*, 1:342–43. Cyrano's posthumously published *Fragment de physique*, perhaps based on work by Jacques Rohault (see *Œuvres complètes*, 1:347–94), has been analyzed in relation to Descartes by Harth; *Cyrano de Bergerac*, 99–108.

52. In "Cyrano de Bergerac's Epistemological Bodies," Romanowski emphasizes Cyrano's use of multiple perspectives.

53. Descartes's own detailed descriptions of mechanical devices, written for Constantijn Huygens, were later published by Nicolas Joseph Poisson, *Traité de la mechanique, composé par Monsieur Descartes* (Paris, 1668).

54. *Principles of Philosophy*, 46–48. On the Lucretian origins of Cyrano's engine, see the note in *Œuvres complètes*, 1:207–8.

55. *Principles of Philosophy*, 171–72.

56. *Œuvres de Descartes*, 1:570.

57. The phrase "the self-assured inner voice" is Thomas Pavel's; "Literature and the Arts," 358.

58. Paul Valéry's long engagement and debate with Descartes are explored by five pieces in Valéry, *Œuvres*, 1:787–854, translated in *Masters and Friends*, 6–85, along with some comments from notebooks, 309–14.

59. Gabbey and Hall identify the *Dictionary* with Rudolf Goclenius's *Lexicon Philosophicum* (editions of 1603 or 1611), which had "reappeared" in abridged editions in 1613 and 1615; "Melon and the Dictionary."

60. *Œuvres de Descartes*, 1:156; *PW* 3:26–28.

61. *PW* 3:46. See Shea, *Magic of Numbers and Motion*, 292–95.

62. Alexander Pope, *An Essay on Man* (1733), lines 245–46.

63. A classic account is Curtius, "Book of Nature," in *European Literature*, 319–26.

64. J. C. Scaliger's *Poetices* (1561), cited by Shepherd in his edition of Sidney's *Apology*. Influential accounts of this concept include Panofsky's *Idea* and Abrams's *Mirror and the Lamp*, 272–85.

65. *Apology for Poetry*, 100.

66. *Principles of Philosophy*, 287, 288.

67. Quoted by Hutchinson, "What Happened to Occult Qualities." Guicciardini observes that "anti-Cartesian feelings pervade Newton's work"; *Isaac Newton on Mathematical Certainty*, 21.

68. Newton, *Principia*, 943.

69. *Biographia Literaria*, 1:304. In chapter 12, Thesis 7 mounts a critique of the Cartesian Cogito, which is equated with self-consciousness or "the conditional finite I" as opposed to "the absolute I AM," which originates in God (1:276–80).

70. *Biographia Literaria*, 1:296–97. The first sentence is borrowed from F. W. J. von Schelling, where the word translated as "naturalist" is "Physiker."

7. A History of Error

1. *Mosaicall Philosophy: Grounded upon the Essential Truth or Eternal Sapience*, 28. This is Fludd's own translation of his last work, *Philosophia Moysaica*, first published in 1638, a year after his death.

2. "Christ sayeth: When I am exalted I will draw bodys unto me"; "Truth's Golden Harrow" (1623), 109. For Jacob, see 122; for Moses, 110. This manuscript, unpublished at the time, responds to Patrick Scot, *The Tillage of Light* (1623).

3. Debus traces the history of the debate, with special attention to Mersenne, van Helmont, and Fludd, in *Chemical Philosophy*.

4. *Doctor Fludds Answer*, 108–9. Page numbers in the text refer to the first edition (1631). Huffman reprints substantial excerpts from this work as well as from "Truth's Golden Harrow" in *Robert Fludd: Essential Readings*.

5. Hacking's *Emergence of Probability* builds on a challenging thesis advanced by Foucault in *Les mots et les choses*. See also Shapiro, *Probability and Certainty*.

6. Despite this forbearance, Fludd later remarks that "this our adverse Author was a Barber Chirurgians sonne" (*Doctor Fludds Answer*, 122). Surgeons had financial motives to oppose the salve.

7. Shapin, *Social History of Truth*, 42.

8. A similar confidence invigorated some of Fludd's contemporaries, particularly Athanasius Kircher; see Findlen, *Athanasius Kircher*; and Glassie, *Man of Misconceptions*.

9. Westman, "Nature, Art, and Psyche," analyzes Fludd's "visual epistemology," with particular attention to Dürer. Godwin reproduces and annotates a great many of these pictures in *Robert Fludd*.

10. Harvey, *Anatomical Exercitations*, 59. The first English translation, quoted here, dates from 1653.

11. *Pulsus* (1629?), in vol. 2 of Fludd's *Medicina Catholica*. Debus discusses Fludd's use of Harvey in *Chemical Philosophy*, 1:271–76, and *Man and Nature*, 66–73.

12. The "Second Partition" of Burton's *Anatomy of Melancholy* begins with "*Unlawfull Cures Rejected*," and in its 4th edition (1632), a year after Foster's attack, Burton lists Fludd, who had been his contemporary as a student at Christ Church, Oxford, among authorities who vouch for the efficacy of "magneticall" or magical cures.

13. The white magic of alchemy serves benign purposes, both literally and symbolically, in Mantel's ingenious novel *Fludd*, set in the 1950s.

14. Keith Thomas, *Religion and the Decline of Magic*, 644.

15. Willey, *Seventeenth Century Background*, 48. In an epilogue to Raven's *English Naturalists*, Browne represents "the coming of modern man": "He desired to reject all infallibilities, to test all propositions, to expose all superstitions"; 350.

16. Lerer, *Error and the Academic Self,* provides a wide-ranging study of blunders.

17. "La diritta via"; *Inferno,* 1.3. Cf. "la verace via" (the true way) at line 12 and "dritto" at line 18.

18. "Chi crederebbe giù nel mondo errante, / che Rifeo Troiano in questo tondo / fosse la quinta delle luci sante?" *Paradiso,* 20.67–69.

19. *The Faerie Queene,* 1.1.10–26.

20. Although a few thinkers in Spenser's time had doubts about spontaneous (or more precisely, equivocal) generation, both literary and medical authorities (including Thomas Browne) gave overwhelming support to the fecundity of Nile mud.

21. Johns cites one instance from 1538: "Thomas Elyot had found it necessary to list heresies so that they could be 'the sooner espeyed and abhorred in suche bokes, where they be craftily enterlaced with holsom doctrine'"; *Nature of the Book,* 424.

22. Letter from Robert Ridley to Henry Gold, Feb. 24, 1527, in Pollard, *Records of the English Bible,* 122, 125. As Lerer points out, Ridley did not need to read the translation in order to accuse it of error; any vernacular rendering would open the door to "lutheranes heretikes & apostates"; *Error and the Academic Self,* 28–29.

23. *Pseudodoxia Epidemica* 1:3 (hereafter cited as *PE*). Volume and page numbers in the text refer to the 1981 Oxford edition.

24. "Of Truth," in *OFB* 15:7.

25. *Novum Organum,* Aphorism 65, in *OFB* 11:101–3.

26. Debus identifies Fludd as Bacon's target in the introduction to *Robert Fludd and His Philosophical Key.* Huffman concludes that the success of Bacon's ideas "contributed a great deal to Fludd's passage to obscurity"; *Robert Fludd and the End of the Renaissance,* 173. According to Seth Ward in *Vindiciæ Academiarum* (Oxford, 1654), "there are not two waies in the whole World more opposite, then those of the *L. Verulam* and *D. Fludd,* the one founded upon experiment, the other upon mystical Ideal reasons"; quoted in Jones, *Ancients and Moderns,* 112. It may be worth noting, however, that Bacon himself provided a recipe for the weapon-salve "upon the Relation of *Men of Credit*" in *Sylva Sylvarum* (1627), "though my selfe, as yet, am not fully inclined to beleeue it" (264).

27. Jones describes the influence of "the 'Bacon-faced Generation'"; *Ancients and Moderns,* 237–67. But Purver (*Royal Society*), Hunter (*Establishing the New Science*), and Lynch (*Solomon's Child*) have questioned the extent to which the practices of the Royal Society followed the theory and methods recommended by Bacon.

28. Glanvill, *Plus Ultra,* 88. *Plus ultra* (Further Beyond) was Bacon's motto, adopted from the Spanish king Charles V, who encouraged his mariners to explore beyond the Pillars of Hercules, which formerly had been considered the "Ne Plus Ultra." The famous frontispiece of the *Instauratio Magna* (1620) pictures a ship sailing beyond the pillars.

29. "Ode, To the *Royal Society*" (1667), line 93, in Sprat, *History of the Royal Society,* xlvi.

30. Gillispie's own view of Bacon is less than enthusiastic: since Bacon "discountenanced imagination," he "would have none of Kepler or Copernicus or Gilbert or anyone who would extend a few ideas or calculations into a system of the world"; and "No discovery has ever been made by following his method"; *Edge of Objectivity,* 77, 82. Solomon, *Objectivity in the Making,* also casts doubt on Bacon's "objectivity."

Daston and Galison argue that "objectivity is a nineteenth century innovation," preceded epistemologically by "truth-to-nature," and that Bacon's remedy for idols "had nothing to do with suppression of the subjective self," but rather advised an extreme counteraction to one-sided predilections; *Objectivity*, 27–32.

31. Digby, *A Late Discourse* (1658). Digby, who opposed occult or astral explanations of the salve, first offered his own mechanistic defense in *Two Treatises* (1644); see Dobbs, "Studies in the Natural Philosophy of Sir Kenelm Digby"; and Hedrick, "Romancing the Salve."

32. Huffman, *Robert Fludd*, 166.

33. Pauli, "Influence of Archetypal Ideas," 207; see chapter 3 above. Arthur I. Miller discusses Pauli's "Jungian take" on Fludd; *Deciphering the Cosmic Number*, 203–7.

34. Dear, *Revolutionizing the Sciences*, 166. Willey begins with a similar view of "what was *felt to be* 'truth' and 'explanation' under seventeenth century conditions": "Interest was now directed to the *how*, the manner of causation, not its *why*, its final cause"; *Seventeenth Century Background*.

35. On the patent, see *Robert Fludd*, 29–31. Gough discusses Fludd's unfulfilled hope to capitalize on steel; *Rise of the Entrepreneur*, 91. Yates analyzes Fludd's "astral mnemonics" in *Art of Memory* and *Theatre of the World*.

36. *Novum Organum*, in *OFB* 11:103–7.

37. *The Garden of Cyrus* (1658), in Browne, *Religio Medici*, 174 (hereafter cited as *RM*). According to Knott, Browne's "fondness for the figure of the labyrinth reveals both an inclination to marvel at the complexity of the divine order and a tendency to dwell upon the human capacity for error, including his own"; "Sir Thomas Browne," 19.

38. *Christian Morals*, 115–16 (hereafter cited as *CM*; page numbers in the text refer to Roberts's edition). Browne was attracted at times by the supposedly ancient writings attributed to Hermes (exposed as forgeries by Isaac Casaubon in the early seventeenth century), but it was their obscurity, not their truth, that pleased him. "I am now content to understand a mystery without a rigid definition. . . . Where I cannot satisfie my reason, I love to humour my fancy"; *RM* 10. On several occasions he approvingly quoted a sentence ascribed to Hermes: "*Sphæra, cujus centrum ubique, circumferentia nullibi*" ([God is] a circle whose center is everywhere, whose circumference is nowhere). A manuscript comment on artificial forms of verse ("odd contrived phancies") shows that Browne was acquainted with Fludd's hermetic ingenuity: "More ænigmatical and dark expressions might be made if any one would speak or compose them out of the numerical Characters or characteristical Numbers set down by Robertus de Fluctibus"; *Works of Sir Thomas Browne*, 3:68. Hack-Molitor, *On Tiptoe in Heaven*, discusses Browne's mystical leanings.

39. Johnson, "A Life of the Author" (1756); *CM* 18. Browne left *Christian Morals* in manuscript at his death in 1682, and it was first published in 1716.

40. *Diary of John Evelyn*, 3:594 (October 17, 1671). Preston puts *Pseudodoxia* within "the culture of collecting"; *Thomas Browne*, 103–20.

41. "The problem that occupies Browne's *Pseudodoxia Epidemica* is the relation of wandering to truth"; West, "Brownean Motion," 186.

42. *RM* 33.

43. Harvey, *Anatomical Exercitations*, 226. See Thomas Hall, *Ideas of Life and Matter*, 1:242–49. Browne greatly admired Harvey's "excellent discourse *of Generation*"

(*PE* 1:288), which he seems to have read more than a decade before it was published.

44. *RM* 33. In the preface to *Anatomical Exercitations*, Harvey had questioned whether the animal in the womb might begin as "some *rude* and *undigested lump.*" A long paragraph in *PE* (1:212–13) describes the gradual emergence of the frog, "according to the amphibious and mixt intention of nature," from a "blacke or duskie substance" in the seed through "the strange indistinction of parts in the Tadpole" to the process by which "successively the inward parts doe seem to discover themselves, untill their last perfection": "what a long line is runne to make a Frogge."

45. Commonplaces about Browne's "Latinity" are analyzed and challenged by Havenstein; *Democratizing Sir Thomas Browne*, 184–97.

46. *RM 33*.

47. *Hamlet*, 2:2:293–98. "What a piece of work is a man! . . . And yet to me what is this quintessence of dust?" Cf. Pascal: "What kind of chimera is man? What a novelty, what a monster, what chaos, what a mass of contradictions, what a prodigy? Judge of all things, idiot earthworm, depository of truth, sinkhole of unknowing and error, glory and refuse of the universe"; *Pensées*, L131/S164, in *Œuvres complètes*, 2:580.

48. *RM* 55. "Neither in the name of multitude doe I onely include the base and minor sort of people," Browne continues. "There is a rabble even amongst the Gentry."

49. *PE* 1:16. Killeen links Browne's deuteroscopic hermeneutics to ways of interpreting politics and science; *Biblical Scholarship*, 10–20.

50. "The falling of Salt is an authenticke presagement of ill lucke," according to Browne, because "salt as incorruptible, was the Simbole of friendship," so that its fall might portend a breach of friendship or perhaps even a breach with God (*PE* 1:425).

51. Browne's iconoclasm is a central concern of Killeen; *Biblical Scholarship*, 185–216.

52. Preston, *Thomas Browne*, 83–84. Preston supplies a very thorough study of Browne's uses of "vulgar" and also explores the many ramifications of the word.

53. The title of the first edition (1646), including the spelling "Tenents," was retained through "The Sixth and Last Edition, Corrected and Enlarged by the Author" (1672).

54. Earlier on the same page Browne's "ingenuous" means "ingenious," but he clearly distinguishes this freeborn class from "the people." Wilding argues that Browne's fear of the multitude, during the mass demonstrations of 1641–42, led him to include "gentry" among "the rabble" in *Religio Medici*, though he modified that verdict a few years later; *Dragon's Teeth*, 103–5.

55. *CM 19*.

56. Geis and Bunn, *Trial of Witches*, give a thorough account of Browne's role. Killeen (*Biblical Scholarship*, 147–53) and Silver ("'Wonders of the Invisible World'") contend that a "scientific" reliance on circumstantial evidence, not magical thinking, guided Browne's testimony.

57. *PE* 1:229. The title essay of Gardner's *Did Adam and Eve Have Navels?* begins with Browne, who considered Michelangelo's picture of Adam's navel a mistake, as if "the Creator affected superfluities" (*PE* 1:377).

58. In "A Digression of the wisdome of God in the site and motion of the Sun" (*PE* 1:464–68), Browne thanks providence for the sun's motion, "for, had it stood still, and were it fixed like the earth," there would have been no seasons. At the end of the chapter he mentions "the hypothesis of Copernicus, affirming the Earth to move, and the Sunne to stand still," but he does not endorse it.

59. *PE* 1:351. Robbins notes that Browne's discussion draws on as many as eighteen predecessors (*PE* 2:930).

60. *PE* 1:81. Browne seems to have taken special pains with this entry; he revised it extensively after the first edition in 1646. Preston counts at least twenty examples of experimental activity in the book; *Thomas Browne*, 186–89.

61. *PE* 1:96, 300, 288. Though seemingly indifferent to telescopes, Browne often does commend "exquisite Microscopes and Magnifying Glasses" (1:155).

62. As Robbins points out (*PE* 1:xxi–xxvii), Browne frequently makes use of George Hakewill's strong modernist argument against the "pretended decay" of nature and mankind, but he never cites or mentions it directly.

63. *PE* 1:71; cf. 1:586–87. On the clash of theories, see Joseph Needham, who commends Browne's "originality and genius" as an embryologist; *History of Embryology*, 133.

64. *CM* 120–21.

65. Temple, "An Essay upon the Ancient and Modern Learning" (1690), in Spingarn, *Critical Essays*, 3:32–72. Levine provides a useful overview in *Battle of the Books*.

66. On the turn from oral to written media, see Nagy, "Death of a Schoolboy," in *Poetry as Performance*. Jacques Derrida famously deconstructs the privileging of speech over writing in *De la grammatologie* (1967) and *La carte postale* (1980).

67. The pursuit of "ardent etymologies" is one of the themes of Lerer, *Error and the Academic Self*.

68. Johns, *Nature of the Book*, 123.

69. John Dunton's very successful periodical, *The Athenian Gazette* (1691–97), opened its pages to questions from readers of every class. According to McEwen, 760 questions about science were posed and answered in the twenty volumes of the *Mercury*; *Oracle of the Coffee House*, 114.

70. Gay discusses Bayle's influence in *Enlightenment*, 1:290–95.

71. Bayle, *Various Thoughts on the Occasion of a Comet*, 6.

72. *PE* 1:535. Browne's speculations on comets are based on commentaries on Aristotle's *Metereologica* by Nicolas Cabeus (1646).

73. *Various Thoughts*, 89.

74. Lipking argues that the form of Bayle's perpetual commentary influenced many later writers, including Johnson and other British biographers;, *Ordering of the Arts*, 76–83.

75. "Truth, he held, is not a body of knowledge that can simply be handed down, by ancestors, priests or rulers. It is something one has to discover for oneself and make one's own, and this necessarily makes it subjective, finite and liable to the influence of ignorance and error. It has to be thought of as the object of a permanent quest, a goal that no human being can ever actually reach"; Labrousse, *Bayle*, 87.

76. Laurence Sterne, *Tristram Shandy*, 85, 86.

77. Locke, *Essay concerning Human Understanding*, 706. In his fourth meditation, Descartes had similarly argued that errors arose not from faults of understanding but from the will: "The scope of the will is wider than that of the intellect; but instead

of restricting it within the same limits, I extend its use to matters which I do not understand. Since the will is indifferent in such cases, it easily turns aside from what is true and good, and this is the source of my error and sin"; *PW* 2:40–41. But Locke does not equate bad judgment with will or error with sin.

78. *Essay concerning Human Understanding,* 718, 719.

79. A similar point has often been made about I. A. Richards's attempt to reform practical criticism; irrelevant associations and stock responses so dominate readings that anything like a "correct" interpretation begins to resemble a spiritual exercise, mysterious and incommunicable. See Richards, *Practical Criticism,* pt. 4.

80. *Essay concerning Human Understanding,* 716.

81. Hume's *Dialogues concerning Natural Religion* were probably completed in 1751 or 1752 but remained unpublished until 1779.

82. Imlac, in Johnson's *Rasselas,* chap. 44, "The dangerous prevalence of imagination" (150).

83. Wimsatt comments on Johnson's affinities with Browne; *Prose Style of Samuel Johnson,* 117–20; Yolton, *John Locke and the Way of Ideas,* analyzes Locke's theory of mind.

84. *Rasselas,* 150–53. According to Mrs. Thrale, "The vacuity of Life had at some early period of his life perhaps so struck upon the Mind of Mr. Johnson, that it became by repeated impressions his favourite hypothesis"; *Thraliana,* 1:179.

85. DeMaria, *Johnson's "Dictionary,"* 70.

86. "The Life of Sir Thomas Browne," in *CM* 18.

87. Boswell's *Life of Johnson,* 2:434.

88. Johnson prefixed his life of Browne to *Christian Morals* on the grounds that "an edition of a posthumous work appears imperfect and neglected, without some account of the author"; *CM* 3. Preston errs in stating that "Johnson committed his only essay on a writer solely of prose in *Lives of the Poets* to Browne" (*Thomas Browne,* 5); Browne does not appear in the *Lives of the Poets,* and Johnson wrote many other lives of writers of prose. Barbour and Preston repeat the error that Browne was "the only writer of prose biographized by Johnson" and also err in calling this Johnson's "most detailed 'literary' life"; *Sir Thomas Browne,* 1.

89. *CM* 37. Johnson emphasizes the need of biographers to note the minute details of private life in *Rambler* 60 (1750) and many other places.

90. *CM* 10. Shuger analyzes Digby's attacks on *Religio Medici* in "The Laudian Idiot."

91. *RM* 69–70; my italics.

92. For Johnson's use of common or vulgar readings as his critical standard, see Tracy, "Johnson and the Common Reader"; and Lipking, "Inventing the Common Reader." In homage to Johnson, Virginia Woolf collected two series of her essays under the title *The Common Reader.*

93. *Rasselas,* chaps. 41–43.

94. In a passage cited by Johnson, Isaac Watts had charged Browne with "arrogant temerity" for declaring himself "to have escaped 'the first and father-sin of pride'." Johnson agrees: "A perusal of the RELIGIO MEDICI will not much contribute to produce a belief of the author's exemption from this FATHER-SIN: pride is a vice, which pride itself inclines every man to find in others, and to overlook in himself" (*CM* 45).

95. See Popper, *Conjectures and Refutations*.

96. *Adventurer* 50:362; cf. Boswell, *Life of Samuel Johnson*, 3:293. Johnson paraphrases Browne from memory; see *PE* 1:72: "So large is the Empire of truth, that it hath place within the walles of hell, and the divels themselves are dayly forced to practise it; . . . although they deceive us, they lye not unto each other; as well understanding that all community is continued by truth, and that of hell cannot consist without it."

97. Shapin suggests that the trust formerly placed in "gentlemen" is now accorded to institutions; but he argues that modern scientists also depend on trusting a limited "core-set" of people they know or know about; *Social History of Truth*, 409–17.

8. The Century of Genius (1)

1. Johnson, *Rambler*, 1:320.

2. Westfall, *Never at Rest*, ix. In "Newton and His Biographer," Westfall confesses that he understood Newton less well at the end of his biography than at its beginning.

3. "Surgite Mortales, terrenas mittite curas; / Atque hinc cœligenæ vires dignoscite Mentis, / A pecudum vita longe lateque remotæ. . . . / Nec fas est propius Mortali attingere Divos"; Halley's "Ode on This Splendid Ornament of Our Time and Our Nation, the Mathematico-Physical Treatise by the Eminent Isaac Newton," lines 27–29, 48 (my translation). MacPike prints Halley's verses, along with "improvements" made by Richard Bentley in the second edition of the *Principia* (1713) and a free translation by "Eugenio" (Francis Fawkes, 1755), in appendices to Halley's *Correspondence*, 203–8.

4. The inscription (1755) inserts "Newton" in the line from Lucretius, *De rerum natura*, 3:1043. Thomas and Ober trace the background and aftereffects of the statue. Albury, "Halley's Ode," stresses the danger of associating a Christian hero with a pagan.

5. Allan Ramsay (1728), William Whitehead (1738), and Henry Jones (1746) all call Newton "godlike." The "nice barrier" (pronounced "bareer") is Fawkes's translation of Halley's ode, line 48. Fara, *Newton*, provides a wide-ranging, iconoclastic survey of Newtonian idolatry.

6. Westfall, *Never at Rest*, 874.

7. Gleick, *Isaac Newton*, 3.

8. Einstein, foreword (1952) to Newton's *Opticks*, lix.

9. T. S. Eliot, "Sweeney Erect" (1919), lines 25–26. By nominating Sweeney as the representative man of his century, Eliot slyly deflates the glorification of greatness in Carlyle and Emerson.

10. Canguilhem, *Vital Rationalist*, 28.

11. "We gladly return to the company of those illustrious men who by aspiring to noble ends, whether intellectual or practical, have risen above the region of storms into a clearer atmosphere, where there is no misrepresentation of opinion, nor ambiguity of expression, but where one mind comes into closest contact with another at the point where both approach nearest to the truth"; James Clerk Maxwell (1871), in Gillispie's foreword.

12. See A. Rupert Hall, *Philosophers at War*.

13. Whitehead, *Science and the Modern World*, 55–56.

14. A similar argument impels Burtt, whose doctoral thesis was titled "The Metaphysics of Sir Isaac Newton."

15. The story was passed on by John Conduitt, who may have heard it from his wife Catherine, Newton's niece, and who had seen other versions by Abraham de Moivre and Henry Pemberton. Voltaire and William Stukeley also vouched for the apple. Iliffe, Keynes, and Higgitt, *Early Biographies*, vol. 1, offers several accounts of the story. A. Rupert Hall, *Isaac Newton*, discusses the early biographical traditions.

16. "The Great Tradition" in writing about the Scientific Revolution is named and analyzed by H. F. Cohen, *Scientific Revolution*: 21–150. The notion of a Newtonian synthesis, which dominates many studies, was appraised in 1948 by Koyré, *Newtonian Studies*, 3–24, and is explicitly supported by Westfall's *Construction of Modern Science*.

17. Halley's ode: "rerumque immobilis ordo, / Et quæ præteriti latuerent sæcula mundi"; James Thomson, "To the Memory of Sir Isaac Newton," line 72.

18. Pope intended the epitaph, written in 1730, for the monument executed by Rysbrack the following year; but a more conventional Latin inscription was chosen.

19. "To the Memory of Sir Isaac Newton," lines 201–2.

20. Hume, *History of England*, 6:542.

21. Feingold, *Newtonian Moment*, surveys the slow and sometimes reluctant acceptance of Newton's ideas by other European countries. Ferrone, *Intellectual Roots of the Italian Enlightenment*, inspects the Italian reception of Newton.

22. Voltaire, *Letters on England* (1733), 68.

23. See Guicciardini, *Reading the "Principia."*

24. According to Kilmister, the "inexplicable creative insight" of Newton's genius inspired awe by showing that mathematical abstractions could be applied to the real world; "Genius in Mathematics."

25. Desaguliers, preface to *A Course of Experimental Philosophy* (1734).

26. "The incomparable Mr. *Newton*, has shewn, how far Mathematicks, applied to some Parts of Nature, may, upon Principles that Matter of Fact justifie, carry us in the knowledge of some, as I may so call them, particular Provinces of the Incomprehensible Universe"; Locke, *Some Thoughts concerning Education*, 248.

27. Manuel examines Newton's collaborations with Locke; *Portrait of Isaac Newton*, 183–87.

28. Daston and Park cite the opening passage of Newton's "New Theory about Light and Colours" (1672) as an example of the interwoven passions of wonder and curiosity; *Wonders and the Order of Nature*, 303–4. But later Newton's "Rules of Reasoning" in the *Principia* contributed to "the learned rejection of wonder and wonders in the early eighteenth century" (350–52).

29. John Maynard Keynes, "Newton the Man," argues extravagantly that Newton was not so much a scientist as a "wonder-child" or magician.

30. The sense of "genius" as "mental power" or "a remarkably clever person" is equivalent to Latin *ingenium*, which also elicits "ingenuity" and "engine."

31. Johnson, *Lives of the Poets*, 1:191.

32. Boswell, *Life of Samuel Johnson*, 5:35.

33. *Science and the Modern World*, 291–92. Whitehead deliberately echoes the final sentence of his hero Shelley's *Defence of Poetry*: "Poets are the unacknowledged legislators of the World."

34. *Copernican Revolution*, 1–2. Blumenberg, *Genesis of the Copernican World*, mounts a sustained and detailed argument for the epochal turn in European thought that Copernicus represented.

35. Copernicus, preface to *On the Revolutions*, 5. Frombork (Frauenberg) was part of Varmia, a Catholic province surrounded by Prussia. Repcheck, *Copernicus' Secret*, provides historical contexts for Copernicus's life and times.

36. Swerdlow, "Derivation and First Draft of Copernicus's Planetary Theory," proposes 1514 as the latest possible date.

37. Danielson discusses the circumstances of publication; *First Copernican*, 103–14.

38. Gingerich, *The Book Nobody Read*, estimates the first edition at 400–500 copies, a considerable number at the time. "The Book Nobody Read" refers ironically to a phrase from Koestler, whose lively but sometimes contemptuous account of Copernicus asserts that *De Revolutionibus* "was and is an all-time worst seller": *Sleepwalkers*, 194.

39. Erasmus Reinhold's *Prutenic Tables* (1551), based on Copernican methods of calculation, became standard in the later sixteenth century.

40. Preface to *On the Revolutions*, 4.

41. "The significance of the *De Revolutionibus* lies, then, less in what it says itself than in what it caused others to say"; Kuhn, *Copernican Revolution*, 135.

42. Danielson, *First Copernican*, 7, 231.

43. The "latitude theory" improbably synchronizes the inclinations of planetary orbits with the motions of the earth. Swerdlow and Neugebauer, *Mathematical Astronomy*, meticulously compare the mathematical astronomy of Ptolemy with that of Copernicus.

44. Johnson, *Lives of the Poets*, 1:294–95.

45. Christianson, *On Tycho's Island*, provides a detailed account of the patronage system that sustained Tycho. The standard life is Thoren's *Lord of Uraniborg*.

46. Tycho described his instruments in *Astronomiæ Instauratæ Mechanica* (*Instruments of the Renewed Astronomy*). The instruments were dispersed after Tycho's death, though some are displayed at the National Technical Museum in Prague.

47. Mosley, *Bearing the Heavens*, explores the image of Atlas that Tycho and his admirers linked to himself.

48. See chapter 3 above.

49. Christianson, *On Tycho's Island*, includes a comprehensive biographical directory of Tycho's many "coworkers."

50. *New Astronomy*, 184, 157.

51. *Epistolarum Astronomicarum Libri* (*Astronomical Letters*), and *Astronomiæ Instauratæ Mechanica* (*Instruments of the Renewed Astronomy*).

52. Mosley, *Bearing the Heavens*, 295–97.

53. Christianson describes Tycho's "fragmented legacy"; *On Tycho's Island*, 237–48.

54. *Diary and Letters of Madam D'Arblay*, 2:271.

55. See Cooper, *"A more beautiful city."* Cooper and Hunter, *Robert Hooke*, include essays by Jacques Heyman and Alison Stoesser on Hooke's architectural work.

56. Recorded by John Conduitt, August 31, 1726; Iliffe, Keynes, and Higgitt, *Early Biographies*, 1:163.

57. *OFB* 11:55, 13, 97.

58. Sprat, *History of the Royal Society*, 36.

59. *New Atlantis. A Worke unfinished* (1627), 31.

60. The principles of this "royalist utopia" are analyzed by J. C. Davis, *Utopia and the Ideal Society*, 279–92.

61. Classic studies of the rise of Baconian science include R. F. Jones, *Ancients and Moderns*, and Charles Webster, *The Great Instauration*.

62. *New Atlantis Continued*, 68.

63. *New Atlantis Continued*, 54–60. Johns points out that this ceremony protects the inventor from rival claimants or pirates; *Nature of the Book*, 480.

64. *New Atlantis*, 38, 46.

65. *New Atlantis*, 17–19.

66. *New Atlantis Continued*, 22.

67. J. C. Davis, *Utopia and the Ideal Society*, lists seven candidates, including Sir Robert Harley (280), but omits Richard Haines (1633–85), an advocate of public workhouses and other projects, whom Hazlitt suggested might be the author. Claeys, *Restoration Utopias* (xxxiii), thinks that the most likely candidate is Richard Hawkins, author of *A Discourse of the Nationall Excellencies of England* (1658). Freeman, "Proposal for an English Academy," makes a thin case for Hooke; see also Manuel, *Freedom from History*, 107.

68. Lisa Jardine surveys Hooke's Oxford years; *Curious Life of Robert Hooke*, 63–89.

69. Hooke expected but did not soon receive an annual salary of £80. After 1664, Sir John Cutler paid him £50 a year to lecture at Gresham College, which supplemented £30 a year from the Society, and Hooke was elected curator "in perpetuity" in January 1665.

70. The complexity of Hooke's relations with the Royal Society, both as curator of experiments and as Cutlerian lecturer, is documented by Hunter, *Establishing the New Science*, which includes Hooke's memoranda on the organization of the Society (232–39).

71. March 23 1664, quoted in Gunther's preface to Hooke's *Micrographia*, vi.

72. Lynch argues that congruity furnishes Hooke with "an explanatory principle applicable to all natural phenomena"; *Solomon's Child*, 114. S. H. Joseph, "Assessment of the Scientific Value of Hooke's Work," in Cooper and Hunter, *Robert Hooke*, offers support for Hooke's conjectures (92–94, 105–6).

73. *An Attempt for the Explication of the Phænomena*, 41; *Micrographia*, 11–32. Gouk associates Hooke's principles of congruity and incongruity with sympathetic vibrations in music, and by extension "with the exoteric expression of natural magic"; *Music, Science, and Natural Magic*, 222.

9. The Century of Genius (2)

1. *Lectures De Potentia Restitutiva, or of Spring, Explaining the Power of Springing Bodies* (1678).

2. Waller, "The Life of Dr. Robert Hooke," in *Posthumous Works of Robert Hooke*, i.

3. Bennett et al., *London's Leonardo*; Chapman, *England's Leonardo*; Ellen Tan Drake, *Restless Genius*; Inwood, *Forgotten Genius*. See also Nichols's edition of Hooke's *Diaries*, subtitled *The Leonardo of London*.

4. In one of his many speculations about human flight—"'Tis not impossible to fit a Pair of Wings for a Man to fly with"—Hooke compares the natural long fins of flying fish to Daedalus's artificial wings; *Posthumous Works*, 56.

5. *Posthumous Works*, 6.

6. Hooke had already touted some inventions to enhance the senses in the preface to *Micrographia*, where he claims to have made a kind of telegraph, "a *distended wire*" that propagates sounds to "a very considerable distance in an *instant*."

7. *Posthumous Works*, 39–40. In 1668 Hooke would invent an ear trumpet to aid the hard of hearing.

8. "Throughout there is no hesitation in making the hypothesis that the true and hidden causes of things are mechanical"; Hesse, "Hooke's Philosophical Algebra," 69.

9. *Posthumous Works*, xxvii.

10. Lisa Jardine documents Hooke's extensive and systematic self-experiments with a variety of pharmaceuticals in *London's Leonardo*, 181–94. In his later years, though still vigorous, he seemed shrunken and stooped, possibly because he suffered from a condition known as Scheuermann's kyphosis; Inwood, *Forgotten Genius*, 10.

11. *Isaac Newton's Papers & Letters*, 47–236.

12. Westfall, *Never at Rest*, 448–49; A. Rupert Hall, "Two Unpublished Letters," 224.

13. Marie Boas Hall documents relations between Hooke and Oldenburg from 1662 to 1677: *Henry Oldenburg*, 243–67. Lisa Jardine argues that Oldenburg did damage Hooke's reputation (perhaps unintentionally); "Robert Hooke, A Reputation Restored," in Cooper and Hunter, *Robert Hooke*, 247–58.

14. After the Dutch fleet ravaged the English in 1667, Oldenburg was accused of "dangerous desseins and practices" and imprisoned for two months in the Tower; Hall, *Henry Oldenburg*, 114–19.

15. Hooke, *Lampas* (1676), in Gunter, *Early Science in Oxford*, 8:207–8.

16. Johns sets the dispute between Oldenburg and Hooke in the context of a "fragmentation of credit" that threatened the authority of the Royal Society and its publications; *Nature of the Book*, 514–42.

17. On Hooke's "Fear of Being Forgotten," see Inwood, *Forgotten Genius*, 378–94.

18. Orgel, "Renaissance Artist as Plagiarist," argues that the age of John Dryden developed a notion of plagiarism unknown in the age of Ben Jonson.

19. Johnson does include "originalness," but without any illustrative quotation. In other writings he often refers to and values "original thought." When Edward Young read *Conjectures on Original Composition* (1759) to him, Johnson "was surprized to find Young receive as novelties, what he thought very common maxims"; Boswell, *Life of Samuel Johnson*, 5:269.

20. *Prose Works of Jonathan Swift*, 1:151.

21. Standard surveys of the idea of progress include Bury (*Idea of Progress*), Nisbet (*History of the Idea of Progress*), and Spadafora (*Idea of Progress in Eighteenth-Century Britain*). Levine analyzes the quarrel between ancients and moderns in *Battle of the Books*.

22. Shadwell, *The Virtuoso*, 5.3.76–79.

23. *Gulliver's Travels*, pt. 3, chap. 5. Swift, like Shadwell, aims his satire not only at Hooke but at his mentor Robert Boyle.

24. September 15, 1689; Gunter, *Early Science in Oxford*, 7:716.

25. *An Attempt to prove the Motion of the Earth*, 27–28. Hooke claims that he meant to publish the lecture in 1670, but delayed in the hope of completing his observations—a task still not accomplished in 1674. An earlier lecture to the Royal Society, "The Inflection of a Direct Motion into a Curve by a Supervening Attractive Principle" (May 23, 1666), had already posited an attractive centripetal force exerted by the sun.

26. In an analysis of the "poetics of proof" in Hooke's *Attempt*, Aït-Touati argues that his "'System of the World' was the logical outcome of a spectacular demonstration of the power of instruments in the realm of astronomy"; through parallax he could "see" the path of a star and thus establish mechanics and experiments as the basis of natural philosophy; *Fictions of the Cosmos*, 168–69.

27. Note to the "Reader," in *Attempt to prove the Motion of the Earth*.

28. *Critique of Judgment* (1796), 175–78. Gammon, "'Exemplary Orginality',", discusses the seeming paradox in Kant's insistence that geniuses do not follow rules but create them.

29. This familiar quotation, which dates in this form from 1833 (Iliffe, Keynes, and Higgitt, *Early Biographies*, 2:31), probably derives from a French phrase, "en y passant sans cesse," in a note (first published in the 1780s) to Voltaire's book on Newton. But Newton himself often expressed similar sentiments about the merit of "patient thought." See Westfall, *Never at Rest*, 105n.

30. The museum in La Sagrada Familia in Barcelona includes a massive hanging chain that Gaudi designed to experiment with catenary construction similar to Hooke's. In pt, 3, chap. 5 of *Gulliver's Travels*, Swift's parody of the "ingenious Architect" who begins building houses at the roof and works downward may have been aimed at Hooke.

31. Gunter, *Early Science in Oxford*, 7:601. At the end of *A Description of Helioscopes* (1676), "to fill in the vacancy of the ensuing page" Hooke adds "a *decimate* of the *centesme* of the Inventions I intend to publish"; the second contains, in cipher, his principle for forming arches (Gunter, 8:151). Mills, Hennessy, and Watson describe "Hooke's Design for a Driven Equatorial Mounting," in Cooper and Hunter, *Robert Hooke*, 77–88.

32. Hooke was inducted into the Society on November 12, 1662. He continued to participate until December 1702, and died on March 3, 1703. Waller records that Hooke intended to leave his considerable estate to the Society but procrastinated and died intestate (*Posthumous Works*, xxvii).

33. Newton to Halley, June 20, 1686. Halley replied that Hooke's claim had been misrepresented, and Newton moderated his attack; *Correspondence*, 2:438, 442–43.

34. In 1679 Hooke had publicly corrected Newton's faulty sketch of a body falling in a spiral on a rotating earth. Their exchanges provoked Newton to ponder the action at a distance entailed by the inverse-square force, which produced the elliptical orbits of the planets. When he returned to the problem in 1686, the law of gravity decisively solved it. But the *Principia* does not acknowledge Hooke's influence. See Westfall, *Never at Rest*, 382–90; and I. B. Cohen's "Guide to Newton's *Principia*"; *Principia*, 76–82.

35. *Principia*, 793. A "General Scholium" was added to conclude the second edition in 1713.

36. *Treatise of the System of the World*, 2nd ed. (1731), 5. This is an English version of the Latin tract that Newton originally intended to be the second book of the *Principia*.

37. Newton to Hooke, February 5, 1676, in *Correspondence*, 1:416. Merton traces the history of the phrase in *On the Shoulders of Giants*.

38. Michael White supposes that Newton is maliciously calling attention to Hooke's short stature; *Isaac Newton*, 187–88.

39. *Opticks*, 369; Query 28. Sawday agrees with Newton's conclusion that Hooke's "intellectual being" depended on mechanical speculations; *Engines of the Imagination*, 222. In Newton's own account the philosophers he admires descend from Moschus the Phoenician and include Pythagoras and other pre-Aristotelian Greeks. McGuire and Rattansi, "Newton and the 'Pipes of Pan'," relate Newton's beliefs to those of the Cambridge Platonists.

40. "I shall venture to dispose of his fictions"; *De Gravitatione*, in *Philosophical Writings*, 14. Dobbs argues that *De Gravitatione*, an unpublished manuscript that she dates just before the *Principia*, "reveals his anger with Descartes's *Principia*, which had misled him for a long time"; *Janus Faces of Genius*, 145. Hall and Hall assign *De Gravitatione* to a much earlier date (1664–68?); *Unpublished Scientific Papers*, 90. Koyré's classic study "Newton and Descartes," in *Newtonian Studies*, dates it "some time around 1670" (83).

41. John Conduitt's version of a memorandum by Abraham de Moivre (1727); *Mathematical Papers*, 1:17. Conduitt probably exaggerates the extent of Newton's early self-reliance and repudiation of Descartes. When Newton reread *Géométrie* in 1680, however, he distanced himself from what he then considered its bungling and manifest errors; *Mathematical Papers*, 4:336–44.

42. When asked his opinion of Newton in 1701, "Leibnitz said that taking Mathematicks from the beginning of the world to the time of Sr I. What he had done was much the better half"; Westfall, *Never at Rest*, 721.

43. *The Geometry of René Descartes*, 3; my translation.

44. Whiteside, "Newton the Mathematician," 114.

45. Johnson, *Lives of the Poets*, 1:191. Johnson's remark that Newton, had he applied to poetry, "would have made a very fine epick poem" (Boswell, *Life of Samuel Johnson*, 5:35) supports the notion of genius as "general powers."

46. Gillispie, *Edge of Objectivity*, 117.

47. Shapin, "'The Mind Is Its Own Place'," analyzes the association of scientific genius with solitude.

48. Wordsworth, *The Prelude* (1850), 3.61–63. The last two lines were added to the poem in 1838/39. See Thomas and Ober, *Mind For Ever Voyaging*, 49–51.

49. Diverse perspectives on the relations between Halley and Newton are offered by the contributors to Thrower, *Standing on the Shoulders of Giants*.

50. Letter to Oldenburg, Feb. 6, 1671/2, in *Correspondence*, 1:100.

51. Letter to Oldenburg, Dec. 7, 1675, in *Correspondence* 1:361.

52. *Correspondence*, 1:364.

53. See Dobbs, *Janus Faces of Genius*, 106–9.

54. Descartes, *The World*, 30.

55. Sargent, *Diffident Naturalist*, 87–108.

56. Newton to Bentley, Dec. 10, 1692, in *Correspondence*, 3:233.

57. *Principia*, 940, 943. Two of the five surviving drafts of the "General Scholium" are translated by Hall and Hall, *Unpublished Scientific Papers*, 348–64.

58. *Opticks*, 370, 369. Seven new queries, including this one, were introduced in the Latin edition (1706) and retained, with revisions, in later English editions.

59. Dec. 21, 1705; Hiscock, *David Gregory, Isaac Newton*, 30.

60. Leibniz and Clarke, *Correspondence*, 4. On the two versions of the passage, see Koyré and Cohen, "Case of the Missing *Tanquam*."

61. In the draft of a letter in 1716, Newton wrote that Leibniz "has spent his life in keeping a general correspondence for making disciples, whilst I leave truth to sift for it self"; Iliffe, "'Is he like other men?',"162.

62. Fara surveys Newton's disciples; *Newton*, 59–97. Pemberton, who edited the 3rd edition of the *Principia*, published an accessible, simplified *View of Sir Isaac Newton's Philosophy* in 1728. Desaguliers made a career by capitalizing on Newton with lectures and books.

63. On Clarke's theology, see Pfizenmaier, *Trinitarian Theology*.

64. Vailati, *Leibniz & Clarke*, discusses the philosophical and theological disagreements at length.

65. *Letters on England*, 43. Voltaire pays homage to Clarke as "a man of unswerving virtue" and "a real reasoning machine" (42).

66. Leibniz and Clarke, *Correspondence*, 27–35. Voltaire adopted Clarke's argument in *Elements of Sir Isaac Newton's Philosophy*, maintaining there are "atoms which will never be divided, as long as the present Constitution of the World subsists" (111).

67. Oct. 16, 1693; Newton's *Correspondence*, 3:287.

68. On Leibniz's doubts about his own theory, see Meli, *Equivalence and Priority*, 145–70, 215–18.

69. *A Treatise of the System of the World*, 124.

70. I. B. Cohen, "Guide to Newton's *Principia*"; *Principia*, 60.

71. *Gulliver's Travels*, pt. 2, chap. 3.

72. Michael White claims that Fludd's writings were an "important source for Newton"; *Isaac Newton*, 121.

73. Spence, *Observations, Anecdotes, and Characters*, 1:462. Andrew Ramsey first quoted these words to Spence in 1730.

74. *Paradise Regained*, 4.221–24, 323–30.

75. The catalog of Newton's library includes Milton's *Poetical Works* as well as Addison's *Notes upon . . . Paradise Lost* (1719), though these may reflect the taste of Catherine Barton, Newton's niece; Harrison, *Library of Isaac Newton*, 70–71.

76. Despite his isolation Newton did rely, of course, on the accumulated resources of scholarship; see Schaffer, *Information Order*.

77. Fara points out that Newton sat for over twenty busts and portraits, which typically showed him deep in thought; *Newton*, 34–38.

78. In 1693, his "black year," Newton suffered a breakdown or "fit of frenzy," which may have been precipitated by a rupture with Fatio de Duillier, a young Swiss polymath with whom his relations had been affectionate and intense. This episode remained a secret until the nineteenth century. Manuel argues that "Newton's crisis was followed by a dramatic reorganization of his personality" in which he achieved "real, palpable, immediate" power in the world at the price of cutting himself off

from his own "boundless inner world"; "to the extent that he became a successful manipulator of men he was alienated from himself"; *Portrait of Isaac Newton*, 224–25.

79. "It is an eminent instance of Newton's superiority to the rest of mankind, that . . . he stood alone, merely because he had left the rest of mankind behind him, not because he deviated from the beaten track"; Johnson, *Adventurer* 131:482.

80. "He has even done honour to human nature, by having extended the greatest and most noble of our faculties, reason, to subjects, which, till he attempted them, appeared to be wholly beyond the reach of our limited capacities"; Pemberton, dedication, in *View of Sir Isaac Newton's Philosophy*. Cf. the inscription (1731) on Newton's tomb in Westminster Abbey: "Sibi gratulentur Mortales, tale tantumque exstitisse HUMANI GENERIS DECUS" (Mortals rejoice, that there has existed such and so great AN HONOR TO THE HUMAN RACE).

81. *Apology (Socrates' Defense)*, 31d.

82. Newton's *Chronology of ancient Kingdoms Amended* (1728) was published shortly after his death, followed by *Observations upon the Prophecies of Daniel, and the Apocalypse of St. John* (1733). Long before these late works, he had devoted much of his time in the 1670s and 1680s to studies of theology and prophecy, recorded in the important manuscript *Theologiæ Gentilis Origines Philosophicæ*. Manuel, *Isaac Newton, Historian*, clarifies Newton's chronologies. The selection of Newton's theological manuscripts edited by H. J. McLachlan (Liverpool, 1950) is limited and unreliable.

83. *Correspondence*, 3:233. Manuel, *Religion of Isaac Newton*, makes use of Newton's voluminous theological manuscripts.

84. Ramifications of Newton's unorthodox theology are explored by the contributors to Force and Popkin, *Newton and Religion*.

85. *Essay on Criticism*, lines 60–61. "Science" means "branch of knowledge" or "trained skill"; "Art" also stands for "trained skills," as opposed to "Nature"; and "Wit" means "intelligence." Gardner, *Frames of Mind*, provides a classic modern argument for heterogeneous mental powers.

86. Letter to Thomas Butts, November 22, 1802. Blake's quarrel with Newton is discussed sympathetically by Frye, *Fearful Symmetry*, and Ault, *Visionary Physics*.

87. Shelley, preface to *Prometheus Unbound* (1819). Cf. *A Defence of Poetry* (1821), which speaks of "that great poem, which all poets, like the co-operating thoughts of one great mind, have built up since the beginning of the world."

10. Revolution and Its Discontents

1. Van Helden surveys the reception of *Sidereus Nuncius* in an appendix to his translation (87–113). The reasons why many of Galileo's colleagues did not accept his findings are explored by Blumenberg; *Genesis of the Copernican World*, 644–74.

2. *Le opere*, 10:340. Biagioli argues that Galileo's own efforts to take credit for his discoveries, and to withhold information from potential competitors, account for his mixed reception by other astronomers; *Galileo's Instruments of Credit*, 77–134.

3. As Galileo points out in a letter, the instrument had to be mounted on a firm stand because hands could not help shaking: *Le opere*, 10:277–78. See Stillman

Drake, *Galileo at Work*, 142–48. Feyerabend stresses the *"strong positive illusions"* that might have disturbed the telescopic vision of early observers; *Against Method*, 89–90.

4. *Sidereus Nuncius*, 92–93, 100–102.

5. "Magna, Longeque Admirabilia Spectacula"; *Sidereus Nuncius*, title page.

6. *Kepler's Conversation with Galileo*, 9–11, 36–37. See chapter 3 above.

7. Blumenberg, *Genesis of the Copernican World*, 661–74, analyzes the "horizon of expectations" in Sizzi's attack on Galileo, which Kepler dismissed as a childish reverie about "a world on paper."

8. *Discoveries and Opinions of Galileo*, 176.

9. Reeves documents this confusion in *Galileo's Glassworks*.

10. The decisive role of Montaigne in shaping modern skepticism is traced by Popkin, *History of Scepticism*, 44–63; Paganini, *Le débat des moderns*; and Bakewell, *How to Live*.

11. *Complete Essays of Montaigne*, 155.

12. *Complete Essays*, 429. Montaigne credits Cleanthes of Samos or Nicetus of Syracuse with originating the theory of a moving earth.

13. Starobinski analyzes Montaigne's paradoxical attitude toward the authority of nature: "It is man's 'nature' to use his rational faculties to contradict and disfigure what is *given* in Nature, that is, to particularize the universal"; *Montaigne in Motion*, 215.

14. Thorne argues that Montaigne's bombardment of quotations reduces the ancients themselves to "little more than a humanist curiosity shop," so that "classical wisdom comes to disgrace itself"; *Dialectic of Counter-Enlightenment*, 77.

15. *Complete Essays*, 435.

16. On the "science without metaphysics" that began with Mersenne (1588–1648) and was developed further by his friend Gassendi (1592–1655), see Popkin, who describes their "constructive or mitigated scepticism"; *History of Scepticism*, 112–27.

17. The "Apology for Raymond Sebond" laughs at the mirrors used by the ancients to magnify their private parts. Which sense was better, the sight that enlarged these "members," or "the touch which showed them small and contemptible?" (453).

18. Donne, *Ignatius His Conclave* (1611), 7.

19. Montgomery analyzes Harriot's drawings; *Moon and the Western Imagination*, 106–13. Carey calls Harriot Donne's "friend"; *John Donne*, 272. Haffenden reviews the evidence for this friendship in his introduction to Empson's *Essays on Renaissance Literature*, 1:36–44.

20. Gilbert, *On the Loadstone*, 313–58. Coffin, *John Donne and the New Philosophy*, remains the standard work on Donne's knowledge and use of science.

21. Donne cites Kepler's book in a marginal note to *Biathanatos* (1608?); the context is an attack on theologians who resist innovation. Tycho, another author whose work Donne knew, had understood the significance of a nova as early as 1572, the year of Donne's birth and a year after Kepler's.

22. *Ignatius His Conclave*, 6–7.

23. In one of his *Devotions* (1623), Donne writes that natural philosophers think "that every *Planet*, and every *Starre*, is another *world* like this: They finde reason to

conceive, not onely a *pluralitie* in every *Species* in the world, but a *pluralitie* of *worlds*"; *Complete Poetry*, 421. See Empson's *Essays,* 1:78–128.

24. Holy Sonnet, first published in 1633; *Complete Poetry*, 249.

25. "As new Philosophy arrests the Sunne, / And bids the passive earth about it runne, / So wee have dull'd our minde, it hath no ends; / Onely the bodie's busie, and pretends; / As dead low earth ecclipses and controules / The quick high Moone: so doth the body, Soules"; "To the Countesse of Bedford" (3), lines 37–42; *Complete Poetry*, 155.

26. "Conversations with William Drummond of Hawthornden," in *Ben Jonson*, 596. According to Jonson, Donne answered "that he described the idea of a woman, and not as she was."

27. *Ignatius His Conclave*, 13. "T'obey our pace"; *Anatomy of the World*, lines 283–84.

28. Hakewill's *Apologie . . . Or an Examination and Censure of the Common Errour Touching Natures Perpetuall and Universall Decay* (1627) was enlarged in 1630 and 1635. On "The Decay of Nature," see R. F. Jones, *Ancients and Moderns*, 22–40; and Coffin, *John Donne*, 264–79.

29. *Anatomy of Melancholy,* 2:45.

30. Babb points out that the rival theories presented by Burton "contradict and neutralize one another"; *Sanity in Bedlam*, 61. Burton did keep close track of astronomical developments, however. In 1628 he added a note that some of Jupiter's moons "I have seene my selfe by the helpe of a glasse 8 foot long" (*Anatomy*, 2:52), and he frequently corresponded with his friend Edmund Gunter, professor of astronomy at Gresham College. Barlow argues that in early editions Burton "clearly favors the old astronomy," but that "the evidence in Burton's final text suggests that he was not only a zealous advocate of the system of infinite worlds but also a harsh critic of the traditional ideas of the Aristotelians"; "Infinite Worlds," 302.

31. "When I build Castles in the aire, / Void of sorrow and voide of feare, / Pleasing my selfe with phantasmes sweet, / Me thinkes the time runnes very fleet. / All my joyes to this are folly, / Naught so sweet as melancholy" (*Anatomy,* 1:lxix).

32. *Anatomy,* 2:48.

33. "Democritus Junior to the Reader," in *Anatomy*, 1:66. Burton later refers to the historical Democritus's belief in a plurality of inhabited worlds; *Anatomy,* 2:49, 52. Vicari argues that Burton rejects the theory of infinite inhabited worlds, which he identifies with the Copernican worldview: *View from Minerva's Tower*, 22–26.

34. Burton cites Wilkins in the fifth edition of the *Anatomy* (1638). It is uncertain whether he read Francis Godwin's *Man in the Moone* (1638). Nicolson surveys these interplanetary texts and concludes that Burton's "Digression" "is in its way the most extensive of cosmic voyages"; *Voyages to the Moon*, 225.

35. *Anatomy,* 2:56–57.

36. *Anatomy,* 2:57, quoting Seneca on comets, from the *Naturales quæstiones*.

37. *Anatomy,* 2:58.

38. I. B. Cohen traces the modern sense of a "revolution" in mathematics to Fontenelle in the early eighteenth century; *Revolution in Science*, 88–90; but Jacob argues that Boyle and others had already used precisely that sense of the word in the mid-seventeenth century; "Truth of Newton's Science," 317.

39. Shapin, *Scientific Revolution*, 1.

40. Respectively by Henry, *Scientific Revolution and the Origins of Modern Science*, and Applebaum, *Scientific Revolution and the Foundations of Modern Science*. Cf. A. R. Hall, *Scientific Revolution*.

41. Butterfield, *Origins of Modern Science*, 7–8. The book is based on a series of lectures that Butterfield gave in Cambridge in 1948 and published the following year.

42. In 1994 H. F. Cohen maintained that historians of seventeenth-century science prize Butterfield because he "expresses an acute sense of their being at work, somehow, at one of the key junctures of world history"; *Scientific Revolution*, 5. Cohen's effort to provide a full-fledged study and justification of that "Great Tradition" has been restructured and expanded in *How Modern Science Came into the World* (2010), a work that frames a comprehensive answer to the famous question posed by Joseph Needham: why was modern science created in Europe rather than China?

43. Ironically, Butterfield's own *Whig Interpretation of History* (1931) had cautioned against such "progressive" rewriting of the past; but he confessed that in practice this Whiggism was difficult to avoid.

44. Dobbs, "Newton as Final Cause and First Mover." In the same volume Westfall responded to Dobbs with "The Scientific Revolution Reasserted."

45. Duhem, *Les précurseurs parisiens de Galilée* (1913), famously traced the beginnings of the Scientific Revolution to fourteenth-century Paris. Gaukroger, *Emergence of a Scientific Culture*, argues that natural philosophy began to replace other ways of understanding the natural world in the thirteenth century.

46. Cunningham and Williams, "De-centring the 'Big Picture'," 220. A version of this relocation is popularized by Holmes, *Age of Wonder*.

47. Koyré credits Gaston Bachelard with the term and idea "mutation"; *Galileo Studies*, 39n. He expanded and revised his argument in "Significance of the Newtonian Synthesis" (1948), which ends by lamenting that as a result "the world of science—the real world—became estranged and utterly divorced from the world of life, which science has been unable to explain"; *Newtonian Studies*, 23. I. B. Cohen discusses "the seminal role" of Koyré, *Revolution in Science*, 396–8, and H. F. Cohen analyzes his views and influence, *The Scientific Revolution*: 73–86.

48. James B. Conant's foreword to Kuhn's *Copernican Revolution* affirms that "the approach to science presented in this book is the approach needed to enable the scientific tradition to take its place alongside the literary tradition in the culture of the United States" (xviii). Kuhn's introduction to *Structure of Scientific Revolutions* proposes "a role for history" or "a historiographic revolution in the study of science, . . . perhaps best exemplified in the writings of Alexandre Koyré" (3).

49. Masterman identifies at least twenty-one different senses of "paradigm." In a 1969 postscript to *Structure of Scientific Revolutions*, Kuhn tried to clarify his use of the word as "the Constellation of Group Commitments" or "Shared Examples." He tried again in "Second Thoughts on Paradigms" (1974).

50. Dear does refer to Kuhn's *Copernican Revolution* in his notes, and briefly to Koyré.

51. Fuller, *Thomas Kuhn*, expands on this misperception in his critique of Kuhn. In Kuhn's own set of reflections on the development of his thought, *The Essential Tension: Selected Studies in Scientific Tradition and Change*, note the absence of "Revolution" in the subtitle.

52. Golinski, *Making Natural Knowledge*, xvii. Golinski's first chapter traces the turn from Kuhn to various sociological and semiotic programs, including that of Bruno Latour, whose account of networks that link people with things, or "nonhuman entities," challenges the notion of science as an exclusively "human product" (37–46).

53. Daston, "Science Studies and the History of Science," concludes that "a new vision of what science is and how it works has yet to be synthesized from the rich but scattered and fragmented materials gathered by some twenty years of historicized history of science," 813.

54. E.g., Shapin, *Never Pure: Historical Studies of Science as If It Was Produced by People with Bodies, Situated in Time, Space, Culture, and Society, and Struggling for Credibility and Authority.*

55. Latour acknowledges the complicity of constructivism in such appropriations in "Why Has Critique Run Out of Steam?"

56. Golinski, *Making Natural Knowledge*, 206. According to Matthew Eddy, quoted on the back jacket, the book "has been called the 'constructivist's bible' in many a conference corridor."

57. Shapin, *Scientific Revolution*, 161–65; cf. 12–13.

58. "Enlightenment" can also be plotted as a disaster, as in Horkheimer and Adorno: "The impartiality of scientific language deprived what was powerless of the strength to make itself heard and merely provided the existing order with a neutral sign for itself"; *Dialectic of Enlightenment*, 17.

59. On Hobbes and Boyle, see Shapin and Schaffer, *Leviathan and the Air-Pump*; on Hobbes and Wallis, see Jesseph, *Squaring the Circle*.

60. Descartes, "First Meditation," in *PW* 2:12.

61. "First Meditation," in *PW* 2:14; "Sixth Meditation," in *PW* 2:55.

62. *OFB* 13:172–73, 305–6.

63. *Apology for Poetry*, 95. Sidney died in 1586; the *Apology* and a similar text, *The Defence of Poesie*, were published in 1595.

64. As Sidney points out (109), this claim originates with Aristotle's *Poetics*. Julius Caesar Scaliger's *Poetices* (1561) provides support for Sidney's ideas. Influential studies of humanist debates about the status of the arts include Panofsky's *Idea* and Weinberg's *History of Literary Criticism*, vol. 1.

65. Bacon succinctly describes this project in "A Preparative to a Natural and Experimental History" (1620), in *OFB* 11:448–73. The proposed *History of the Arts* that was to culminate his plan refers to "mechanical arts" (463–65), which are equivalent, not subordinate, to nature; cf. *The Advancement of Learning*, in *OFB* 4:64–65.

66. *Metaphysics*, book E. See Gaukroger, *Emergence of a Scientific Culture*, 79, 400–403.

67. In *De Consolatione Philosophiae* Boethius, who introduced the term *quadrivium* in the early sixth century, famously acknowledged that the Wheel of Fortune held sway over human affairs.

68. Galileo proposed the law of falling bodies in a letter to Paolo Sarpi in 1604 (*Le opere*, 10:115) and elaborated it in *Two New Sciences* (1638), which claims experimental verification (though not the legendary test at Pisa). See also his early manuscripts *On Motion, and On Mechanics* (1590? 1600?). Koyré denied that Galileo had founded his theories on experiments: "All of Galileo's experiments, at least all of the

real ones, those which resulted in measurements, in precise values, were falsified by his contemporaries"; *Galileo Studies*, 107. But subsequent research has found evidence that many of Galileo's experiments were in fact "real" and correct. The complex relations between those experiments and Galileo's thought experiments are discussed by Dear, *Discipline & Experience*, 124–50.

69. Louis Elzevir, "Printer to the Reader," in *Two New Sciences*, 8. Fletcher, *Time, Space, and Motion*, considers this "perhaps the crucial ideological claim to be made in the coming of the modern age" (23), and extends the theme or metaphor of motion to drama, poetry, and metaphysics.

70. *Two New Sciences*, 147. As Drake points out (xvii), the often-reprinted translation by Crew and de Salvio, *Dialogues concerning Two New Sciences*, makes Galileo claim to have "discovered by experiment" some properties of motion, while the text says only "I find" (*comperio*). The translators' insertion offended Koyré, *Galileo Studies*, who doubted that Galileo's new science had been based on actual experiments.

71. Plotnitsky and Reed argue that Galileo's understanding of "science" involves many different ways of interpreting and discussing nature: "In this work mathematics and science, culture, rhetoric, and the strategies and the very textual construction of writing are practiced each with equal rigor and in all their mutually shaping interactions"; "Discourse, Mathematics, Demonstration," 64.

72. See chapter 4 above.

73. Each of these arguments is analyzed by Dear in *Discipline & Experience*.

74. *New Atlantis*. See chapter 8.

75. "It was *an individual* who had to have the experience, construct the proof, build the model, or use the machine. Essentially everything was based in and ultimately dependent upon first-person activities, both cognitive and practical. It was the age of the Epistemic I, the first-person knower"; Machamer, introduction to *Cambridge Companion to Galileo*, 14.

76. "That Galileo was in fact the most influential person of all time—not the greatest, just the most influential—is also easily proved"; Weidhorn, *Person of the Millennium*, 140.

77. "The Romantic School" (1833), in *Prose Writings of Heinrich Heine*, 116–17.

78. In June 2010 the Institute and Museum of the History of Science in Florence reopened as the Museo Galileo. It includes, along with telescopes and other scientific displays, three of Galileo's fingers and a molar. Cf. Shorto, *Descartes' Bones*.

✄ BIBLIOGRAPHY

Aarsleff, Hans. *The Study of Language in England, 1780–1860.* Princeton, N.J.: Princeton University Press, 1967.

Abrams, M. H. *The Correspondent Breeze: Essays on English Romanticism.* New York: W. W. Norton, 1984.

———. *The Mirror and the Lamp: Romantic Theory and the Critical Tradition.* Oxford: Oxford University Press, 1953.

Acworth, Bernard. *The Cuckoo and Other Bird Mysteries.* London: Eyre & Spottiswoode, 1946.

Aczel, Amir D. *Descartes' Secret Notebook: A True Tale of Mathematics, Mysticism, and the Quest to Understand the Universe.* New York: Broadway Books, 2005.

Adorno, Theodor W. "Postludium" (1968) to "Ad vocem Hindemith: Eine Dokumentation." In *Impromptus,* in *Musikalische Schriften,* ed. Rolf Tiedemann, 4:240. Frankfurt am Main: Suhrkamp Verlag, 1982.

Aït-Touati, Frédérique. *Fictions of the Cosmos: Science and Literature in the Seventeenth Century.* Trans. Susan Emanuel. Chicago: University of Chicago Press, 2011.

Albury, W. R. "Halley's Ode on the *Principia* of Newton and the Epicurean Revival in England." *JHI* 39 (1978): 24–43.

Applebaum, Wilbur. *The Scientific Revolution and the Foundations of Modern Science.* Westport, Conn.: Greenwood Press, 2005.

Ariès, Philippe. *The Hour of Our Death.* Trans. Helen Weaver. New York: Knopf, 1981.

Arnulf, Arwed. "Das Titelbild der Tabulae Rudolphinae des Johannes Kepler. Zu Entwurf, Ausführung, dichterischer Erläuterung und Vorbildern einer Wissenschaftsallegorie." *Zeitschrift das Deutschen Vereins für Kunstwissenschaft* 54/55 (2000–2001): 176–98.

Artigas, Mariano, Rafael Martínez, and William R. Shea. "New Light on the Galileo Affair?" In *The Church and Galileo,* ed. Ernan McMullin, 213–33. Notre Dame, Ind.: University of Notre Dame Press, 2005.

Ashworth, William B. "Natural History and the Emblematic World View." In *Reappraisals of the Scientific Revolution,* ed. David C. Lindberg and Robert S. Westman, 303–32. Cambridge: Cambridge University Press, 1990.

Aubrey, John. *Brief Lives.* Ed. Andrew Clark. 2 vols. Oxford: Clarendon Press, 1898.

Aughton, Peter. *The Transit of Venus.* London: Weidenfeld & Nicolson, 2004.

Ault, Donald D. *Visionary Physics: Blake's Response to Newton.* Chicago: University of Chicago Press, 1974.

Austen, Gillian. *George Gascoigne.* Woodbridge, UK: D. S. Brewer, 2008.

Babb, Lawrence. *Sanity in Bedlam: A Study of Robert Burton's "Anatomy of Melancholy."* East Lansing: Michigan State University Press, 1959.

Bacon, Francis. *The Letters and the Life of Francis Bacon, including All His Occasional Works.* 7 vols. Ed. James Spedding. London, 1868–90.

———. *New Atlantis. A Worke unfinished.* London, 1627.

———. *The Oxford Francis Bacon [OFB].* Oxford: Clarendon Press, 1996–.
Vol. 4, *The Advancement of Learning.* Ed. Michael Kiernan. 2000.
Vol. 11, *The "Instauratio magna" Part II: "Novum organum" and Associated Texts.* Ed. and trans. Graham Rees with Maria Wakely. 2004.
Vol. 12, *The "Instauratio magna" Part III: "Historia naturalis et experimentalis": "Historia ventorum" and "Historia vitæ & mortis."* Ed. and trans. Graham Rees with Maria Wakely. 2007.
Vol. 15, *The Essayes or Counsels, Civill and Morall.* Ed Michael Kiernan. 2000.

———. *Sylva Sylvarum, or A Natural History In ten Centuries.* London, 1627.

———. *The Works of Francis Bacon.* Ed. James Spedding, Robert Leslie Ellis, and Douglas Denon Heath. 15 vols. London: Longmans, 1887–1901.

Baigrie, Brian S., ed. *Picturing Knowledge: Historical and Philosophical Problems concerning the Use of Art in Science.* Toronto: University of Toronto Press, 1996.

Baillet, Adrien. *La vie de M. Descartes.* 2 vols. Paris, 1691.

Baird, J. L. *Rossignol: An Edition and Translation.* Kent, Ohio: Kent State University Press, 1978.

Bakewell, Sarah. *How to Live: Or a Life of Montaigne in One Question and Twenty Attempts at an Answer.* New York: Other Press, 2010.

Banville, John. *Kepler.* London: Secker & Warburg, 1981.

Barbour, Reid, and Claire Preston, eds. *Sir Thomas Browne: The World Proposed.* Oxford: Oxford University Press, 2008.

Barlow, Richard G. "Infinite Worlds: Burton's Cosmic Voyage." *JHI* 34 (1973): 291–302.

Barrett, Deirdre, and Patrick McNamara, eds. *The New Science of Dreaming.* 3 vols. Westport, Conn.: Praeger Publishers, 2007.

Bayle, Pierre. *Various Thoughts on the Occasion of a Comet.* Trans. Robert C. Bartlett. Albany: State University of New York Press, 2000.

Benjamin, Walter. "Theses on the Philosophy of History." In *Illuminations*, trans. Harry Zohn, 253–64. New York: Schocken Books, 1969.

———. "To the Planetarium," from *One-Way Street (Einbahnstrasse*, 1928). In *Reflections*, trans. Edmund Jephcott. New York: Harcourt Brace Jovanovich, 1978.

Bennett, Jim, Michael Cooper, Michael Hunter, and Lisa Jardine. *London's Leonardo— The Life and Work of Robert Hooke.* Oxford: Oxford University Press, 2003.

Benson, Michael. "What Galileo Saw." *New Yorker*, 8 September 2003, 38–43.

Bernstein, Jeremy. "Heaven's Net: The Meeting of John Donne and Johannes Kepler." *American Scholar* 66 (Spring 1997): 175–95.

Bevis, John. *Aaaaw to Zzzzzd: The Words of Birds.* Cambridge, Mass.: MIT Press, 2010.

Biagioli, Mario. "Did Galileo Copy the Telescope? A 'New' Letter by Paolo Sarpi." In Van Helden et al., *Origins of the Telescope*, 203–30.

———. *Galileo, Courtier: The Practice of Science in the Culture of Absolutism.* Chicago: University of Chicago Press, 1993.

———. *Galileo's Instruments of Credit: Telescopes, Images, Secrecy.* Chicago: University of Chicago Press, 2006.

Blake, William. *Milton a Poem.* Ed. Robert N. Essick and Joseph Viscomi. Princeton, N.J.: Princeton University Press, 1993.

Blumenberg, Hans. *The Genesis of the Copernican World.* Trans. Robert M. Wallace. Cambridge, Mass.: MIT Press, 1987.

Blumenfeld, Harold. "'Ad Vocem' Adorno." *Musical Quarterly* 70 (1984): 529–34.

Boklund-Lagopoulou, Karin. *"I have a yong suster": Popular Song and the Middle English Lyric.* Dublin: Four Courts, 2002.

Bonelli, M. L. Righini, and William R. Shea, eds. *Reason, Experiment, and Mysticism in the Scientific Revolution.* New York: Science History Publications, 1975.

Booth, Sara E., and Albert Van Helden. "The Virgin and the Telescope: The Moons of Cigoli and Galileo." In Renn, *Galileo in Context,* 192–216.

Boswell, James. *The Life of Samuel Johnson.* Ed. G. B. Hill and L. F. Powell. 6 vols. Oxford: Clarendon Press, 1934–50.

Boyle, Robert. *The Works of Robert Boyle.* Ed. Michael Hunter and Edward B. Davis. 14 vols. London: Pickering & Chatto, 1999–2000.

Brahe, Tycho. *Astronomiæ instauratæ mechanica.* Uraniborg, 1598.

———. *Epistolarum astronomicarum libri.* Uraniborg, 1596.

———. *Astronomiæ instauratæ mechanica.* Uraniborg, 1598. Revised English trans., *Instruments of the Renewed Astronomy.* Ed. Alena Hadravova, Petr Hadrava, and Jole R. Shackelford. Prague: Koniasch Latin Press, 1996.

Bredekamp, Horst. *Galilei der Künstler: Der Mond—Die Sonne—Die Hand.* Berlin: Akademie Verlag, 2007.

———, ed. *Galileo's O.* Vol. 1, *Galileo's "Sidereus Nuncius,"* ed. Irene Brückle and Oliver Hahn. Vol. 2, Paul Needham, *Galileo Makes a Book.* Berlin: Akademie Verlag, 2011.

———. "Gazing Hands and Blind Spots: Galileo as Draftsman." In Renn, *Galileo in Context,* 153–92.

Broch, Hermann. *Hugo von Hofmannsthal and His Time: The European Imagination, 1860–1920.* Trans. Michael P. Steinberg. Chicago: University of Chicago Press, 1984.

Brod, Max. *Tycho Brahe's Path to God.* Trans. Felix Warren Crosse. Evanston, Ill.: Northwestern University Press, 2007.

Brooke, John Hedley. *Science and Religion: Some Historical Perspectives.* New York: Cambridge University Press, 1991.

Brown, Sarah Annes. *Ovid: Myth and Metamorphosis.* London: Bristol Classical Press, 2005.

Browne, Thomas. *Christian Morals.* Ed. S. C. Roberts. Cambridge: Cambridge University Press, 1927.

———. *Pseudodoxia Epidemica* (1646). Ed. Robin Robbins. 2 vols. Oxford: Clarendon Press, 1981.

———. *Religio Medici, and Other Works.* Ed. L. C. Martin. Oxford: Clarendon Press, 1964.

———. *Works of Sir Thomas Browne.* Ed. Geoffrey Keynes. 4 vols. Chicago: University of Chicago Press, 1964.

Bruhn, Siglind. *The Musical Order of the World: Kepler, Hesse, Hindemith.* Hillsdale, N.Y.: Pendragon Press, 2005.

Bruno, Giordano. *The Ash Wednesday Supper* (1584). Trans. Stanley L. Jaki. The Hague: Mouton, 1975.

Burroughs, John. *Birds and Poets, with Other Papers.* Boston: Houghton Mifflin, 1895.

Burton, Robert. *The Anatomy of Melancholy* (1632). Ed. Nicholas K. Kiessling, Thomas C. Faulkner, and Rhonda L. Blair. 6 vols. Oxford: Clarendon Press, 1989–2001.

Burtt, E. A. *The Metaphysical Foundations of Modern Physical Science.* New York: Harcourt Brace, 1925.

Bury, J. B. *The Idea of Progress: An Inquiry into Its Origin and Growth.* New York: Macmillan, 1932.

Bush, Douglas. *Science and English Poetry: A Historical Sketch, 1590–1950.* New York: Oxford University Press, 1950.

Butler, Todd. *Imagination and Politics in Seventeenth-Century England.* Aldershot, UK: Ashgate, 2008.

Butterfield, Herbert. *The Origins of Modern Science, 1300–1800.* Rev. ed. New York: The Free Press, 1965.

———. *The Whig Interpretation of History.* London: G. Bell and Sons, 1931.

Butts, Robert E. "Some Tactics in Galileo's Propaganda for the Mathematization of Scientific Experience." In *New Perspectives on Galileo,* ed. Robert E. Butts and Joseph C. Pitt, 59–85. Dordrecht: D. Reidel, 1978.

Calvino, Italo. "Man, the Sky, and the Elephant" (1982). In *The Literature Machine,* trans. Patrick Creagh. London: Secker and Warburg, 1987.

Campanella, Tommaso. *A Defense of Galileo, the Mathematician from Florence* (1622). Trans. Richard J. Blackwell. Notre Dame, Ind.: University of Notre Dame Press, 1994.

Campbell, Mary Baine. *Wonder and Science: Imagining Worlds in Early Modern Europe.* Ithaca, N.Y.: Cornell University Press, 1999.

Canguilhem, Georges. *A Vital Rationalist: Selected Writings.* Ed. François Delaporte. Trans. Arthur Goldhammer. New York: Zone Books, 1994.

Carey, John. *John Donne: Life, Mind and Art.* London: Faber and Faber, 1990.

Caspar, Max. *Kepler* (1948). Trans. C. Doris Hellman. New York: Dover Publications, 1993.

Chalker, John. *The English Georgic: A Study in the Development of a Form.* Baltimore: Johns Hopkins University Press, 1969.

Changeux, Jean-Pierre, and Paul Ricoeur. *What Makes Us Think? A Neuroscientist and a Philosopher Argue about Ethics, Human Nature, and the Brain.* Trans. M. B. DeBevoise. Princeton, N.J.: Princeton University Press, 2000.

Chapman, Allan. *England's Leonardo: Robert Hooke and the Seventeenth-Century Scientific Revolution.* Bristol: Institute of Physics, 2005.

Cheney, Patrick. *Spenser's Famous Flight: A Renaissance Idea of a Literary Career.* Toronto: University of Toronto Press, 1993.

Chester, Robert. *Loves Martyr, or, Rosalins Complaint* (1601). Ed. Alexander B. Grosart. London: Trubner, 1878.

Chomsky, Noam. *Cartesian Linguistics: A Chapter in the History of Rationalist Thought.* New York: Harper & Row, 1966.

Christianson, John Robert. *On Tycho's Island: Tycho Brahe and His Assistants, 1570–1601.* Cambridge: Cambridge University Press, 2000.

Claeys, Gregory, ed. *Restoration and Augustan British Utopias.* Syracuse: Syracuse University Press, 2000.

Clare, John. *John Clare by Himself.* Ed. Eric Robinson and David Powell. New York: Routledge, 2002.

———. *Poems of the Middle Period, 1822–1837.* Ed. Eric Robinson, David Powell, and P. M. S. Dawson. 4 vols. Oxford: Clarendon Press, 1998.

Clark, Stuart. *Thinking with Demons: The Idea of Witchcraft in Early Modern Europe.* Oxford: Clarendon Press, 1997.

Clarke, Arthur C. *Profiles of the Future: An Inquiry into the Limits of the Possible.* New York: Harper & Row, 1973.

Clarke, Desmond M. *Descartes: A Biography.* New York: Cambridge University Press, 2006.

———. *Descartes's Theory of Mind.* Oxford: Oxford University Press, 2003.

Clavelin, Maurice. *The Natural Philosophy of Galileo: Essays on the Origins and Formation of Classical Mechanics.* Trans. A. J. Pomerans. Cambridge, Mass.: MIT Press, 1974.

Coelho, Victor, ed. *Music and Science in the Age of Galileo.* Dordrecht: Kluwer, 1992.

Coetzee, J. M. *Elizabeth Costello: Eight Lessons.* London: Secker & Warburg, 2003.

Coffin, Charles M. *John Donne and the New Philosophy.* New York: Columbia University Press, 1937.

Cohen, H. Floris. *How Modern Science Came into the World: Four Civilizations, One 17th-Century Breakthrough.* Amsterdam: Amsterdam University Press, 2010.

———. *Quantifying Music: The Science of Music at the First Stage of the Scientific Revolution, 1580–1650.* Dordrecht: Reidel, 1984.

———. *The Scientific Revolution: A Historiographical Inquiry.* Chicago: University of Chicago Press, 1994.

Cohen, I. Bernard. *The Birth of a New Physics.* New York: W. W. Norton, 1985.

———. *Revolution in Science.* Cambridge, Mass.: Belknap Press of Harvard University Press, 1985.

———. "What Galileo Saw: The Experience of Looking through a Telescope." In *From Galileo's "Occhialino" to Optoelectronics*, ed. Paolo Mazzoldi, 445–72. Singapore: World Scientific, 1993.

Cohen, Ralph. *The Unfolding of "The Seasons."* Baltimore: Johns Hopkins University Press, 1970.

Cole, John R. *The Olympian Dreams and Youthful Rebellion of René Descartes.* Urbana: University of Illinois Press, 1992.

Coleridge, Samuel Taylor. *Biographia Literaria or Biographical Sketches of My Literary Life and Opinions* (1817). Ed. James Engell and W. Jackson Bate. Princeton, N.J.: Princeton University Press, 1983.

Connor, James A. *Kepler's Witch.* San Francisco: HarperCollins, 2004.

Cooper, Lane. *Aristotle, Galileo, and the Tower of Pisa.* Ithaca, N.Y.: Cornell University Press, 1935.

Cooper, Michael. *"A more beautiful city": Robert Hooke and the Rebuilding of London after the Great Fire.* Stroud, UK: Sutton, 2003.

Cooper, Michael, and Michael Hunter, eds. *Robert Hooke: Tercentennial Studies*. Aldershot, UK: Ashgate, 2006.

Copernicus, Nicholas. *On the Revolutions* (1543). Trans. Edward Rosen. Baltimore: Johns Hopkins University Press, 1992.

Cottingham, John. *Cartesian Reflections: Essays in Descartes's Philosophy*. New York: Oxford University Press, 2008.

Coward, T. A., and J. A. G. Barnes. *Birds of the British Isles and Their Eggs*. London: F. Warne, 1969.

Crashaw, Richard. *The Complete Poetry of Richard Crashaw*. Ed. George Walton Williams. Garden City, N. Y.: Anchor Books, 1970.

Cressy, David. *Birth, Marriage, and Death: Ritual, Religion, and the Life-Cycle in Tudor and Stuart England*. Oxford: Oxford University Press, 1997.

Crowe, Michael J. *The Extraterrestrial Life Debate, 1750–1900*. Cambridge: Cambridge University Press, 1986.

Cunningham, Andrew, and Perry Williams. "De-centring the 'Big Picture': *The Origins of Modern Science* and the Modern Origins of Science" (1993). In Hellyer, *Scientific Revolution*, 218–46.

Curley, E. M. *Descartes against the Sceptics*. Cambridge, Mass.: Harvard University Press, 1978.

Curtius, Ernst Robert. *European Literature and the Latin Middle Ages*. Trans. Willard Trask. Princeton, N.J.: Princeton University Press, 1953.

Cyrano de Bergerac. *Œuvres complètes*. Ed. Madeleine Alcover. 3 vols. Paris: Honoré Champion, 2000.

Damasio, Antonio R. *Descartes' Error: Emotion, Reason, and the Human Brain*. New York: G. P. Putnam, 1994.

Danielson, Dennis. *The First Copernican: Georg Joachim Rheticus and the Rise of the Copernican Revolution*. New York: Walker & Company, 2006.

D'Arblay, Madame [Frances Burney]. *Diary and Letters of Madam D'Arblay*. Ed. Austin Dobson. London: Macmillan, 1904.

Daston, Lorraine. "Science Studies and the History of Science." *Critical Inquiry* 35 (2009): 798–813.

Daston, Lorraine, and Peter Galison. *Objectivity*. New York: Zone Books, 2007.

Daston, Lorraine, and Katharine Park. *Wonders and the Order of Nature, 1150–1750*. New York: Zone Books, 2001.

Davies, John. *The Poems of Sir John Davies*. Ed. Clare Howard. New York: Columbia University Press, 1941.

Davis, J. C. *Utopia and the Ideal Society: A Study of English Utopian Writing, 1516–1700*. Cambridge: Cambridge University Press, 1981.

da Vinci, Leonardo. *The Notebooks of Leonardo da Vinci*. Ed. Jean Paul Richter. New York: Dover Publications, 1970.

Dear, Peter. *Discipline & Experience: The Mathematical Way in the Scientific Revolution*. Chicago: University of Chicago Press, 1995.

——. "A Mechanical Microcosm: Bodily Passions, Good Manners, and Cartesian Mechanism." In *Science Incarnate: Historical Embodiments of Natural Knowledge*, ed. Christopher Lawrence and Steven Shapin, 51–82. Chicago: University of Chicago Press, 1998.

——. *Revolutionizing the Sciences: European Knowledge and Its Ambitions, 1500–1700*. Princeton, N.J.: Princeton University Press, 2009.

Debus, Allen G. "Harvey and Fludd: The Irrational Factor in the Rational Science of the Seventeenth Century." *Journal of the History of Biology* 3 (1970): 81–105.

———. *The Chemical Philosophy: Paracelsian Science and Medicine in the Sixteenth and Seventeenth Centuries.* 2 vols. New York: Science History Publications, 1977.

———. *Man and Nature in the Renaissance.* Cambridge: Cambridge University Press, 1978.

———. *Robert Fludd and His Philosophical Key.* New York: Science History Publications, 1979.

Debus, Allen G., and Michael T. Walton. *Reading the Book of Nature: The Other Side of the Scientific Revolution.* Kirksville, Mo.: Sixteenth Century Journal Publishers.

Dekker, Thomas. *The Plague Pamphlets of Thomas Dekker.* Ed. F. P. Wilson. Oxford: Clarendon Press, 1925.

de Man, Paul. *Blindness and Insight: Essays in the Rhetoric of Contemporary Criticism.* Minneapolis: University of Minnesota Press, 1983.

DeMaria, Robert, Jr. *Johnson's "Dictionary" and Language of Learning.* Chapel Hill: University of North Carolina Press, 1986.

Desaguliers, J. T. *A Course of Experimental Philosophy.* London, 1734.

De Santillana, Giorgio. *The Crime of Galileo.* Chicago: University of Chicago Press, 1955.

Descartes, René. *The Geometry of René Descartes.* Trans. David Eugene Smith and Marcia L. Latham. Chicago: Open Court, 1925.

———. *Œuvres de Descartes.* Ed. Charles Adam and Paul Tannery. 13 vols. Paris: L. Cerf, 1897–1913.

———. *The Philosophical Writings of Descartes.* Trans. John Cottingham, Robert Stoothoff, and Dugald Murdoch. 3 vols. Cambridge: Cambridge University Press, 1984–91.

———. *Principles of Philosophy.* Trans. Valentine Rodger Miller and Reese P. Miller. Dordrecht: Reidel, 1983.

———. *The World and Other Writings.* Trans. Stephen Gaukroger. Cambridge: Cambridge University Press, 1998.

Des Chene, Dennis. *Life's Form: Late Aristotelian Conceptions of the Soul.* Ithaca, N.Y.: Cornell University Press, 2000.

Dick, Steven J. *Plurality of Worlds: The Origins of the Extraterrestrial Life Debate from Democritus to Kant.* Cambridge: Cambridge University Press, 1982.

Digby, Kenelm. *A Late Discourse made in a Solemne Assembly of Nobles and Learned Men at Montpellier in France Touching the Cure of Wounds by the Powder of Sympathy.* Trans. R. White. London, 1658.

Dijksterhuis, E. J. *The Mechanization of the World Picture.* Trans. C. Dikshoorn. Oxford: Clarendon Press, 1961.

Dobbs, Betty Jo. *The Janus Faces of Genius: The Role of Alchemy in Newton's Thought.* Cambridge: Cambridge University Press, 1991.

———. "Newton as Final Cause and First Mover" (1993). In Osler, *Rethinking the Scientific Revolution*, 25–39.

———. "Studies in the Natural Philosophy of Sir Kenelm Digby." *Ambix* 18 (1971): 1–25.

Dobson, Mary J. *Contours of Death and Disease in Early Modern England.* Cambridge: Cambridge University Press, 1997.

Donne, John. *The Complete Poetry and Selected Prose*. Ed. Charles M. Coffin. New York: Modern Library, 1952.

——. *Ignatius His Conclave*. Ed. T. S. Healey. Oxford: Clarendon Press, 1969.

Drake, Ellen Tan. *Restless Genius: Robert Hooke and His Earthly Thoughts*. New York: Oxford University Press, 1996.

Drake, Stillman. *Galileo at Work: His Scientific Biography*. Chicago: University of Chicago Press, 1978.

——. "Music and Philosophy in Early Modern Science." In Coelho, *Music and Science in the Age of Galileo*, 3–16.

Drake, Stillman, and C. D. O'Malley, trans. *The Controversy on the Comets of 1618*. Philadelphia: University of Pennsylvania Press, 1960.

Dubos, René. *Mirage of Health: Utopias, Progress, and Biological Change*. New York: Harper, 1959.

Duhem, Pierre. *Études sur Léonard de Vinci*. 3 vols. Paris: A. Hermann, 1906–13.

——. *To Save the Phenomena: An Essay on the Idea of Physical Theory from Plato to Galileo* (1908). Trans. Edmund Doland and Chaninah Maschler. Chicago: University of Chicago Press, 1969.

Dupré, Sven. "Galileo's Telescope and Celestial Light." *Journal for the History of Astronomy* 34 (2003): 369–99.

Duran, Angelica. *The Age of Milton and the Scientific Revolution*. Pittsburgh: Duquesne University Press, 2007.

Dyson, Freeman. "Our Biotech Future." *New York Review of Books*, 19 July 2007.

Eamon, William. *Science and the Secrets of Nature: Books of Secrets in Medieval and Early Modern Culture*. Princeton, N.J.: Princeton University Press, 1994.

Edgerton, Samuel Y. "Galileo, Florentine *disegno*, and the 'Strange Spottednesss of the Moon.'" *Art Journal* 40 (1984): 225–32.

——. *The Heritage of Giotto's Geometry: Art and Science on the Eve of the Scientific Revolution*. Ithaca, N.Y.: Cornell University Press, 1991.

——. *The Mirror, the Window, and the Telescope: How Renaissance Linear Perspective Changed Our Vision of the Universe*. Ithaca, N.Y.: Cornell University Press, 2009.

——. *The Renaissance Recovery of Linear Perspective*. New York: Basic Books, 1975.

Edwards, Karen L. *Milton and the Natural World: Science and Poetry in "Paradise Lost."* Cambridge: Cambridge University Press, 1999.

Eliot, T. S. *Selected Essays*. New York: Harcourt, Brace, 1950.

Elton, William R. *"King Lear" and the Gods*. San Marino, Calif.: Huntington Library, 1966.

Empson, William. *Essays on Renaissance Literature*. Ed. John Haffenden. 2 vols. Cambridge: Cambridge University Press, 1993.

——. *The Structure of Complex Words*. London: Chatto & Windus, 1951.

Evelyn, John. *The Diary of John Evelyn*. Ed. E. S. de Beer. 6 vols. Oxford: Clarendon Press, 1955.

Fantoli, Annibale. *Galileo: For Copernicanism and for the Church*. Trans. George V. Coyne. 3rd ed. Rome: Vatican Observatory Publications, 2003.

Fara, Patricia. *Newton: The Making of Genius*. London: Macmillan, 2002.

Farrington, Benjamin. *The Philosophy of Francis Bacon: An Essay on Its Development from 1603 to 1609 with New Translations of Fundamental Texts*. Liverpool: Liverpool University Press, 1964.

Fattori, M., and M. Bianchi, eds. *Spiritus.* Roma: Edizioni dell'Ateneo, 1984.

Feingold, Mordechai. *The Newtonian Moment: Isaac Newton and the Making of Modern Culture.* New York: Oxford University Press, 2004.

Ferguson, Kitty. *Tycho & Kepler: The Unlikely Partnership That Forever Changed Our Understanding of the Heavens.* New York: Walker, 2002.

Ferrone, Vincenzo. *The Intellectual Roots of the Italian Enlightenment: Newtonian Science, Religion, and Politics in the Early Eighteenth Century.* Trans. Sue Brotherton. Atlantic Highlands, N. J.: Humanities Press, 1995.

Ferrone, Vincenzo, and Massimo Firpo. "From Inquisitors to Microhistorians: A Critique of Pietro Redondi's *Galileo eretico.*" *Journal of Modern History* 58 (1986): 485–524.

Feyerabend, Paul. *Against Method.* 3rd ed. London: Verso, 1993.

Field, J. V. *Kepler's Geometrical Cosmology.* Chicago: University of Chicago Press, 1988.

Findlen, Paula, ed. *Athanasius Kircher: The Last Man Who Knew Everything.* New York: Routledge, 2004.

Finocchiaro, Maurice A. *The Galileo Affair: A Documentary History.* Berkeley: University of California Press, 1989.

———. *Galileo and the Art of Reasoning: Rhetorical Foundations of Logical and Scientific Method.* Dordrecht: D. Reidel, 1980.

———. *Retrying Galileo, 1633–1992.* Berkeley: University of California Press, 2005.

Flanagan, Owen. *Dreaming Souls: Sleep, Dreams, and the Evolution of the Conscious Mind.* New York: Oxford University Press, 2000.

Fletcher, Angus. *Time, Space, and Motion in the Age of Shakespeare.* Cambridge, Mass.: Harvard University Press, 2007.

Fludd, Robert. *Doctor Fludds Answer unto M. Foster, or, The Squesing of Parson Fosters Sponge, ordained by him for the wiping away of the Weapon-Salve.* London, 1631.

———. *Medicina Catholica, seu mysticum artis medicandi sacrum.* Frankfurt, 1629–31.

———. *Mosaicall Philosophy: Grounded upon the Essential Truth or Eternal Sapience.* London, 1659.

———. *Robert Fludd: Essential Readings.* Ed. William H. Huffman. London: The Aquarian Press, 1992.

———. "Truth's Golden Harrow: An Unpublished Alchemical Treatise of Robert Fludd" (1623). Ed C. H. Josten. *Ambix* 3 (1949): 91–150.

———. *Utriusque cosmi maioris scilicet et minoris metaphysica, physica atque technica historia.* Oppenheim, 1617.

Force, James E., and Richard H. Popkin, eds. *Newton and Religion: Context, Nature, and Influence.* Dordrecht: Kluwer Academic, 1999.

Foucault, Michel. *Les mots et les choses: Une archéologie des sciences humaines.* Paris: Gallimard, 1966.

———. *The Order of Things.* New York: Pantheon Books, 1971.

Fowler, W. Warde. *A Year with the Birds.* Oxford: Blackwell, 1886.

Freedberg, David. *The Eye of the Lynx: Galileo, His Friends, and the Beginnings of Modern Natural History.* Chicago: University of Chicago Press, 2002.

Freeman, Edmund. "A Proposal for an English Academy in 1660." *Modern Language Review* 19 (1924): 297–300.

Freud, Sigmund. *The Collected Papers of Sigmund Freud.* Ed. Ernest Jones. 5 vols. London: Hogarth Press, 1925.

Freudenthal, Gad. *Aristotle's Theory of Material Substance: Heat and Pneuma, Form and Soul*. Oxford: Clarendon Press, 1995.

Frye, Northrop. *Fearful Symmetry: A Study of William Blake*. Princeton, N.J.: Princeton University Press, 1947.

Fuller, Steve. *Thomas Kuhn: A Philosophical History for Our Times*. Chicago: University of Chicago Press, 2000.

Gabbey, Alan, and Robert E. Hall. "The Melon and the Dictionary: Reflections on Descartes's Dreams." *JHI* 59 (1998): 651–68.

Gal, Ofer, and Raz Chen-Morris. *Baroque Science*. Chicago: University of Chicago Press, 2013.

Galilei, Galileo. *Dialogues concerning Two New Sciences*. Trans. Henry Crew and Alfonso de Salvio. New York: Macmillan, 1914.

———. *Discoveries and Opinions of Galileo*. Trans. Stillman Drake. New York: Anchor Books, 1957.

———. *Galileo on the World Systems*. Trans. Maurice A. Finocchiaro. Berkeley: University of California Press, 1997.

———. *Galileo's "Sidereus Nuncius" or "A Sidereal Message."* Trans. William R. Shea. Introduction and notes by William R. Shea and Tiziana Bascelli. Sagamore Beach, Mass.: Science History Publications, 2009.

———. *Le opere di Galileo Galilei*. Ed. Antonio Favaro. 20 vols. Florence: G. Barbèra, 1890–1909.

———. *On Motion, and On Mechanics*. Trans. I. E. Drabkin and Stillman Drake. Madison: University of Wisconsin Press, 1969.

———. *Scritti letterari*. Ed. Albero Chiari. Florence: F. Le Monnier, 1943.

———. *Sidereus Nuncius or The Sidereal Messenger*. Trans. Albert Van Helden. Chicago: University of Chicago Press, 1989.

———. *Two New Sciences*. Trans. Stillman Drake. Madison: University of Wisconsin Press, 1974.

Galilei, Galileo, and Christoph Scheiner. *On Sunspots*. Trans. Eileen Reeves and Albert Van Helden. Chicago: University of Chicago Press, 2010.

Gammon, Martin. "'Exemplary Originality': Kant on Genius and Imitation." *Journal of the History of Philosophy* 35 (1997): 563–92.

Garber, Daniel, and Michael Ayres, eds. *The Cambridge History of Seventeenth-Century Philosophy*. Cambridge: Cambridge University Press, 1998.

Gardner, Howard. *Frames of Mind: The Theory of Multiple Intelligences*. New York: Basic Books, 1983.

Gardner, Martin. *Did Adam and Eve Have Navels?* New York: W. W. Norton, 2000.

Garin, Eugenio. *Science and Civic Life in the Italian Renaissance*. Trans. Peter Munz. Garden City, N.Y.: Anchor Books, 1969.

Garrod, H. W. *The Profession of Poetry and Other Lectures*. Oxford: Clarendon Press, 1929.

Gascoigne, George. *The Complete Works of George Gascoigne*. Ed. John W. Cunliffe. 2 vols. Cambridge: Cambridge University Press, 1910.

Gatti, Hilary. *Giordano Bruno and Renaissance Science*. Ithaca, N.Y.: Cornell University Press, 1999.

Gaukroger, Stephen. *The Collapse of Mechanism and the Rise of Sensibility: Science and the Shaping of Modernity, 1680–1760*. Oxford: Clarendon Press, 2010.

———. *Descartes: An Intellectual Biography*. Oxford: Clarendon Press, 1995.

———. *Descartes' System of Natural Philosophy*. Cambridge: Cambridge University Press, 2002.

———. *The Emergence of a Scientific Culture: Science and the Shaping of Modernity, 1210– 1685*. Oxford: Clarendon Press, 2006.

———. "The Nature of Abstract Reasoning: Philosophical Aspects of Descartes' Work in Algebra." In *The Cambridge Companion to Descartes*, ed. John Cottingham, 91–114. Cambridge: Cambridge University Press, 1992.

Gay, Peter. *The Enlightenment: An Interpretation; The Rise of Modern Paganism*. New York: Knopf, 1966.

Geis, Gilbert, and Ivan Bunn. *A Trial of Witches: A Seventeenth-Century Witchcraft Prosecution*. London: Routledge, 1997.

Gieser, Suzanne. *The Innermost Kernel: Depth Psychology and Quantum Physics; Wolfgang Pauli's Dialogue with C. G. Jung*. Berlin: Springer, 2005.

Giglioni, Guido. "The Hidden Life of Matter: Techniques for Prolonging Life in the Writings of Francis Bacon." In *Francis Bacon and the Refiguring of Early Modern Thought*, ed. Julie Robin Solomon and Catherine Gimelli Martin. 129–44. Aldershot, UK: Ashgate, 2005.

Gilbert, William. *On the Loadstone and Magnetic Bodies, and on the Great Magnet the Earth* (1600). Trans. P. Fleury Mottelay. Ann Arbor, Mich.: Edwards Brothers,1938.

Gilder, Joshua, and Anne-Lee Gilder. *Heavenly Intrigue: Johannes Kepler, Tycho Brahe, and the Murder behind One of History's Greatest Scientific Discoveries*. New York: Doubleday, 2004.

Gillispie, Charles Coulston. *The Edge of Objectivity: An Essay in the History of Scientific Ideas*. Princeton, N.J.: Princeton University Press, 1960.

Gingerich, Owen. *The Book Nobody Read: Chasing the Revolutions of Nicolaus Copernicus*. New York: Walker & Company, 2004.

———. "The Curious Case of the M-L *Sidereus Nuncius*." *Galilæana* 6 (2009): 141–65.

———. "*Dissertatio cum Professore Righini et Sidereo Nuncio*." In Bonelli and Shea, *Reason, Experiment, and Mysticism*, 77–88.

———. *The Eye of Heaven: Ptolemy, Copernicus, Kepler*. New York: American Institute of Physics, 1993.

———. *The Great Copernicus Chase and Other Adventures in Astronomical History*. Cambridge: Cambridge University Press, 1992.

Gingerich, Owen, and Albert Van Helden. "From *Occhiale* to Printed Page: The Making of Galileo's *Sidereus Nuncius*." *Journal for the History of Astronomy* 24 (2003): 251–67.

Glanvill, Joseph. *Plus Ultra: Or the Progress and Advancement of Knowledge since the Days of Aristotle* (1668). Ed. Jackson I. Cope. Gainesville, Fla.: Scholars' Facsimiles & Reprints, 1958.

Glassie, John. *A Man of Misconceptions: The Life of an Eccentric in an Age of Change*. New York: Riverhead Books, 2012.

Gleick, James. *Isaac Newton*. New York: Pantheon Books, 2003.

Godwin, Joscelyn. *Robert Fludd: Hermetic Philosopher and Surveyor of Two Worlds*. Boulder, Colo.: Shambhala, 1979.

Golinski, Jan. *Making Natural Knowledge: Constructivism and the History of Science.* 2nd ed. Chicago: University of Chicago Press, 2005.

Goodman, Kevis. *Georgic Modernity and British Romanticism: Poetry and the Mediation of History.* Cambridge: Cambridge University Press, 2004.

Gough, J. W. *The Rise of the Entrepreneur.* New York: Schocken Books, 1969.

Gouhier, Henri. *Les premières pensées de Descartes: Contribution à l'histoire de l'Anti-Renaissance.* Paris: J. Vrin, 1958.

Gouk, Penelope. *Music, Science, and Natural Magic in Seventeenth-Century England.* New Haven: Yale University Press, 1999.

Grant, Edward. *Much Ado about Nothing: Theories of Space and Vacuum from the Middle Ages to the Scientific Revolution.* Cambridge: Cambridge University Press, 1981.

Gray, John. *The Immortalization Commission: Science and the Strange Quest to Cheat Death.* New York: Allen Lane, 2011.

Grünbein, Durs. *The Bars of Atlantis: Selected Essays.* Ed. Michael Eskin. New York: Farrar, Straus and Giroux, 2010.

———. *Descartes' Devil: Three Meditations.* Trans. Anthea Bell. New York: Upper West Side Philosophers, 2010.

Guicciardini, Niccolò. *Isaac Newton on Mathematical Certainty and Method.* Cambridge, Mass.: MIT Press, 2009.

———. *Reading the "Principia": The Debate on Newton's Mathematical Methods for Natural Philosophy from 1687 to 1736.* Cambridge: Cambridge University Press, 1999.

Gunter, R. T., ed. *Early Science in Oxford.* 14 vols. Oxford: Oxford University Press, 1920–45.

Hacking, Ian. *The Emergence of Probability: A Philosophical Study of Early Ideas about Probability, Induction and Statistical Inference.* London: Cambridge University Press, 1975.

Hack-Molitor, Gisela. *On Tiptoe in Heaven. Mystik und Reform im Werk von Sir Thomas Browne (1605–1682).* Heidelberg: C. Winter, 2001.

Hakewill, George. *An Apologie of the Power and Providence of God in the Government of the World. Or an Examination and Censure of the Common Errour Touching Natures Perpetuall and Universall Decay.* London, 1627.

Hall, A. Rupert. *From Galileo to Newton, 1630–1720.* New York: Harper & Row, 1963.

———. *Isaac Newton: Eighteenth-Century Perspectives.* Oxford: Oxford University Press, 1999.

———. *Philosophers at War: The Quarrel between Newton and Leibniz.* Cambridge: Cambridge University Press, 1980.

———. *The Scientific Revolution, 1500–1800: The Formation of the Modern Scientific Attitude.* London: Longmans, Green, 1954.

———. "Two Unpublished Letters of Robert Hooke." *Isis* 42 (1951): 224.

Hall, Marie Boas. *Henry Oldenburg: Shaping the Royal Society.* Oxford: Oxford University Press, 2002.

Hall, Thomas S. *Ideas of Life and Matter: Studies in the History of General Physiology, 600 B.C.–1900 A.D.* 2 vols. Chicago: University of Chicago Press, 1969.

Halley, Edmond. *Correspondence and Papers of Edmond Halley.* Ed. Eugene Fairfield Mac Pike. Oxford: Clarendon Press, 1932.

Hallyn, Fernand, ed. *Les Olympiques de Descartes.* Geneva: Librairie Droz, 1995.

——. *The Poetic Structure of the World: Copernicus and Galileo.* Trans. Donald M. Leslie. New York: Zone Books, 1990.

Harris, William V. *Dreams and Experience in Classical Antiquity.* Cambridge, Mass.: Harvard University Press, 2009.

Harrison, John. *The Library of Isaac Newton.* Cambridge: Cambridge University Press, 1978.

Harth, Erica. *Cyrano de Bergerac and the Polemics of Modernity.* New York: Columbia University Press, 1970.

Harvey, William. *The Anatomical Exercises* (1632). Ed. Geoffrey Keynes. New York: Dover Publications, 1995.

——. *Anatomical Exercitations, Concerning the Generation of Living Creatures.* London, 1653.

Havenstein, Daniela. *Democratizing Sir Thomas Browne: "Religio Medici" and Its Imitations.* Oxford: Clarendon Press, 1999.

Haycock, David Boyd. *Mortal Coil: A Short History of Living Longer.* New Haven, Conn.: Yale University Press, 2008.

Hedrick, Elizabeth. "Romancing the Salve: Sir Kenelm Digby and the Powder of Sympathy." *BJHS* 41 (2008): 161–85.

Heidegger, Martin. *What Is Called Thinking?* (1954). Trans. Fred D. Wieck and J. Glenn Gray. New York: Harper & Row, 1968.

Heilbron, J. L. *Galileo.* Oxford: Oxford University Press, 2010.

Heine, Heinrich. *The Prose Writings of Heinrich Heine.* Ed. Havelock Ellis. London: W. Scott, 1887.

Heller-Roazen, Daniel. *The Fifth Hammer: Pythagoras and the Disharmony of the World.* New York: Zone Books, 2011.

Hellyer, Marcus, ed. *The Scientific Revolution: The Essential Readings.* Oxford: Blackwell, 2003.

Henry, John. *The Scientific Revolution and the Origins of Modern Science.* 2nd ed. New York: Palgrave, 2002.

Herbert, George. *The Works of George Herbert.* Ed. F. E. Hutchinson. Oxford: Clarendon Press, 1941.

Hesiod. *Theogony and Works and Days.* Trans. Catharine M. Schlegel and Henry Weinfield. Ann Arbor: University of Michigan Press, 2006.

Hesse, Mary B. "Hooke's Philosophical Algebra." *Isis* 57 (1966): 67–83.

Hindemith, Paul. *The Craft of Musical Composition.* Trans. Arthur Mendel. 2 vols. New York: Associated Music Publishers, 1945.

Hirsh, John C. *Medieval Lyric: Middle English Lyrics, Ballads, and Carols.* Oxford: Blackwell, 2005.

Hiscock, W. G., ed. *David Gregory, Isaac Newton and Their Circle.* Oxford: Printed for the editor, 1937.

Hobbes, Thomas. *Leviathan* (1651). Ed. Richard Tuck. Cambridge: Cambridge University Press, 1991.

Hobson, J. Allan. *Dreaming: An Introduction to the Science of Sleep.* Oxford: Oxford University Press, 2002.

Hofmannsthal, Hugo von. *The Lord Chandos Letter and Other Writings.* Trans. Joel Rotenberg. New York: New York Review Books, 2005.

Holmes, Richard. *The Age of Wonder: How the Romantic Generation Discovered the Beauty and Terror of Science.* New York: Pantheon Books, 2008.

Holton, Gerald. *The Scientific Imagination: Case Studies*. Cambridge: Cambridge University Press, 1978.

Hooke, Robert. *An Attempt for the Explication of the Phænomena, Observable in an Experiment Published by the Honourable ROBERT BOYLE, Esq.* London, 1661.

——. *An Attempt to prove the Motion of the Earth from Observations*. London, 1674.

——. *The Diaries of Robert Hooke, The Leonardo of London, 1635–1703*. Ed. Richard Nichols. Lewes: Book Guild, 1994.

——. *Micrographia: or Some Physiological Descriptions of Minute Bodies Made by Magnifying Glasses. With Observations and Inquiries thereupon* (1665). Mineola: Dover Publications, 2003.

——. *The Posthumous Works of Robert Hooke, M.D., S.R.S.* Ed. Richard Waller. London, 1705.

Horkheimer, Max, and Theodor W. Adorno. *Dialectic of Enlightenment*. Trans. John Cumming. New York: Herder and Herder, 1972.

Houlbrooke, Ralph. *Death, Religion, and the Family in England, 1480–1750*. New York: Oxford University Press, 1998.

Huff, Toby E. *Intellectual Curiosity and the Scientific Revolution: A Global Perspective*. Cambridge: Cambridge University Press, 2011.

Huffman, William H. *Robert Fludd and the End of the Renaissance*. London: Routledge, 1988.

Hultsch, Henrike, and Dietmar Todt. "Learning to Sing." In *Nature's Music: The Science of Birdsong*, ed. Peter Marler and Hans Slabbekoorn, 80–107. Amsterdam: Elsevier Academic, 2004.

Hume, David. *The History of England* (1762). 6 vols. Indianapolis: Liberty Classics, 1983.

Hunter, Michael. *Establishing the New Science: The Experience of the Early Royal Society*. Woodbridge, UK: Boydell Press, 1989.

——. *Science and Society in Restoration England*. Cambridge: Cambridge University Press, 1981.

Huppert, George. "*Divinatio et Erudito*: Thoughts on Foucault." *History and Theory* 13 (1974): 191–207.

Hutchinson, Keith. "What Happened to Occult Qualities in the Scientific Revolution?" *Isis* 73 (1982): 233–53.

Iliffe, Robert. "'Is he like other men?' The Meaning of the *Principia Mathematica* and the Author as Idol." In *Culture and Society in the Stuart Restoration*, ed. Gerald MacLean, 159–78. Cambridge: Cambridge University Press, 1995.

Iliffe, Robert, Milo Keynes, and Rebekah Higgitt, eds. *Early Biographies of Isaac Newton, 1660–1885*. 2 vols. London: Pickering & Chatto, 2006.

Inwood, Stephen. *The Forgotten Genius: The Biography of Robert Hooke, 1635–1703*. San Francisco: MacAdam/Cage, 2003.

Jacob, Margaret J. "The Truth of Newton's Science and the Truth of Science's History: Heroic Science at Its Eighteenth-Century Formulation." In Osler, *Rethinking the Scientific Revolution*, 315–31.

Jacquot, Jean. "Harriot, Hill, Warner, and the New Philosophy." In *Thomas Harriot: Renaissance Scientist*, ed. John W. Shirley. 107–28. Oxford: Clarendon Press, 1974.

Jama, Sophie. *La nuit de songes de René Descartes*. Paris: Aubier, 1998.

Janiak, Andrew. *Newton as Philosopher*. Cambridge: Cambridge University Press, 2008.

Jardine, Lisa. *The Curious Life of Robert Hooke, the Man Who Measured London*. New York: HarperCollins, 2004.

Jardine, Nicholas. *The Birth of History and Philosophy of Science: Kepler's "A Defence of Tycho against Ursus" with Essays on Its Provenance and Significance*. Cambridge: Cambridge University Press, 1984.

Jesseph, Douglas M. *Squaring the Circle: The War between Hobbes and Wallis*. Chicago: University of Chicago Press, 1999.

Johns, Adrian. *The Nature of the Book: Print and Knowledge in the Making*. Chicago: University of Chicago Press, 1998.

Johnson, Samuel. *The Idler and The Adventurer*. Ed. W. J. Bate, John M. Bullitt, and L. F. Powell. New Haven, Conn.: Yale University Press, 1963.

———. *The Lives of the Poets*. Ed. Roger Lonsdale. 3 vols. Oxford: Clarendon Press, 2006.

———. *The Rambler*. Ed. W. J. Bate and A. B. Strauss. 3 vols. New Haven, Conn.: Yale University Press, 1969.

———. *Rasselas and Other Tales*. Ed. Gwin J. Kolb. New Haven, Conn.: Yale University Press, 1990.

Jones, Richard Foster. *Ancients and Moderns: A Study of the Rise of the Scientific Movement in Seventeenth-Century England*. 2nd ed. St. Louis, Mo.: Washington University Press, 1961.

Jonson, Ben. *Ben Jonson*. Ed. Ian Donaldson. Oxford: Oxford University Press, 1985.

Kant, Immanuel. *Critique of Judgment* (1796). Trans. Werner S. Pluhar. Indianapolis: Hackett, 1987.

Kavey, Allison B., ed. *World-Building and the Early Modern Imagination*. New York: Palgrave Macmillan, 2010.

Kater, Michael H. *Composers of the Nazi Era: Eight Portraits*. New York: Oxford University Press, 2000.

Keilen, Sean. *Vulgar Eloquence: On the Renaissance Invention of English Literature*. New Haven, Conn.: Yale University Press, 2006.

Kemp, Martin. "From 'Mimesis' to 'Fantasia': The Quattrocentro Vocabulary of Creation, Inspiration and Genius in the Visual Arts." *Viator: Medieval and Renaissance Studies* 8 (1977): 347–98.

———. *Seen/Unseen: Art, Science, and Intuition from Leonardo to the Hubble Telescope*. Oxford: Oxford University Press, 2006.

Kepler, Johannes. *Epitome of Copernican Astronomy, Books IV and V*. Trans. Charles Glenn Wallis. In *Great Books of the Western World*, ed. Mortimer J. Adler, Clifton Fadiman, and Philip W. Goetz. 16:839–1004. Chicago: W. Benton, 1952.

———. *Gesammelte Werke*. Ed. Walter von Dyck and Max Caspar. 20 vols. Munich: C. H. Beck, 1937–93.

———. *The Harmony of the World*. Trans. E. J. Aiton, A. M. Duncan, and J. V. Field. Philadelphia: American Philosophical Society, 1997.

———. *Kepler's Conversation with Galileo's Sidereal Messenger*. Trans. Edward Rosen. New York: Johnson Reprint Corporation, 1965.

———. *Kepler's Somnium: The Dream, or Posthumous Work on Lunar Astronomy*. Trans. Edward Rosen. Madison: University of Wisconsin Press, 1967.

——. *Mysterium Cosmographicum: The Secret of the Universe*. Trans. A. M. Duncan. New York: Abaris Books, 1981.

——. *New Astronomy*. Trans. William H. Donahue. Cambridge: Cambridge University Press, 1992.

——. *A New Year's Gift, or On the Six-Cornered Snowflake*. Ed. and trans. Colin Hardie. Oxford: Clarendon Press, 1966.

——. *Optics: Paralipomena to Witelo Whereby the Optical Part of Astronomy Is Treated*. Trans. William H. Donahue. Santa Fe, N.Mex.: Green Lion Press, 2000.

——. *The Six-Cornered Snowflake: A New Year's Gift*. Trans. Jacques Bromberg. Philadelphia: Paul Dry Books, 2010.

Ker, W. P. *English Literature Medieval*. London: Williams & Norgate, 1912.

Keynes, John Maynard. "Newton the Man." In *Newton Tercentenary Celebration, 15–19 July 1946*. 27–34. Cambridge: Cambridge University Press, 1947.

Killeen, Kevin. *Biblical Scholarship, Science and Politics in Early Modern England: Thomas Browne and the Thorny Place of Knowledge*. Farnham, UK: Ashgate, 2009.

Kilmister, Clive. "Genius in Mathematics." In *Genius: The History of an Idea*, ed. Penelope Murray, 181–95. Oxford: B. Blackwell, 1989.

Knight, G. Wilson. *Shakespearian Dimensions*. Brighton: Harvester Press, 1984.

——. *The Wheel of Fire: Interpretations of Shakespearian Tragedy with Three New Essays*. London: Methuen, 1949.

Knott, John R., Jr. "Sir Thomas Browne and the Labyrinth of Truth." In *Approaches to Sir Thomas Browne*, ed. C. A. Patrides, 19–30. Columbia: University of Missouri Press, 1982.

Koestler, Arthur. *The Sleepwalkers: A History of Man's Changing Vision of the Universe* (1959). London: Arkana, 1989.

Kott, Jan. *Shakespeare Our Contemporary*. Trans. Boleslaw Taborski. London: Methuen, 1964.

Koyré, Alexandre. *From the Closed World to the Infinite Universe*. Baltimore: Johns Hopkins University Press, 1957.

——. *Galileo Studies* (1939). Trans. John Mepham. Hassocks, UK: Harvester Press, 1978.

——. *Metaphysics and Measurement: Essays in Scientific Revolution*. Cambridge, Mass.: Harvard University Press, 1968.

——. *Newtonian Studies*. London: Chapman & Hall, 1965.

Koyré, Alexandre, and I. Bernard Cohen. "The Case of the Missing *Tanquam*: Leibniz, Newton & Clarke." *Isis* 52 (1961): 555–66.

Kozhamthadam, Job. *The Discovery of Kepler's Laws: The Interaction of Science, Philosophy, and Religion*. Notre Dame, Ind.: University of Notre Dame Press, 1994.

Kristeller, Paul Oskar. "The Moral Thought of Renaissance Humanism." In *Renaissance Thought II: Papers on Humanism and the Arts*, 53–56. New York: Harper & Row, 1965

Kuhn, Thomas S. *The Copernican Revolution: Planetary Astronomy in the Development of Western Thought*. Cambridge, Mass.: Harvard University Press, 1957.

——. *The Essential Tension: Selected Studies in Scientific Tradition and Change*. Chicago: University of Chicago Press, 1977.

——. "Second Thoughts on Paradigms." In *The Structure of Scientific Theories*, ed. Frederick Suppe, 459–82. Urbana: University of Illinois Press, 1974.

———. *The Structure of Scientific Revolutions.* 3rd ed. Chicago: University of Chicago Press, 1996.

Labrousse, Elisabeth. *Bayle.* Trans. Denys Potts. Oxford: Oxford University Press, 1983.

Lambert, Ladina Bezzola. *Imagining the Unimaginable: The Poetics of Early Modern Astronomy.* Amsterdam: Rodopi, 2002.

La Primaudaye, Pierre de. *The French Academie.* 2 vols. Trans. T[homas] B[owes]. London, 1586, 1594.

Latour, Bruno. *On the Modern Cult of the Factish Gods.* Durham, N.C.: Duke University Press, 2010.

———. *We Have Never Been Modern.* Trans. Catherine Porter. Cambridge, Mass.: Harvard University Press, 1993.

———. "Why Has Critique Run Out of Steam? From Matters of Fact to Matters of Concern." *Critical Inquiry* 30 (2004): 225–48.

Leibniz, G. W., and Samuel Clarke. *Correspondence.* Ed. Roger Ariew. Indianapolis: Hackett, 2000.

Lerer, Seth. *Error and the Academic Self: The Scholarly Imagination, Medieval to Modern.* New York: Columbia University Press, 2002.

Leroy, Maxime. *Descartes, le philosophe au masque.* 2 vols. Paris: Rieder, 1929.

Lessing, Wolfgang. *Die Hindemith-Rezeption Theodor W. Adornos.* Mainz: Schottverlag, 1999.

Levine, Joseph M. *The Battle of the Books: History and Literature in the Augustan Age.* Ithaca, N.Y.: Cornell University Press, 1991.

———. "Natural History and the History of the Scientific Revolution." *Clio* 13 (1983): 57–73.

Lewis, C. S. *The Discarded Image: An Introduction to Medieval and Renaissance Literature.* Cambridge: Cambridge University Press, 1964.

Libbrecht, Kenneth. *The Snowflake: Winter's Secret Beauty.* Stillwater, Minn.: Voyageur Press, 2003.

Lindorff, David. *Pauli and Jung: The Meeting of Two Great Minds.* Wheaton, Ill.: Quest Books, 2004.

Lipking, Lawrence. "The Gods of Poetry: Mythology and the Eighteenth-Century Tradition." In *Augustan Subjects: Essays in Honor of Martin C. Battestin,* ed. Albert J. Rivero, 68–86. Newark: University of Delaware Press, 1997.

———. "Inventing the Common Reader: Samuel Johnson and the Canon." In *Interpretation and Cultural History,* ed. Joan H. Pittock and Andrew Wear, 153–74. London: Macmillan, 1991.

———. *The Ordering of the Arts in Eighteenth-Century England.* Princeton, N.J.: Princeton University Press, 1970.

Locke, John. *An Essay concerning Human Understanding* (1689). Ed. Peter H. Nidditch. Oxford: Clarendon Press, 1975.

———. *Some Thoughts concerning Education* (1693). Ed. John W. Yolton and Jean S. Yolton. Oxford: Clarendon Press, 1989.

Lüthy, Christoph. "Where Logical Necessity Becomes Visual Persuasion: Descartes's Clear and Distinct Illustrations." In *Transmitting Knowledge: Words, Images, and Instruments in Early Modern Europe,* ed. Sachiko Kusukawa and Ian Maclean, 97–133. Oxford: Oxford University Press, 2006.

Lynch, William T. *Solomon's Child: Method in the Early Royal Society of London.* Stanford, Calif.: Stanford University Press, 2001.

Machamer, Peter, ed. *The Cambridge Companion to Galileo.* Cambridge: Cambridge University Press, 1998.

Machamer, Peter, and J. E. McGuire. *Descartes's Changing Mind.* Princeton, N.J.: Princeton University Press, 2009.

Mantel, Hilary. *Fludd.* London: Viking Press, 1989.

Manuel, Frank E. *Freedom from History.* New York: New York University Press, 1971.

———. *Isaac Newton, Historian.* Cambridge, Mass.: Belknap Press of Harvard University Press, 1963.

———. *A Portrait of Isaac Newton.* Cambridge, Mass.: Belknap Press of Harvard University Press, 1968.

———. *The Religion of Isaac Newton.* Oxford: Clarendon Press, 1979.

Marino, Giambattista. *L'Adone.* Paris, 1623.

Marion, Jean-Luc. *Cartesian Questions: Method and Metaphysics.* Chicago: University of Chicago Press, 1999.

Maritain, Jacques. *The Dream of Descartes.* Trans. M. L. Andison. New York: Philosophical Library, 1944.

Martens, Rhonda. *Kepler's Philosophy and the New Astronomy.* Princeton, N.J.: Princeton University Press, 2000.

Masterman, Margaret. "The Nature of a Paradigm." In *Criticism and the Growth of Knowledge,* ed. Imre Lakatos and Alan Musgrave, 59–89. Cambridge: Cambridge University Press, 1970.

Mayr, Otto. *Authority, Liberty, and Automatic Machinery in Early Modern Europe.* Baltimore: Johns Hopkins University Press, 1986.

Mazzeo, Joseph Anthony. *Renaissance and Seventeenth-Century Studies.* New York: Columbia University Press, 1964.

McEwen, Gilbert D. *The Oracle of the Coffee House: John Dunton's "Athenian Mercury."* San Marino, Calif.: Huntington Library, 1972.

McGinn, Colin. *The Meaning of Disgust.* New York: Oxford University Press, 2011.

McGuire, J. E., and P. M. Rattansi. "Newton and the 'Pipes of Pan'." *Notes and Records of the Royal Society of London* 21 (1966): 108–43.

McKillop, Alan Dugald. *The Background of Thomson's "Seasons."* Minneapolis: University of Minnesota Press, 1942.

McMullin, Ernan. "Galileo on Science and Scripture." In Machamer, *Cambridge Companion to Galileo,* 271–347.

Meier, C. A., ed. *Atom and Archetype: The Pauli/Jung Letters, 1932–58.* Trans. David Roscoe. Princeton, N.J.: Princeton University Press, 2001.

Meli, Domenico Bertoloni. *Equivalence and Priority: Newton versus Leibniz.* Oxford: Clarendon Press, 1993.

Merchant, Carolyn. *The Death of Nature: Women, Ecology, and the Scientific Revolution.* San Francisco: Harper & Row, 1980.

Merleau-Ponty, Maurice. *La prose du monde.* Paris: Gallimard, 1969.

Merton, Robert K. *On the Shoulders of Giants: A Shandean Postscript.* New York: Free Press, 1965.

Miller, Arthur I. *Deciphering the Cosmic Number: The Strange Friendship of Wolfgang Pauli and Carl Jung.* New York: W. W. Norton, 2009.

Milton, John. *Areopagitica.* London, 1644.

———. *The Life Records of John Milton.* Ed. J. Milton French. 5 vols. New Brunswick, N.J.: Rutgers University Press, 1949–58.

Montaigne, Michel de. *The Complete Essays of Montaigne.* Trans. Donald M. Frame. Stanford, Calif.: Stanford University Press, 1958.

Montgomery, Scott. L. *The Moon and the Western Imagination.* Tucson: University of Arizona Press, 1999.

———. *The Scientific Voice.* New York: Guilford Press, 1996.

Mosley, Adam. *Bearing the Heavens: Tycho Brahe and the Astronomical Community of the Late Sixteenth Century.* Cambridge: Cambridge University Press, 2007.

Moss, Jean Dietz. *Novelties in the Heavens: Rhetoric and Science in the Copernican Controversy.* Chicago: University of Chicago Press, 1993.

Nagy, Gregory. *Poetry as Performance: Homer and Beyond.* Cambridge: Cambridge University Press, 1996.

Nashe, Thomas. *The Works of Thomas Nashe.* Ed. R. B. McKerrow. 5 vols. London: Sidgwick & Jackson, 1910.

Needham, Joseph. *A History of Embryology.* Cambridge: Cambridge University Press, 1959.

Newton, Isaac. *Correspondence.* Ed. H. W. Turnbull. 7 vols. Cambridge: Royal Society, 1959–77.

———. *Isaac Newton's Papers & Letters on Natural Philosophy.* Ed. I. Bernard Cohen. Cambridge, Mass.: Harvard University Press, 1958.

———. *The Mathematical Papers of Isaac Newton.* Ed. D. T. Whiteside. 8 vols. Cambridge: Cambridge University Press, 1967–81.

———. *Opticks or A Treatise of the Reflections, Refractions, Inflections & Colours of Light.* 4th ed., 1730. New York: Dover Publications, 1979.

———. *Philosophical Writings.* Ed. Andrew Janiak. Cambridge: Cambridge University Press, 2004.

———. *The Principia: Mathematical Principles of Natural Philosophy* (1687). Trans. I. Bernard Cohen and Anne Whitman. Berkeley: University of California Press, 1999.

———. *A Treatise of the System of the World.* 2nd ed., 1731. Ed. I. Bernard Cohen. Mineola, N.Y.: Dover Publications, 2004.

———. *Unpublished Scientific Papers of Isaac Newton.* Ed. A. Rupert Hall and Marie Boas Hall. Cambridge: Cambridge University Press, 1962.

Nicholl, Charles. *The Chemical Theatre.* London: Routledge & Kegan Paul, 1980.

Nicolson, Marjorie Hope. *The Breaking of the Circle: Studies in the Effect of the "New Science" upon Seventeenth Century Poetry.* Evanston, Ill.: Northwestern University Press, 1950.

———. *Newton Demands the Muse: Newton's Opticks and the Eighteenth Century Poets.* Princeton, N.J.: Princeton University Press, 1946.

———. *Voyages to the Moon.* New York: Macmillan, 1948.

Nisbet, Robert A. *History of the Idea of Progress.* New York. Basic Books, 1980.

Nuland, Sherwin B. *How We Die: Reflections on Life's Final Chapter.* New York: Alfred A. Knopf, 1994.

Ogilvie, Brian W. *The Science of Describing: Natural History in Renaissance Europe.* Chicago: University of Chicago Press, 2006.

Orgel, Stephen. "The Renaissance Artist as Plagiarist." *ELH* 48 (1981): 476–95.

Osler, Margaret J., ed. *Rethinking the Scientific Revolution.* Cambridge: Cambridge University Press, 2000.

Ovid. *Ovid's "Metamorphosis" Englished, Mythologized, and Represented in Figures.* Trans. George Sandys (1632). Ed. Karl K. Hulley and Stanley T. Vandersall. Lincoln: University of Nebraska Press, 1970.

Paganini, Gianni. *Skepsis: Le débat des moderns sur scepticisme; Montaigne, Le Vayer, Campanella, Hobbes, Descartes, Bayle.* Paris: J. Vrin, 2008.

Pagel, Walter. *Paracelsus: An Introduction to Philosophical Medicine in the Era of the Renaissance.* 2nd ed. Basel: Karger, 1982.

Palisca, Claude V. *The Florentine Camerata: Documentary Studies and Translations.* New Haven, Conn.: Yale University Press, 1989.

———. "Was Galileo's Father an Experimental Scientist?" In Coelho, *Music and Science in the Age of Galileo,* 143–51.

Panofsky, Erwin. *Idea: A Concept in Art Theory* (1924). Trans. Joseph J. S. Peake. Columbia: University of South Carolina Press, 1968.

———. *Galileo as a Critic of the Arts.* The Hague: Nijhoff, 1954.

Paracelsus. *The Hermetic and Alchemical Writings of Aureolus Philippus Theophrastus Bombast.* Ed. Arthur Edward Waite. 2 vols. London: J. Eliot, 1894.

Park, Katharine. "The Organic Soul." In Schmitt, Skinner, and Kestler, *Cambridge History of Renaissance Philosophy,* 464–84. Cambridge: Cambridge University Press, 1988.

Park, Katharine, and Lorraine Daston. "Introduction: The Age of the New." In *Early Modern Science: The Cambridge History of Science,* 3: 1–18. Cambridge: Cambridge University Press, 2006.

Parker, Blanford. *The Triumph of Augustan Poetics: English Literary Culture from Butler to Johnson.* Cambridge: Cambridge University Press, 1998.

Parrett, Aaron. *The Translunar Narrative in the Western Tradition.* Aldershot, UK: Ashgate, 2004.

Pascal, Blaise. *Œuvres complètes.* Ed Michel Le Guern. 2 vols. Paris: Gallimard, 1998.

Patterson, Annabel. "That Old Man Eloquent." In *Literary Milton: Text, Pretext, Context,* ed. Diana Treviño Benet and Michael Lieb, 22–44. Pittsburgh: Duquesne University Press, 1994.

Patterson, Lee. "Court Politics and the Invention of Literature: The Case of Sir John Clanvowe." In *Culture and History, 1350–1600: Essays on English Communities, Identities, and Writing,* ed. David Aers, 7–41. Detroit: Wayne State University Press, 1992.

Pauli, Wolfgang. "The Influence of Archetypal Ideas on the Scientific Theories of Kepler." In *The Interpretation of Nature and the Psyche,* trans. Priscilla Silz. 171–72. New York: Pantheon Books, 1955.

Pavel, Thomas. "Literature and the Arts." In *Descartes' Discourse on Method and Meditations on First Philosophy,* ed. David Weissman, 349–70. New Haven, Conn.: Yale University Press, 1996.

Pemberton, Henry. *A View of Sir Isaac Newton's Philosophy.* London, 1728.

Peterson, Mark A. *Galileo's Muse: Renaissance Mathematics and the Arts.* Cambridge, Mass.: Harvard University Press, 2011.

Pfeffer, Wendy. *The Change of Philomel: The Nightingale in Medieval Literature.* New York: P. Lang, 1985.

Pfizenmaier, Thomas C. *The Trinitarian Theology of Dr. Samuel Clarke (1675–1729): Context, Sources, and Controversy.* Leiden: E. J. Brill, 1997.

Pliny. *Pliny's "Natural History": A Selection from Philemon Holland's Translation* (1601). Ed. J. Newsome. Oxford: Clarendon Press, 1964.

Plotnitsky, Arkady, and David Reed. "Discourse, Mathematics, Demonstration, and Science in Galileo's *Discourses Concerning Two New Sciences.*" *Configurations* 9 (2001): 37–64.

Plutarch. *Moralia,* vol. 12. Trans. Harold Cherniss. Cambridge, Mass.: Harvard University Press, 1957.

Pollard, Alfred W., ed. *Records of the English Bible.* London: H. Frowde, 1911.

Pollard, John. *Birds in Greek Life and Myth.* London: Thames and Hudson, 1977.

Popkin, Richard H. *The History of Scepticism: From Savonarola to Bayle.* Rev. ed. New York: Oxford University Press, 2003.

Popper, Karl R. *Conjectures and Refutations: The Growth of Scientific Knowledge.* London: Routledge & K. Paul, 1963.

Pormann, Peter E., and Emilie Savage-Smith. *Medieval Islamic Medicine.* Washington, D.C.: Georgetown University Press, 2007.

Poulet, Georges. *Studies in Human Time.* Trans. Elliott Coleman. Baltimore: Johns Hopkins University Press, 1956.

Pound, Ezra. *Literary Essays of Ezra Pound.* New York: New Directions, 1954.

———. *Personæ: The Collected Shorter Poems of Ezra Pound.* New York: New Directions, 1950.

Preston, Claire. *Thomas Browne and the Writing of Early Modern Science.* Cambridge: Cambridge University Press, 2005.

Prouty, C. T. *George Gascoigne: Elizabethan Courtier, Soldier, and Poet.* New York: Columbia University Press, 1942.

Purver, Margery. *The Royal Society: Concept and Creation.* London: Routledge & K. Paul, 1967.

Putscher, Marielene. *Pneuma, Spiritus, Geist. Vorstellung vom Lebensantrieb in ihren geschichtlichen Wandlungen.* Wiesbaden: Steiner, 1973.

Raven, Charles E. *English Naturalists from Neckam to Ray: A Study of the Making of the Modern World.* Cambridge: Cambridge University Press, 1947.

———. *John Ray, Naturalist: His Life and Works.* Cambridge: Cambridge University Press, 1950.

Ray, John. *The Wisdom of God Manifested in the Works of the Creation* (1691). 9th ed. London, 1727.

Redondi, Pietro. *Galileo Heretic.* Trans. Raymond Rosenthal. Princeton, N.J.: Princeton University Press, 1987.

Rees, Graham. "Bacon's Speculative Philosophy." In *The Cambridge Companion to Bacon,* ed. Markku Peltonen, 121–45. Cambridge: Cambridge University Press, 1996.

———. *Francis Bacon's Natural Philosophy: A New Source.* Chalfont St. Giles: British Society for the History of Science, 1984.

Reeves, Eileen. *Galileo's Glassworks: The Telescope and the Mirror.* Cambridge, Mass.: Harvard University Press, 1998.

——. *Painting the Heavens: Art and Science in the Age of Galileo.* Princeton, N.J.: Princeton University Press, 1997.

Reiss, Edmund. *The Art of the Middle English Lyric: Essays in Criticism.* Athens: University of Georgia Press, 1972.

Renn, Jürgen, ed. *Galileo in Context.* Cambridge: Cambridge University Press, 2001.

Repcheck, Jack. *Copernicus' Secret: How the Scientific Revolution Began.* New York: Simon & Schuster, 2007.

Revard, Stella P. "Apollo and Christ in the Seventeenth-Century Religious Lyric." In *New Perspectives on the Seventeenth-Century Religious Lyric,* ed. John R. Roberts, 143–67. Columbia: University of Missouri Press, 1994.

Reynolds, Henry. "Mythomystes, wherein a short svrvay is taken of the natvre and valve of trve poesy and depth of the ancients above ovr moderne poets" (1632). In Spingarn, *Critical Essays of the Seventeenth Century,* 1:141–79.

R. H. *New Atlantis. Begun by the Lord Verulam, Viscount St. Albans: and Continued by R. H. Esquire. Wherein is set forth a Platform of Monarchical Government. With a Pleasant intermixture of divers rare Inventions, and wholsom Customs, fit to be introduced into all Kingdoms, States, and Common-Wealths.* London, 1660.

Richards, I. A. *Practical Criticism: A Study of Literary Judgment.* New York: Harcourt Brace, 1935.

Righini, Guglielmo. "New Light on Galileo's Lunar Observations." In Bonelli and Shea, *Reason, Experiment, and Mysticism,* 59–76.

Rodis-Lewis, Geneviève. *Descartes: His Life and Thought.* Trans. Jane M. Todd. Ithaca, N.Y.: Cornell University Press, 1998.

Roger, Jacques. *The Life Sciences in Eighteenth-Century French Thought.* Trans. Robert Ellrich. Stanford, Calif.: Stanford University Press, 1997.

Romanowski, Sylvie. "Cyrano de Bergerac's Epistemological Bodies: 'Pregnant with a Thousand Definitions'." *Science-Fiction Studies* 25 (1998): 414–32.

Roos, Anna Maria E. *Luminaries in the Natural World: The Sun and the Moon in England, 1400–1720.* New York: Peter Lang, 2001.

Rosen, Edward. "Kepler's Attitude toward Astrology and Mysticism." In Vickers, *Occult and Scientific Mentalities,* 253–72.

——. *The Naming of the Telescope.* New York: Henry Schuman, 1947.

Rosenfield, Leonora Cohen. *From Beast-Machine to Man-Machine: Animal Soul in French Letters from Descartes to La Mettrie.* New York: Oxford University Press, 1941.

Rossi, Paolo. *Francis Bacon: From Magic to Science.* Trans. Sacha Rabinovitch. London: Routledge, 1968.

——. "Hermeticism, Rationality, and the Scientific Revolution." In Bonelli and Shea, *Reason, Experiment, and Mysticism,* 247–73.

——. *Logic and the Art of Memory: The Quest for a Universal Language.* Trans. Stephen Clucas. 2nd ed. Chicago: University of Chicago Press, 2000.

Ryle, Gilbert. *The Concept of Mind.* London: Hutchinson, 1949.

Sargent, Rose-Mary. *The Diffident Naturalist: Robert Boyle and the Philosophy of Experiment.* Chicago: University of Chicago Press, 1995.

Sawday, Jonathan. *Engines of the Imagination: Renaissance Culture and the Rise of the Machine.* London: Routledge, 2007.

Schaffer, Simon. *The Information Order of Isaac Newton's "Principia Mathematica."* Uppsala: Tryck Wikströms, 2008.

Schmidle, Nicholas. "A Very Rare Book." *New Yorker*, 16 December 2013, 62–73.

Schmitt, Charles B., Quentin Skinner, and Eckhard Kestler, eds. *The Cambridge History of Renaissance Philosophy*. Cambridge: Cambridge University Press, 1988.

Schmitt, Jean-Claude. *Ghosts in the Middle Ages: The Living and the Dead in Medieval Society*. Trans. Teresa L. Fagan. Chicago: University of Chicago Press, 1998.

Schorske, Carl E. *Fin-de-siècle Vienna: Politics and Culture*. New York: Alfred A. Knopf, 1980.

Schouls, Peter S. *Descartes and the Possibility of Science*. Ithaca, N.Y.: Cornell University Press, 2000.

Schubert, Giselher. "Disharmonie unterm Sternenzelt. Hindemiths Kosmos." *Neue Zeitschrift für Musik* 161, no. 6 (2000): 28–35.

Schwartz, Regina. *Remembering and Repeating: On Milton's Theology and Poetics*. Chicago: University of Chicago Press, 1993.

Sebald, W. G. *After Nature*. Trans. Michael Hamburger. New York: Random House, 2002.

Sebba, Gregor. *The Dream of Descartes*. Carbondale: Southern Illinois University Press, 1987.

Segre, Michael. *In the Wake of Galileo*. New Brunswick, N.J.: Rutgers University Press, 1991.

Sepper, Dennis L. *Descartes's Imagination: Proportion, Images, and the Activity of Thinking*. Berkeley: University of California Press, 1996.

Settle, Thomas B. *Galileo's Experimental Research*. Berlin: Max-Planck Institute for the History of Science, 1996.

Sewell, Elizabeth. *The Orphic Voice: Poetry and Natural History*. New Haven, Conn.: Yale University Press, 1960.

Seznec, Jean. *The Survival of the Pagan Gods: The Mythological Tradition and Its Place in Renaissance Humanism and Art*. Trans. Barbara F. Sessions. New York: Pantheon Books, 1953.

Shadwell, Thomas. *The Virtuoso* (1676). Ed. Marjorie Hope Nicolson and David Stuart Rodes. Lincoln: University of Nebraska Press, 1966.

Shaftesbury, Anthony Ashley Cooper, Third Earl of. *Characteristicks of Men, Manners, Opinions, Times* (1711). 3 vols. Indianapolis: Liberty Fund, 2001.

Shapin, Steven. "'The Mind Is Its Own Place': Science and Solitude in Seventeenth-Century England." *Science in Context* 4 (1991): 191–218.

———. *Never Pure: Historical Studies of Science as If It Was Produced by People with Bodies, Situated in Time, Space, Culture, and Society, and Struggling for Credibility and Authority*. Baltimore: Johns Hopkins University Press, 2010.

———. *A Social History of Truth: Civility and Science in Seventeenth-Century England*. Chicago: University of Chicago Press, 1994.

Shapin, Steven, and Simon Schaffer. *Leviathan and the Air-Pump*. Princeton, N.J.: Princeton University Press, 1985.

Shapiro, Barbara. *Probability and Certainty in Seventeenth-Century England*. Princeton, N.J.: Princeton University Press, 1983.

Sharratt, Michael. *Galileo: Decisive Innovator*. Cambridge: Blackwell, 1994.

Shea, William R. "Galileo and the Church." In *God and Nature: Historical Essays on the Encounter between Christianity and Science*, ed. David C. Lindberg and Ronald L. Numbers, 114–35. Berkeley: University of California Press, 1986.

———. *Galileo's Intellectual Revolution: Middle Period, 1610–1632*. 2nd ed. New York: Science History Publications, 1977.

———. *The Magic of Numbers and Motion: The Scientific Career of René Descartes*. Canton, Mass.: Science History Publications, 1991.

———. "Owen Gingerich's Curious Case." *Galilæana* 7 (2010): 97–110.

Shea, William R., and Mariano Artigas. *Galileo in Rome: The Rise and Fall of a Troublesome Genius*. New York: Oxford University Press, 2003.

Shirley, John. *Thomas Harriot: A Biography*. Oxford: Clarendon Press, 1983.

Shorto, Russell. *Descartes' Bones: A Skeletal History of the Conflict between Faith and Reason*. New York: Doubleday, 2008.

Shuger, Debora. "The Laudian Idiot." In Barbour and Preston, *Sir Thomas Browne*, 36–62.

Sidney, Philip. *An Apology for Poetry*. Ed. Geoffrey Shepherd. Edinburgh: Nelson, 1965.

———. *The Poems of Sir Philip Sidney*. Ed. William A. Ringler, Jr. Oxford: Clarendon Press, 1962.

Silver, Victoria. "'Wonders of the Invisible World': The Trial of the Lowestoft Witches." In Barbour and Preston, *Sir Thomas Browne*, 118–45.

Simon, Gérard. *Kepler astronome astrologue*. Paris: Gallimard, 1979.

Skeat, Walter W., ed. *Chaucerian and Other Pieces, Being a Supplement to the Complete Works of Geoffrey Chaucer*. Oxford: Clarendon Press, 1897.

Solomon, Julie Robin. *Objectivity in the Making: Francis Bacon and the Politics of Inquiry*. Baltimore: Johns Hopkins University Press, 1998.

Solomon, Julie Robin, and Catherine Gimelli Martin, eds. *Francis Bacon and the Refiguring of Early Modern Thought*. Aldershot, UK: Ashgate, 2005.

Spadafora, David. *The Idea of Progress in Eighteenth-Century Britain*. New Haven, Conn.: Yale University Press, 1990.

Spence, Joseph. *Observations, Anecdotes, and Characters of Books and Men Collected from Conversation*. Ed. James Osborn. 2 vols. Oxford: Clarendon Press, 1966.

Spenser, Edmund. *The Yale Edition of the Shorter Poems of Edmund Spenser*. New Haven, Conn.: Yale University Press, 1989.

Spiller, Elizabeth. *Science, Reading, and Renaissance Literature: The Art of Making Knowledge, 1580–1670*. Cambridge: Cambridge University Press, 2004.

Spingarn, J. E., ed. *Critical Essays of the Seventeenth Century*. 3 vols. Oxford: Clarendon Press, 1908–9.

Sprat, Thomas. *History of the Royal Society* (1667). Ed. Jackson I. Cope and Harold Whitmore Jones. St. Louis, Mo.: Washington University, 1958.

Spurgeon, Caroline F. E. *Shakespeare's Imagery, and What It Tells Us*. Cambridge: Cambridge University Press, 1935.

Starobinski, Jean. *Montaigne in Motion*. Trans. Arthur Goldhammer. Chicago: University of Chicago Press, 1985.

Stephenson, Bruce. *Kepler's Physical Astronomy*. New York: Springer-Verlag, 1987.

———. *The Music of the Heavens: Kepler's Celestial Music*. Princeton, N.J.: Princeton University Press, 1994.

Sterne, Laurence. *The Life and Opinions of Tristram Shandy, Gentleman.* Ed. James A. Work. New York: Odyssey Press, 1940.

Stone, Harriet. *Tables of Knowledge: Descartes in Vermeer's Studio.* Ithaca, N.Y.: Cornell University Press, 2006.

Summers, Joseph H. *George Herbert: His Religion and Art.* Cambridge, Mass.: Harvard University Press, 1954.

Svendsen, Kester. *Milton and Science.* Cambridge, Mass.: Harvard University Press, 1956.

Sweetman, Brendan, ed. *The Failure of Modernism: The Cartesian Legacy and Contemporary Pluralism.* Washington, D.C.: Catholic University of America Press, 1999.

Swerdlow, Noel M. "The Derivation and First Draft of Copernicus's Planetary Theory: A Translation of the Commentariolus with Commentary." *Proceedings of the American Philosophical Society* 117 (1973): 423–512.

———. "Galileo's Discoveries with the Telescope and Their Evidence for the Copernican Theory." In Machamer, *Cambridge Companion to Galileo,* 252–60.

Swerdlow, Noel M., and O. Neugebauer. *Mathematical Astronomy in Copernicus's "De Revolutionibus."* New York: Springer-Verlag, 1984.

Swift, Jonathan. *The Prose Works of Jonathan Swift.* Ed. Herbert Davis et al. 16 vols. Oxford: B. Blackwell, 1939–74.

Symons, Dana M. *Chaucerian Dream Visions and Complaints.* Kalamazoo, Mich.: Medieval Institute Publications, 2004.

Szpiro, George G. *Kepler's Conjecture: How Some of the Greatest Minds in History Helped Solve One of the Oldest Math Problems in the World.* Hoboken, N.J.: John Wiley & Sons, 2003.

Thomas, Keith. *Man and the Natural World: Changing Attitudes in England, 1500–1800.* London: Allen Lane, 1983.

———. *Religion and the Decline of Magic.* New York: Scribner's, 1971.

Thomas, W. K., and Warren U. Ober. *A Mind For Ever Voyaging: Wordsworth at Work Portraying Newton and Science.* Edmonton: University of Alberta Press, 1989.

Thomson, James. *The Seasons* (1726–46). Ed. James Sambrook. Oxford: Clarendon Press, 1981.

Thoren, Victor E. *The Lord of Uraniborg: A Biography of Tycho Brahe.* Cambridge: Cambridge University Press, 1990.

Thorne, Christian. *The Dialectic of Counter-Enlightenment.* Cambridge, Mass.: Harvard University Press, 2009.

Thrale, Hester Lynch. *Thraliana: The Diary of Mrs. Hester Lynch Thrale.* Ed. K. C. Balderston. 2 vols. Oxford: Clarendon Press, 1942.

Thrower, Norman J. W., ed. *Standing on the Shoulders of Giants: A Longer View of Newton and Halley.* Berkeley: University of California Press, 1990.

Tolstoy, Leo. *Tolstoy on Shakespeare: A Critical Essay on Shakespeare.* Trans. V. Tchertkoff and I. F. M. New York: Funk & Wagnalls, 1906.

Topsell, Edward. *The Fowles of Heauen or History of Birdes* (1613–14?). Ed. Thomas P. Harrison and F. David Hoeniger. Austin: University of Texas, 1972.

Toulmin, Stephen. *Cosmopolis: The Hidden Agenda of Modernity.* New York: Free Press, 1990.

Tracy, Clarence. "Johnson and the Common Reader." *Dalhousie Review* 57 (1977): 405–23.

Treviranus, Gottfried Reinhold. *Biologie oder Philosophie der Lebenden Natur für Natur-forscher und Aerzte.* Göttingen, 1802–22.

Vailati, Ezio. *Leibniz & Clarke: A Study of Their Correspondence.* New York: Oxford University Press, 1997.

Valéry, Paul. *Masters and Friends.* Trans. Martin Turnell. Princeton, N.J.: Princeton University Press, 1968.

——. *Œuvres.* Ed. Jean Hytier. Paris: Gallimard, 1957.

Van Helden, Albert. "Galileo and the Telescope." In Van Helden et al., *Origins of the Telescope,* 183–201.

Van Helden, Albert, Sven Dupré, Rob van Gent, and Huib Zuidevaart, eds. *The Origins of the Telescope.* Amsterdam: KNAW Press, 2010.

Vartanian, Aram. *Diderot and Descartes: A Study of Scientific Naturalism in the Enlightenment.* Princeton, N.J.: Princeton University Press, 1953.

Vergil, Polydore. *On Discovery* (1499). Trans. Brian P. Copenhaver. Cambridge, Mass.: Harvard University Press, 2002.

Vicari, E. Patricia. *The View from Minerva's Tower: Learning and Imagination in "The Anatomy of Melancholy."* Toronto: University of Toronto Press, 1989.

Vickers, Brian. "Frances Yates and the Writing of History." *Journal of Modern History* 51 (1979): 287–316.

——, ed. *Occult and Scientific Mentalities in the Renaissance.* Cambridge: Cambridge University Press, 1984.

Voelkel, James R. *The Composition of Kepler's "Astronomia Nova."* Princeton, N.J.: Princeton University Press, 2001.

Voltaire. *The Elements of Sir Isaac Newton's Philosophy.* Trans. John Hanna. London, 1738.

——. *Letters on England* (1733). Trans. Leonard Tancock. Harmondsworth, UK: Penguin Books, 1980.

von Franz, Marie-Louis. "The Dream of Descartes." Trans. Andrea Dykes and Elizabeth Welsh. In *Timeless Documents of the Soul,* ed. Helmuth Jacobsohn. Evanston, Ill.: Northwestern University Press, 1968.

Walker, D. P. "Francis Bacon and *spiritus.*" In *Science, Medicine and Society in the Renaissance,* ed. Allen G. Debus, 2:121–30. New York: Science History Publications, 1972.

——. *Studies in Musical Science in the Late Renaissance.* London: Warburg Institute, 1978.

Warton, Thomas. *The History of English Poetry, from the Close of the Eleventh to the Commencement of the Eighteenth Century.* 3 vols. London, 1774–81.

Watson, Richard. *Cogito, Ergo Sum: The Life of René Descartes.* Boston: David R. Godine, 2002.

Watson, Robert N. *Back to Nature: The Green and the Real in the Late Renaissance.* Philadelphia: University of Pennsylvania Press, 2006.

Wear, Andrew. *Knowledge and Practice in English Medicine, 1550–1680.* Cambridge: Cambridge University Press, 2000.

Weber, Max. "Science as a Vocation." In *The Vocation Lectures,* ed. David Owen and Tracy B. Strong, trans. Rodney Livingstone. 1–31. Indianapolis: Hackett, 2004.

Webster, Charles. *The Great Instauration: Science, Medicine and Reform, 1626–1660.* London: Duckworth, 1975.

———. *Paracelsus: Medicine, Magic, and Mission at the End of Time*. New Haven, Conn.: Yale University Press, 2008.

Webster, John. *The White Devil* (1612). Ed. F. L. Lucas. London: Chatto & Windus, 1958.

Weeks, Andrew, *Paracelsus: Speculative Theory and the Crisis of the Early Reformation*. Albany: State University of New York Press, 1997.

Weidhorn, Manfred. *The Person of the Millennium: The Unique Impact of Galileo on World History*. Lincoln, Neb.: iUniverse, 2005.

Weinberg, Bernard. *A History of Literary Criticism in the Italian Renaissance*. 2 vols. Chicago: University of Chicago Press, 1961.

West, William N. "Brownean Motion: Conversation within *Pseudodoxia Epidemica*'s 'Sober Circumference of Knowledge'." In Barber and Preston, *Sir Thomas Browne*, 168–87.

Westfall, Richard S. *The Construction of Modern Science: Mechanisms and Mechanics*. New York: Wiley, 1971.

———. *Never at Rest: A Biography of Isaac Newton*. Cambridge: Cambridge University Press, 1980.

———. "Newton and His Biographer." In *Introspection in Biography: The Biographer's Quest for Self-Awareness*, ed. Samuel H. Baron and Carl Pletsch, 175–89. Hillsdale, N.J.: Analytic Press, 1985.

———. "The Scientific Revolution Reasserted." In Osler, *Rethinking the Scientific Revolution*, 41–55.

Westman, Robert S. "Nature, Art, and Psyche: Jung, Pauli, and the Kepler-Fludd Polemic." In Vickers, *Occult and Scientific Mentalities*, 177–229.

Whitaker, Ewan A. "Galileo's Lunar Observations and the Dating of the Composition of *Sidereus Nuncius*." *Journal for the History of Astronomy* 9 (1978): 155–69.

———. "Selenography in the Seventeenth Century." In *Planetary Astronomy from the Renaissance to the Rise of Astrophysics*, pt. A, *Tycho Brahe to Newton*. Ed. René Taton and Curtis Wilson. 119–43. Cambridge: Cambridge University Press, 1989.

White, Alan R. *The Language of Imagination*. Oxford: B. Blackwell, 1990.

White, Michael. *Isaac Newton: The Last Sorcerer*. London: Fourth Estate, 1997.

Whitehead, Alfred North. *Science and the Modern World*. New York: Macmillan, 1925.

Whiteside, D. T. "Newton the Mathematician." In *Contemporary Newtonian Research*, ed. Zev Bechler, 109–28. Dordrecht: D. Reidel, 1982.

Wilding, Michael. *Dragon's Teeth: Literature in the English Revolution*. Oxford: Clarendon Press, 1987.

Willey, Basil. *The Seventeenth Century Background*. London: Chatto & Windus, 1934.

Williams, Bernard. *Descartes: The Project of Pure Enquiry*. Hassocks, UK: Harvester Press, 1978.

Willughby, Francis. *The Ornithology of Francis Willughby . . . In Three Books, Wherein All the Birds Hitherto Known, Being reduced into a Method sutable to their Natures, are accurately described, translated into English with Three considerable discourses, by John Ray*. London, 1678.

Wilson, Catherine. *The Invisible World: Early Modern Philosophy and the Invention of the Microscope*. Princeton, N.J.: Princeton University Press, 1995.

——. "Soul, Body, and World: Plato's *Timaeus* and Descartes' *Meditations.*" In *Platonism at the Origins of Modernity: Studies on Platonism and Early Modern Philosophy*, ed. Douglas Hedley and Sarah Hutton, 177–91. Dordrecht: Springer, 2008.

Wilson, Curtis. *Astronomy from Kepler to Newton: Historical Studies*. London: Variorum Reprints, 1989.

Wilson, Edward O. *Consilience: The Unity of Knowledge*. New York: Knopf, 1998.

Wimsatt, W. K. *The Prose Style of Samuel Johnson*. New Haven, Conn.: Yale University Press, 1941.

Winkler, Mary G., and Albert Van Helden. "Representing the Heavens: Galileo and Visual Astronomy." *Isis* 83 (1992): 195–217.

Wittgenstein, L. *Lectures & Conversations on Aesthetics, Psychology and Religious Belief*. Ed. Cyril Barrett. Berkeley: University of California Press, 1972.

Wootton, David. *Galileo: Watcher of the Skies*. New Haven, Conn.: Yale University Press, 2010.

Yates, Frances A. *The Art of Memory*. Chicago: University of Chicago Press, 1966.

——. *Giordano Bruno and the Hermetic Tradition*. Chicago: University of Chicago Press, 1964.

——. "The Hermetic Tradition in Renaissance Science." In *Art, Science, and History in the Renaissance*, ed. Charles S. Singleton, 255–74. Baltimore: Johns Hopkins University Press, 1967.

——. *The Rosicrucian Enlightenment*. London: Routledge and Kegan Paul, 1972.

——. *Theatre of the World*. London: Routledge & K. Paul, 1969.

Yolton, John W. *John Locke and the Way of Ideas*. Oxford: Clarendon Press, 1968.

Zagorin, Perez. *Francis Bacon*. Princeton, N.J.: Princeton University Press, 1998.

✍ INDEX